PIN–UP

INTERVIEWS

powerHouse Books
Brooklyn, NY

INTERVIEWS

The most fruitful and natural exercise for our minds is, in my opinion, conversation.

Michel de Montaigne

Every issue of PIN–UP is driven by the desire to introduce the culture of architecture and design to new audiences. Fueled by a healthy curiosity for the fresh and the new, but also the forgotten and the overlooked, PIN–UP never shies away from the seemingly superficial — but always with the belief that surfaces are deceptively shallow, hiding surprising depths, and that a less serious approach can often be the more revealing. Nowhere is this more apparent than in the many interviews that have been the cornerstone of the magazine since the first issue in November 2006. These friendly PIN–UP chat sessions allow architects, artists, and designers to break out of their formal molds, dropping trade jargon in favor of candid revelation. Here, 57 fascinating creative personalities tell it like it is in plain, straight, unembellished speech. The result is an unorthodox architectural tome that is as funny and fun as it is smart and thought provoking — 448 pages of unadulterated architectural entertainment.

Felix Burrichter
Editor/Creative Director

INTERVIEWS

LONDON

DAVID ADJAYE

Interview by Nicholas Boston

David Adjaye describes what he does as helping to birth an architectural network. So it was no surprise that on the day we spoke, in an airy conference room at the 42-year-old architect's North London headquarters, the water broke.

An excitable and demonstrative talker, Adjaye's depth perception suddenly took a trip and with the sweep of one hand he toppled his water glass, shattering it. No one was more alarmed than Adjaye himself. "Sorry, sorry, sorry!" he said, with a look of astonishment as if he didn't know his own strength. He quickly returned to discussing the thing that had excited him in the first place: *AMA*, which stands for African Metropolitan Architecture. Ten years in the making, it is Adjaye's fourth book. At 700-plus pages, *AMA* is an architectural planner's archive, visually articulating the urban design and layout of all 53 capital cities on the African continent.

"I'm an Akan boy," Adjaye said, referring to the ethnolinguistic group in Ghana to which he belongs. (Adjaye was born to Ghanaian parents in Dar Es Salaam, Tanzania, but raised from a very early age in London.) "In Ashanti culture there are male and female names for the first day of the week, Kofi and Ama. Ama is the feminine figure, and all things creative. So, I love this book being called *AMA*. I got a little girl!"

Nicholas Boston	You opened a branch in Berlin. What is it about that city that made you feel it was the right site for an office?
David Adjaye	Berlin happened because we won a competition in the city for an urban-infill project and so we had to have a presence there. On the back of that, we were doing some private work for a few of our clients, so it just sort of made sense. Berlin, for me, is really the center of Europe. Geographically, there is something very strategically important about Berlin. Making a practice in Berlin could, in one way, be seen as unnecessary, but in another way it is strategically very necessary to be connected to a sort of European paradigm. I think it's no irony that all the artists move there — some friends of mine have studios there or have worked there — and there's a very strong cultural life. I wanted to be part of that. Right now, our Berlin branch is working on a project in Düsseldorf, projects in Switzerland, projects in the East, in Kiev. It's a small studio, a very small team. They do art projects, studio projects, competitions, that sort of thing.
NB	How is that different from your practice in London and also your practice in New York? How would you differentiate the three?
DA	Well, Berlin is the little studio atelier. London is the administrative network center, the hub. London is where it originated, so it's the genesis of our whole idea of practice. It's evolved to become the office that prototypes the strategies for all the other places. It's still a studio office — it's very much not trying to be a commercial office — but large-scale models are getting laid here, all the big computer stuff, mock-up facades and all that kind of stuff. New York happened because of winning the commission for the Denver Museum of Contemporary Art in 2004, and then in the last year suddenly starting to win quite a lot of projects in America and having to spend a lot of time in the States; I suddenly realized that maybe this idea that I'd prototyped in Berlin was a way of making a practice. This discombobulated network of sites offers me an opportunity to have different cultures operating that I move *into*. So it's not always about a kind of imperial London studio going *out* into the world; it's more like making localized networks. I'm very interested in that and I will open more offices. But when I say I'm opening an office, I really mean I'm opening studios. You know, the same way that a painter, if he's working in a certain locale, will leave the work there, so that when he returns to the work, it's still in the mood of the climate, as it were. I slightly see my practice that way. Like, you know, when I go to New York, I'm in a very different frame of mind. We have an office on Canal and Broadway, and it's a big lofty space and it's very much about a certain kind of production. I have my little room there and when I go, I work in a very New York sort of way, I've noticed. And I kind of like that. I like this idea of different practices in different places.

NB I know you don't personally assign the names to many of the public spaces that you design and build, but Bernie Grant1, Stephen Lawrence2 — there's been a lot of naming and remembrance attached to your work. What is your opinion of the need to honor and memorialize in the built environment, given that that can become problematic in certain ways?

DA Of course. I think, just intellectually, that it can become deeply problematic. But at the same time I think that that kind of criticism misses the point of what I call a birthing of this kind of moment, architecturally. Every 40 years, 50 years, there's a birthing of new institutions — buildings — which have names. Either it's the Whitney or the Rockefeller Center, or whatever. In those contexts, we all happily accept the language. Those names become just a part of the history of the city. But then when we have a birthing again of a collection of new names, there's controversy: is it important to name these buildings? And I'm thinking, "What are you talking about? That's what cities do!" Cities have always brought named structures into being and it's only history that judges whether they're valuable and lasting or not. I found that in the late 90s we hit this kind of moment, especially in England. A lot of my projects were about synthesizing, or rebirthing, a new identity or a new sentence to the story. There was an explosion, or a mini-eruption, of "black" institutions that moved from being agencies hidden within the fabric of the city to becoming monuments that are actually ascribing an emotion and adding to the context of the city at large. I thought that was fascinating. In making those public buildings I was trying to ascribe not a singular monumentality to these spaces, but a network monumentality. What was happening is that there was a network developing or becoming visibly inscribed, publicly, which had the effect of forming the psychology of a whole generation. I mean, I have young kids who already have this nexus within their brain. It's really interesting because I never even remotely had anything like this in my brain at their age. You know, they can say to themselves, "Well, in New York there's the Studio Museum, in London there's this," and it's, like, a really big deal. As an architect, I feel that my job is to allow that to become a debate. I've had these kinds of conversations where people are like, "Do we want a 'Stephen Lawrence' center? Do we want a 'Bernie Grant' center?" In America, this would not be an issue; nobody would even blink, because everything is named; everything is about private patronage. Whereas here in London we're still trying to get used to the idea that, actually, private patrons kind of exist and, actually, they've always been the ones to make things. Now we have a government which is kind of realizing this, so they're allowing this kind of "new" culture to come to England and people are naming institutions after themselves in this country. It's actually seen as a new phenomenon and is slightly tripping people out in England because we are just not used to it. We're slightly like, "Is it vulgar?"

NB You say that a younger generation now has this landscape — this road map — in their minds, of built spaces housing institutions that form a network of sites which represents their cultural positionality. But there are also the

people who steer or are central to those institutions, many of whom you've worked with: Thelma Golden, the director of the Studio Museum in Harlem in New York, the cultural theorist Stuart Hall here in London, the artist Chris Ofili, and a number of other people who together form a network, whether formal or informal. How important do you think this idea of social networks is in terms of getting work done?

DA I think that there isn't a direct relationship between network and production, but there is certainly a kind of intellectual debate that a network can foster. All those people you mentioned are friends first, from [critic and curator] Okwui Enwezor right through. They are people I've known for ages, and they're my generation. People like Stuart Hall are the generation I looked up to and whom I finally got to meet and articulate ideas with. What is interesting to me is that now in the 21st century there is actually, for the first time, this very public network of black people — black people in the West — operating in the cultural industries as a very visual and visualizing force. And I find it very encouraging. I think it's absolutely what should be around. What I hate is when people think that somehow the network *makes* work, that, you know, you get work — you get commissions, you get shows — because you know these people. It's not true. I'm getting work from people who have no idea about these other people. I'm more unsure about the relationship between network and material production, but I am completely convinced of the idea that the network produces a debate, which itself becomes currency, informally or formally sometimes — you know, just by the discourse that occurs in a circular motion through the groups. We're all migratory in our kind of scenarios. We experience things, we meet, we talk. And that has its impact and influence. But the process is not formalized. So "the network," for me, is just a human way of dealing. It's so fundamental to my intellectual life just to be stimulated and to engage, not to be in a vacuum but in a context which has different outreaches — writers, curators, artists. The great thing about any period is that you are connected to a group of people who are mining culture and society and speculating about where it could be and what it can do. So I'm actually neither saying "the network" is a problem, nor am I saying it's an advantage, because I think if you say it's an advantage, it starts to imply that that's a strategic methodology, which I certainly don't intend. I'm not interested in describing methodology. But it's definitely a very important part of my life — the people that I talk to and the people that I debate with are structural to my life.

NB When you hear people talking about a cool, international black pack, what do you think of?

DA Is that what they're actually saying now? [Laughs.]

NB I've heard it said myself. [Laughs.]

DA Oh. My. God. "The Cool International Black Pack." Sounds like a Vegas show! A Broadway production! Well, I think that it's hilarious, but it definitely has to do with this idea that it's never been allowed to exist before. Actually, I just

got back to London last week — I'm enjoying *ten* days in London, I'm really enjoying it — but I came back and I saw [the special "black"] Italian *Vogue* and that's kind of incredible. I mean, it's cliché but it's also incredible that it's, like, celebrating black models' beauty. But I was with friends, some black friends of mine, and they were all really excited, and then there were some Indian people and they were not that excited. They were just like: "What's going on? Why are they doing this? What is this about?" It was just like... there it is. Oh God, why would they do that? Cause it's kind of great? It's beautiful? I don't know.

NB I was talking to the artist Steve McQueen about this issue of Italian *Vogue* and he was excited about it, but then he was saying that there are no adverts in it endorsed by black models. But the thing is there are no contracts, so what do you expect?

DA There are no contracts, and there's no contact. I mean, all the diaspora follows *Vogue* as a kind of style leader, but actually, somehow, those brands that advertise in magazines like *Vogue* see themselves as white brands really. You know, they don't see themselves as catering to minorities. The minorities are supposed to aspire, but the advertisers' main audience, as they see it, is the wealthy white population. That's what's so depressing about fashion for me. If it ain't some kind of trust-fund-looking white girl, it ain't gonna sell. Because they don't know that many images of the bourgeois black girl. I mean, they haven't been to Lagos! If they had, they would know! [Laughs.] It's like, how many dozens of billionaires' daughters are there out in Lagos that nobody knows about? You guys have no idea. They're like 16 and they're busting ten-grand Chanel bags like nothing. What do they do? They don't walk to the shops, they get on a private jet to go shopping. I'm sorry, that's like way above the New York girl who's strolling down to Fifth Avenue, or wherever. This is a whole other level of operation, where it's like, "Okay, Daddy, let's get on the jet, let's go shopping!" [Laughs.] So I think it's actually a bit naïve of the global brands and their misperceived idea about what wealth is. Wealth is happening everywhere. This new definition of wealth means that all these brands, within the next 15, 20 years, are going to have to completely redefine exactly how they operate. It can no longer be so centric; it has to be polycentric. I was talking to a team that is developing a massive project in the Middle East, and I was making the point that: "Excuse me, you're going into brown turf now." I mean commercial enterprise is the most ruthlessly unfair thing. It's unfair because it's only interested in whatever will get it what it needs, which is cash. So if that means it has to be as racist as possible, as eugenic [laughs] as possible, it utterly will be. And it also means that if it has to become absolutely very liberal and embracing, it will, because that's where the money is. It will be ruthlessly embracing. I recently started working with the menswear designer Ozwald Boateng on his stores. Ozwald wants to do, kind of, global-lifestyle things, because that's the natural progression of his brand and what he does. I don't think of myself as a brand in the way that Ozwald operates

because, you know, for me, the idea of "brand" is very much a fashion idea; it's really very much how fashion organizes itself, sees itself. The word is then borrowed and dumped on other designers, but we really don't operate that way. I mean, I build buildings. Architecture is about the production of cities, about contributing to debates about what the infrastructure of the city is — how does it evolve, how does it grow, do we need to destroy it, do we need to remake it?

NB The 52 capital cities in Africa.

DA Fifty-three! My gosh, a black man not knowing the number of capital cities in Africa! [Laughs.]

NB I know! Take my card away! [Laughs.]

DA O.K. Serious now. I'm basically making an archive. I'm not doing a Rem Koolhaas book about, you know, deconstructing the meaning of blah, blah, blah… [Laughs.] You know, that's great, but he does that. And he does it really well. I'm not interested in any way in competing with that. I just saw that the whole idea of Africa became a, kind of, exoticized leisure destination. And I found that even in intellectual circles. It is still highly exoticized. Fortunately, as a child I traveled through a lot of African countries and I still do, because I'm interested… because I'm interested in black people… because I'm a black person [laughs], so that's what I do. But I certainly found that in the public mind there were no images. Have you been to Lagos? It's like one of the most metropolitan cities in the world. It's more metropolitan than Shanghai, more metropolitan than Tokyo even. It's as complex and as nuanced. Lagos residents are the most sophisticated urbanites, if you understand the city as a piece of artificial infrastructure. There are 30-million people living in an urbanized plate. The infrastructure might be failing but it's a plate and they've been doing it for a very long time, and it's a hyper-density that nobody's actually understood. They are streets ahead in terms of understanding urbanism, I mean urbanism as a kind of testing the boundaries of what the city infrastructure can handle. They're beyond Manhattan. So, for me, city is about what is the network, how is it used, who uses it, and who's used to it? The idea of urbanism is a very sophisticated playing game in most African minds. And so I just thought, look, let me just take the metropolitan condition of these 53 different nations and just let me show you.

MIAMI

DANIEL ARSHAM

Interview by Felix Burrichter

Daniel and I meet in his studio in Miami's Design District, about 20 minutes' drive from Miami Beach, just north of the city's downtown. It's a small part of Wynwood, an area mostly known as a lower-middle-class neighborhood where an increasing number of artists are choosing to live. The Design District constitutes approximately four blocks of expensive Italian design stores, galleries, and trendy boutiques — It's the Rodeo Drive of design, with a strange flavor of East Village bohemia drenched in the ever-so-tropical Miami sun. Daniel's studio — which he and a group of friends converted from a former restaurant — is in the back alley of a small building lot, right next to a run-down, one-story, pink building with a purple glass-cube wall. Daniel greets me on the street, and inside I have to adjust my eyes from the glistening sun to this long, dark space, subdivided into several working areas for different artists. We walk through an arc of tinted mirrors that is a remnant of the restaurant; there is no daylight, and few furnishings, except for a table, a bookshelf, and a cuckoo clock. Daniel offers me a big, comfortable, brown-leather chair to sit in while he reclines on a barstool.

Felix **I feel like you should be sitting here.**
Burrichter

David **You wanna switch?**
Arsham

FB Yeah I think that's better.

We switch seats.

FB Do you also live here?

DA No. I live on the beach. But I sometimes fall asleep in this chair...

FB What I find so remarkable about your work is that it has so many architectural elements in it. What's your background?

DA The high school I went to is actually just across the street from here, the Design and Architecture Senior High School. It's this kind of program where, in addition to the regular curriculum, they have all these architecture and design courses. So I did take that step pretty early on. And then I went to Cooper Union. Even though I wasn't enrolled in the architecture program, the architects shared the same shop as the sculpture classes, so a lot of friends from school were architects.

FB But every single one of the subjects you work on has some relationship with architecture; are you an *architecte manqué*, or do you feel you can express architecture better through art than through actual architecture?

DA I'm not sure. The closest thing that I've ever wanted to do in terms of constructing a complete space is that 1:3 scale model of the Emmanuel Perrotin gallery here in Miami. But that piece still remains a model, it's not a real space. It's a functional space, but its function is still that of a temporary viewing space. I think of my general interest in architecture more in the sense of a complete sculpture. With these things that I've done, like the building cuts and the building cavities in the walls, by activating that piece of the architecture, the whole space becomes part of that work. If you're using the wall or whatever form is there, the relationship between that and with whatever is right next to it essentially becomes the whole body of work. Even the building can become part of the work that way.

FB When I look at your work I almost read some sort of Modernist critique that leads like a red thread throughout. You seem very influenced by recent architectural history.

DA The relationship between the scale of modern architecture and the natural environment fascinates me. My cave drawings started because I went to these caverns in New Mexico; prior to that I had been doing a series of architectural models based on Le Corbusier's Domino proposal and taking that design that was never put into action and projecting this phrase of

"WANT WANT WANT," over and over. And then I went to see the caverns in New Mexico, and these spaces are amazing. They're easily a quarter of a mile high. It's like being in a circular skyscraper. So I felt that the monumentality of modern architecture is dwarfed compared to this natural phenomenon. Based on that I started drawing the caves and at some point the architecture and the caves kind of combined, and the architecture looks almost like something growing from the cave, like some giant stalagmite.

FB Imagery-wise there seems to be an idolization of modern architecture, but when you look at the titles you give your work, for example the iceberg pictures, it seems the architectural object has a negative effect on its environment.

DA Yeah, it's a complicated relationship. It's a love-hate thing. I feel like architects should have known that the only outcome of Modernism's social ambitions would be failure. I mean, none of it is really working out. In terms of alleviating any of society's ills by creating a clear open space where the way the building stood was rendered explicit and you could see the I beams, you know, that whole thing of not hiding the apparatus that makes the building stand, I just feel that it's technological naïveté; it's more about the idea of the advancement of technology than exploring actual possible means of creating something beautiful.

FB There is kind of an urban legend that has been spun around the Seagram Building. It was said that originally Mies van der Rohe wanted all the blinds of the building to be synchronized. If someone wanted the blinds down, they would have all had to go down at the same time. And if somebody wanted them back up again, they would all go up together.

DA Really? That would have been pretty amazing to watch.

FB So you like to explore the really hyper-controlling aspect of the Modernist aesthetic in your work?

DA Yes, although in more recent work I am kind of stepping back from that, and the natural and the man-made parts of the architectural forms are becoming simpler and simpler, to the point where in some of the drawings they're just blocks, something that's very definable. And some of them are staircases, and they start to resemble these kind of usable forms, so it's like you're stepping back, how you get from the skyscraper to the column to the white wall. It's kind of regressive. And then those blocks are not necessarily specific to a particular style in architecture. They're more these archaic, basic elements of architecture.

FB Those drawings reminded me a little bit of Superstudio's work in the 1970s.

DA Obviously, I've seen their work a lot and I've known about it for a very long time. Their project of the Continuous Monument, this idea of this thing that goes all around the world, definitely has some kind of relationship with these drawings. That project dated from an era when the International Style

was at its height, and I feel it was a critique of this homogenous architectural form that was everywhere. So I think formally there's a connection, but my work is more about the reason why those forms are shaped the way they are.

FB Superstudio's idea was to create this homogenous gridded landscape and for that to be the new continuous surface of the earth from which they would then cut out pieces of nature or some kind of form of life. When I look at your series of drawings with the architectural objects, it almost seems as if nature has reappropriated them and turned that process around.

DA Exactly. Instead of having nature piercing out of the squares in the grid, it's the reverse where the cubes are piercing out of nature.

FB So is there a narrative behind that process?

DA Not really. When I started looking at the drawings all together, when I had them all lined up next to each other, I noticed that a lot of them started to look like they're in between this place of being constructed and being demolished. Here in Miami, it's really strange, because you see so many projects being built now. You'll see a building that's under construction and right next to it one that's being demolished, and there is this point where they meet in the middle, this time period where the building that's being made looks almost identical to the one they're tearing down. And similarly in these drawings the forms kind of imply something; for instance, the staircase implies that it leads up to something, the columns imply a slab sitting on top. I made sure that there were absolutely no cracks in any of these shapes: they all look like they're new. To me they look like they're existing, and the thing that was there is gone now.

FB Are you from Miami?

DA I was born in Cleveland, Ohio, but I grew up in Miami, and I've been here almost my whole life. The past summer I spent a few months in New Mexico, in Carlsbad where I visited the caves. I also went to White Sands, New Mexico. It's the most purifying white sand you've ever seen. That's where they did the first nuclear testing. It feels like being on the moon, and the sand almost feels like snow. It's amazing.

FB So do you have a place in New Mexico?

DA No. My girlfriend had been living there the year before, and so I wanted to finish up the work for my last show and I decided to go there. I really like the area.

FB You explored all these different aspects of iconic Modernist architecture and of these very basic architectural forms. How do you go from that to the Tiffany Stained Glass project that you did for your exhibition at your last show at Emmanuel Perrotin in Paris?

DA I think that's a whole different idea that I've been working on. The Arts and Crafts movement has really interested me, especially its relationship

between nature and architecture, and the mixture of the two, where neither one loses its prominence. So that project is more about simplifying that type of form down to something that's made of materials that are readily available. In this case it was a Tiffany-style stained-glass ensemble, except it was made of tar paper, which is also a material that is originally meant to protect from the elements, just like stained glass would shield you from the glances of the outside world. What is interesting is that when you see my installation from the inside, you can see through the silhouette of the various translucent layers of the tar paper, but on the reverse side, when you look in from the outside, it looks like a carpet that has been hung, as if there is construction going on or something. In that way, your view from the inside is perfect, but from the outside back in is not.

FB So this was inspired by Arts and Crafts, where architecture and nature have a very symbiotic relationship, and then your other drawings show a very harsh contrast between the two. Do you work on that simultaneously, or are those different working periods?

DA Well, the placement of these stained glass windows had a lot to do with the columns that were shown in the same space, these kind of broken stalactite/stalagmite columns. If you like, the Tiffany windows were kind of a way to start the argument of contemporary re-integration of the natural back into architecture. These days, that only happens as an accident, or it's always a haunting reminder, like peeling paint. That's the only way that the natural has a right to exist in modern architecture. And in the columns installation it's a complete rupture — it's pushing that idea of imperfection. The perfect white-wall gallery space doesn't have any type of natural integration to it, and the wall cavities that I did for the same show, but also for PS1's Greater New York show, try to play with the relationship of the perfect space and nature. They're these anomalies, although I don't really like that word, because it has this paranormal ring to it. But the thing about them is that they remain white, but they are not completely destructive; they remain within the boundaries of the material. In a way it's corrupting the perfect white space with a kind of natural form.

FB Most of the time when you install your work in a gallery, it's always in that perfect white space. Here in Miami it's more of a modern building; in Paris it's an old building. But it's always the same...

DA ...white space. [Laughs.]

FB Have you ever seen your work presented in a different, more personal setting?

DA Ideally my work, especially the sculptures, would appear in spaces that are functional beyond simply being an exhibition space. But somehow in those kinds of spaces they seem much more real, almost threatening. I had a study for a leaking air-conditioning grid in my studio for the past six months, and it was so much more powerful in this real-life setting. In a gallery space, obviously the setting is constructed, and they look more designed.

FB When I first saw small formats of your drawings, I thought they were actual photographs because they looked so hyper-real.

DA When you see them up close, though, they don't! It's funny because people always ask me if they are photographs, and I'm like, "I'm not that good!" I mean, all the drawings are made based on photographs: I make collages first and then I carefully construct the perspectives, and then I start painting.

FB So do you have the fantasy at all to actually take the objects and reality and transform them into a kind of Land Art installation?

DA The only piece I made in a small scale where I've ever thought it would be interesting to do that is the *Staircase Sculpture*. Its structure is completely separated from the functional apparatus of a building. It just stands for itself. It's closed all around, so it's basically a tower that you walk up. I'd love to see one of those things erected somewhere in the middle of nowhere. Kind of like a form in itself, but also a place from which you can see other things elsewhere. Besides that, all my drawings from that series were called *Blank Proposal*, so they remain proposals, but they're not meant to be realized.

FB You said you live in Miami Beach. Does your personal living space reflect your interest in architecture?

DA Well, one day I would definitely like to have my own space that I would like to design myself. But right now my apartment would probably tell you less about me than about my girlfriend.

NEW YORK

SHIGERU BAN

Interview by Kevin Greenberg

Vaulted to fame early in his career for his innovative structural use of cardboard and paper, Shigeru Ban is now equally well known for temporary humanitarian-aid housing, as well as for his geeky fascination with moving parts and mechanical elements. At the same time, luxury developers find their appetites increasingly whetted by the low-slung elegance he brings to residential commissions.

Born in Japan and trained in the U.S., Ban shuttles between offices in New York, Paris, and Tokyo — just as his architecture continually shifts between the temporary and the permanent, the moving and the fixed, the primitive and the polished, as if always trying to escape easy summary or categorization. The same can be said of the man himself: he walks quickly, with a nervous gait, his face a mask, his dark eyes glittering sharply behind a composed, sometimes quizzical expression, often obscured by his trademark mustache. He grows still in conversation and his words become quiet, measured, and precise — rather like the old-fashioned dining room at the Kitano, an elegant Japanese-style hotel on Manhattan's Park Avenue, where PIN–UP met him.

Kevin Greenberg	It's interesting that you chose to stay at the Kitano.
Shigeru Ban	Not really. I simply prefer Japanese service. But my room actually has a western-style bed. Traditional Japanese tatami-mat rooms are a little bit... [Laughs.]

KG You're not traditionally Japanese anyway. To begin with, you never studied in Japan. You were first at SCI-Arc in Los Angeles, and then at Cooper Union in New York, with architect John Hejduk as your professor.

SB Yes, I was a big fan of John Hejduk and he was the reason I wanted to come and study in the U.S. He was teaching at Cooper Union, but they would only accept foreign students who transferred from another U.S. school, so that's how I ended up at SCI-Arc first.

KG But as a Japanese architect...

SB Why would you consider me a Japanese architect? Because I was born in Japan? I was educated mainly in the U.S. and have worked mostly outside of Japan.

KG But your primary office is in Tokyo.

SB I mostly live in Paris now. I have no projects in Japan, or very few. The Tokyo office is focused on work in other countries.

KG Would you like to do more projects in Japan?

SB Yes, because it's actually the easiest country in which to make a building. The clients are not so aggressive, and also the general contractors are very well trained in their support and respect for the architect. Sometimes it's very difficult to work with general contractors abroad.

KG What has your experience been like building in New York in recent years, for instance with the Metal Shutter Houses you're working on right now?

SB New York is my second home, and I have my business partner Dean Maltz here, who was a fellow student at Cooper Union. We've known each other for more than 25 years, so working here is very comfortable for me.

KG This fall Rizzoli is publishing an entire book about your work with paper. How did that come about?

SB Actually, before Rizzoli came to me, another publisher had already asked me to publish a monograph, and I had accepted. When Rizzoli approached me, I told them I didn't want to make the same kind of book twice, but if there was some kind of specific theme for this book I'd be very interested. So we agreed to focus on my paper-tube structures, temporary structures, and disaster relief, which are among the key themes of my career.

KG What drew you to paper as a material in the first place? Does it have some

special significance, or was it simply its structural properties that interested you as a young architect?

SB I'm fascinated with any material and with finding out the potential beauty of it. I'm not developing anything new, just using existing structure differently. In the beginning, paper was simply a replacement for timber. When I started working on my own, in 1986, I was asked to design the Alvar Aalto exhibition at the Axis Gallery in Tokyo. The budget was very low, and I couldn't afford wood to build the installation, so I found paper tubes and I began testing paper as a material, and found out that waxed paper in particular is very strong. But you know, the fact that it's paper doesn't really matter.

KG Still, your use of paper is very specific to your work. Would you say that, in a way, because of the need to use these paper tubes for the Axis Gallery exhibition, it was Alvar Aalto who introduced you to the joys of paper?

SB Well in a way the answer is yes. John Hejduk's teaching was based on Le Corbusier and Mies van der Rohe, so it was all very International Style. When I was first introduced to Alvar Aalto's work at Cooper, I wasn't very interested in it. But then I visited Finland by chance — I was working for the architectural photographer Yukio Futagawa, and we went there to shoot Alvar Aalto's works — and I was really amazed to see how Aalto understood designing with context and local materials in mind. It really opened my eyes.

KG Speaking of paper, what kind of stationery do you use in your personal life?

SB Mmm, I've never thought about it! I mainly use leftover, recycled paper, or the flipside of photocopy paper — that's my sketchbook.

KG In recent years, you've taken on projects that are much more lavish and monumental than your early work. At the same time your practice has focused more and more on temporary structures for refugees, and on humanitarian relief.

SB It's a kind of balance that is very important for me mentally. After school, when I started working in Japan, I was really shocked how architects are not very well respected in society. And I think it's because of the kind of clients who retain architects. We're mostly working for very rich people, corporations, or developers. Even historically, architects have always worked for very rich people, or powerful religious groups who used architects to materialize visually their power and money, to make a monument. And as architects, we love doing it. It's in the service of our ego. Now I'm not opposed to making monuments, because they become very significant for the general public. But when people experience a catastrophe, like an earthquake, and they lose their houses, their lives are disrupted, they need temporary housing — I don't see many architects who want to take on that challenge. So I thought I could use my experience and knowledge to work with local students and local architects, and help out. I'm more and more convinced that you must find a balance between erecting monuments for the very rich and these kind of humanitarian activities.

KG These humanitarian efforts have become increasingly sophisticated and beautiful. Do you see yourself moving toward a model where these types of interventions are no longer temporary, but instead a permanent solution for housing the underserved?

SB I think that even a temporary structure has to be beautiful, especially for a victim who's undergone psychological trauma after a terrible experience such as an earthquake. The space has to be comfortable but also visually pleasing. But perhaps the structures are also becoming more sophisticated because I'm becoming better as an architect? [Laughs.]

KG Some of your recent projects seem to hark back to your early work: elegant villas and high-end private residences, like the aforementioned Metal Shutter Houses in New York, or Dellis Cay, where you're building a hotel villa on a private island in the Caribbean. Is there a strategy?

SB [Laughs.] There's no strategy. These projects come naturally. I do try to be very picky in choosing projects, and most of the time it's not so much the scale of the project or the size of the budget that interests me, but whether the client and I share the same spirit or sensibility. Dellis Cay is a good project with a good client. But let's be honest, it's nothing special, because the developer is looking for the name of the different architects involved [who include David Chipperfield, Zaha Hadid, Kengo Kuma, and Piero Lissoni]. It's happening everywhere in the world. So even though the client is special, the message is a bit common. The Metal Shutter Houses, on the other hand, are a very special project. The clients own a gallery, and they were living upstairs when I accepted the job. But then they got a loan from the bank and asked me to design a whole condominium on top of the gallery, so the project changed quite drastically.

KG The moving metal parts in the Metal Shutter Houses were designed together with the structural engineers from Buro Happold. What role do structural engineers play in your work?

SB A very important one. When I first started working with paper-tube structures, I asked a very prominent Japanese structural engineer, Gengo Matsui, to help me. He was already 75 years old, and young architects like me were not supposed to work with such a famous, prominent, expensive structural engineer. But I didn't care. I knocked on his door, and he was very interested in working with me, as a kind of hobby. He never made me pay. So instead of going to his office, as you would with a normal project, I got invited to his house. Just before dinner he would spend a half-hour with me, calculating. He did everything by hand, without the use of a computer. It was very good training for me.

KG In some of your work, structure is expressed very beautifully, like the Japan Pavilion at the Expo2000 in Hanover. In other buildings, the *parti pris* seems to be more about an artful concealment of tectonic expression, like the Naked House [2000].

SB I'm not intending to conceal or express structure. The important thing is the relationship with the site and with nature. When I have a project that has nothing to do with context, like a pavilion, the structure and material become the most important elements. But in general I enjoy having different restrictions driving the design process. If I'm given unlimited money with an unlimited site on flat land, it becomes very difficult to design something.

KG What were some of the most difficult — or most enjoyable — restrictions you've encountered so far?

SB The Nomadic Museum [2005], definitely. It went from New York to Los Angeles to Europe and then China. It was such a challenging requirement from the client, to make a museum easy to build, easy to dismantle, and economical to move to all of those places. It was a very unusual brief. So I had the idea of renting shipping containers locally, rather than shipping the whole structure every time. It wasn't the first time I'd used containers, though. I did a small project in Japan a long time ago using containers, so I just expanded the idea further. Most of my ideas happen like this; they don't just come suddenly.

KG Some of your best-known projects were designed for temporary use, like the Takatori Catholic Church [built in 1995 as a response to the Kobe earthquake]. Recently we've seen a few high-profile examples from other architects: Zaha Hadid's Mobile Art Pavilion for Chanel comes to mind, or the Serpentine Gallery's annual summer pavilions.

SB You know, I'm not very happy to get singled out for this type of project — I also like building something permanent! [Laughs.] But sometimes you realize that architecture doesn't always need to be permanent... People are traveling a lot now, and you don't have to go to the office to work. The problems inherent in a project change every ten years, so a building has to be increasingly flexible these days. Because I've done these types of temporary structures successfully in the past, I can understand why I'm being approached to create more of them, over and over again. The only one I don't think I'll get is the Serpentine Pavilion, because this year I built a temporary structure for the London Design Festival. I doubt they would want to hire the same architect again for something so similar. [Laughs.]

KG You're one of the most disaster-prone contemporary architects! How was it working on the 2003 competition for the World Trade Center, as a member of the THINK team, together with Rafael Viñoly, Frederic Schwartz, and Ken Smith?

SB You know, at first this project didn't interest me at all. In the face of such tragedy, I just couldn't think about building. So when I was approached — along with so many other architects — for a design for a new tower, I couldn't think of anything. But then my New York business partner, Dean, said: "Why don't you just accept it? Who knows if we'll get short-listed or not." So I gave in. The collaboration went very well, and we made second

place. I must admit I was happy we weren't chosen for first place, because it's so obvious that there's too much politics involved. If I had gotten myself into it, I wouldn't have been able to participate in the competition for the Centre Pompidou Metz.

KG Which you won and which is being built. You even built a temporary cardboard office on top of the original Centre Pompidou in Paris. How did that happen?

SB I simply couldn't afford to rent an office in Paris. [Laughs.] I had once built my own temporary studio with my students at Keio University in Tokyo, and so, as a joke, when we started working on Metz, I proposed building a temporary office on top of the Pompidou. The museum's president immediately accepted, under the condition that I ask Renzo Piano for permission first. And he accepted too, so I had no choice!

NEW YORK

BARRY
BERGDOLL

Interview by Linda Yablonsky

Since becoming the Philip Johnson Chief Curator of Architecture and Design at MoMA in 2007, Barry Bergdoll has produced several notable architecture shows, including the touring "Mies in Berlin" (2001, with Terry Riley, whom he succeeded at MoMA), "Home Delivery: Fabricating the Modern Dwelling" (2008), "Bauhaus 1919–1933: Workshops for Modernity" (2009), and "Rising Currents: Projects for New York's Waterfront" (2010). He is currently planning a big show on Latin American architecture for 2013. Specialized in 19th-century French architecture, Bergdoll formerly chaired the art-history department at Columbia University, where he became known for his expertise in the work of Karl Friedrich Schinkel and Marcel Breuer. When we met in the white cube of his office, 55-year-old Bergdoll was dressed in a relaxed gray suit and striped shirt. Two photographs of Mies van der Rohe buildings (Haus Esters and Haus Perls), borrowed from the department's archives, were hanging on one wall, while another was devoted to books — as is Bergdoll, who has been a book collector since his childhood in the dairy land outside Philadelphia, the city that first inspired his passion for architecture. In fact, if he had not fallen in love with cities, Bergdoll may well have become a librarian.

Linda Yablonsky Are there ways that books are like architecture?

Barry Bergdoll Um... yeah!

LY What are they?

BB The key way that books are like architecture is time. It takes time to read a book and it takes time to experience architecture. There's a prescribed sequence and then there are other ways to move through it. Without going into whether or not architecture has a narrative, which is one way that you could describe it, they are two forms of expression that can only be experienced through time, and can only be experienced partially. At one sitting you can't see both the inside and the outside. It's not like a painting. A painting is in front of you. You have an immediate experience of it. You can have a more in-depth confrontation, but you don't have to move around it or turn its pages in order to experience it. That's one of many reasons it's difficult to exhibit architecture.

LY That is a question for me every time I go into a museum to see a show about architecture. Personally, I can't read a blueprint very easily or even a floor plan. I just can't visualize the space very well. Even with models and designs, such shows never seem to bring the architecture to life. And moreover, the architecture on show is enclosed in another building altogether, in a different environment that competes with it.

BB That pretty much sums it up. In that sense architecture is a bit like music. I mean, everyone likes to go to a concert and listen to it but most people wouldn't pick up a musical score and say, "This is a beautiful piece of music." They need to hear it performed, and a blueprint is the same thing. Most people cannot pick up a blueprint and say, "What a beautiful space." They need to experience the space. And since architecture is primarily about making spaces, and architecture exhibits are primarily about exhibiting the many different ways that one can represent space, architecture is always an act of translation from design to realization. So the job of an architectural curator is another level of translation.

LY I saw the architecture display that was inaugurated last year at the Art Institute of Chicago, when the new Renzo Piano addition opened. I think it's fantastic they have an entire gallery dedicated to architecture, all the time.

BB That was done by a former student of mine, Joe Rosa. He's the architecture curator at the Institute. At MoMA we also have a gallery that's permanently devoted to architecture, sadly not as big as their new one. We're the only people in this museum who exhibit something that we can't actually put into the galleries. We use a whole variety of materials that are architectural, but they're not necessarily architecture. Some of the most successful architecture exhibitions get around that problem by multiplying the

number of media that represent architecture and allowing them to interact. You almost need a surplus of information to substitute for the reality and the time-based experience of the building. I tried to get around that in "Home Delivery" by working outdoors and having five buildings constructed. In other words to try to do what was generally thought to be impossible, which was to exhibit buildings.

LY Perhaps another analogy between architecture and books is that they create a mental space and good architecture does the same. You're not just moving through it: architecture gives you a different sense of yourself, as books do. I'm sure you know that a lot of people don't particularly like Yoshio Taniguchi's MoMA building.

BB [Laughs.] Not to be insulting, but I've rarely been interviewed by such an opinionated interviewer!

LY Well, I am just curious how you experience this building as a curator of architecture and design who has to work with the given space in a way that makes whatever you're presenting accessible to the public, and makes the work look as good as you know it is.

BB I feel quite strongly that exhibiting architecture is quite different from exhibiting painting and sculpture for all the reasons that I cited at the beginning — that one is dealing with representations and that one has to somehow create a parallel experience about the architecture. The role is just as you say: to make the space that you're in as unobtrusive as possible. So to talk about the museum as a place for exhibiting art, and to talk about the Taniguchi building as a place for exhibiting architecture are two fundamentally different things. My practice is to attempt to deal with the building in order to exhibit architecture. And there I think that it's interesting. You're not only doing an architecture exhibition. You are reinventing the genre of the architecture exhibition. And much like an architect who is called on to do a renovation and has to deal with constraints, so this building issues a certain number of constraints. Sometimes they are an impediment to what you want to do, and sometimes they can really provide creative opportunities. It's hard to do really exciting things with the collection of architecture when we have only one 49-by-49-foot gallery, with a ceiling that's quite low. That works fine if you're showing architectural sketches. So even though architecture is the biggest thing that needs to be in the institution, a lot of its representations are actually quite small and intimate. When it functions as a drawings gallery, it's perfectly fine. When you want to create environments, that space is some-what confining. There are only so many ways you can use a truncated cube. I think the most exciting parts of the Taniguchi building are where there is an unexpected visual connection to the exterior, to the city. We have a space that I think is very beautiful for its outside views of contemporary architecture. We show contemporary design there, and it overlooks the garden and overlooks the city rather beautifully and sometimes you can make very interesting connections, but we can only exhibit things there that are not light sensitive.

LY You also had half of the sixth floor for your Bauhaus show, which I enjoyed very much. But one of the ironies of this vast building is that the galleries are sometimes so small that things seem rather cramped in them.

BB Well, they're often very crowded with people.

LY Which makes it just as difficult to get close to things as it was in the old building...

BB In that sense MoMA is a victim of its success.

LY Hopefully you'll get the whole sixth floor for architecture sometime again soon.

BB I'm actually working on an exhibition about Latin American architecture that's going to be in exactly the space where the Bauhaus was.

LY I'm happy to hear it. I've had very little experience of Latin America, but every time I've visited Mexico City I thought its contemporary architecture was amazing.

BB That's why I want to do this show. The incredible creativity of Latin American architecture from a northern perspective has always been seen as derivative, but in fact it's a cauldron of invention, creativity, and experimentation. By showing it, I hope to recalibrate the story that we tell about 20th-century architecture. Latin America is generally a chapter towards the end, showing how Le Corbusier's ideas were applied in Latin America, rather than focusing on it in its own right. This show might contribute to an even larger story of 20th-century architecture. And that seems to me to be one of MoMA's specific missions. As much as it's been critiqued, analyzed, and deconstructed, the inaugural International Style show ["Modern Architecture: International Exhibition," 1932] tried to give a shape to history and it's the shape that's been applied, fought against, critiqued for nearly 80 years. That is the canon that MoMA is associated with, and I take that very, very seriously. I think one of the interesting things to do in the 21st-century is to say, "Okay, now the museum has amazing historic content but that content can be opened back up again. It can integrate other histories." And one of them is Latin American architecture. In my own education as an architectural historian, it was almost as though Latin America didn't exist.

LY What made you want this job? You had a very good career in academia, were very popular with your students, and you seem very much a scholar.

BB To be frank, I never wanted the job until it was offered to me. I was invited to consider it and I said exactly what you just said: I have a fabulous job, I love teaching, I'm unbelievably happy at Columbia University. I still do one seminar a year, which reminds me each time how much I adore working with students. It is always difficult, but also really exhilarating to do something completely new — to work in a big, bureaucratic institution that is dedicated to something that I believe in. I had done exhibitions before as an invited curator, many exhibitions with many other institutions, so I did know about

making exhibitions. And I knew that I liked the challenge of thinking about ideas in spatial and highly public terms, which is a very different format from either lecturing or writing books.

LY Are you happy with this office?

BB I have one critique of it. You see that I'm looking at the world through rather grim, gray glasses, as it were, because these windows are very deeply tinted. Taniguchi didn't want a violent transition between the black stone facing and the silver wall with a clear open space in between, and the result is a set of windows that was thought about in terms of the view of it from the street rather than of its occupants' happiness.

LY What brought you to architecture to begin with?

BB I'm a typical case of a child of the 1950s and 60s who grew up in the suburbs, discovered that really he liked cities, and wanted to protest against his childhood by going to school in New York. And then I thought, "What is it I like about cities? I like the buildings, the built fabric of the city."

LY Where did you grow up?

BB I grew up in a suburb of Philadelphia called Wallingford, which is adjacent to Swarthmore. I went to Columbia as an undergraduate and went back and forth about whether I was going to major in urban studies or art history. I had discovered art history for myself at the Philadelphia Museum of Art. At Columbia I toyed with the idea of being an architect but, well, it was the 70s and not a very exciting time in architecture, at least as it appeared to a 20-year-old. And also, as you say, I have a very scholarly turn of mind, an inclination towards historical thinking. I actually find it impossible, even in daily life, to do anything without a historical perspective. I always want to know where something came from. So it's not surprising that I've preoccupied myself with the history of this department. Sometimes I think of it as a martial art, where you're supposed to use the power of your opponent — and the history of the department is something that you have to use in that symbiotic way and not necessarily follow it. I'm fascinated also by why some things are remembered in ways that sometimes are out of proportion. The inaugural International Style show was a pretty flimsy affair as an installation exhibition, and not that many people actually saw it. It's like Mies van der Rohe's Barcelona Pavilion, which was unbelievably influential with people who never had any direct experience of it. The "Rising Currents" show takes its inspiration from a largely forgotten exhibition at MoMA called "The New City," which was a critique of federal urban renewal in the 1960s.

LY You've spoken very well about your passion for architecture. How did your passion for books begin?

BB I enormously admired my maternal grandfather, and he had books all over the house. He and my grandmother traveled a great deal to Europe, and

collected books everywhere. My biggest dream would be a dining room completely lined with books, so if you were having a debate with somebody you could say, "Actually, I just found something really interesting in this book," and it would become part of the dinner party.

LY Don't you have a dining room lined with books?

BB I think that's the one room where there aren't any books!

LY What was the first book you bought for yourself?

BB Oh, I've no idea. I began buying books as a kid. A lot of novels, but as a teenager books about cities and city planning. I remember buying Edmund Bacon's *The Design of Cities* [1967], one of the coolest books around. Anything related to Philadelphia — I became obsessive about Philadelphia as a city. I got jobs in Philadelphia so I could take lunch hours in the city, so I could not only have money to buy books but also time to wander the streets. I mean, I took a job that was basically for the lunch hour.

LY Were your parents in the arts too?

BB Not at all. On my mother's side there was a long history of lawyers and my father ran the family business, which was a dairy. But that did have a lasting effect: I cannot bear the thought of drinking a glass of milk!

LY Did you ever have to milk a cow?

BB It was a dairy, not a dairy farm. We bought the milk from the farmers, and on a day off from school I would sometimes get up and go on one of the milk trucks at the crack of dawn. It was still dark and we'd collect all the raw milk and then bring it back to the dairy, which was a wonderful little factory, a Modernist building that was in a valley, so you had a plunging view. I was completely fascinated by the bottling and bottle-washing machines. It was straight out of Charlie Chaplin.

LY Have you ever borrowed a book that you didn't return?

BB [Laughs.] Actually, a classmate borrowed a book and to this day I wonder why I lent that very valuable book. But as a child I wanted a library. I used to spend a vast amount of time organizing my books. I even imagined a scheme where the other neighborhood kids could borrow my books, so they wouldn't have to go as far as the public library. I don't know why I didn't become a librarian.

LY Do you still have the books you had as a child?

BB No, most of them went on to my brothers and sisters. They have big families and when I go to visit them, I sometimes find myself reading my old books to one of their children. But I still have the books on architecture and cities that I brought with me to college. It's something I've had to learn here: to shed books. So I find myself doing something that is almost against my nature, which is giving books to the library upstairs, but I know that they're

only a floor above me and other people are going to use them. And I have to fight my inner librarian: I can't spend all day organizing my books, putting them in alphabetical order, and making sure the shelf looks great!

LY I was about to ask you how you organized your books, because if you put them in alphabetical order they wouldn't all fit together on the shelf. And some books are more beautiful than others, so those are the ones that you might want to display more prominently.

BB Do you want to know how these are organized?

LY Yes, because I can't tell.

BB It's my own mental topography: architects' monographs are in alphabetical order, and the other things are in clusters by topic. So there's a run of the history of modern architecture, and then a run that's a history of modern design, but then there are clusters that are made up of current and recent projects. One whole shelf is prefabrication and "Home Delivery," another whole shelf is Bauhaus, and one is Mies — since we have a Mies van der Rohe archive and we're always working on Mies. And a whole section is Latin American architecture.

LY So all the books here have to do with architecture and design. What have you got at home?

BB Tons more architecture and design and my other life, which is as a scholar of 19th-century architecture.

LY Why the 19th century?

BB Most American cities took form in the 19th century. But when I came to New York it was 20th-century architecture. And irony of ironies, the thing that really excited me was that the professor who turned out to be my advisor and is still a great friend, Rosemarie Bletter, had a seminar on the Bauhaus in the course catalogue. Yet she never offered it the whole time I was in college. But I came to the 19th century partially because Rosemarie Bletter had an inspiring lecture on it and also because it was disliked by most people. It was the thing against which Modern architecture had posited itself. I'd always been attracted to the idea of working on something that was unfashionable, so I decided I was going to work on English 19th-century architecture. I got a fellowship to Cambridge and discovered, much to my horror, that it was a very fashionable topic — exactly because it was supposed to be unfashionable. Happily, 19th-century France was even more unfashionable, and that's where I ended up specializing. So I've become a curator in 21st-century architecture, but I'm trained as a historian of 19th-century France.

LY You have read a lot of fiction. Is there one novel or novelist that provided a transformative experience?

BB My reading was always eclectic. As an eight-year-old, I decided I was going

43 BARRY BERGDOLL

to read the library in alphabetical order in one summer, but I think I only got halfway across the "A" shelf. More recently I've been obsessed with the work of W.G. Sebald.

LY What's the best book design you've seen?

BB Again, I have an eclectic range of tastes and in some ways I like very traditional, old-fashioned books. For example, every now and again I start the project of reading Marcel Proust in the Pléiade edition, which is the standard French edition on bible paper. I enjoy it tremendously: it is so pleasurable to have in the hand. And I'm incredibly impressed by the book designs of Irma Boom. She did the catalogue for an exhibition at Bard Graduate Center on Sheila Hicks, the fabric designer. That is one of the most beautiful catalogs I've ever seen.

LY Do you think architects are artists?

BB Definitely.

LY Should they also be philosophers?

BB I don't think it's a prerequisite but I think the architects that have had the greatest impact have either acted as though they had a philosophical position, or formed a philosophical position, or worked with philosophical ideas. Mies for instance. Certainly Frank Lloyd Wright. I mean, we wouldn't think of them as hardcore intellectuals or philosophers but I think that in a post-1970s, post-Peter Eisenman world, the relationship of architecture and philosophy has become a very intensely self-conscious one.

LY Do you think we're turning into a city of glass here in New York? And is that a good thing or not?

BB I think it's a bad thing. I was rather distraught when lots of glass buildings went up in Philadelphia in the 1980s, without a doubt the worst period in the history of architecture. It was one of the last great masonry skylines in America and it's gone. The buildings are there but it's gone. I felt a little bit the same way about the destruction of the Edward Durell Stone building on Columbus Circle, because I thought that the collage and texture of materials and time were lost there. The Gulf and Western building had been refaced. The TimeWarner center is a very glassy building. I thought that beautiful brick apartment building shouldn't be the only holdout for textural difference. I'm a dyed-in-the-wool Modernist and I love expression in glass, but I also like a city to be made of many parts and many layers. A city should always be a palimpsest of historical time.

NEW YORK

BEN
VAN BERKEL

Interview by Aric Chen

Architect Ben van Berkel — principal of the Amsterdam-based firm UNStudio, together with his wife Caroline Bos — has a penchant for complexity. He also makes a mission of collaboration, has a dry sense of humor, and, yes, he's been known to wear dark Prada suits. But appearances aside, don't think of van Berkel as just another Dutch architect.

With projects spanning from UNStudio's breakthrough Möbius House in Holland (1993–98) to the Mercedes-Benz Museum in Stuttgart (2001–06) and the 2007 design for a condominium tower at 5 Franklin Place Manhattan, van Berkel has created a language defined by autonomy. Operating in a post-ideological vein, his formal acrobatics — warping walls, folding volumes — produce an architecture that becomes its own context; spiraling, twisting, looping back into themselves, his buildings are self-contained, though not entirely self-referential. They provide an orientation absent of a clear beginning or end, reflecting the architect's interest in organizational systems as channels of social interaction to be articulated through space.

But what really makes van Berkel tick? PIN–UP met with him at an outdoor café in New York's Tribeca neighborhood to talk about the meaning of UNStudio, the house he designed that burned down, the problem with architec-ture and architects, and why the latter should all pose naked (seriously).

Aric Chen	UNStudio stands for United Networks. What's that really about?
Ben van Berkel	It's more or less saying that we like collaboration, in the most complex sense of the word, though you can also read it as "un-studio." We like to work with different specialists — not just engineers, but trend forecasters, art historians, maybe someone in fashion or a photographer — to make sure that, as designers, we're not only thinking in linear manners. I like the word relational; I do believe in relational strategies, relational ideas, that you need to bounce these ideas back and forth so you don't always see so clearly what the outcome might be. Don't forget, buildings and the design process are much more complex today than even ten years ago.
AC	Is it possible to draw a correlation between the idea of collaboration and the physical forms of your buildings? Some of them read like relational diagrams.
BvB	Yeah, I think so. Maybe it's also related to the different types of projects we do, like what we're doing right now for the Venice Biennale [a conceptual "changing room"] or our "Holiday Home" installation for the Institute of Contemporary Art in Philadelphia [2006]. I love to do these museum projects to understand and play with the values within architecture. Of course, every day we have to deal with commercial or political values. But for me, what is most essential is to know how to turn these values on and off, maybe like good art does. We need to always re-question the essence of architecture, through this relational aspect, so there are many readings to be found in the work.
AC	So how do you get from that to looping spaces and morphing walls?
BvB	In a way, we're dealing with new forms of articulation. In the Renaissance, they talked about articulation in terms of how you enter a space, how that was articulated in the entrance condition of a church or whatever. And I'm similarly interested in that idea, that you articulate a facade and that facade is connected not only to its external qualities but it's also linking itself to the interior and, again, producing other readings of what you might see.
AC	That sounds rather baroque.
BvB	A lot of people say I'm baroque, but I hope I'm not.
AC	Right now you're working on 5 Franklin Place, a condominium building in Manhattan. It's for the same developer for whom you designed VilLA NM [2000–07], the house in upstate New York that burned down earlier this year.
BvB	That was really terrible. For me, it was terrible, but especially for the client and his family. They were and are still devastated.
AC	Do they know what caused the fire?
BvB	No. But I think it was simply an accident.

AC	Will the house be rebuilt?
BvB	They're seriously talking about rebuilding it now, and we've pulled out the drawings and have discussed whether we should make any alterations. But everyone loved it so much that I don't think we're going to alter it. Hopefully, we'll rebuild it.

AC	Do you like being grouped with the other Dutch architects?
BvB	Well, I'm Dutch, yes, and I'm fine with it. But on the other hand, if you look at some of the other Dutch architects right now who are known abroad, they were all educated and have lived and worked outside Holland. With my seven years in England, I consider myself less Dutch.

AC	Living in a small city like Amsterdam, does it ever feel claustrophobic? Like, "There goes Winy Maas again…"?
BvB	It's really funny because we only meet at airports and actually we get along quite well.

AC	Do you draw parallels between your work and that of other Dutch architects?
BvB	Honestly, I think of myself as coming from a generation of architects in which, at the Architectural Association [where van Berkel studied in the 1980s], I was always fascinated with what things outside the profession could trigger in the profession itself — like what you can do with geometry, new materials, new building techniques. In that sense, I do believe I'm different than some of the other Dutch architects who right now have an interest in political and social topics. I think that's daring and fascinating; I'm not critical of it at all. But I question architecture always from the inside out.

AC	I heard you started off studying interior design.
BvB	People don't write so much about it. But I was at the Rietveld Academie, in Amsterdam. Actually, I wanted to study architecture but the program had a very funny name; it was not called interior design, but architectural design. Later, I discovered it was not dealing with architecture, but more interior design.

AC	So you wound up in an interior-design school by accident?
BvB	Well, it was really furniture design and, yes, interiors.

AC	You still design furniture, which I guess could be seen as an articulation of space and manipulation of geometry at a different scale.
BvB	In some ways, furniture is more fascinating because I believe the things we touch are closer to the way we live: the tables you touch, the chairs you sit on. They're less in the background than architecture. You can also more easily experiment with new techniques and materials.

AC	Beyond your work, you have a reputation for being one of the more, well, likable architects out there.

BvB Why do you think that is?

AC You tell me. Do you find architects to be likable?
BvB I like architects. Well, not always.

AC What is it that makes architects so unpleasant sometimes?
BvB I don't know, maybe it's the media.

AC Ouch.
BvB Actually, architects were not really so known before. Maybe it was our fault, because we were sitting in this ivory tower, not wanting to communicate about our work. I do believe that we have a responsibility to do that, to communicate better, with the amount of money that's spent on our projects and the public forces we have to involve.

AC In a way, UNStudio represents both sides: there's Caroline [Bos], the ivory-tower writer, and you, the public-face architect.
BvB Sometimes I say Caroline is the better architect, because she doesn't design. She is actually an art historian and an amazing writer. She really is there in the studio to make sure we all know how to formulate what we're doing and why we're doing it.

AC How has your collaboration influenced your faith in theory and her faith in practice?
BvB That's an interesting question. What we've learned over the years is to be even more critical, to find new models, new working strategies, and, through that back and forth, to know much better where the major themes are developed in the process.

AC A while back, you told me you wanted your staff to pose naked for your office Christmas card. Is the world really ready to see naked architects?
BvB Yes, architects should go "naked"; they should openly communicate, I do believe that. We need to be more honest when we are doing a lot of important public work and I think we should allow more to be questioned about what we do, yes.

AC So you're going to pose naked, literally, for PIN–UP?
BvB Yeah, if you want.

AC Really?
BvB Yes, I'll do it. But you would never run it.

AC Which architect would you like to see naked?
BvB [Laughs.] Maybe Bernini.

AC So there's a baroque side to you after all.

BvB Maybe. But actually, you'll find a lot of other sides, too. I'm interested in science fiction, philosophy, literature; I'm reading everything connected to cosmology. I like a lot of things.

AC So how do interests such as science fiction translate into your work?

BvB When I saw the iPod for the first time — this was a long time ago — I didn't know what it was. In German, they say *weltfremd*, and what I mean by that is I wasn't aware it was a musical device. It looked so alien to me. That was a wake-up call that you can still make alien things, in the sense that you can make something that is autonomous. Autonomy in architecture, or autonomy in design, is totally out of the discussion at the moment, and I'd like to bring it back.

AC You mean, the idea of the unknowable.

BvB Yes, the unknowable, I'm very much interested in the unknowable. And you can find it in the fantasy of some science-fiction writers, or science-fiction imagery. I'm particularly interested in this.

AC And philosophy?

BvB I read everything, going back to the Greek philosophers, to Foucault, Deleuze, Nietzsche, Hegel; I'm heavily interested in philosophy. It helps you create associations you cannot really find so easily in, say, a story. A story offers linguistic and chronological coherence, but philosophy gives you concepts.

AC Do you think some architects take philosophy too far?

BvB Yes, sometimes. It's like the story of the diagram. When Deleuze started to write about the cartographer — I like maps, they get me very inspired and they're all about organizational structures — but what Deleuze said about the diagram was that it is a map. You look at the diagram as a map and it gives you direction and orientation. I was super-fascinated by this idea that architecture could be seen in a similar manner, that it is a map, that you just map an organization, give it a direction, and that's how the whole structure can start to unfold. But I've never taken it literally, that a diagram can become a building. In my opinion, a lot of architects don't do well when they take metaphors or other external influences too literally. What's important is to instrumentalize them into architecture. I love that word, instrumentalize. I think if you cannot do that then you cannot design.

AC Is that what separates architecture from art? The different ways they concepts are instrumentalized?

BvB In a way, I wish you could not separate them. In my opinion, architecture is also art, although of course with a building you have more practical concerns. I definitely believe that good artists are good at triggering people's minds so that they want to come back to art; they want to rethink it and re-analyze it. And in my opinion, we experiment with this in architecture, but we don't

do it enough. We could get more readings from a building than only making it functional.

AC This goes back to your interest in autonomy. The space becomes the object.

BvB Yes, there's another level of understanding that you maybe don't see at first but that you discover while you are using it. The fascinating aspect of architecture today is that you can almost step into it as an artwork and make it organizational, functional, and comfortable at the same time. Why not? Why can someone like Olafur Eliasson, who is an artist, flirt so much with architecture, whereas we are not flirting enough with art?

AC It sounds like you're unapologetically, well, not a formalist exactly, but you're not claiming to save the world or reconfigure society, either.

BvB Yes, maybe. But on the other hand, I think that architecture, if it's not communicating, then it is not architecture. So architecture should communicate on many levels, even on the social, cultural, and political levels, but I don't like to put too much emphasis on that. I hope that people will discover something in it. But we can also talk about what I like to call the conspiracy of architecture — the way we now deal with the commercial aspects of architecture. And we all do it; even the most avant-garde architects are dealing with all these values. But I'm interested in architecture that can turn these values on and off, where you cannot read anymore whether it is cultural or commercial, that it does something else with you.

AC Like your Mercedes-Benz Museum, for example. It's a museum, it's cultural, but it's also part commercial, part showroom...

BvB Yes. Lately, people also say it's part parking garage.

AC That can be nice, too.

BvB Yeah, I know a lot of beautiful parking garages. But of course I did not invent this idea myself, this doubleness that I'm talking about, this hybrid of commerce and culture.

AC Do you drive a Mercedes?

BvB They offered me several times to go for a Mercedes and I never did.

AC Why not?

BvB They're too big. Living in Amsterdam, I'd kill every cyclist if I drove around in a Mercedes.

AC Do you think architects have a style problem?

BvB I guess my answer is, who cares about the blobs or whatnot? Let's rethink every kind of transformative quality we can bring to whatever stylistic reference we go for. Let's rethink how we proportion certain forms, or the information we can bring into a project. The stylistic aspect for me is not interesting. You can see...

AC	Actually, I was asking about personal style.
BvB	You mean how we talk?
AC	No, the way you dress.
BvB	Ah, Okay. But don't forget that that was not the fault of architects. It was the fashion designers who started that. They came in black, remember.
AC	Right, Rei Kawakubo of Comme des Garçons is often credited with starting that.
BvB	Yes, and then everyone copied it, including the architects in the 1980s and 90s. I remember when I once came to Columbia University in a black suit, someone came to me and asked, "Why the hell is everyone here wearing black suits? I mean, it's scary." And since then, I never went with a black suit anymore.
AC	You're wearing a black suit jacket today.
BvB	But with jeans. Can you believe it?

BARCELONA

RICARDO BOFILL

Interview by Felix Burrichter

While most architects spend a lifetime perfecting a signature style, Ricardo Bofill seems to avoid it at all costs. The fascinating 69-year-old Catalan is perhaps best known for the Postmodern public-housing projects he built in France in the 1980s, but his oeuvre spans several decades and creative periods that range from Surrealist-inspired multi-color beach resorts to the glass-and-steel extravaganza of Barcelona Airport's brand-new Terminal 1. On my way to our meeting in the Barcelonan industrial suburb of Sant Just Desvern, we drive by a strange-looking 16-story apartment complex, whose semi-circular balconies seem randomly stacked onto the terra cotta-colored façade, making it appear like a living organism. "This is Walden 7," my cab driver screams excitedly, "It was built by the architect Ricardo Bofill!" When I tell her that is who I'm going to see, she gets even more excited: "He used to be married to Julio Iglesias's daughter," she says, in fact referring to his son, Ricardo Bofill Jr., who works as an architect alongside his father (and has an ¡Hola!-worthy marital record). But the little mix-up doesn't really matter — it just goes to show that in his native Spain, and especially in Barcelona, Bofill is a household name.

Taller de Arquitectura, as his office is formally known, is located in a former cement factory, which Bofill bought almost 45 years ago and has transformed over the years into a palatial office and living compound resembling an overgrown medieval castle. His apartment is on the top floor, with breathtakingly high ceilings and a rooftop garden (without handrails) enjoying a direct view over Walden 7 on the adjacent lot. A handsome Bofill, in crisp white shirt and black jeans, greets me in a clover-shaped office (four former cement silos knocked together). During the one-and-a-half hour interview at his square desk, he smokes at least half a pack of Marlboro Lights while jovially talking about his early days as an architect, the steady changing of style in his career, and why he hates institutions and loves Catalonia.

Felix Burrichter Converting these premises into offices was one of your first projects I believe?

Ricardo Bofill Yes, it was a disused cement works, I was 24 and it was a very cheap neighborhood, I'd already built houses in Barcelona and wanted to jump up in scale. At that time I'd developed a different working method. I was already interested in a different architecture — I didn't like Le Corbusier, I didn't like Gropius, I was interested in Spanish vernacular architecture, architect-less architecture. And the buildings I designed at that time, like in Sitges, where I built modular housing [Kafka's Castle, 1968], or in Alicante [Xanadu and La Muralla Roja, 1965], were greatly inspired by the vernacular architecture of southern Spain and North Africa.

FB You studied in Barcelona and Geneva, right?

RB Yes, first in Barcelona, and then I went to Geneva because I was thrown out of Barcelona University for belonging to a left-wing student movement. It was at the time of Franco. I stayed two years in Switzerland, and afterwards moved to Paris. And then at one point I decided to go back to my father in Spain. He was an architect and builder, and was building a lot, which allowed me to build very early on — I completed my first house at the age of 19 [in 1960], when I was still a student in Geneva. It was a little holiday home in Ibiza. One of my first projects with my father was a series of town houses built with no money, with cheap local materials such as brick. There was nothing in Spain back then, it was a very poor country.

 And afterwards I thought about reworking the process of architecture, and of volume, and I carried out a series of experiments. Then, in 1968, we did a series called "The City in Space," which was an entire conception of the city, a break with the rationalist bloc, a break with the cheap architecture that was being built in Spain at the time. We conducted two experiments, one in Madrid, which was banned by the Franco government, and another, which was the culmination of our research, was Walden, which we completed in 1974. The idea for our housing was based on a modular system, because for me the concept of the traditional family unit, with a father, mother, and two children, is just one case among others: one can also live alone, communally, or in a homosexual couple, for example. The idea was that you could buy one module, two modules, three modules, or however many you needed, horizontally or vertically. It was really a whole other way of imagining urban life and an experiment in communal living. But with Walden 7 it was kind of the end of my research into that. But it was also during this period that I undertook research into the conversion of old ruins, and that's when the conversion of this cement works happened. It's fantastic because it preserves the memory of industrial architecture. Afterwards we spent two years cutting things out, taking away various elements, and then we had to put windows in, and there was already a desire to introduce a historicist architecture — a Catalan architecture,

but transformed. Then we gave it a Brutalist treatment, and there are also the Surrealist elements we left in, all of which correspond to the different periods of my history.

FB You said earlier that when you left university Le Corbusier's architecture didn't interest you...

RB Not only did it not interest me, I was totally against it! I was quite radical when I was young, and for me Le Corbusier and co. were responsible for all the sorry housing projects in Europe and especially in the Soviet bloc. Dividing the city into functions, treating houses like machines — the urban solutions put forward at the time seemed anti-urban to me, the simplification of the city into something other. And I've spent my life hating this Modern movement and trying to find alternatives, trying out other solutions, trying to bring back the spirit of the Mediterranean town, the European town, the mixture of functions, the mixture of spaces, the street, the square, the mixture of social strata.

FB There were no contemporary architects who inspired you at that time?

RB At the time there was only Louis Kahn and Alvar Aalto, and to a certain degree Frank Lloyd Wright. But for me Le Corbusier was the devil! For example, the plan he drew up for Barcelona was just absurd. He was certainly a man with enormous talent and extraordinary force, but his ideas were pretentious and totally monstrous — I think that at bottom he was an evil person.

FB Your projects in the late 60s and early 70s have a Surrealist element to them.

RB Yes, absolutely. At the time, each new project was a tryout for me. In that period, we didn't want to define the final form in advance, but instead let the process produce the project. Each project was different because we didn't necessarily want to produce "beautiful" projects. So we experimented with processes. For example, in plan, the value given to layout-forming elements, or the use of space, or construction materials — we never wanted to predetermine the final result, a bit like, as I was saying earlier, in vernacular architecture. Another big influence was Antoni Gaudí. I've always been greatly inspired by Catalan architecture, and there's obviously no way around Gaudí! He was a genius! But what I learnt from him wasn't the Gaudí style, but his vision of architecture. He was a man who never repeated the same door twice, the same two windows. No! He innovated constantly, and refused repetition. A simple man, but an inventor. He started out as an anarchist, and finished as a visionary traditionalist. So, according to Gaudí, one must never repeat the same door twice. But that's impossible today, we no longer have the same craftsman resources. I transferred that to a contemporary context by saying to myself: "I must never repeat the same two projects. Each project must be different!" That's the great lesson of Gaudí. Moreover, when they began work again on the Sagrada Familia, they asked me if I wanted to do it, and I said, "No, it's impossible. If you have a

painting by Picasso, you can't continue it if it's unfinished!"

Another great influence for me was my journeys to Italy, and the study of Italian-Renaissance architecture: Alberti, Brunelleschi, etc. So here we spent nearly ten years with a research team on what you might call our Classical period, which others have called Neoclassical; but actually that's not true, it's a modern Classicism, it's a Classicism with another function, with other materials, with another idea, trying to recreate squares, streets...

FB How did the transition occur from vernacular architecture to experiments like Walden, and then to what you call modern Classicism?

RB Walden 7 was, if you like, a critical response to the entire Catalan, and even European, intelligentsia. It was a critical response because we said: "There! It's a monument in the middle of suburbia, a vertical monument in the suburbs!" And straight away there were critics who said: "One cannot experiment with social housing, with architecture for the poor." Because Walden 7 was a social-housing project, you know, although it isn't any more because there is a law in Spain to the effect that after 20 years buildings lose their social-housing status. But at the time that's exactly what it was, it was a building populated with people of all varieties: trannies, junkies, singers, writers, unemployed people... It was a very interesting mixture, but greatly criticized. But I was expecting that, because I'd put all my research, all my experimental ideas, everything I was talking about earlier, into one single building. I exhausted myself intellectually with Walden, and it's then that I changed. And I tried, with a team of around 20 people, working "word by word" to learn and acquire all the different architectural languages possible. Once I'd studied Classicism, once I'd studied all these architectures, the culture and language of a building became a secondary element. And above all, a non-ideological element, because — especially at that time — if you didn't produce a certain architecture you were a reactionary. Architecture was very ideologized, aesthetics had become something ideological, but I wanted to erase all that. For example, there are great writers, like Céline, who was rather right-wing, and who was a very good writer, or those like Borges, who write in a totally formal, classic way and are very good, and then there are the *nouveaux romans*, which are nice. Personally I think one should know all the different writing styles in order to be able to use them in each particular case one sees fit in the manner one wishes. At the time I hadn't yet learnt this freedom that allows one to change, evolve, and write in a different way with architecture.

FB So what was the project that followed Walden 7?

RB After Walden 7, I went first to Algeria and then to France. In France I proposed a housing scheme in Cergy-Pontoise which we called La Petite Cathédrale [1971]. It was a French-style Walden if you like, because the French had more advanced techniques for building mega-structures. But it was never realized. And then, on the other hand, in Algeria I built an agricultural village [1980] entirely in brick, which was a very, very inexpensive construction.

Interestingly, it was at the same time as Postmodernism. You could say that I was one of the creators of Postmodernism. Why Postmodernism? Because architects were starting to say to themselves that the International Style was an architecture with a very narrow vocabulary. And what I said at the time was that the architectural debate needed to be opened up, that one should be able to write with more than just one language. What's funny is how much, after Postmodernism became the official style in America, it didn't interest me anymore, because there was no longer an idea behind it, it was just an aesthetic choice. Each time we started a movement — and I was at the beginning of a lot of movements — its popularization was very rapid, too rapid, so the architecture became banal and the whole movement became banal, so I had to get out. I don't like institutions. For example, each time I'm asked to join the academy in France, I say, "No thank you." I don't want to be part of an academy, what interests me is invention, and reinvention. Mine is a very different career to other architects — important architects at least. I run into them from time to time, but I go another way, because I've got other ideas, another life strategy. What interests me is learning, getting to know the world — from Sweden to Africa — in a different way. And architecture allows me to get to know the world differently. When I'm in Chicago and I look at the world I've a different view from when I'm in Tokyo or Beijing. It's rather a kaleidoscopic view. You know, no general theory works for everything — neither for architecture, nor for economics, nor for politics. Each application [of it] will become corrupted along the way...

FB If you were to give names to the different periods in your oeuvre, what would they be?

RB I'd call the first period "critical realism," because we were working with limited means, very small budgets, local projects, in brick. The second period was the period of research into our working methodology, or working processes, up till Walden 7. Afterwards there was an almost Postmodern period, at the beginning of Postmodernism, which brought me to this modern Classicism I talked about earlier. That lasted ten to 15 years, I had a lot of work, and now we're in an architecture where we've already had all the influences and a certain knowledge of the world, which can always be deepened. But now it's an architecture that tries to adapt. There is a book that marked me a lot, by Christian Norberg-Schulz, called *Genius Loci: Towards a Phenomenology of Architecture* [1980]. Now we're in a very eclectic and very globalized period, but as architects what we can't do is to put up a building in Barcelona, Madrid, or Chicago and then go and transport it to Senegal. You know I'm very into what you might call "poor architecture." For example, the project in Senegal [Résidence de la Paix, Dakar, 2007] is "social" architecture which costs 200 euros per square meter, but for me it's the same thing as when I construct a building in New York that costs 30,000 euros per square meter. And right now there's an economic crisis, which is good in that we are starting to think about economical housing again. Up till now so many architects abandoned social theory in favor of

technology and creating unusual objects — the "star system," as it's called. But what is often forgotten is that 90 percent of construction consists in housing. And the most difficult thing to do is social housing. So now we're in the process of relearning that, with projects in Africa, India, we're trying to do things in Latin America, even in Barcelona — very, very, very cheap housing, very basic. And in Russia, too. The Russians want to change their entire construction system, as well as their entire prefabrication system. They came to see us because we are very good at doing prefab, so we're going to build a neighborhood in Moscow soon, for which we're developing a whole system of prefabrication, because that's what they want.

FB The famous Arcades du Lac in Saint-Quentin-en-Yvelines [1982] or Les Espaces Abraxas in Marne-la-Vallée [1982] were all prefabricated as well, no?

RB Yes they were, but prefabrication has developed a lot since then. And in Moscow we're trying to find a new vocabulary in order to be able to pass it on to other architects as well, because we're well aware that afterwards other architects will be involved. In fact it's a very industrial job, very tied in with the fabrication system, and very close to the construction industry, so right now that's where we are. Sometimes we allow ourselves a more pronounced architectural gesture, but it's much more difficult to do social housing well: the problems of repetition and fabrication, it's all terribly complicated. Even after all these years it's still a challenge for me. Recently I've been spending a lot of time in cement works, but not this one! [Laughs.]

FB During your "new Classicism" period, there was a big exhibition at MoMA, with Leon Krier, in 1985, right at the height of Postmodernism. Lots of architects at the time included a sort of irony in their architectural language, as if they were poking a little fun at Classicism. But looking at your work over the years, I don't see that sense of irony...

RB All my designs talk about a reappropriation of signs — signs are reappropriated and take on a different meaning. It's more of a Spanish irony, if you like, this reappropriation of the meaning of things. For example, a Classical column contains a spiral fire-escape staircase. I try to take away the symbolic language that was attached to these things in the past. It's funny, but in Germany it's something that has very bad press because there was this whole problem with Albert Speer's architecture. Speer only produced copies, and bad copies at that. So now, in Germany, they have a bad conscience and are afraid of Classicism, and of gigantism. But for me gigantism isn't a problem because I come from a liberal left-wing family, so I can say without shame that Terragni — architect to the Italian fascists — was a very good architect. In Germany, it's still difficult to say that. But in any case, Germany is also a country where they're not that keen on the city: there's only Berlin, the others aren't real cities! [Laughs.]

FB So the word "gigantic" isn't an expletive for you?

RB I'd be more inclined to say monumental, not necessarily gigantic. But even

my monumental projects always have a second, human scale. When you go into the new Barcelona Airport terminal, it's very big, the ceiling's very high, out of scale — but afterwards there's always a second scale at human size within this big scale. And in any case, since the modern era we're living in often gives carte blanche to vulgarity, and public space is reduced to the level of merchandise, advertising, and other "values," the only way to counter that is to make the space a monumental space.

FB If one compares your recent projects in Spain — like the new Barcelona Airport terminal [2009], the W Hotel Barcelona [2009], or the Nexus II building [Universitat Politènica de Catalunya, Barcelona, 2001] — and your recent projects abroad, especially in Russia [Star Way complex, Konstantinovsky Congress Center, St. Petersburg, 2007], I have the impression that outside Spain clients ask you to repeat things you did in the 1980s, while at home you seem to have evolved to a fourth style period, all in glass, without historicizing details.

RB Yeah, okay, but don't forget that clients like asking for what they've already seen elsewhere. We're the last links between Classicism and the modern age. There aren't any more like us, it's a fact. That's why there are a lot of people who come to us wanting that.

FB Are you often criticized for that by the public?

RB No, mostly the general public loves what we do.

FB Do you sometimes return to your large-scale housing projects such as Les Arcades du Lac, the Quartier Antigone in Montpellier [1980 onwards], or Les Espaces d'Abraxas?

RB Yes, and the residents are happy. We haven't had any major social problems. But let me tell you something: what hurt me was the "Neoclassical" criticism, especially in France. The French are a people who like to classify everything; after all, they invented the modern dictionary! [Laughs.] Their sticking the Neoclassicist label on me made me very angry, so I went back to Barcelona.

FB But why does being labeled a Neoclassicist bother you so much?

RB I hate Neoclassicism! The 19th century in France or Italy was a century of normative, official architecture, and bam!, I find myself stuck with this label. Neoclassicism closed off architecture, it smothered the creativity of earlier eras.

FB What importance does Catalan culture have for your work, or for you personally, today?

RB Well, you know, Catalonia is a small, marginal country, but with lots of resources, business people, artists... But, like with all small countries, either you make the effort to get to know the world, to take an interest in what happens outside your own little world — and you have to make

the effort that curiosity demands and take the trouble to get to know other cultures — or you die, because no one's going to come and see you. It's not like if you were living in New York, London, or Paris. It's changed a bit since I was young, but Barcelona remains a provincial city. So one must simply convert this lack into an asset. That's what I've learned living here. Catalonia is a small country, but with very varied landscapes, so that also gives you a connection with nature, even if it's in miniature. There's the sea, the mountains. And then Catalonia is an avant-garde country. There were always lots of painters, sculptors, architects, designers... There isn't that nostalgia for the empire that one finds, for example, in Madrid. And that's also reflected in the day-to-day mentality of the city, even politically — the emancipation of women, the recent legalizations with regard to different lifestyles, like gay marriage, drugs — these are things that we were already talking about 30, even 40 years ago. It's a country of good professionals, good doctors, good lawyers...

FB And good architects?
RB Yes, that too... a bit. [Laughs.]

NEW YORK

SANTIAGO CALATRAVA

Interview by Horacio Silva

Santiago Calatrava knows bridges. In a career spanning four decades, he has emerged as the *pontifex maximus* among architects, having lent his name to dozens of spectacular overpasses. All of his designs — like the Guillemins high-speed train station in Liège, Belgium (2009), the expressive Auditorio de Tenerife in the Canary Islands (2003), or the forthcoming PATH Station at New York's Ground Zero, to name but a few — are complicated, soaring structures that are sometimes unspeakably expensive to build but always seduce with their beautiful engineering. Spanish-born and Swiss-trained, Calatrava speaks seven languages — all of them, presumably, with the same rapid-fire seriousness he displays in English — and divides his time between offices and homes in Zürich, Valencia, and New York. He is also an accomplished artist, whose collaboration with Frank Stella was shown at the Neue Nationalgalerie in Berlin. PIN–UP sat down for coffee with the restless soon-to-be 60-year-old (who still has a full head of dark hair) in the all-white conference room of his New York office on Park Avenue.

Horacio Silva	**Nice coffee. How did you come to represent Nespresso? That's an odd fit, don't you think?**
Santiago Calatrava	**No, no, I don't have anything to do with Nespresso. They interviewed me once for their magazine and published some of my work, but that's it.**
HS	**I read you were a spokesperson for it — you and Roger Federer.**
SC	**Well, I do love coffee and I do love tennis. Actually, I have a nephew who was ranked in the top 50.**
HS	**I've heard of him — Alex Calatrava. He was a solid player. So tell me about what you're working on at the moment.**
SC	**Well we are currently working here in the United States on the PATH station for the new World Trade Center at Ground Zero. It's a very demanding project, a project that requires a lot of energy. And it's going ahead well, I have to say.**
HS	**With more than a little controversy...**
SC	**Well, you cannot do such an enormously significant public project without controversy. There are too many feelings involved. But the good news is that it's going ahead. Our target is now September 11 next year, when they will open the memorial, the memorial gardens, and the memorial center.**
HS	**What else are you juggling at the moment?**
SC	**We are currently working on the South Terminal Redevelopment Program for Denver International Airport. In Dallas we are completing the Margaret Hunt Hill Bridge, and starting on a second one, called the Margaret McDermott Bridge. Both are over the Trinity River. We are also working on a very beautiful project in Lakeland, Florida, which is located between Orlando and Tampa. It's a campus master plan and first academic building for the University of South Florida Polytechnic.**
HS	**Are you an equal-opportunity gun for hire, or are you more attracted to projects of a certain nature?**
SC	**You know, we have done a lot of work for public institutions so maybe there is something there. I have built several well-known railway stations. Currently I am building three! Then there are the many bridges. We are also building a very large beautiful arena outside of Rome. It's called Città dello Sport and it's located near a university. The idea is for it to be a place to develop the science of sport: sports medicine, physiotherapy, and all of those things.**
HS	**Speaking of sports, what was it like watching Björk at the opening ceremony of the 2004 Olympics at the sports complex you built in Athens?**
SC	**It was probably one of the most beautiful, moving things ever for me. Really.**

You know, we designed everything, down to the Olympic flame. And when it came toward the athletes and rose up with fire, it was really a magical moment. Nobody believed that we could finish it on time, and we did. I mean, it's an enormous team process that you have to go through for years, fighting against all kinds of situations and difficulties, right down to the winds, which were tremendous and made working up high very difficult. And then, of course, there was the very hostile press.

HS Ah, the wretched press. Growing up in Valencia, were you very sports-minded?

SC I'd say so. Mostly soccer and squash. But you have to be in very good condition for both so I don't play either very much. [Laughs.]

HS Looking around your office, you're surrounded by a lot of your own artwork. At what age did you become hands-on with the arts?

SC I was very young when I started drawing. I think I was even drawing before I could speak. So when I was eight or nine years old I was sent to a school close to our house, which offered evening art courses. I guess I was admitted because it was considered exceptional to be interested in art at such an early age. All the other students were much older — 20, 50, 60, 70-year-olds. In fact, some of them were complaining because they felt that I was too young, and because somebody had to pick me up from home and take me back.

HS Was that your first exposure to architecture?

SC Yes, formally. But at home I was very prepared for art. My father was an art lover. He went to Madrid for business and came back and spoke only about the Prado and there were always discussions about Velázquez or Goya at our dinner table, and about music as well. I definitely grew up in an ambience of music and art and whenever I got the chance to travel with him, I would. Unfortunately he passed away when I was very young.

HS When did you leave Spain?

SC I lived in Spain until I was 22. However, my mother started sending me to France when I was 13 or 14 to learn the language. She came from a family that was involved with international trade at the time and my grandfather had been living in France for 20 years — they exported food to the rest of Europe and had an office in Paris.

HS Was there ever any doubt that you were going to go into architecture or engineering?

SC My mother originally wanted me to be a doctor, but I had to follow my instincts. I started my education in an art school. Then I studied architecture, and from there I went into engineering.

HS That's when you moved to Switzerland?

SC Yes, I went to Switzerland to study civil engineering. I received a Ph.D.,

or doctorate in technical science, from the ETH [Eidgenössische Technische Hochschule] in Zürich. My thesis is very much related to topology and geometry. I spent 14 years away from my origins in art and had to start from zero again. In the meantime, however, I had learned about forces, equilibrium, and form. I made my first sculpture again with some of my children's toys. [Laughs.]

HS Are you a prolific artist?

SC I'm rather slow, but I try to work on something every day. All in all I've produced about 70 pieces, maybe 80; that includes both painting and sculpture. I've also done some ceramics and furniture pieces — like this desk we're sitting at. They're often things that relate to my private life, like a set of silverware for my family. But I've also executed some large pieces that can be seen on the street. I designed the 90-meter-high moving obelisk for the Plaza de Castilla in Madrid and another piece that stands on the campus of the University of Haifa in Israel.

HS What is it about the commercial realm that seduced you away from art?

SC I am actually one of the stubborn few who consider architecture an art form. When you look at the façade of Notre Dame in Paris, or enter the Capilla del Condestable in Burgos, you are experiencing works of art. Is that architecture? Indeed it is architecture, because without the shape, the rest would not be possible. It is interesting to see how those things work together, and how architecture nourishes itself from everything else. It's like a sponge — and an ephemeral one at that.

HS Do you do your own complicated engineering calculations? I have this image of you at home in bed last thing at night doing your own calculations!

SC [Laughs.] You know, we do have engineers in my firm. Our firm employs about 100 people and around one third are engineers. So we are very involved in the engineering of our projects, although we are also very much accustomed to working with other engineers and partnering with other people. This allows us to build in several places at once, without having to put engineers in place.

HS And frees you up for your artwork! Are you planning any more exhibitions of your artwork in the near future?

SC Yes. We are about to open an exhibition together with Frank Stella in the Neue Nationalgalerie in Berlin, a building designed by Ludwig Mies van der Rohe. Frank Stella is a great friend whom I admire enormously, and he has a great interest in architecture. He has produced an enormous canvas for the show, it's over 30 meters long. After Berlin, the exhibit will move to the Pablo Serrano museum in Zaragoza, Spain. It's a great honor to show next to such a wonderful artist as Frank.

HS Which other artists do you admire?

SC I'm also a big fan of Alex Katz, whose work is very different than Frank Stella's, of course — very figurative, very beautiful. I visited his studio downtown once with one of my sons. We all went to a small restaurant near there, somewhere around Broadway. There were all these mirrors in the restaurant and at one point during our meal I remember looking up into the mirrors and realizing that all the people — the faces, the gestures, the clothes — were reflected around us and we all looked like we were in an Alex Katz painting. [Laughs.] When you think of the great artists living in this city — Ellsworth Kelly, Jasper Johns, Joel Shapiro — New York to me is very exciting. It's incredible, like Paris at the turn of the 20th century. Maybe not all New Yorkers understand that, but all those great artists who have definitively shaped the second half of the 20th century, they are still here, working! And they will, without any doubt, mark the beginning of the 21st century.

HS More than any working architect, you are known for your bridges. What is it about bridges that attracts you?

SC I grew up in Europe, and one of the most foundational periods in Europe was the Roman period, no matter where you go. Valencia, my hometown, is a Roman city; Zürich is a Roman city — Turicum; Paris is a Roman city — Lutetia; London, is a Roman city — Londinium; Lyon is a Roman city — Lugdunum. And on and on, you see? The Romans founded many of those cities by rivers, because the river was a natural fountain. After founding these cities, they built a bridge, and then put up a fortress on the other side to defend the entrance to the bridge. The controlling of this crossing is how cities grew. Take the Brooklyn Bridge as a more modern example. Before it was built, Brooklyn almost did not exist. From the moment John A. Roebling built the Brooklyn Bridge, an almost entirely new New York emerged on the other side. Or think of the Golden Gate Bridge. When the great artist Christo wrapped it and effectively made it disappear, what was left was still a nice place, but it wasn't the same. So a bridge is a fundamental element, not just a utilitarian link. In recent years, very invasive, enormous infrastructure programs have been put in place — like the interstate program by Eisenhower — and I think we are slowly losing sight of the artistic value a bridge can bring to a place. Which is a pity because bridges have the power to symbolize a place. They can be a gate and they can be a link. They carry enormous cultural significance. They are even *sagrado*... they have a sacred dimension — for Christians, and especially for Catholics. In Latin, *pontifex* simply means "greatest bridge-maker." From the beginning I believed very much in the significance of bridges.

HS Another recurring motif in your work is the color white. What do you find seductive about it?

SC I guess my relation to white has a lot to do with my origins, being born in Spain. Valencia is a Mediterranean city where white is very common. It is a beautiful color and I like that it is very demanding, that it requires a lot of

maintenance to keep it clean. When I was an architecture student there was a period in which I was very interested in vernacular architecture, and I was traveling around the Mediterranean at a time when few if any tourists were there. I remember Ibiza when there was nothing except for the occasional white farmhouse. So this is probably the reason for my love of white. White is also all about subtle contrasts — with it you see shadow, light exposure, and all the chiaroscuro. You see all the scars and the shadows of your project.

HS You once cited Antoni Gaudí and Eero Saarinen as two of your biggest influences. They really couldn't be more different from one another.

SC I recognize in both an enormous artistic dimension. Gaudí was very much Art Nouveau, and the contemporary expressions that came with that. But what is interesting about Gaudí is that he related to a resource which has almost disappeared today, which is craftsmanship. And this lifting up of craftsmanship into the realm of artistic achievement is very important to me. Our time is so poor when it comes to that. If you go back to the Baroque, to the architect Balthasar Neumann and the Würzburg Residenz he designed, the iron and stuccowork he did there would never be possible today. Neumann was the chief orchestrator but there is so much quality work coming from those craftsmen. And this, in my opinion, is what is lacking in modern architecture.

HS And what do you admire most about Saarinen's work?

SC What I love about Saarinen is his expressivity. His TWA terminal at JFK is a miracle of expression to this day — it's like architecture as flight. For contemporary architecture, the work of Gaudí is a bit difficult, it belongs to another era. But the work of Saarinen, although he passed away many years ago, still has validity. His curves and way of treating the overall sense of the building to achieve an idea are very powerful and very beautiful. So while they are very different, you can see why I'm attracted to both of them.

HS Obviously a lot of your work is indebted to craftsmanship and ornamental gestures from the past. But do you agree that there is also a sci-fi element at play in your work?

SC Well, science fiction is very much based on a delirium of technology, isn't it? I say delirium, because I am thinking of *Flash Gordon* or *Star Wars*, and things like that. [Laughs.] But there is no doubt that in my architecture technology plays a very important role, so maybe you are right. But with each project I work on, I have to produce an enormous amount of square footage, an enormous amount of cubic footage — at a low price! — so unlike science fiction, I can't afford to lose attention to reality or human scale.

RAFAEL
DE CÁRDENAS

Interview by Michael Bullock

The day I meet Rafael de Cárdenas, the 36-year-old New York-born architect and interior designer is still in awe from a Beyoncé concert the night before. "It's all about her mannerisms," he exclaims, flicking an imaginary mane of hair from side to side. We're seated in a booth at Niko, a tony Japanese restaurant on Mercer Street in SoHo that de Cárdenas designed. In many ways Niko is exemplary of his approach — a mix of classic upscale-eatery elements, bold colors, dynamic patterns, low-brow materials, and specially commissioned artists' pieces (in this case by Jim Drain). Since founding his firm Architecture at Large in 2006, de Cárdenas has made a name for himself with a slew of eye-popping, media-genic projects, including retail, furniture design, art installations, and residential commissions (for actress Parker Posey and model Jessica Stam, among others). De Cárdenas never strives to reinvent the wheel, but rather to convey, and perfect, a certain mood or moment. But behind his often surface-heavy designs is a sophisticated thought process fueled by a set of references that owe just as much to his background as a menswear designer for Calvin Klein as to his work for architect Greg Lynn and scholar and theorist Sylvia Lavin. In conversation, de Cárdenas is refreshingly unpretentious — what matters to him most is creating architecture and design that is as contemporary and relevant as a hit pop song.

Michael Bullock	Explain to me again, why did you think Beyoncé was so mind-blowing?
Rafael de Cárdenas	Because she sings, moves, and performs like she is Beyoncé — no one else can do that. Her movements, her choreography, they're hers. And the way the music relates to it all, it becomes a motif that runs throughout and becomes a language. She hasn't invented anything new, but she's perfected certain mannerisms and completely made them her own. Few people are able to hone their performance in such a specific way and captivate everyone — and that's exactly what she does!
MB	Let's talk about your own performance. How did you transition from fashion designer to architect? The more typical story would be the other way round…
RdC	I first studied at Rhode Island School of Design and was recruited directly out of school to be a menswear designer at Calvin Klein. But I always had an interest in architecture — I don't know why. So I thought I would study architecture and then go back into fashion, but as a show producer. At the time I was really into Alexandre de Betak, and I thought that that's what I would do, too. But then, when I started architecture grad school at Columbia, I actually really hated it. So after my first year, I transferred from Columbia to UCLA.
MB	What did you hate?
RdC	This was the mid 90s and architecture was going through that whole conceptual "we don't make anything, we just talk about shit" phase, especially at Columbia. I just wasn't into the whole paper architecture thing. I believe that as an architect, or a fashion designer, or a writer, you need to make the thing you practice. You can't just talk about making it. There's a weird thing in architecture — that somehow complexity is celebrated for its own sake. I don't care about that. I may not be the most talented or the smartest architect out there, but I'm enough of both to do architecture the way that I want to do it. And I'm always pushing it further in the direction I want to go. But I didn't learn to think this way until I went to UCLA and started working for Greg Lynn.
MB	Were you his star student?
RdC	I wouldn't say star, but I was definitely one of his favorites. More importantly, I was one of Sylvia Lavin's favorites, his wife and the head of UCLA's architecture and design program at the time. I think that's how I got into Greg's good graces.
MB	Do you consider them your architectural mentors?
RdC	Yes, especially Sylvia. She is awesome and I owe her a lot. When she was my thesis advisor, I remember she once asked me to describe two projects, one by Steven Holl and the other by David Chipperfield. I used the word "elegant"

to describe both and Sylvia scolded me, explaining that the word "elegant" means so little: it only means elegant, and elegant is something that you know only when you see it. She said the way I described those projects, they sounded like one and the same. I began fumbling for the right words and she told me, "The words exist — you just need to sharpen your knives."

MB So after you graduated from UCLA you went to work for Greg Lynn, helping him teach [at the Universität für angewandte Kunst] in Vienna, and working on the World Trade Center competition back in 2003.

RdC Yes. The time I worked on the World Trade Center competition was probably one of the highlights of my life. Greg had joined forces with Reiser + Umemoto, Foreign Office Architects, and UNStudio, and we all entered as one team under the name United Architects.

MB That's a lot of ego on one project! How did they all collaborate?

RdC It actually fragmented into what people were naturally good at. The towers were designed by everyone, but, for example, UNStudio figured out the whole transportation hub — the subways, the freeways, vertical circulation, etc. — the overall logistics were largely figured out by Foreign Office Architects, Greg Lynn's team was responsible for 3D-modeling software, and so on. So the division of labor happened organically.

MB You were the new school team?

RdC Yeah. Herbert Muschamp from *The New York Times* even called us the "dream team." He championed us in a big way and he would come once a week so we could show him our progress. I remember his references were always cultural. One day we were talking about *The New York Times Magazine*'s competition for a time capsule, and he said that Calatrava's submission, in elevation, looked like May West's lips, but then in profile it had this big sharp peak that would cut you if you actually tried it to kiss it — he called it a deadly kiss. I loved that reference!

MB The work you're doing today is very different from Greg Lynn's. How did your time with him most influence you?

RdC I learned a certain methodology from Greg. But Greg's studio was run very differently from the way I run my practice now. In a weird way, it was more hierarchical. It was Greg's singular vision, and I don't know that I'm strict like that. First of all, I don't champion my own style, because style by nature is easily exhausted — it has a lifespan. So I try to move beyond it and suggest moods and atmospheric effects. In a way, I learned more about running my business from Calvin Klein's studio, at least from an organizational standpoint. The idea of being commercially successful while running a design practice that's culturally relevant may sometimes seem incongruous. But Calvin Klein, at the time I worked there, made a strong contribution to the world of design while also making a great profit — so I learned that those two can be harmonious.

MB It's funny that you learned to run your studio from a fashion designer, because I would have thought the goals and pace were too different to be applicable.

RdC I don't think that different sets of rules necessarily apply to fashion and architecture. Contemporaneity is the same, whether in fashion, or writing, or anything else; there's a way to be contemporary and you have to know what that is. You have to be very familiar with the zeitgeist, have your ear to the pavement, and know what is going on, in order to diagnose it immediately and create the contemporary.

MB But the time frame in each field has a big impact. Fashion turns out two or more collections a year while buildings can take forever to be completed.

RdC Well, one definition of architecture is the construction of a freestanding building. Alternatively, you can claim many types of projects that work architecturally, which is what I do. Architectural work can be made at many different scales — I've done full projects out of tape or saran wrap! Many people probably wouldn't consider that architecture, but I don't really care what they think. I consider it architecture and I claim it for architecture, whether architecture will have it or not. Because the discourse of architecture, to me, is not very culturally relevant. It's far too tied to academia, and academia is out of step with the contemporary.

MB The first time I heard mention of you was in relation to the aNYthing clothing store on Hester Street on the Lower East Side. Was that your first project under your own name?

RdC Yes, although at the time I was still working full time for [film-production company] Imaginary Forces. But I was working on experience-design projects — which were very costly to produce — and they stopped happening because of the economic downturn. So I started working on my own projects more and more. Parker Posey's apartment and aNYthing were the first.

MB aNYthing was also the beginning of a long collaboration with Aaron Bondaroff, who has since founded the gallery, art publishing house, and international pop-up shop OHWOW whose spaces you also designed. Would you say that your work for Aaron is the best representation of your own style?

RdC I don't think I have a signature style. It's just that all the projects I've created for Aaron are almost all one brand, so it's good for them to be branded. I like commerce — I don't think it's a bad word. Retail space has to be commercially viable. But I also do a lot of residential projects which, by nature, are very different. I play out a lot of my different interests in all of my work. I think that part of being a designer is designing something that is appropriate to its use, and to the specific brand.

MB But then your residential work is very different. Many of the projects, like the apartment you did for Jessica Stam, are a very brightly colored take on 1930s and 40s Hollywood glamour.

73 **RAFAEL DE CÁRDENAS**

RdC You're right, a lot of my residential projects have this kind of 1930s, Billy Haines, Hollywood-boudoir, L.A.-film-noir glamour gone sour. That's appealing to me in a huge way, like a sickly sweet femininity that's cut by something catastrophical. I like residential interiors that do that.

MB There is a lot of drama and bold color, but there's also a lot of comfort.

RdC But there's also discomfort! It can be uncomfortable when someone diagnoses who you are. I don't always necessarily give my clients what they ask for...

MB Are you talking about playing psychologist with objects?

RdC Well, to a degree, objects are all about psychology. They mean something, and their organization and reorganization can mean different things, sort of the way words have different meanings in different orders. Of course ultimately I want my clients to like my project, and they usually do. But 100-percent happiness with my project does not equal happiness — you could have the most bangin' interior in the world and still have a shitty life, and vice versa. So you can't give it that much importance either.

MB One thing almost all of your projects have in common — whether they're residential, retail, or otherwise — is the use of electric color and decorative patterns, two things most architects are afraid of.

RdC Architecture with a capital A, the way that we've inherited it from Modernism, is a very macho practice and it has completely divorced itself from interior design and decoration. Most architects are basically afraid to put on some lipstick and a little eyeliner — they're afraid to be caught in drag! But I think that architecture is already decoration: we plasticized the way we were supposed to live so long ago, and buildings per se are totally artificial. So I don't understand why there is so much fear attached to further micro-embellishment. The nice thing about interior decoration is that it's allowed to not be macho. It's not scrutinized with the same intensity. Yes, decoration suggests things like status and social hierarchy, but in architecture history, long before the arrival of Modernism, decoration also served very simple purposes. For example, a baseboard simply hides the imperfection of how a wall meets the floor. Those are useful devices, and they can take any form you want. So I decorate everything as much as I want to because decoration is another layer of meaning that you can add to a project. Architecture may be macho, but I'm not!

MB Another decidedly un-macho trademark of yours is the pop-up shop, of which you have done quite a few. What do you think of this phenomenon?

RdC It has market appeal, and it's also a useful tool for the kind of end-of-the-world economy we're living in right now. There's a lot of uncertainty and it's hard to make a ten-year financial plan, because who the fuck knows what's gonna happen? So I think the pop-up store phenomenon is a product of that sentiment. It also seems a very appropriate concept for a generation

that is so steeped in the ephemera of media and social networking. The pop-up store is a physical manifestation of the tweet — they have a kind of relationship. But I think the pop-up store, at least in title, is already exhausted.

MB In a way, you've used the current economy to your advantage though, making a name for yourself with mostly small-scale dynamic projects.

RdC I've only ever worked in this economy, so it's not like I had some boom-time economy and then I got hit with this — it's all I know! I'm varied because of my experiences in fashion, and because I have a sort of innate commercialism — which I don't know where I get, maybe it's just being Jewish — and somehow I'm able to make things work. But I'm by no means established — I feel very precarious!

MB You may feel precarious, but you were recently able to launch an entire 25-piece furniture collection at Johnson Trading Gallery. How did that come about?

RdC I knew Paul Johnson before because I'd bought furniture from him for clients for a while. One day he asked me if I designed furniture myself, which I didn't really. And then he asked if I was interested in making some. It was very different from anything I'd ever done, so I approached it the best way I knew how, purposefully referencing the furniture design of other architects — Bruce Goff and Frank Lloyd Wright, specifically.

MB Were you nervous having a big show like that? It got a lot of media attention.

RdC I'm still nervous about it! I never set out to produce a show that people would react to so strongly. But I've also heard some rumbling within the design community that's gotten back to me...

MB Well, I think it's obvious that you have different interests to most furniture designers. At Johnson Trading Gallery especially, you see impeccably crafted high-concept design, made with incredible materials. Your work, by comparison, seemed far more focused on the visual impact. Maybe this sounds horrible, but your show was almost like a Lady Gaga moment in furniture...

RdC I don't have a problem with a Lady Gaga moment in furniture! I actually prefer design choices that date objects and fingerprint them to a specific time and which suggest the greater cultural context. For example, I'm far more interested in the avocado-green stove at Case Study House #21 than some beige one that has never been contemporary and always classic. Being contemporary is more interesting to me than being tasteful.

MB Does that attitude better prepare you for criticism, or can it still make you uncomfortable?

RdC I don't think anyone likes criticism. I know I don't.

MB Of course. One would always rather have one's work seduce.

RdC Well, everything in life is seduction. You want everyone to fall in love with you, and to love everything you do. Everybody wants that, no?

MB Hmm... I think most people are motivated more by money than by the desire to be loved.

RdC Monetary gain is part of it, but if my goal were to make lots of money there are far more efficient ways than being an architect. And the very specific thing that I claim as architecture most architects probably would not, and they don't want me in their club. So I'm actually all about being part of a club that wants you out — that makes me want to be part of it even more!

BERLIN

DAVID
CHIPPERFIELD

Interview by Felix Burrichter

Sir David Chipperfield is on a roll. Not only is he the curatorial director of this year's Venice Architecture Biennale, he has also just won the contract to renovate Berlin's most revered postwar gem — Ludwig Mies van der Rohe's Neue Nationalgalerie. A member of that illustrious club of starchitects (a label he himself would shun) whose name is recognized far beyond architecture circles, the 58-year-old runs an international practice with offices in Berlin, London, Milan, and Shanghai. Although based in Britain, the firm's biggest office is in Germany, where Chipperfield has earned an exceptional level of both professional respect and public admiration. And it is in the German capital that his greatest achievement is to be found: the painstaking, decade-long rebuilding of the Neues Museum, whose scars he carefully preserved as witness to Berlin's tumultuous 20th-century history. On the occasion of an exhibition of photographs of the Neues Museum by the artist Candida Höfer, PIN–UP sat down with its architect at Berlin's Johnen Galerie to discuss the impact the project has had on his practice as a whole, the benefits of building in Germany, and the importance of finding common ground.

Felix Burrichter	Let's start by talking about the Neues Museum, since it's by far your most significant realization in Berlin. It has been said that all the ideas developed by your practice during its quarter century of existence gelled into a unique *Gesamtkunstwerk* in this project.
David Chipperfield	It is true in some sense. But with all statements like that, there is a certain amount of truth and a certain amount of fabrication, or exaggeration. Before we started the Neues Museum we asked ourselves, "How relevant is such a task to what we normally do? Is this a sort of weird project where we're just going to spend ten years dealing with preservation concerns, with the *Denkmalamt* [historic heritage commission] and all of those bureaucratic and technical issues that come with the rebuilding of an historic monument?" While we had an idea about how we'd like it to go, we couldn't be sure where it would take us. I wasn't sure whether this was going to be like a parallel career, exotic and rather fascinating, but with its own trajectory. Dusting ourselves off at the end, I think we would like to believe that it had an enormous influence on us, for two reasons. Firstly, in terms of time and the way one matures through one's own experience: I've been practicing architecture for just over 25 years, and when we started the Neues Museum in 1997 I'd been working as an architect for about 12 years and the project lasted about 12 years, so it's taken up 50 percent of my professional life. Secondly, as a practice it's only recently that we've managed to do a few projects in England, since I've always worked outside my own country — our first three buildings were in Japan, and then we worked in Germany, Italy, America, and Spain — and from the outset it made me think about what it meant to build in a specific context. I've always been interested in context and the significance of what one does in a particular place, and I think that heightened our sensitivity to the idea of context. And, I suppose, with the Neues Museum, there was in a way even more context than we wanted — you couldn't have more context than this geological pile of Piranesian rubble that was evidence of traumatic events of the 20th century, was a fundamental part of the urban structure, and had its own particular history. So it was like every other architectural project, but to an intense degree.

FB Could you name some specific aspects?

DC In a way there are many very positive aspects. We always have to deal with the public expectation about what architecture should look like and how it should perform, but never as explicitly and as animatedly as we did with the Neues Museum. All architectural projects depend on a certain collaboration between the client, the city administration, the planning department, the contractors, and the design team, but never more so than in that project. In all projects you're dealing with materiality and technical problems,

but never more so than at the Neues Museum. There is a team of people from our office who worked on this for ten years — they were present throughout and got incredible experience and, to some degree, confidence in all of those tasks, but especially in the political, the idea of collaboration, not as a process of compromise, but as something fundamental to the realization of ideas. The Neues Museum could not have been realized without first of all making the atmosphere in which we could conduct the conversations. There was a sort of diplomacy that was part of this, but not diplomacy in a decorative way, but diplomacy in terms of how you explain ideas to people, and how you hold on to those ideas but, at the same time, how you take on board other opinions, and how you include different aspects. So I think that was our achievement more than anything else.

FB The Neues Museum apparently also had an impact on the design process in your office, in that you started working a lot more with physical models, applying materials directly onto them.

DC Well, I'm a bit of a dinosaur as I come from that pre-computer time, so we've always made large physical models in our office. I've always had more confidence in physical models than computer models. But I also think that for the younger generation, the physical model is an incredibly useful tool. Normally, when you design a building, you start with form, shape, and space, and then gradually you start to think about actual materials — at the beginning you don't quite know what its material qualities will be. The strange thing with the Neues Museum is that we started the other way around: we already had all the materials, and we were trying to give form and space back to it. That was a really good lesson for us. It was something we already had a sympathy for, but I think that seeing space not just as volumes, but actually as something where the materiality is fundamental, or where the color, or, to use that word, the decoration is an integral part from the beginning, is important. So you're right, instead of making white cardboard models, we tend to think quite early on about what those walls might be made of.

FB Let's talk about representation of architecture, which is always a difficult subject because space is obviously something that has to be experienced. It's very hard to capture in an image, whether it's a computer rendering or a photograph. And you in particular are someone who has very specific ideas about how your buildings are represented or photographed, if one is to believe the little controversy surrounding photographs that were taken of Des Moines Public Library [completed in 2006].

DC [Laughs.] That was a very funny story. A librarian decided that someone shouldn't take photographs and it was blamed on the architect. And now the story has gone viral and one of the most famous facts about me in America is that I ban photography in the library at Des Moines, which I absolutely never did — it was a complete invention.

FB I'm glad we were able to clear that up!

DC Yes! But going back to representation, I think there is a serious side to this. Computer renderings have allowed architects to be more and more specific and simulate something that looks more and more real at the conceptual stage. And clients, in the case of a competition, like the security that they're not just listening to three architects, or ten architects, saying what their ideas for the projects are, but that they know exactly what it's going to look like. That puts the architect in a very weird position because at the beginning of a project, when you know least about it, you're doing a sort of drawing that isn't far from — and can only be judged as — reality. And I think that is incredibly dangerous for architecture because it tends to freeze-shrink the conceptual process, since instead of a project's being able to develop through that early stage, the architect has to be clear at the beginning, and is then chained to that concept or image. It's very difficult to escape from. And, secondly, in the beauty contest of images, the one that captures everybody's eye is usually the most explicit one. If you're trying to do something very calm and quiet it doesn't come across very well in a computer rendering, unlike something with a big wavy roof and things sticking out! [Laughs.] But what you can't compare or measure at that stage is what the built quality of those two things might be; all you can do is measure one image against another, and that has tended to push us, and push clients in the commissioning process, towards buildings which are more iconographic and are more obvious at the rendering stage, as opposed to those things which might improve during the development process, or might have qualities which do not reveal themselves so easily.

FB So you don't play the game of showing beautiful images?

DC Of course we do. We have to! [Laughs.] But our work doesn't necessarily lend itself so well to that, so there are certain competitions where we already know, "Well, that's going to be difficult..."

FB Some of your most significant projects are in Germany, and in Berlin in particular. What do you think makes your approach so appealing to German clients?

DC I'm not sure it is, but I think we've built up an extraordinary office here in Berlin which has probably benefited, slightly, from being the best of both things: it's both German and it's international, there's a sort of combination of Anglo-Saxon tendencies and Germanic tendencies, without going into too much detail about what those tendencies might be.

FB Oh please do!

DC I think, in a caricatured way, German standards in building culture are more set, and I think there is a slightly higher expectation of quality. On German construction sites, the people who are putting things together, or painting walls, or fixing doors, generally conform to a certain self-policed level of expectation of quality, which in England, for example, doesn't exist, I'm

sorry to say. There, if you can get away with one screw instead of three and the door doesn't fall off, you do it. If the wall looks okay with one coat of paint, well, let's see if anyone finds out you didn't apply a second coat. The sort of standards that the profession imposes may, sometimes, also be a bit heavy and a bit bureaucratic in Germany. On the other hand, it just stops things from falling down. I think there is a respect for planning, and a respect for doing things well. To some degree, Germany and some other European countries are a little bit old-fashioned, in a nice way.

FB This explains why you like to work in Germany. But it doesn't explain why you think your aesthetic, or your process of working, might be popular with German clients.

DC A lot of the work we've done here is museum and public related, and I think there is a real understanding of that in Germany. For example, the Folkwang Museum [Essen, 2010], for us, professionally, was a very tough project to do because the budget was quite low, but I think the concept was clear, and it has been very well received. Had it been in England, I think there would have been a sort of feeling like, "Well, isn't it a bit cold and boring?" Whereas in Germany it's understood to be something appropriate. There's a certain austerity about our work which finds more sympathy and empathy here.

FB What is your view of the current state of architecture in the Berlin? In a recent interview, when asked about the Stadtschloss rebuilding, you said that Berlin has changed a lot in the past few years, and that you weren't so sure who still needed it.

DC It's always dangerous to talk about the Stadtschloss here in Berlin! The point I was trying to make was that the city has become much more comfortable about its physical form. I think there was a period after the Wall came down when everyone felt, "Oh my god, look how exposed we are, look how fragmented this city is, look how ugly it is! We have to tidy up quick, let's start putting it back." And I think in the last ten years that mood has changed, and everyone has come to realize that the slightly fractured, the gaps, the incompleteness, is part of Berlin's character and is not just a negative part, but a positive one. And I think the representational issues about Berlin are less worrisome to a younger generation, and I don't think they feel this city is incomplete if you don't do this or you don't do that. Because, for heaven's sake, you can't fill all the gaps! So I'm not being negative about the rebuilding of the Stadtschloss, I'm actually trying to be more positive about the city's coming to terms with its own identity, which I think is fascinating.

FB You're the director of this year's Venice Architecture Biennale, whose theme is "common ground." How much common ground has already been found since you were appointed last December?

DC The Architecture Biennale is a strange animal because it tries to be like the Art Biennale, but architects don't have artifacts in the same way — well,

we have artifacts, but they are not necessarily exhibits to put on the wall. So the Architecture Biennale can easily run the risk of becoming a sort of self-promotional architectural fair and I really want to preclude that.

I want to know instead where architects get their ideas from, and who they respect. Who were their fathers? Who were their sisters? Who were their children? And funnily enough, everybody — just about — has bought into this, despite architects' normally considerable egos. So I'm trying to show how people are connected and to challenge this notion that the profession tends to show itself as the accumulation of singular efforts, as though the architectural community were a group of stars with different styles, rather like fashion brands — if you buy Zaha you get that, if you buy Herzog & de Meuron you get this, with Chipperfield you get that, and so on. It tends to suggest that we don't share things, that we don't have common concerns and influences, and that the only thing that differentiates us is a stylistic approach.

Obviously common ground would be easy if I just went to all the usual suspects. For example, I can make common ground very easily by finding people who think the same as me. But common ground is also a phrase that is used when from the outset you accept the notion of difference — it's a common ground between differences, otherwise it's not very interesting. So it was very important not just to go to the ones who do architecture the same way I think about it, but to go much wider. So I went to see well-known colleagues for whom I have deep respect, and who I believe should be under a tent called architectural culture. I'm not trying to say, "These are the world's top 50 architects"; rather, I'm trying to say, "These people have all contributed to architecture."

FB Can you name any specific examples?

DC There's this very talented Irish firm, Grafton Architects, who have done a very good building in Milan, and they just won a big competition in South America. They've been very influenced by the Brazilian architect Paulo Mendes da Rocha, who is now 80 years old. So they're going to visit him in his studio in São Paulo and they want to build a model of one of his projects because it's so influenced them, and they want to show two models in the Biennale, their model and his model. It's a sort of homage to him, and it will be accompanied by a film that they'll make in his studio. So that's one example.

FB And has there been anyone with whom you were personally surprised to find common ground?

DC No, because my whole philosophy would collapse if I didn't think it was there — it's what I believe in. And in the end that's what the Neues Museum was: an exercise in common ground. So that project shows above all that you can find common ground between anyone, and that it shouldn't necessarily be seen as a bad compromise. If you just articulate ideas strongly enough, I think that you can always find common ground.

PARIS

CLAUDE DALLE

Interview by Aric Chen

For a New Yorker getting set to meet him in Paris, the French decorator Claude Dalle can seem something of a mystery. For those living in Paris, he's the elephant in the room: hard to ignore, but better left unmentioned. "Claude Dalle? You're kidding, right?" one Parisienne responded when I asked if she knew anything about him. Slightly more forthcoming, another acquaintance hinted coyly, "He's a very special man... He's worked on palaces for Arab royalty" — not to mention for Mobutu Sese Seko, the notorious Zairean dictator — "with gold tigers and things like this. Go to his shop; it's very informative."

So there I was — standing in the 12th arrondissement, in the shadow of the Bastille opera on the rue du Faubourg Saint-Antoine. And there was Dalle's "shop" — in fact, three mega-showrooms, rising up to six stories each, where Dalle's name and that of his empire (ROMEO) flickered in neon, strip-club lights. From the outside, these carnivalesque palaces are as dolled up as an oligarch's mistress, their façades studded with Dalle's burnished "CD" monogram — as if this were Christian Dior — alongside gilt medusa heads that could have been chiseled off the Palazzo Versace itself. And inside? Welcome to the period rooms of the Museum of Over-the-Topness: a pink rococo *lit à couronne*; faux Klimts; colossal Atlases; a menagerie of bronze jaguars, leopard-print rugs, and zebra-print settees; an army of blackamoor candelabra trudging through indiscriminate acres of marquetry, mirrored walls, silk damask, and crushed, burnt, and tufted velvet; and Ionic columns — in clear acrylic — standing against a boulle-work commode conspicuously labeled, in French, "Old Furniture — more than 100 years old." So this, I realized, is why everyone kept so mum; Dalle's work is... indescribable.

So who is this Claude Dalle and what is this world he's created? Though they agreed to my interview, his staff were bafflingly reticent about providing any background information. And cue the theme song to *Doctor Zhivago* — because that's what the showroom's sound system was playing when my minder, an aging bottle blond with a zeal

for makeup, scurried over to forbid me from taking notes. "It is not allowed," she warned in broken English, wearing an ominous white lab coat. I felt a cold wind from a more suspicious past: price tags (yes, there are price tags) are still listed in francs; doorways festooned with strands of garlic to ward off evil (seriously) welcome Saudi princes and African tyrants trading their oil wealth and blood money — and cash that could go toward clean water and measle shots for millions of children — for a dozen or so ormolu consoles. A shiver shot up my spine.

But, eventually, the mystery man appeared, and the chill quickly thawed. Dalle did not arrive in a sedan chair, as I'd imagined, but instead appeared as a likeable fellow — almost down to earth — looking dainty in a dark suit with a red pocket square and pinstriped shirt. His full head of hair and round face make him look much younger than his 74 years, and his easy, old-country manner and benign, self-knowing smirk have charmed not only autocrats but also the likes of Gianni Agnelli, Aristotle Onassis, Frank Sinatra, and, more recently, Alain Ducasse. Indeed, the wall came down, the veil lifted, and, in an interview in his incongruously toned-down office, Dalle began to let on to what he's really about.

Aric Chen How did Romeo-Claude Dalle come into being?

Claude Dalle My parents came from the south. My father was from Venice, my mother Corsican. And my grandmother was a gypsy. I was born and raised in the rue du Faubourg Saint-Antoine *quartier*, an area famous for its furniture makers and polishers. My father was a cabinetmaker and so I literally grew up among wood shavings. You can't be much more bred-in-the-bone than that. My family was very humble, and I received little education, so when it came time for my father to work out what to do with me, he found me a job with a company called Bianco. Monsieur Bianco was a very kind and very talented cabinetmaker, and that's where I got my start.

AC What was the Bianco style like?

CD It was of its time, classic 1930s and 40s.

AC So what we would now call "modern"?

CD If you like. But truly, what does "modern" mean? It means nothing and everything, according to who you ask.

AC So you learned your craft at Bianco, then branched out on your own?

CD In the 1970s, I bought out a company called Guérin. It was established in 1830 by the two Guérin brothers — so it was really inscribed in the history of the Faubourg. You know, I grew up on the rue Saint-Nicolas and — though some people disagree — I believe this is where the Revolution began. In the late-18th century there were as many as 14 bistros on the street, servicing all the workers in the woodworking ateliers. For months on end, these guys hadn't been paid, yet they were making furniture for the visibly rich. They were understandably unhappy about this! Then one day, in July 1789, when they'd had a bit too much to drink, they decided to go attack the Bastille prison, which was just a few minutes away. Of course, there were only two prisoners in the Bastille at the time, so it was more symbolic than real as far as political action goes. But the rest is history. And in the basement of my store, many of the Revolutionaries hid out. There is graffiti carved into the limestone walls — though I don't tell the government because I don't want my basement to be requisitioned!

AC So the history of the Faubourg and the history of Romeo are closely intertwined?

CD The Faubourg Saint-Antoine has been the heart of the French furniture industry for centuries. Ruhlmann, Mercier, Jansen, Sormani — they all had their headquarters here. In that sense, yes, Romeo is very much inscribed in tradition.

AC Why is it called Romeo?

CD	Romeo is one of the most recognizable symbols of love. And since it's the woman who usually buys the furniture and oversees the decoration of a home, we do everything to keep women happy! Personally, I do everything to keep women happy. Don't you?
AC	Sure. Who are your clients?
CD	The Sultan of Brunei, the royal families of Saudi Arabia, Qatar, and Bahrain. Dubai has been booming for us the past few years. Also, the presidents of Senegal, Gabon, a lot of other African countries. Mobutu was a client of ours when he was president of Zaire.
AC	Is your style "Late Dictator"?
CD	We also had Frank Sinatra as a client. And a friend. We used to play cards together. Gianni Agnelli was a client. Then there was Aristotle Onassis. He was extremely considerate. He called once to say he was running ten minutes late for an appointment. I naturally insisted he take all the time he needed. One doesn't rush an Onassis.
AC	Did you grow up with a certain fantasy of the good life?
CD	I grew up in very humble surroundings, so no. My style has changed over time. It has evolved as my client base has become more sophisticated. That said, what you see in the showroom doesn't necessarily correspond to my personal taste. It is there for a certain type of client with a certain type of taste or tastes.
AC	What is your house decorated like?
CD	It's a mix of contemporary and reproduction pieces. Large paintings. I particularly like Abstract Expressionist–style paintings.
AC	When did you get your first big break?
CD	I'm still waiting for it...
AC	You have an impressive client list. What is your ideal client like?
CD	The one who pays the best! No, seriously, there are two types of client: the ones who have all the money in the world but behave as if they are Mr. or Mrs. Normal, and the client who is capricious and arrogant. We mostly have the former, which is why so many of them become friends. We try to create an atmosphere that makes our clients happy. Simple as that.
AC	What, in all of the store, is your favorite piece?
CD	There are a few 19-century antiques — sideboards, commodes — downstairs that I like. But otherwise, that's like me asking you, "Do you have a type of woman that you prefer?"
AC	No.
CD	See! Me neither. I like all kinds — blondes, brunettes, redheads. It's the same

with the furniture and objects we create. They are all relevant, and most importantly, they appeal to our clientele.

AC How have things changed since your early days?

CD Today, we employ 200 people, so I spend a lot of my time troubleshooting. In the old days, we would work through until 10:00 at night. At 8:00 p.m. we'd stop, bring out the tables, lay the linens, cook up a simple meal — pasta or something — have a little wine, then go back to work. Nowadays, no one wants to work. Today, it's just complaints and complications. If you ask a secretary to hurry up, she'll sue you for sexual harassment.

AC What would be your dream project?

CD That's difficult because today's dreams are not necessarily the dreams of tomorrow. My dream project would be to live happily.

AC There are all these garlands of garlic hanging in obscure corners of the store. What's that about?

CD It's my Corsican side coming out. They're to ward off the evil eye.

AC Do they work?

CD I haven't seen the devil yet.

PARIS

ODILE DECQ

Interview by Aurélien Gillier

In the stifling quiet of a Parisian August, at the end of a courtyard in the historic Marais neighborhood, the Goth-rock blare of The Sisters of Mercy lacerates the hush. The sonic blast is coming from the offices of French architect Odile Decq, a rock star of sorts in her field, known for her I'm-with-the-band allure — a Siouxsie Sioux redux of heavily kohl-rimmed eyes, teased black tresses, and sculptural rings on every finger. But, behind the mosh-pit appearance hides a pragmatic optimist who, for the past three decades, has been the principal of ODBC, the architecture firm she co-founded with her late partner, Benoît Cornette. Winner of the 1996 Venice Architecture Biennale, Decq has taught several generations of students at universities around the world, including the renowned Ecole Spéciale d'Architecture (ESA) in Paris, of which she became the director. But it wasn't until recently that her work began to reach a wider public through her ever-more prestigious architectural realizations, which include the Museo d'Arte Contemporanea di Roma (MACRO, 2001–10), the FRAC Bretagne in Rennes (2005–12), and the Phantom restaurant (2008–11), located in one of France's most prized national treasures, the Opéra Garnier. As she reaches maturity, Odile Decq has every reason to turn up the volume.

Aurélien Gillier	Throughout your career you've worked in so many different fields: as a teacher, as the director of ESA, making art installations, creating stage design, and in recent years building large-scale architecture projects. How do you define yourself socially?
Odile Decq	I don't define myself. I'm an architect!

AG Have you ever been asked whether you were an interior designer or a "real" architect?

OD I haven't heard that question in a long time. Nobody asks me that any more. But it could easily come back. It's a question that girls are automatically asked. I've been practicing for 30 years, and I've been hearing that for 30 years. I'm not a militant feminist, but I'm fed up with frequently being taken for a feminist spokesperson, and of people asking me this kind of question in full knowledge of the insinuations behind it. It's very tiresome!

AG Do you think that, like Denise Scott Brown in her 1975 essay "Room at the Top? Sexism and the Star System in Architecture," you could take a vocal stand on the condition of women architects?

OD I don't know this text, but I think it's not a question of campaigning for the condition of women, but rather of affirming that it's possible to be a woman, an architect, and respected, even though there still aren't many of us.

AG Don't you think the trend is evolving, especially in architecture schools where the ratio of boys to girls has changed?

OD The trend has evolved and that's all! If you look at registrations with the French National Order of Architects, when I started we were eleven percent and now we're still only 30 percent.

AG With regard to the position of architect, is it not an advantage to be a woman?

OD It has advantages and disadvantages. Where the advantages are concerned, when you're on site with a bunch of guys in front of you, I always say to my female colleagues that there's no point yelling to get yourself heard, given that their voices would become too shrill and they'd just seem ridiculous. It's better to say things firmly, keeping your voice down, and with a big smile. In architectural practices, it's the women who are sent on site because everyone knows things will go differently. But we're always asked about this, the proof is that you, yourself, began with this subject.

AG Sorry to contradict you, but actually it was you who brought up the subject of women architects!

OD Oh, I'm sorry! [Laughs.] I'm probably used to always hearing the same questions because with the way I look, people often don't think I'm an architect.

AG I've read all sorts of things about your look: sometimes you're labeled a Goth, sometimes a Punk, and I've also heard you described as a female Robert Smith.

OD I'm more Siouxsie and the Banshees than Robert Smith! [Laughs.] But overall, I would probably say that my look is more Goth than Punk, even if Goth came out of Punk. The group I was always most into is The Sisters of Mercy.

AG Would you say the look is a creation, or even an extension, of your architectural persona?

OD I'd never asked myself the question in that way. I just sort of fell into this look one day. It's actually done me rather a disservice, since people imagine all sorts of things about me — that I'm not serious, or I must be a weirdo. But, first and foremost, it's a kind of armor, a way of protecting myself vis-à-vis the people I meet. It makes some people suspicious, and you feel that straight away. I never go any further with them because I know from experience that nothing interesting can happen with people who can't get past the barrier of prejudice. But most of the time, I totally forget I'm like that!

AG You only wear black. Is this a rejection of optimism?

OD I started wearing black during my studies, before every other architect started wearing it. With dyed-blond hair, I wore black-leather pants for their rebellious connotations. At the beginning, it wasn't about a particular color, but little by little it became an addiction. And it's a serious addiction!

AG Has this addiction also infiltrated your architecture?

OD It's fairly recent. At the beginning I never wanted to impose on others what I did for myself. When I won competitions, people were afraid I'd give them too much black. But attitudes seem to have changed. Now, people know about black in my work.

AG Also, your addiction to black is clearly evolving — at the MACRO, you use a lot of red too. The area in Rome where the museum is located is a fairly strictly protected neighborhood. Were there particular issues concerning preservation of the historic fabric?

OD Not really, apart from the façades and a little bit of the structure which we had to keep. But what might seem like an obligation is actually what has allowed contemporary architecture to exist in Rome — behind the façades we could do almost anything. That certainly wasn't the case for Phantom at the Opéra Garnier.

AG So how do you manage to take architectural risks when dealing with an icon like the Opéra Garnier?

OD Well, to begin with, you must always fully understand the constraints. At the Opéra Garnier we weren't allowed to touch the façades, the pillars, or the vault. We nonetheless had to enclose the restaurant because the original space was open, all the while making sure not to create "windows," which

was something the Ministry of Culture didn't want. My first idea was to create a sort of glass undulation behind the pillars; as we went forward with the project, we continued this undulation round the entire perimeter, because this undulating screen responded to the questions and restrictions set by the clients. The architect in charge of the building's conservation was supportive of the idea of introducing contemporary architecture within the confines of the Opéra. But, when I went to present my scheme to the relevant architect of the Bâtiments de France [an organization of the French state that acts as architectural-heritage inspector], he insisted on pointing out to me that the project was to be inserted into Charles Garnier's Opéra, a historic monument that had never been in any way modified since its creation, and asked me if I really understood what I was doing... But then, after we'd presented our scheme to an important committee, we were told it constituted an exemplary project that could now be submitted to the National Committee for Historic Monuments. We subsequently appeared before them, and they unanimously accepted our proposals.

AG Without the constraints imposed on you at the Opéra, I imagine your project would have been quite different?

OD I really couldn't say. You know, as an architect you always respond to a brief with constraints. We're not like artists. An artist's work is a response to what he or she wants to do, whereas an architect has to respond to a specific program with all its restrictions.

AG What's your opinion of contemporary architecture in Paris?

OD I think it could take more risks! When I began studying at architecture school, everyone said that 19th-century architecture was horrible, that we should think and build modern. And then at the end of my studies it was the beginning of Postmodernism where people began to reconsider 19th-century architecture. But today, I think we've come to over-fetishize the 19th century and Haussmann's Paris. As a result it controls anything and everything, and Paris is turning into a museum. When people talk about skyscrapers in Paris, it sparks a huge debate, and we do small projects on the city's periphery, without in any way sorting out the status of central Paris. A project like the Centre Pompidou could never happen in Paris today.

AG Isn't it also a question of political drive? For example, the Centre Pompidou would never have seen the light of day without the tenacity, authority, and persuasive force of Georges Pompidou.

OD Yes, but that isn't the case anymore today. On the one hand, there's no money left in the public sector, and then the kind of projects Sarkozy gave his backing to were the renovation of the Grand Palais, the creation of the Museum of the History of France, and the fiasco that was "Grand Paris" [a debate about an urban renewal plan for Greater Paris], which never went any further than the initial hype. All this ballyhoo to produce next to nothing — a new transport plan, an underground rollercoaster, for 32-billion euros — it's

unbelievable! There's no vision or ambition anymore, no real will to change and reorganize the city.

AG And what do you think of Carla Bruni-Sarkozy?

OD Apart from the fact she dresses like Jackie Kennedy, I've nothing to say about her. I don't know her and she doesn't interest me as a singer. I frequently travel to Italy — she's Italian — and Italians hate her.

AG And her role as France's first lady?

OD This isn't a kingdom for goodness' sake!

AG Are you so sure?

OD Actually, yes, we do live in a kingdom. In France, there is a sort of royal court and a lot of architects think that you need to go get your handout from the king, or those who administer power on his behalf. For example, when you're planning to go abroad to do something — be it an architectural, artistic, or other project — your natural reflex is to go to the city, the region, or the government to ask for their financial or political help, because there's a belief that the state can always give you the aid you need to leave. Whereas, I think that we're quite capable of getting what we need without asking the state. And with this system of handouts, you're dependent on those who supply the money, you can no longer really do what you want, and you're less free to say what you feel. I'm not interested in that.

AG You say that even though you've worked on a majority of public projects?

OD I have absolutely no problem with that. I won the competitions and completed the buildings, and I don't feel I owe anyone anything. I've always wanted to remain free. But at the same time, I'm not going to bite the hand that feeds me!

AG You also work a lot abroad. I imagine that helps one to be less subservient?

OD Yes. My survival comes from abroad. I've always traveled to give lectures and teach in foreign architecture schools — I love doing it and it comes easily to me. When I started out, I would give lectures abroad without even being paid, which I didn't mind because I found it was necessary. I was often asked for names of other French architects, but they would always set too many conditions: they wanted to be paid and to travel in business class, and in the end they weren't invited to give talks. When you're starting out, you have to be prepared to make concessions.

AG Where have you taught?

OD I've taught at the Vienna Academy of Fine Arts, at the Architectural Association in London, at Columbia University in New York, and I've led workshops at SCI-Arc in Los Angeles.

AG Is that how one becomes director of the Ecole Spéciale d'Architecture?

OD No, not at all. One becomes director, to a certain extent, because one

teaches there. ESA is a partnership which elects its director from among candidates who are, for the most part, teachers at the school.

AG What makes the Ecole Spéciale so special?

OD It's a private school which answers to no ministry or bureaucracy, so it's outside of the system, and can therefore be more free. We're also very internationally minded. English and French intermix, and lectures in English are not translated, which would be unthinkable in all the other French architecture schools which are state financed. Moreover, ESA adheres to no particular trend — we're open to all of them. Our teachers are all very different, but young and dynamic, like Reza Azard, Cédric Libert, Jean-Christophe Quinton, Thomas Raynaud, or the artist, Simon Boudvin.

AG Does Peter Cook also qualify as a young and dynamic teacher?

OD No, but Peter Cook is such a major figure — an institution! When I heard he was going to have to retire as director of the Bartlett School of Architecture, I asked him if he wouldn't like to come and teach at ESA. And we've managed to hang on to him ever since. We weathered a bit of criticism about his being past retirement age, but let's be serious: does someone like Peter Cook ever retire? He's still taking on architectural projects, he's building an architecture school in Australia, a library in Vienna, and other projects in Spain. I've never seen anyone with such a full travel schedule. And he's 73!

AG You live in Paris. What does your home look like?

OD It's a large apartment that will never really be finished. It's rather *camping de luxe*! [Laughs.] I think most architects' places are never finished. That's the difference between architects and their clients. People are afraid of construction work — they prefer to buy apartments that are finished. Only architects will move into a half-finished apartment. I know plenty who've only got half a bathroom... in my place the wiring isn't finished.

AG Is it your tendency never to finish things?

OD No, don't be silly! I finish jobs for other people! [Laughs.] My place isn't finished, firstly, because I moved in when the work wasn't completed and then, as time went on, I realized I could live with it, and now I don't have the time to sort it out. I admit it can sometimes be a pain. When I come home in the evening it would sometimes be nice to walk into a completed apartment. Even people who come to visit will say, "Ah! There's still no sink in the kitchen," and then I'll tell them that I'm "going to the well" when I need water because the only faucet is in the bathroom. But what do I need a kitchen sink for when I've got a dishwasher? [Laughs.]

AG Is this lifestyle also a part of your penchant for risk-taking?

OD I think the idea of risk-taking and responsibility hardly exists anymore. It reminds me of an article I read about a survey at Harvard which showed that over 70 percent of the students didn't want to become managers.

Today's youth is so afraid of tomorrow that they don't even dare invent the future. To invent the future, you have to dream it. Many of them think that everything's already screwed, that the future will be worse, and that the planet will be destroyed. I think that, on the contrary, it's in our time that we can still make change happen. The best examples right now are in Tunisia and Egypt, even if we don't know what these revolutions will lead to.

AG So, could one say the French Islamic-veil law is an example of risk-taking, even if ill-advised?

OD I think the worst laws that have been introduced here are those concerning the precautionary principle, which kills risk-taking. It's terrible because it impedes society, it impedes thought, it impedes everything! I see it all the time in my profession: if something isn't expressly allowed by law, then on principle, it's forbidden. I think it's the greatest danger threatening our society.

AG Because it leaves no room for the unpredictable?

OD Yes, exactly. Creation happens because it's unpredictable. It's like with scientific discoveries: many of them weren't at all foreseen and in fact were complete accidents. You have to leave space for the unforeseen.

AG But you also have to find the kind of clients who are willing to take risks with you.

OD You have to adapt the risk-taking to the client, but you must always take him or her further than they imagined. The client's limits are those of his or her imagination, while the architect's role widens the field of possibilities, and therefore you need to educate the client in order to take him or her further. It's the same as with teaching, when you get students to see that they can go much further than they thought they were capable of. And that's a great joy! Everything in life is like that — discovering that nothing's impossible.

AG Are you not at all worried about the current economic climate?

OD I've had problems before, and have already been through several lean periods where I had to scale down my team. You say to yourself that you're not condemned to practice only architecture, you accept other jobs, you take on projects in design, and you enter lots of competitions. That's how I won the commission for the MACRO in Rome. I'm not worried because I find it serves no purpose. I know how to adapt to all sorts of conditions.

PARIS

DELFINA DELETTREZ

Interview by Horacio Silva

Delfina Delettrez Fendi may not be everyone's furry cup of tea — certainly the Surrealist motifs that inform her graphic, dazzlingly sinister jewelry are not for the timorous. But in the five years that she has been in business Delfina (the daughter of accessories designer Silvia Venturini Fendi, and Bernard Delettrez, a French jeweler) has emerged as a bona fide fashion player and media darling whose designs are sold at some of the world's most storied boutiques and are worn by strong-willed, modern-day Schiaps. The 25-year-old Delfina, who has a five-year-old daughter whose father is Delfina's former beau, the Italian actor Claudio Santamaria, is not as hard-edged as her jewelry, which by her own admission can sometimes hurt the wearer. Although Delfina calls Rome home and lives in an apartment in a converted brick factory, PIN–UP caught up with her for a chat at her Paris pied-à-terre in the picturesque Rue de Furstemberg in Saint-Germain-des-Prés. It was the morning after the fashion show (and late-night after-party) for Kenzo, for which she also creates the jewelry, and her apartment-cum-showroom was overrun with editors oohing and aahing over the not-so discreet charm of her latest namesake collection, yet Delfina was attentive and forthcoming on a host of subjects, including her frequent design nods to architecture (which she endearingly pronounces "arshitecture") and the pressures of trying to put a first name to a famous last.

Horacio Silva	**This is a really beautiful part of Paris — it's my favorite little street.**
Delfina Delettrez	**It's incredible, isn't it? It's like living in a theater because everything is happening around you. It's fun to see drama being played out below. Last night was like a chorus with two people singing like crazy.**
HS	**It looks like a great place to have a lovers' quarrel.**
DD	**Yes, I've seen that too! [Laughs.] It's always something different.**
HS	**Speaking of drama, you spent a lot of time in Brazil growing up.**
DD	**Yes, the wild part of my childhood.**
HS	**What age are we talking about?**
DD	**From zero to about four, before I went to school. But I was born in Rome because my mom really wanted me to be born in Italy. We're a very traditional Italian family in that respect.**
HS	**They wanted you to be baptized by the pope etc.**
DD	**[Laughs.] Yeah, kind of. Then we moved to Rio and went back and forth until I was around nine or ten, until it became difficult to keep doing that. It was like having two different childhoods. One was very wild, with no rules, where my only goal was to play outside in nature. My mom didn't want me to sit at home watching T.V., so it was a childhood of constant research and asking questions about nature. I always wanted to know more and I was lucky because I was surrounded by inspiring people who were like living nature encyclopedias. Rome was inspiring too because I was able to observe so many great people who came to visit and all those great women at home whose style I admired so much.**
HS	**What sort of houseguests are we talking about?**
DD	**From Woody Allen to Pavarotti to Piero Tosi...**
HS	**The costume designer? I love the work he did for Visconti's *The Leopard*.**
DD	**Me too. My family worked with Visconti for the movie *Gruppo de famiglia in un interno*; they also worked with Fellini on the movie *E la nave va*. So I was exposed to all these great anecdotes from before I was born — it was amazing to hear all the stories.**
HS	**It sounds like you were a student of nature in Rio, and of human nature in Rome.**
DD	**Pretty much. I was really fascinated with dissecting insects and stuff like that. I don't have very lucid memories, but I have flashes of memory and I recall perfumes. I remember the acidity of the colors in nature and the surreal stuff that was happening around me. I remember waking up in the**

morning in our house by the sea, in Buzios, to find the beach full of little sharks because the tide would bring them in. One morning we woke up and found a cow in our swimming pool! Another time I got bitten by a snake and I remember my mother panicking, and the *fazendeiro* said, "Don't worry, if she hasn't died in the first minute she'll be fine."

HS The what?

DD The *fazendeiro* is like the ranch owner or caretaker, the one who actually stays home at the *fazenda*. He does everything.

HS I see.

DD So even for my mom, it was like, "Whoa!" Brazil was good for her because it taught her to let go. But you know, both influences are very evident in my work because I design for women and I am inspired by nature. And Rome made me love the manufacture. It formed my aesthetic sense. I'm an aesthete. It's an obsession. And the architecture!

HS Why do you think the architecture in Rome gets such a free pass? People rarely complain about or criticize Rome's architecture, some of which is an eyesore.

DD Maybe because it's made of so many layers that it's like living in seven different cities in one and the juxtapositions are expected and somehow work. There're all these different architectural spirits — the Fascist one, the Neoclassical, the 70s buildings, and so on. I love the decadence of Rome. Things really change and evolve gradually. But you're right, no one ever complains. Well, maybe a little bit. What about the controversy over the extension to the Ara Pacis? Remember the Romans are very conservative at the end of the day.

HS Where is your place in Rome?

DD It's near the pyramid [of Cestius] and the *gazometro*. I just love that area but nobody wanted to live there before because it was kind of dangerous. Then they cleaned it up and I got the space about six years ago. It used to be an old brick factory and it was empty, totally destroyed. There was a museum in front that I used to go to all the time. It has this contrast of this very industrial feeling mixed with Classical statues and ruins. I really love the contrast of the industrial machine and those marble statues so I wanted to recreate the same feeling in my house. Nothing is hidden in my place, not even the practical things like the pipes and ducts. Everything is exposed. It's a mix of materials: we've got copper, redwood, and all the walls are made of the original bricks of the factory. I've got this fascination with the church, of course living in Rome. So I got a lot of the furniture from old monasteries that used to throw things away. I've got a sacristy, I've got a safe box from this church, I've even got a holy-water font!

HS It sounds like you went to god's sample sale.

DD [Laughs.] Yes! It started when I was kid. My brother and I, every Sunday —

it's kind of blasphemous, but maybe not — would play church for our family. He was the priest and I was performing the ceremony for the whole family. I don't know why. Like I said, I had this fascination.

HS Did your parents have Buñuel on a permanent loop or something? It sounds like you grew up in one of his films.

DD [Laughs.] I don't know. Something like that. It's funny because my parents actually had a fake marriage, so I don't know, my whole life has been a little surreal.

HS What do you mean a fake marriage?

DD She was wearing this red Karl Lagerfeld dress and everybody thought they actually got married, but they didn't. But it is all a little Buñuel. Like Buñuel, I love nuns' uniforms and I actually wear nuns' clothes quite a bit and I shop where the nuns go shopping.

HS Where does a nun shop, out of interest?

DD By Borgo Pio, near Largo di Torre Argentina. There are two shops and they're incredible.

HS So you buy basic nun staples to mix with designer pieces?

DD Yeah, they have blue gowns or black gowns. If you don't put on the white coif they look like incredibly made clothes.

HS Other than Buñuel, where did the fascination with Surrealist iconography come from?

DD Well, from my mom. She would take us traveling all around Europe and throw us into museums. I remember being so fascinated by those Magritte paintings, for example, where there is always a hidden side to them that makes you feel almost angry because you want to take out the obstructions and see the face. Same with Dalí paintings; I would stare at them and each time I would discover new things. I just loved the oneiric aspect, the total freedom and, of course, the nonsense.

HS You said oneiric? Are you a daydreamer? A student of dreams?

DD Both. I definitely like to study my dreams.

HS Did you ever do psychotherapy or dream therapy?

DD Yeah. But then I decided to do it by myself. Not really analyzing it but writing about it. Sometimes I just remember sensations or images, but when I can I like to write down my dreams in the morning. Sometimes my daughter wakes up and tells me all of her dreams. So I write them down too, because I would love one day for her to be able to read and connect with her craziness. [Laughs.]

HS Assuming you've read books that help to decode recurring dream imagery,

what do your dreams say about you?

DD Yeah, I have Freud's *The Interpretation of Dreams* and all that. But I'm not telling! [Laughs.] Enough to say that we're all pretty twisted.

HS Speaking of Freud, it's as good a time as any to bring up family issues. Has being a Fendi been a curse or a blessing?

DD Both. But more of a blessing because, in a sense, it formed me. It helped me find my path without forcing me at all. My family is very democratic in that way. But when I actually decided to follow a similar path to them and become a designer it was also a curse because you have to prove yourself more. You have to make people understand that it's not fun and games for you, that you're not a...

HS Bored rich-kid dilettante?

DD Yes. Or that you really feel these things and it's not a case of your parents forcing you to choose the easiest path. That's why I started doing jewelry on my own. It would have been easy for me to work at Fendi. But no, I had this passion and there was no point fighting it. I said, let's do my own thing. But I've got all these great minds surrounding me and they're like teachers to me. We all help each other and give advice. It's nice to able to share my view of fashion with three generations, with my mom and my grandmother. We all have different stories to tell and a different perspective.

HS Your family is an estrogen-heavy cast of very formidable characters — it's almost like an Almodóvar film! Isn't that daunting sometimes? How do you fight for space at the table to be heard?

DD It's difficult. That's why we all have strong identities. We need to, in order to be heard! Even my aunt [Ilaria Venturini Fendi] didn't follow the family path and is doing something totally different: fashion but recycling. So we all have the same passion, but they are very far removed from each other. We don't have to push so much to get attention; in a way our work speaks for us.

HS How did you learn jewelry?

DD [Laughs.] I'm still learning and making mistakes. I'm learning with the artisans. And it wasn't always easy. Sometimes, at the beginning, I would put stones upside down. But through my mistakes I would discover something new. This un-didactic approach is what makes me able to twist this sense of traditional jewelry. Sometimes, if you study jewelry, you have to pay so much respect to classical roots, you cannot make your own rules.

HS Did you go to school to study jewelry design or did you learn with the family ateliers?

DD No, not the family atelier. No, no, no! I was actually in acting school and when I became pregnant I couldn't continue because school was very physical, so I had nothing to do. So I took a family stone that I had, because

we have this tradition of giving stones to each other, and I just took it to a goldsmith's atelier in Rome. I wanted to make a ring so I could finally wear the stone. Maybe it's because I was pregnant and had so much time and if this hadn't happened at that moment things wouldn't have turned out the way they did. It's a very slow process, this kind of jewelry as art, and I used to be, "C'mon, I want fast things." But it made me calm down. Then when I saw all these pieces come alive, and realized I was doing these frogs and sweet stuff, I was like, "What is happening to me?"

HS Ha, your hormones were kicking in!

DD Yeah. Then other times I would freak out because my body was telling me totally different things and my designs also changed. Remember, I started designing when I was three months pregnant with my daughter. I found myself inviting people and showing them my creations and I had special commissions almost immediately. So in Rome I started to have my own private clientele. Sarah Lerfel [of the store Colette in Paris] saw them and she was like, "Let's do something here," and, a month after my daughter was born, I presented at Colette. From then on I started to have requests, to have press, and my fun little game became a full-time job. I had to make a decision, but it was an easy decision because I was — pfffff — full of ideas!

HS What's your store in Rome like?

DD It's a tiny, tiny little room on Via del Governo Vecchio, where all the artisans are. It's an old pharmacy from the 1800s with all the original drawers, which I painted an acid green. It's very intimate, you have to ring a bell to be let in and it's a bit daunting, which I like. But when you're inside you feel like you're having a special private appointment. It's like a witch's laboratory, with my collection of butterflies and insects and dead animals, like a cabinet of curiosities.

HS You were obviously exposed to a lot of design growing up. How important was design to your family? — design in general, not just fashion design.

DD Design of every kind has always been very important to my family. We used to live in a house that was very removed from my taste: it was a house full of antiques, very classic. I remember being jealous of my friends' apartments that were more contemporary and modern and I didn't want people to come inside my house. I was embarrassed. And then my mom renovated everything ten years ago and made everything totally different, and super beautiful. Now I sometimes miss that feeling of the old. But when you're a child...

HS Was it like living in a furniture showroom?

DD Mmm, in a way. We have a lot of Giò Ponti, Fontana Arte, and even Swedish wood furniture.

HS It sounds like it's a temple to Modern design.

DD But it's an interesting mix. My mom knows how to mix a lot of different

epochs and make them look incredible. I am more into one theme. I am, in a way, obsessive. I wouldn't say I'm one note because my house is industrial meets ecclesiastic. But it's always going to feel like Rome because San Paolo is directly in front of me.

HS Can we talk specifically about your pieces that incorporate architectural iconography?

DD The Infinity Collection, for example, is very much about architecture but in a way they are more magic-trick pieces. You know those infinity mirrors? I love them! I had just bought one and thought it was incredible. But you cannot plug in a piece of jewelry so I needed to find a way of having these strange reflections, so it was more of a magic trick. I'll show you. [She demonstrates a metal knuckleduster whose polished reflective surface creates a hall-of-mirrors-like optical illusion with a single inset pearl.] You actually have one jewel multiplied.

HS That's one jewel?

DD Yes, that's one pearl. Even when I was young, I remember in my mother's bathroom she had this trick with two mirrors and if you're in the right position your image is replicated. And to me the mirror is something very spiritualistic.

HS But you also featured columns in some of the bracelets in one of your collections.

DD Yes, that was another collection called the Metaphysical Collection. It was more inspired by Roman statues and Piranesian ruins but mixed with metaphysical aspects of de Chirico because it was presented on these black-and-white enormous Stockman mannequins wearing jewelry with these columns. Every mannequin was posed in a different position with the columns. This is more architectural, but less figurative than the mirrored pieces in the Infinity Collection.

HS Are there always elements of architecture in your work?

DD Yes, I like strong forms. In order for things to speak to me, they have to be strong and evident and tell you something, even if they hurt a bit to wear. [Laughs.]

HS How important is it for you to show in a design context, like at the last Design Miami, rather than a fashion context?

DD To be honest I was scared, because Design Miami is such a prestigious fair and I thought I wouldn't be able to do anything that would be understood by the design world. I always put the same thought into the display as I do into the pieces themselves, so when I saw the space I wanted to build an installation that was really big and full of mirrors. I wanted to give the sensation of pieces that didn't look like jewelry from afar, but more like pieces of furniture. Even if the focus was high jewelry, they were unique

pieces, so the focus was also on the craftsmanship. I liked that. You were obliged to see the jewelry through a loupe from a specific angle. It was a game of reflections all around.

HS Do you think it legitimizes you as a designer by showing in a design rather than a fashion context?

DD Well, in a way, it really helped me to detach myself from the seal of approval that comes with my family's name. I was happy because I was shown as a designer and not as someone who was riding a good wave. The importance was on the work and not on other things.

HS I have to say that I hate jewelry at those design fairs, but it worked really well. It was one my favorite things there.

DD I think it's the first time that the fair had accepted something like this. You usually find galleries that show a lot of jewelry but nobody really worked on the setting, on the windows. To me it has the same importance. It has to speak to you. The setting has to really make you understand my interest of the moment, what inspired the pieces. That's why I hate windows.

HS You hate windows?

DD Sorry, I mean commercial windows, like vitrines. I wanted to put the pieces very close to you and elevate their importance by giving every piece its own way of being displayed. There were only ten pieces and they were very different from each other but similar too, so it was about showing the evolution of the different pieces.

HS At the risk of sounding like one of those red-carpet interviewers, what are you wearing? Your skirt is divine.

DD A friend made it. His name is Marco de Vincenzo.

HS Milan-based, or Rome?

DD Rome-based, and he shows in Milan. He has his own line but he actually works with my mom at Fendi, in the accessories department.

HS Ah, the family business. Which brings me to the million-dollar question that no one ever seems to ask you because they assume the answer will be no. Is there really zero chance of your eventually taking over Fendi?

DD [Laughs.] Ha, never say never!

LONDON

FREDRIKSON STALLARD

Interview by Caroline Roux

They might not yet be on first-name recognition level like Gilbert and George and Viktor and Rolf — or Siegfried and Roy, for that matter — but Patrik Fredrikson and Ian Stallard are certainly one of the design world's most colorful and compelling all-male partnerships. A duo since 1995, they officially began working together under the name Fredrikson Stallard in 2002, and have carved out a significant place in the burgeoning world of limited-edition design. Represented since 2005 by David Gill Galleries in London, they regularly show work that subverts the norms of furniture design and explores materials in unexpected ways. They invited PIN–UP to their beautifully converted carpet factory in Shoreditch, East London — coincidentally just around the corner from Gilbert and George's favorite Turkish grill — which functions as their workspace, gallery, and home.

Caroline Roux	After you started working together properly in 2002 as Fredrikson Stallard, you seemed to get this reputation as the princes of darkness. Everybody who interviewed you talked about how gothic you were and how you made crosses out of brushes and how your space was filled with stuffed animals. Now you've become known more for work that is vibrant, glossy, statement making, attention grabbing, baroque, and particularly for working within the design-art camp. What ever happened to the princes of darkness?
Ian Stallard	Oh god, the princes of darkness! That was never at all intentional. We weren't really gothic, we were just very monochrome. We only worked in black and white because we were concerned with form and narrative. At the time, I was still very much working with ceramics, and Patrik was designing furniture.
Patrik Fredrikson	I think there are two or three key pieces...
IS	There was the Dragon Vase in white or black — a very simple classic form with Chinese-style dragonheads coming out of it. It updated the traditional Chinese vase by simplifying it and taking it down to the barest essentials. I guess when you see the dragonheads in black and white you think of gargoyles.
PF	And then there was the Villosus Vase with horsehair growing out of it.
IS	But that was never meant to be unsettling either. We didn't sit there thinking, "Oh, let's do something that's really voodoo and weird!" It was about combining materials — like porcelain and another material — that are luxurious, beautiful, and have similar levels of class. That's how we came up with horsehair. We never thought of it as dirty, filthy, or evil — we always thought of it as beautiful.
PF	The first product that really got us noticed was Candle #1. That wasn't intended to be gothic, either; it was just a cast of a 19th century candle and a candleholder all in one in wax, so it would burn all the way down. It has been copied so much now. In fact, you can actually buy similar ones in supermarkets.
CR	What a compliment *that* is!
IS	Yes, apparently we should be flattered, as we're so often told.
PF	Flattery is great, but royalties are better! [Laughs.]
IS	Then there were two other pieces: the Cross Brush — a scrubbing brush in the form of a crucifix — and the Lovers' Rug, which is made from two puddles of red urethane, each containing the volume of blood the average person has in their body. Some people find the Lovers' Rug quite morbid, although we thought of it as quite romantic. With both pieces we were very aware at that time that they would attract attention, but we certainly didn't expect hate mail for the Cross Brush, which we did receive from the U.S. We never intended to insult Christianity at all. In fact, Patrik is a Christian.

CR	A practicing Christian?
PF	Oh, of course. Every Sunday I do my little ritual.

CR	So how did you throw off the cloaks of the princes of darkness?
IS	We made a pink sofa. [Laughs.]
P	We started working with David Gill in 2005. Once you join a gallery, the first thing they say is: "Can we have some color?" So we gave it to them!
IS	Shocking pink, just because it's the most colorful, the color-est, the colorest-est color that there is!
PF	It was for our Pyrenees Sofa, a piece we made in 2007 for our first show with David Gill.
IS	David had asked us to re-interpret upholstery. There were a few ideas we were working on at the time which fitted with what he was looking for. One of them was to use upholstery foam. But instead of using slabs of the material to construct something, we started chiseling the chair form from it. By carving out various seating areas it formed this mountainous ridge, which is why we decided to name it Pyrenees.
PF	Strangely, the bright pink one — we call it "Fredrikson Stallard Pink" now — is the one everyone wants a picture of, and everyone wants to borrow. It's the one everyone really wants, but doesn't quite dare to buy — or maybe their interior decorators don't want them to! [Laughs.] It does take over. You'd really have to have just that in a room.

CR	To the right of this sofa we've got something absolutely fantastic, a bit beaten up but an incredible form. Is it your very, very first version of the King Bonk Chair and Ottoman? [The piece is named after the biggest marble in the school playground, not a vigorous sexual act. In its completed state it is made in fiberglass and finished in a hyper-glossy duotone paint specially created for Bentley cars.]
PF	Yes, those two pieces, the chair with its ottoman, are what got the gallery so interested in our work in the first place. David Gill came to our studio and saw a little model in foam tied up with string and said, "What's this?," and we said, "Well, it's the study for an armchair." But he thought it was just amazing as it was.
IS	There is actually no folder or file in our computer whatsoever for that piece. Every piece we do has a folder, but this one doesn't. The only way to translate the model into a full-size piece was to hand-sculpt it out of a huge Styrofoam block. There are certain curves and shapes that we just didn't think could ever really truly be reconstructed by a computer: the slight imperfections that were not your classic, computer 3D curves. It's very hands-on, very crafted.
PF	When you design a piece on screen, it can look amazing but you can't touch or feel it. You can spin it around, but it still doesn't feel real. It's not the same as having it full size, right in front of you.

CR	So you like getting your hands dirty? Does that lead to some kind of absolute emotional or sensual engagement that you can't have on a screen?

PF Exactly. It's more hands-on. The whole process of actually making something is very important.

IS We definitely have a love of crafts and craftsmanship. With King Bonk it was a huge block of polystyrene and a chainsaw, if you can call working with a chainsaw craftsmanship. [Laughs.]

CR So you own a chainsaw?

IS Oh yes, we do.

CR And how many assistants do you tend to have?

IS We don't like to have too many people around. Normally it's just two.

CR So your life is kind of hermetic: you live and work in the same space, you have very few people coming in to work for you, and you very occasionally escape to go to the gallery and then you come back again. That's incredibly intense. To people outside, it might look quite difficult to cope with. What is it like to have a life/work relationship?

IS It goes through stages. It's great, but it can also be very difficult. Before we moved here, in 2005, we had an apartment, a messy ceramics studio, and a design office. As a result everything was always in the wrong place, including us.

PF And the time it takes to travel between them — it just wasn't worth it.

IS So we built this place exactly how we wanted it. It meant we were able to work in a totally different way, whenever we wanted to, day or night. Everything was here and we were able to switch from sitting at the computer to making full-size plaster exploding table things.

CR In the middle of the night?

PF [Laughs.] Yeah, we do that all the time!

IS When everything is a mere few steps from your bed it leads to a whole kind of energetic explosion of creativity, especially in the beginning. It's really fantastic and it allowed us to live with our work and see how it functions. When we first came here we wanted to have the apartment — which is slightly separated from the work space — as a concrete cloister. It had been beautifully plastered with this incredible concrete finish and we just put the mattress on the floor and it looked outstanding.

PF It was quite amazing. We'd asked the plasterer for something really rough, like a concrete war bunker. He did one wall first but he wasn't happy. When we came back from a meeting he'd gone over the whole wall again and it was smoother than a baby's ass.

IS He'd done it with this incredible snakeskin finish because we'd mixed the pigment in a certain way. Normally you're supposed to mix it dry, but we mixed it in wet. In the end, rather than taking three days to dry it took three weeks.

IS And it was 500 percent over budget! [Laughs.]

CR	At Milan's Salone di Mobile earlier this year, you were launching a chair to go into production with the American furniture company Bernhardt. It's called the Hyde and is a generous lounge chair with a walnut frame and leather or suede upholstery. It's simple and beautiful, but somehow people had some very strong reactions to it.
IS	Yes, we did get some flak for that. Some people thought we'd moved into territory that didn't belong to us. Because we're already in the design-art camp, we weren't "allowed" to move into production furniture anymore. But we loved going through the whole process of limitations, where function and price were really important. But you know, these worlds of design art and production design aren't entirely separated anyway. It was the one-off Pandora Chandelier we did for Swarovksi that led to the Bernhardt commission. That's where Jerry Helling, Bernhardt's CEO, first saw our work. I'm sure we'll get grief for the Hot Rod Vases that we're showing next. We're very aware that we might be pushing it too far. But isn't it better to go into areas where you shouldn't be?
PF	Yes, Hot Rod will knock people sideways. They'll either love it or hate it. But you get one go at this life and profession, so you have to take chances. Some of our colleagues are happy churning out the same old stuff. We're not like that. With Hot Rod, we're moving a little closer to making art.
CR	What was the starting point for a piece like Hot Rod? It seems to combine of all sorts of influences: hot-rod airbrushing, pin-up girls, flames, the traditional forms of Chinese vases...
PF	We worked with a lot of Chinese forms before, so they were already in the "luggage" of our research. And there's something quite satisfying in keeping with those forms because they are quite extraordinary.
IS	And we'd been looking at the technique of airbrushing hot-rod cars, and the whole pin-up girl culture for a while. Not even with anything specific in mind; we were just interested by it.
PF	It's all about symbolism, which is terribly interesting. And when we were looking at Chinese vases, we asked ourselves, "What would they look like if they had been made in the States?"
CR	So you're saying the car is to America what the vase is to China?
IS	In a way. Certainly in Chinese imperial times the vase was a status symbol, a symbol of wealth — which is exactly what the car became in America. Also, in China, dragons represented sex, power, fertility, and good luck. And during World War II American soldiers used pin-ups as good-luck symbols. Chinese vases have the imagery of dragons, flames, and smoke, as do hot-rod designs. So the more we looked, the more we found parallels between the two. We wanted to find a way to integrate the girls into our vases in the same way the dragons became part of the form of ancient-Chinese vases.
CR	Do you think the girls on the vases are sexy?
IS	They're different. I think originally we imagined they would be quite slutty,

but in fact they've ended up being beautiful. At one point they were too beautiful, so we had to actually push them to look a bit more, what's the word I'm looking for, politely...

CR Dirty?

IS Yes, make them more... Well, we didn't want to have them looking at you. When they're staring right at you, you start to feel really uncomfortable. Pornography is all about the direct gaze, and we never wanted them to be pornographic.

CR But then the danger is that they become arch and aloof. Don't you need to have some point of contact?

PF Of course, and there is. If you look at the whole series of 15 that we're presenting, there will be variations. As we progressed, we took their clothes off.

CR It's just like real life!

IS It is, isn't it? In a kind of tentative way though.

CR The vases are being produced by people far removed from the worlds of art and design, who make a living by airbrushing hot rod designs onto cars and bikes. How have they responded to this project? Do they think you're completely mad?

PF I'm not sure. There are two people involved and they work as a team: the artist and the finisher. They're both crazy about cars and bikes.

IS The finisher is doing this for money, but he's really more concerned about building his trike — a bit of incredible engineering and a Jaguar engine, with a really cheap, fake-leather American sofa stuck on top. Anyway, he's probably thinking we're weird people from London. But I think the other guy really enjoys doing something different and sees it as an artistic challenge. You can kind of tell from the way he paints that he's incredibly respectful of women. We've had to actually alter some of the originals to make it less respectful.

CR Are you nervous about their launch?

IS Of course, we're always terrified!

PF Oh, I sleep like a baby! [Laughs.]

CR How come you ended up being photographed at the V&A for this story, rather than in your lovely home?

IS For various reasons. First, we were recently part of a show there called "Telling Tales," curated by Gareth Williams. The idea for the show was to look at a contemporary generation of furniture designers who produce work that has a narrative, which is exactly how we like to think of our work. It was fantastic to be surrounded by designers we admire, like Jurgen Bey, who works in a similar way to us.

PF The other reason is that we have a special history with the V&A, especially me. Since I moved from Sweden to London, the museum has been like an

anchor for me. I would go there all the time and spend hours in the different galleries. So to have work showing there was tremendous, not to mention its being next to Jurgen Bey! He's the reason I do what I do. His Tree Trunks Bench, where he took classical backs of chairs and cast them in bronze, made me change track from art direction and start studying industrial design.

CR On your visits to the V&A, where in the museum did you go?

PF Oh everywhere, absolutely everywhere. The last thing we went to see was the Chinese vases. We'd seen them before, but we went back once we started working on the hot-rod vases. And I can't tell you how excited I am about the new ceramics gallery, which just opened.

IS I actually used to go see the ceramics a lot when I first moved to London, starting my ceramics courses at St. Martin's. Grayson Perry was my tutor at that time, and he was a huge influence on me. It was quite funny: he would dress as Grayson when he came to teach, but he'd always show us pictures of himself, mainly naked or dressed up as Claire. He'd say, "This is a picture of a vase I did in 1992, this is another picture of my cock. And this is me in a dress that I made, with my cock out again." [Laughs.] It was quite unnerving because he was from Essex, like me, which is quite a boring part of the country — quite common, really.

CR Patrik, you're originally from Malmö in Sweden. How would you describe that?

PF When I go back there it's all about nature. We actually took a two-week break in the wilderness there this summer. And it was literally wilderness. We rented a house on a tiny Swedish island in the middle of nowhere... There was absolutely nothing else around. It was wonderful. One night, when it was raining really hard, a moose swam over to our house.

IS I actually looked at it through the binoculars and thought it was a big black swan. Just shows how good *I* am with nature!

PF But it was so far out! We were both looking and thinking, "What's that really strange bird?" It *did* look like a black swan. They have loads of those there.

IS But they're from Australia!

PF But then we took out the binoculars and were like, "Shit, it's a moose swimming right up towards our house." And as it came right out of the water, I was like, "Where's my camera?!"

IS No. You had your camera. You said, "Where're my shoes?!"

PF "Where're my shoes???"

CR So did you get a good picture?

IS Yes, we did!

ACAPULCO

SIMON FUJIWARA

Interview by Stuart Comer

Within just half a decade, British artist Simon Fujiwara has infiltrated the art world with brash lies, shocking taboos, and surreal eroticism. Born to a Japanese father and a British mother, Fujiwara is a cosmopolitan polymath whose witty, self-reflexive performances, installations, and sculptures betray the intricacies of growing up gay and precocious in a remote coastal town in Cornwall. Both Fujiwara and his work hum with sassy intelligence. He is a commanding story-teller whose anecdotes are delivered with such disarming persuasion that their ambush on truth and history becomes only slowly apparent to unsuspecting audiences. Drawing on many tropes of 20th-century art, from performance and sculpture to Surrealism and institutional critique, his work effortlessly encompasses architecture, theater, and archaeology, displaying a truly global outlook. PIN–UP met up with Fujiwara — who was trained as an architect — at his winter home in Acapulco to speak about fact, fiction, and porcelain door handles.

Stuart Comer	Simon, when we met around 2007, you were working as part of the architecture collective Pankof Bank, and you were doing a project for the Architecture Foundation in London, which was more of a performance piece than a classic architecture exhibition.
Simon Fujiwara	Yes, we formed Pankof Bank in 2006 with my best friend and my boyfriend at the time, who was teaching at Cambridge, where I studied architecture. We wanted to work with architecture but also with other ideas that we'd tried to explore during our time at school but couldn't fully encompass. The collective was an experiment and we would often be using performance to activate spaces. But the project failed for me because I realized I couldn't believe in art's making as direct a difference to urban space.

SC Failure isn't really acceptable if you're making a building, but does it potentially work as an art form?

SF The problem was that I felt we weren't actually articulating the failure of our project. Perhaps naïvely we were trying to effect social change, to work with our frustrations about the overly theoretical projects we produced at architecture school, where we were talking about social change all the time, with the assumption that the architect could be at the front of everything — ecology and social change and betterment through design. When we actually worked in public space I missed the theoretical world, the lack of constraints, the direct engagement with ideas, and the ability to play through rhetoric without taking a position. But if you talk to the others they may have a different view...

SC So how, in the space of three or four years, did you move from this collective activity to generating solo performances and installations that are deeply personal and deal with issues of sexuality and your family, and in particular your father?

SF When I was part of the collective, I think I was always the one more interested in driving our practice into more artistic terrain, as opposed to an architectural discourse. I felt a loss of personal voice and I realized I was much more interested in metaphor and in narrative. So when I started to make my own work, I was driven by these personal concerns. I realized that I could use my own history and identity as the model or vessel to discuss architectural issues. I think that was the biggest lesson I learned: to stop interactive work and just sit and tell people my own single position and let them react.

SC When you do your live performances, you're always directly engaged with your audience, and even your installations are often activated by live performances that have a direct interface with the audience. What kind of model of theater are you drawing on?

SF I think that's actually something you learn in architecture school, where

for three years you turn up every two weeks with some pieces of broken cardboard for a model and some half-finished drawings. You stand in front of a jury, and try to tell them why this building is so important, why it's going to integrate Asians, blacks and every race in the world, why it's disabled-friendly, why it's going to be the building of the future because it's green... Essentially the objects you take with you are props, and it's your power of persuasion — your rhetoric — that's going make the jury believe in your building or not. Then, of course, after half an hour you take everything away and the next candidate comes up. This act of performing every two weeks with props and grand ideas makes you realize more and more that the props matter less, eventually, than your ability to persuade, or to explain, or to guide people through these hypothetical, fictional buildings.

SC No matter how inclusive it might be of multiple aspects of society, the architectural approach you're talking about still sounds very Modernist, very "master builder." Was that specific to Cambridge? Or do you think that Modernism hasn't really been expunged from architectural discourse in general?

SF Modernism is something I never consciously consider. There may be resonances between the way I use small objects and artifacts to create grander narratives and the Modernist notion that every element of the building is integral to the idea. But I've been drawn more to what I learned about the Baroque in my trips to Rome when I was an architecture student: the Baroque theatricality, the idea that the deepest of human beliefs and constructs — God, society, power, the church, spatial experience — can be united with a nice paint effect or a well-lit sculpture of a woman in a semi-orgasmic state. I think I always found the artifice of the Baroque a more genuine reflection of the human condition. Modernism, as it was taught to me, had a closer, essential relationship to materiality, which I am less interested in at this point in time.

SC Speaking of semi-orgasmic states, there is an idea of sexuality that underlies almost everything you've done in the last two years. At what point did you decide to make things more sexually explicit, to place this erotic imaginary at the heart of your work?

SF Well, I think it's partly because my sexuality's not reproductive. The generation of gay artists before me had the job of breaking out of the hetero-normative world to find a footing in the art world where their voice could be taken seriously. And it left me with many questions, such as, if we're constantly, as gays, stating that we're not reproductive, that we're not normative, etc., then what are we left with? Are we creating an identity through negation? Are we creating a cocooned culture of our own which is just as exclusive as a heterosexual culture? This is perhaps why I tried with early projects to re-imagine the family into the homosexual world. On one level I think it has been successful, given that it's very rare that people discuss my production as a "gay artist's" work.

SC What about sexuality in relation to architecture?

SF Eroticism and sexuality were just never discussed in architecture school. It was something I discovered really far too late with the first project that I made after I left architecture school, the *Museum of Incest* [2008–09] — the first museum dedicated to the history of incest. Sexuality is such an enigma that it causes conflicts and fascination. And I thought, well, this is kind of like a metaphor for architecture, which is constantly changing, because the idea for a building will never be solved with the material for a building. Where the material world meets the imaginary world — like sexuality — it's a conflict that's there forever. So I wanted to deal with incest as an impossible conundrum, as a historical taboo, and see what that taboo would look like as a building. I threw in a personal narrative about the fact that my father is an architect and has many unrealized projects. I used his projects to form this fictive museum, which finally ended up as a tour where I would sit and show slides and models — exactly the way that I would every week at architecture school — and describe my way through the building.

SC If you have an incestuous relationship with your father that would make him gay by implication. And you make that quite explicit in your performance piece *Welcome to the Hotel Munber* [first created in 2006], in which you imagine your father as a homosexual under Franco's regime. It's left unclear whether that's a fictional device in the performance or not. How did you arrive at this notion of speaking through your parents' erotic lives?

SF I work a lot with the idea that history is not dead, that many things have been left out of the story that can be reinvigorated. So many people throughout history have lived their lives without mentioning things that we can now mention openly. For example, my parents who lived in Franco-era Spain never even imagined that homosexual oppression was happening, because they were not personally implicated in it. They were living in a fascist dictatorship and were having the time of their lives! They couldn't speak the language and so weren't oppressed by what was happening because they couldn't understand it. And they weren't gay. They were outsiders. Listening to their stories, I always thought, "What if I was living in that time, what would I be feeling?" My thoughts progressed to imagining my father as a gay man trapped in a fascist dictatorship, and the story developed from there. I drew on texts I was reading around that time, Georges Bataille for example, but the initial impulse was to ask a question of my parents, and therefore of the entire generation above me: "Mum, Dad, were you really looking around you?"

SC Your father is a collector, so you grew up in a museum of sorts. How might that have shaped your direction as an artist?

SF Well, initially it shaped my direction as an architect, because my father lived in Japan for most of my childhood, so I had partly an imaginary relationship with him. He had done a whole range of things, from window-dressing to selling saucepans as a door-to-door salesman, before training in a two-year night school as an architect. And now he does sort of pastiche buildings in

Japan, which range from a Navajo adobe baby shop in downtown Tokyo to an English country house. My early relationship with my father was through architecture and design. For instance, when he would come to England, which was once a year, it was always on a trip to collect as many antiques as possible to fill these strange, bizarre buildings that he was designing. Beyond that, it was usually a phone call: "How are you, son?" "Fine." "Oh, by the way, can you get me 150 porcelain door handles?" So at the age of 14 I was going to antique markets and buying door handles for him! The moment I arrived at architecture school I was so loaded with this personal relationship to architecture that everything down to the door handles had a personal significance. After a year, one of my tutors said, "You know Simon, every time you do your presentations, it's like you're wearing your heart on your sleeve. I can't help but think it's a device to stop us criticizing you, because it's much harder to critique your building when you're practically in tears at the end of your presentation."

SC After finishing your architecture studies at Cambridge, what compelled you to seek a visual-art education at the Städelschule in Frankfurt?

SF When I left Cambridge I didn't know any artists, and I felt very isolated. I couldn't really have conversations with my architecture-graduate friends about art. So for me, going to art school was about meeting people my age who were doing what I was doing. I remember the first exhibition I did when I arrived. I completely emptied the studio out and turned the studio sink into a fountain that was constantly spewing milk. It went rancid during the three days of the exhibition and filled the whole school with the smell of sick. Nobody could eat in the canteen! I received a very positive reaction, and people were really excited by the piece. But I also remember art students saying, "Well, he's not really an artist, he's an architect." What I had thought would be a freer context for art was bound by the same prejudices as in architecture school. I realized that I would never be free of the history I have as an architect, so I decided to make it the subject of my work.

SC Do you think you'll ever go back to architectural practice? Or is that just not remotely of interest to you?

SF I think one reason I left architecture was that I felt that I could never, ever really accommodate all of the pragmatism, the multiple needs of multiple people, multiple audiences. I mean, even within the art world you're constantly up against pragmatic issues of budget, of time, everything. And to communicate an idea in built architecture is a much more problematic issue than in art. Just starting with the question of whether architecture should communicate anything. But one of the great things I learned in architecture school is to look at things anthropologically, to think of humans as having a set of social issues and economic issues when they come to your building, which will inform how they interact with it. And when I go from that to the art world where there are many different characters and many myths about them, I see things more structurally. For instance the whole construction of

the "artist" is itself something I could never really believe in, especially in a climate where people didn't believe I was an artist myself.

SC Is that why, in your work and in your performances, you incorporate role-play and constantly assume, and shift between, different identities?

SF In the art world, if you state you're one thing, people very quickly begin to pick up on that energy and push you in that direction. It's so evident in the way that every press release, everything that's written about an artist lists their date of birth, where they're born, or where they grew up, and their work is judged on that. I like to play with the notion that I could have been born anywhere, perhaps because of the way I look, because it's not immediately possible to place where I'm from. It's interesting that even in this global age it's still worth mentioning where I grew up, as if to say, "But how did this emerge from St. Ives, Cornwall?"

SC But even in St. Ives there was a circle of avant-garde, highly cosmopolitan artists. In fact, in *The Mirror Stage* [first created in 2009] your set includes a replica of a painting by Patrick Heron, who was part of a community of prominent artists living in Cornwall that included Barbara Hepworth, Henry Moore, and Ben Nicholson.

SF Yes, St. Ives has a funny history. Even though it's so remote, there was a very strong connection to New York, Paris, and other parts of the world through abstract art. Eventually this died out, after the 1960s and 70s it kind of washed away. By the time I arrived it was just yellow iceberg lettuce and really bad fish and chips. I was aged 11 when they decided to build a Tate in St. Ives to commemorate the local artistic history. There were huge local protests about it, because everybody wanted a leisure center instead. I also remember the first time I went to the Tate, and people were looking at the paintings in disgust because public money had been spent on this massive museum. Visitors commented, "My kid could have done this!" I was a kid, and I thought, "Well, I couldn't have done that, and I'm completely moved by it!" Within five years the fish and chips were suddenly piled on plates vertically, and there was caffe latte on every corner. The first restaurant that opened after the Tate arrived was called Al Fresco, and we all wondered, "Al who?" It completely revolutionized the town and gentrified it. I saw firsthand as a child what a museum could do, and how this myth of local history, once it's formalized into a building, can dramatically change a place. Now, of course, people love it.

SC So much of your work is like a museum within itself. The piece you produced for the Frieze Art Fair in 2010, *Frozen City*, dealt with an archaeological dig, the uncovering of an invisible museum of sorts. When did your interest in archaeology arise?

SF Archaeology has always been a fascination of mine, because it's like architecture in reverse. An architect tries to understand the social context and the time in which he or she lives and then distils it all down into bricks and

mortar, creating a built artifact to reflect this context. The archaeologist, by contrast, finds a shoe, a brick, or a column and has to extrapolate what the entire civilization would have been like. A lot of archaeologists' careers are built on how well they can generate a headline story around the piece of rock they find. Again, it comes down to storytelling. An important starting point for the *Frozen City* project during Frieze was to consider how much one can spin from a fragment of mosaic or a mural, and how much one really knows about what an archaeologist is saying. I was clear from the beginning that it was a fiction — I even put a portrait of myself as a Roman artist in one of the digs. I wanted it to be clear that the work was one man's perverse, masturbatory vision of Roman civilization, which had already been the masturbatory vision of one or two emperors!

SC What kind of legacy do you think your work might leave 200 years from now? How is it going to age?

SF It's a very difficult question and one I never think about.

SC I'm especially thinking about the performances, since you won't always be around to perform them. Would you let them be performed by someone else?

SF If I'm dead I won't have a choice!

SC You could say it's not allowed.

SF I would never do that. My work is about reinterpreting history. I keep telling other people's histories, so I can hardly stop anyone from doing the same to me. In terms of what I think I might leave behind, I don't know. I know certainly that I can't always be there to perform, and I've tried to develop a kind of language for my installations to perform themselves, using empty sets to implicate the viewers as the performers.

SC Have you ever received a commission to make a building?

SF I have not.

SC Would you accept, if you did?

SF I'd have to consult my therapist first.

BERLIN

CYPRIEN
GAILLARD

Interview by Victoria Camblin

A fire extinguisher key hangs on a chain around Cyprien Gaillard's neck. It is a discreet homage to nightly escapades that, in 2003, evolved from hooliganism to an aesthetic experience: setting off fire extinguishers at inappropriate times and locations, first in forbidden corners of Paris, then in trespassed-upon French countryside, and, finally, on Robert Smithson's famous *Spiral Jetty* (1970). In only a few years, these cloudy interventions in ammonium phosphate lead the way to an artistic career that has included solo exhibitions at London's Hayward Gallery and Kassel's Kunsthalle Fridericianum. It is from the perch of a friend that I have watched this process unfold over the last six years, as the skateboarding, *Koyaanisqatsi*-obsessed Parisian's fascination with destruction and vandalism has crystallized into the most intuitive relationship to architecture I have ever encountered. Like a Scheherazade of Brutalism, Cyprien not only recounts how a housing project or high-rise looks and feels, but also how it tastes (the Park Inn at Berlin's Alexanderplatz, he once commented, tastes of cherries). Looking at architecture from a near-autistic closeness, Gaillard casts those altars of creation — whether they were built by Minoru Yamasaki or Montezuma — in an intimate human drama, at times a comedy of errors, at others a tragedy.

Victoria Camblin	We have never spoken about the sex factor of your work — setting off fire extinguishers in the wilderness is an ejaculatory gesture; so is monumentalizing the white cloud of smoke that emerges after a building is dynamited [*Desniansky Raion*, 2007]. Are you sensitive to this "manly" analysis?
Cyprien Gaillard	Well, Land Art always had a pretty macho component — that's Michael Heizer's legacy, the image of the artist conquering the desert aboard his Caterpillar. Land Art was never about being "in tune," it was never meant to be a hippie, ecological practice. Heizer blew up the side of a canyon for *Double Negative* [1969] — and among other things, I think that's a demonstration of how hard it is to actually work with the landscape.

VC There's a historical reason for men having dominated Land Art, sure — but at what point does working with a landscape become working against it, even taking it?

CG Maybe it's about experiencing the landscape. I've always viewed lumberjacks as romantics — they want to spend time in nature, but that's not enough. You have to cut down and move trees to find a way to interact with nature so that it becomes a material in itself. And during the two years I spent making the fire-extinguisher films, I spent a lot of time in these places, places I'd perhaps been to as a teenager and loved, but where just taking a picture wasn't enough. I want to engage with the landscape as much as I can, and I think that by somehow "ruining" these places — by interacting with them through destruction — you reveal them, in their fragility.

VC So we're still talking about a kind of insemination here. Maybe one that results in a communion, in an ethereal, even spiritual way if not a macho one per se — Michel Leiris wrote in his autobiography [*L'Age d'Homme*, 1939] about jacking off onto the temple of Zeus in Olympia and how it felt as if he'd just performed a sacrifice...

CG But the destructive part of my work, which to some people seems so macho — working in these monumental places and moving tons of concrete — is really happening on such a small scale. I've been invited to do a piece in Rotterdam, for instance, where the harbor is expanding. The city commissioned a number works about the idea of land reclamation, as though asking for artists' stamps of approval on what is actually an ecological catastrophe. So my proposal was to take the rubble from a housing estate that was demolished nearby and pour it all into the harbor. They were a bit weird about my wanting to just dump demolition debris into the water, but the idea is to highlight the massiveness of this expansion, in which my work becomes just a tiny splinter. A truck drives down to the ocean, opens up and pours a load of debris into the water, and if that looks ecologically scandalous, it just puts into perspective the huge scale of this official state act of destruction. I mean, who decides the future of the landscape?

VC So what you're doing is somewhere between what graffiti writers and city planning commissions do?

CG In *Histoire du Vandalisme: Les Monuments Détruits de l'Art Français* [1959], Louis Réau talks about mistakes made by the state — pouring concrete over archaeological sites to build tower blocks, and so on — and never once does he refer to what "vandalism" means to most people: breaking private property or tagging a building or lighting a fire. Even riots and car burning are nothing compared to what goes on in city halls. Urban renewal is the true mass destruction! I try to reclaim it on an individual scale, to put it under my name, to identify with it. I might have been out there chopping down trees or starting fires, but if you want to see the real machos, look at Potsdamer Platz here in Berlin. Look at the mayor of Glasgow when he decides to rig up all these new buildings for the Commonwealth Games in 2014, spending a fortune on evicting people and dynamiting buildings and leaving clouds of dust covering the horizon. Then they go and talk about ecology and say they want more parks.

VC That's interesting because a lot of the buildings you focus on in your work, or that are candidates for being destroyed, are actually in very green surroundings. The Ricardo Bofill building you feature in *The Lake Arches* [2007], for instance, sits behind a giant lake.

CG That building is called Les Arcades du Lac, a huge public-housing project designed by Bofill that looks like a Neoclassical temple, surrounded by an artificial lake. Originally I'd only seen the lake in old pictures, with people swimming in and windsurfing on it. I had decided I wanted to do something with the building, so on my 25th birthday I asked my friend Nico, who had a car, to drive us there. We just assumed we would be able to go swimming — I had a kind of ancient greek bathing scene in mind. So I started filming and my friends dived in with a header. They immediately stood up: the water was only up to their knees and Nico had broken his nose. It was quite serious, but I just kept filming. At some point Nico looked at the camera with his bloody nose, and you could see the question in his eyes, "Is this why we came here?" It was very harsh. What had started as a Greek bath had turned into a kind of Greek tragedy. A small Smithsonian tragedy, even, of diving into a landscape that doesn't always bounce you back, that rejects the artistic gesture.

VC The fact that you keep recording in these circumstances raises the question of your documentary style. You're not necessarily authoring critiques in which you intervene directly in what's happening to these structures or take a stab at the politics of urban renewal.

CG Well, on the one hand I do want to criticize the idea of urban renewal, and the arrogance I see in architects and planners' thinking they can make buildings that will age better than those they're tearing down. For me, decay is part of the natural course of things, and there's an arrogance towards history, a hypocrisy even, in this desire to always fix things when in fact it's

just creating a façade. Meanwhile, on the inside things are just decaying in every way possible. My work is about pointing out the mistakes in how governments deal with this entropic situation, spending three-million euros on the demolition of a harmless building just sitting in a field 40 minutes from the city center, for instance.

VC So you think this whole rhetoric about "sustainability" is nonsense because it's not the building that's the problem — it's the social circumstances?

CG Well, take Glasgow for example. They're building these flimsy little villages that are going to have their moment of glory in 2014 for the Commonwealth Games. But what will happen to them afterwards? And yes, I think some of these buildings should be left alone. Build a park around it, but why do you have to demolish it? You abandoned it years ago, it has a life of its own now, independent of the original architect's plan. No one lives there, you don't even have to restore it. Let it become a beautiful ruin.

VC Your work serves to fulfill that role — the state won't monumentalize these buildings, so you do?

CG The thing is, these buildings do exist as monuments, like readymades. But I've been creating new monuments, too. One thing that few people realize is that when these buildings are torn down in Europe, on the one hand you have mayors wanting to get rid of them, but on the other hand they are supposed to show more of an ecological conscience than they used to. Since there's an enormous amount of waste when you demolish a 24-story building, they say they will process and recycle the rubble from the demolition. After the building is dynamited, the concrete is crushed into smaller rocks on site, and this recycled concrete is then sold to the contractors who have been hired to rebuild. Not necessarily on the exact same site, but for the foundations of an office building, or a parking lot. You will find the ghost of the old building within all the new structures of the city.

VC It sounds like there's some ethereal beauty in the process after all?

CG It's definitely fascinating, and the work I've done recently consists in reusing concrete in the same way. Last year I moved concrete from Glasgow all the way to London, and had it cast as an obelisk. The obelisk was then installed in the Hayward Gallery, which is itself a listed building. In a way one concrete building became the conservator of another that didn't make it.

VC It's like a modern-day version of old Cairo, which was built of stones from the pyramids.

CG Or temples in Rome that were dismantled to build churches. And today, London Bridge can end up in Arizona. These things we think of as monumental and unmovable and that we'll be stuck with forever might end up crossing the Atlantic.

VC Is that why you moved a bronze-and-concrete duck from Beaugrenelle,

in Paris, to the front of Mies van der Rohe's Neue Nationalgalerie for the Berlin Biennial last year?

CG Yes. The whole housing project in Beaugrenelle was about to be demolished and rebuilt. There was this ridiculous sculpture of a duck in the middle of it, and I gave it a new home. I also did a project where I moved rubble from Paris to the Château d'Oiron in the Loire valley. The château had just been restored and the alley leading up to it hadn't been finished yet. So I moved rubble from a demolition site to pave the alley and now there it is, this 1,000-square-meter monument that tourists walk on to get to the château. It's a public sculpture now!

VC Despite all your international travels, there's still a strong sense that you're coming from a very French sphere of reference. It's a semi-revolutionary discourse — geographically, socially, but also formally.

CG Of course, coming from France, there is a long tradition of revolution, rioting, and destroying buildings. But if you look at how the media sensationalized the 2005 youth riots in France, compared to what the state is doing to these buildings, it's really sick — a totally anti-revolutionary situation.

VC It seems to me that what you're grappling with isn't the state so much as the institution of Modernism, and sorting out what we're supposed to do with its legacy.

CG In *The Language of Post-Modern Architecture* [1977], Charles Jencks wrote that Modernism died precisely when Pruitt-Igoe, an urban-housing project in St. Louis, Missouri, was demolished in 1972. Of course, for Jencks that was a good thing. But Minoru Yamasaki, the architect who built Pruitt-Igoe, went on to build the World Trade Center as this example of Postmodern architecture, and we all know what happened to that building. Yamasaki's story provides the perfect link between terrorism and state demolition, and meanwhile Jencks's thesis just sort of self-destructs. So ultimately, Modernism isn't really what my work is about — it's about how things are now. I look at everything in its current state, whether it's a state of decay or restoration. The housing projects in Glasgow are as interesting to me as Teotihuacán — it's not about pre-Aztec architecture or archaeology, it's about its present context. What's the link between, say, row houses in Cleveland and pre-Columbian art?

VC They both exist and influence our world somehow?

CG It's the Cleveland Indians! That mascot has been popping up in my work a lot recently — he's my little reminder to city planners of *l'ironie du sort*, of how situations can change on you. Imagine these men trying to come up with a name and mascot for their baseball team in 1901, and deciding on this horrible caricature of a Native American. Just like Jencks's theory about the death of Modernism, it came around to bite them in the ass: the loss experienced by their so-called Indians eventually happened to Cleveland, just a century or so later. Who's laughing now?

VC	Does this relate to those "building ghosts" you mentioned earlier? A "Montezuma's revenge"-like energy that's beyond our grasp, but whose power is omnipresent in the buildings?
CG	My point is simply that destruction is all around us. I want to be a part of it, not a victim of it.
VC	In the postcolonial West we have often shown a kind of naïveté in the face of human creation. We underestimate the extent of ancient and non-Western human ability.
CG	That's the *Forbidden Archaeology: The Hidden History of the Human Race* [Michael Cremo and Richard Thompson, 1993] theory: the Egyptians were obviously incapable of building the pyramids, so aliens had to have done it. Architecture and archaeology are tragic, though. Look at Babylon: it's occupied by American troops, carving "Bob" into the stones and listening to heavy metal, landing helicopters on the cradle of civilization. It's completely anachronistic. It's real vandalism.
VC	It's a historical phenomenon that nature is always blamed in our collective perception of how buildings decay, even though it's usually a small group of people, in a very short period of time, doing all the damage. We've spoken before about the labyrinth at Reims Cathedral being destroyed just before the French Revolution — not by revolutionaries, but just because some archbishop found it irritating. A medieval masterpiece, destroyed at the whim of some guy with a little power. It makes the romantic discourse about nature overpowering man's creation totally ludicrous.
CG	Yes, in the end what we think of as so monumental is actually very human. It's a question of heritage: a series of bishops, prefects, or mayors, each dealing with the mistakes and the legacies of other officials — a quiet discourse acting itself out on a vast landscape. In the end I'm touched by the clumsiness of how we deal with history. What do you do when something doesn't work? These legacies are always with us, even if we don't see them. Think of Niagara Falls: at some point a mayor just decided to light the whole thing up at night. The lighting spectacle celebrates a failure to preserve this natural site, which is extremely violent. The falls are eroding back year by year, but the most important part is the lightshow, the casinos, and the drinking tourists. So it's a totally entropic place, right on the frontier of America and Canada. Only once you take into account all the elements — natural erosion, the human processes involved, the social factors — can you really understand these places. Otherwise it's just an aesthetic experience: "Oh, this is so majestic!" I used to go to demolitions and be completely overwhelmed by the spectacle of it all. But then I started to go further into the whys and hows, and found that the real beauty in it is the human tragedy/comedy. That's the romantic aspect. I always compare it to my relationship to my parents. When you're little you don't question them — they're rocks of authority. And then when you're a teenager you start judging them, and you realize your father's not a hero or your mother's vulnerable to sickness. And

only then, after you get the dark sides and go past the monumental façade, only then can you really love them. It's one of those universal processes.

VC So your relationship with these buildings has evolved — you now love them for what they really are: aging, susceptible to decay, and full of physical vulnerability?

CG Yes. And my work is more and more about that. I shot my most recent film in Cancún. There's no other place in the world where alcohol and archaeology are so close. You spend all night in a club, and then you go visit Mayan ruins the next day with all the spring breakers, who are themselves ruined in a way — they have bright red eyes and are puking all over the ruins! It creates a new situation of equilibrium: after a night of mayhem, Cancún's scandalous behavior gives way to a new kind of peace again.

VC It's a boozy kind of entropy!

CG You know, there's no Armageddon after all the chaos — there's chaos, and then a hangover. I've actually been finding these brands of beer named after archaeological sites: they have a beer in Angkor Wat named after the temple, and in Luxor as well.

VC Drink it, and drink the elixir of history?

CG Well, it's just another way to relate to a building. I've found myself hungover looking at monumental places many times. It's a state that gives you the distance to be surprised and astonished by the most unexpected things, to be a little bit autistic in your experience. And of course, it's a cyclical process of recovery. You know it only takes a day. You drink a soda and recuperate, and it's like you taste the building — drinking its energy.

VC What do architects think about your work?

CG I always had this idea of making a large garden or park that I would call the "21st-Century Park of Ruins," where I would ship buildings about to be demolished stone by stone to the park for them to be able to decay there in peace. A building from Naples beside a building from France — a kind of architectural capriccio bringing buildings together in a green setting. When I asked an architect about this idea, he of course told me that it was totally stupid, that it would cost 25 times more to move the buildings than to rebuild them as replicas. But honestly, I haven't seen a new building that excites me in a long time.

MARTINO GAMPER

Interview by Caroline Roux

Martino Gamper comes from the mountains. The Dolomites, to be exact, in the German-speaking part of Italy, near the Austrian border. In recent years, he has made a significant name for himself in the design world, especially with his highly original reappropriations of existing furniture, pieces that neither glorify nor shun their sometimes pedigreed origins (Giò Ponti or Carlo Mollino), but simply look smart and fresh. In 2008, he was named a "Designer of the Future" at Design Miami in Basel, and collectors, especially in Europe, are clamoring to acquire examples of his witty work. Gamper is hands-on by nature, and he's perhaps just as famous for his obsession with food and cooking as for furniture design. Known for staging impromptu dinners for friends and clients, he cooked a *grand repas* on the day of our interview in his studio in London, with interns helping to chop and stir (for those who are keen to know, the menu included cooked chickpeas with onion, lemon, and parsley; parsnips fried with garlic and drizzled with cream; homemade pasta with celery, pine nuts, capers, and anchovies; and a delicious apple crumble with ginger and cream for dessert). Also present was his wife, New Zealand-born artist Francis Upritchard, who has a studio in the couple's house in nearby London Fields, and an allotment near Martino's studio.

Caroline Roux	How many languages do you speak?

Martino Gamper	Four, three? English, Italian, German... A bit of French and Spanish. Spanish better than French.

CR And do you use different languages for different things? What would you prefer to write in, for example?

MG English, almost.

CR Really? Is English your adult language?

MG Yeah, it is. I've been reading a lot of English. It's more immediate. If it's something more emotional, probably Italian. I find it quite difficult to write in German, even though I attended a German-language school. But there's definitely a lot of room to play with words. I'm sure if I were to do something else, I'd be a writer.

CR You're sort of tri-cultural: you're originally from Merano, in South Tyrol; you were educated at the Fine Arts Academy in Vienna; you worked with industrial designer Matteo Thun in Milan; and now you live in London. Does that affect your work?

MG It's helped me a lot, first of all historically, to understand how things have happened in the past. In Vienna, definitely, the Arts and Crafts, the Jugendstil had a real influence. Milan was important for post-war design. And now London, because it's the contemporary center. Vienna is a very heavy place — it's about thinking and the conceptual.

CR And cakes.

MG And cakes, yes. Nothing moves too fast there, and it's a small place so you have time to think. There is a lot of conversation, especially at college. And whatever you study in Vienna, you're taught philosophy. Even the mentor for our design course was a philosopher.

CR Does that still feed into your work today?

MG Not a lot, but I think it's always good to know. In Milan, it was about the craft, and also about style and detail. I spent four years there working with Matteo, but I felt it wasn't really my culture. There was no space for me to be different. The mid to late 90s were a weird time in Milan, too. The city had suddenly lost its crown to London or other places in Europe. If Milan was a place for passion about details and preciseness, London is the opposite. In London there is more opportunity and freedom. You don't have to know anything, you just follow your gut feeling.

CR Well, look at Tom Dixon...

MG Exactly! Completely self-taught. So going to the Royal College of Art was good for me to mix those two experiences together of teaching and

having worked beforehand. I started working when I was 14, doing a five-year apprenticeship for furniture maker Peter Karbacher. It was a real job working ten-hour days, and I really didn't have much free time to do teenage things.

CR Are you allowed to leave school at 14?

MG You could then, so I chose to. I wasn't really good in school, so I decided I wanted to get a job, and I liked it. But I realized that you get into this trap — work, work, work — and you don't have any time to think about what you're actually doing. So at 19 I stopped. I thought, "The world is bigger than this place." I took a break and traveled for two years — South America, Central America, New Zealand, the Philippines, Thailand, Australia — I just went with the flow. Living this completely free life, I realized that work and play don't have to be so separate. You don't have to have a job, make money, and in your spare time buy yourself your life, your happiness. I'm not trying to be super alternative or, "Oh I don't like money," or "I'm anti-capitalist," but life's not always about money.

CR Do you ever feel sad that some of the pieces you're commissioned to make get hidden away in a very rich person's beautiful palazzo and nobody else really gets to see them again?

MG Sometimes. But that's why I think my cooking events are important, because they are accessible to people.

CR Is it true that you did your first cooking event at Hat on Wall? [A boho private drinking club in Clerkenwell whose bar was run by the son of architect David Chipperfield.] That was quite a little design scene in the early noughties!

MG Yeah, it was at Hat on Wall in 2000; [British designer] Michael Marriott was always there, because he'd designed the place, and Rainer Spehl, though he's been in Berlin for six years now. And a lot of former RCA people: Carl Clerkin, Gitta Gschwendtner. The usual suspects! [Laughs.] Lots of late nights, lots of drinking. There wasn't a kitchen, but we decided to try doing a dinner once and it became a monthly fixture for two or three years. We'd cook for about 25–30 people at a time. There were a lot of near disasters, a lot of improvisation. We once nearly set the place alight when we roasted chestnuts.

CR What was the best meal ever?

MG Um, well, the weirdest one was when we went foraging for ingredients in Epping Forest, just outside London. We got fern sprouts, they're like asparagus, and wild garlic, and fresh dandelion. It's better than just going to the shop and buying it. We steamed the ferns, and then we put some breadcrumbs and butter on them. We put the wild garlic in a soup with nettles. And the dandelion went into a salad with potatoes.

CR Is it true you're obsessed with ginger? I hear someone even made you some ceramic ginger!

MG In silver actually. Full size, like seven centimeters big. It's half a kilogram of silver! It was a jeweler called Karl Fritsch, and he made it as an engagement present for Francis and me. I just like the freshness of ginger. It gives a bit of energy: it warms in the winter, and in the summer it's quite nice and refreshing. You can combine it with a lot of foods. But I don't like dry ginger, the powder, or candied ginger — it tastes very different. Same goes for ginger cookies.

CR Food is one of the key differences that you see when you go from one country to another. Does your interest in food go back to when you were 19 and you first traveled around the world?

MG It probably goes back earlier than that, because when I was twelve I used to hang out with my aunt in the summer, working in the mountains. My uncle ran a very simple farm *pensione*, like agri-tourism. I'd help in the farm and the kitchen. And I used to go out with a girl in Italy whose family had a restaurant. So I was always connected to food, and people's passion about food. When I traveled, I used to work to make money, cooking or waiting tables. I once baked pizzas in New Zealand in a tiny ski resort. The worst pizza ever! Even I couldn't save them!

CR So how does your interest in food connect to your design?

MG There are a lot of connections. In both disciplines you have a given amount of ingredients, and in both cases there aren't really any new ingredients coming into the world — well, with the exception of new types of polymers, and NASA stuff maybe. But basically all design is made of the same given materials. So it's all about the combination and how you construct, techniques that you use to refine it. You have a piece of wood, and you can decide to cut it this way, or that way, you know, drill it. The same with food: if you have a potato, you can slice it that way, fry it this way, and so on. Both can be spontaneous, as well. Like our lunch today — I didn't plan it.

CR So you work with what you've got, like you did with the exhibition "100 Chairs in 100 Days," for example, where you used found chairs to make new ones.

MG Yeah. I quite like trying to work with something that's given, rather than "anything is possible." I also quite like narratives, and I think with both food and design you can create narratives.

CR You make a lot of one-off pieces, but in a serial way, adhering to one strong theme. It's almost like another way of mass producing.

MG That was one of the ideas behind "100 Chairs," thinking: okay, I've done lots of one-offs — here a chair, there a chair — and unless I get really serious about this, I won't be taken seriously. People will think that these are just some scattered chairs. I will make 100 eventually, but unless I really show them in one go, it won't have any impact. So I thought, as you said, you can have mass production of individual pieces. If you just keep on doing it, it is mass production!

CR How do you feel about your work being in auctions and fetching big sums in salerooms?

MG I hate it. There's time for that when I'm dead. The market went crazy a few years ago, and I'm really pleased it's calmer now.

CR At this year's Milan Furniture Fair you showed two new chairs, one that you designed for the British company Established & Sons, and another for the Italian manufacturer Magis. Was this your first adventure into industrially mass-produced design?

MG The Arnold Circus stool was actually my first mass-produced product, and we've probably sold a few hundred. It was created three years ago, for The Picnic in Arnold Circus [an event to reclaim a public space in East London that local kids were making off-limits]. It's made of injection-molded plastic. You can buy it for 50 pounds in the shop, or directly from us. In terms of companies, someone from Magis had contacted me before, and I never really got back to them. I was just doing something else, thinking, "Maybe next week, next month." Eight months passed. Then I got a phone call from my friend, the designer Jerszy Seymour, saying, "I'm here with Eugenio Perazza [the owner of Magis] and he wants to talk to you!" Konstantin Grcic is managed by him in the U.S., so I thought, "Well, I should really give it a try, and not be too... stubborn." [Laughs.] I even went to Italy to work directly with the guys in the workshop. That was nice. Usually the designer just comes in, takes a look, and leaves again. I suddenly took my jacket off and started banging metal with a hammer. That surprised them a lot, and they had fun and they also became much more willing to experiment.

CR And what about Established & Sons?

MG That chair is made of bentwood, an extended-back classic bentwood chair.

CR What do you like about bentwood?

MG Well, I think it gives wood a completely different feeling. If you don't bend the wood, it becomes quite a cruel-looking construction — rigid, clumsy, and stiff. And also, strength-wise, you can use much smaller kinds of sections. I actually think it was created for that in the 19th century, to really make mass-produced chairs. I did a bentwood chair for the Conran Inspiration project in September 2008, but it all went a bit wrong, and we had a bit of a falling out over money, because they started selling it without asking us for permission, or a contract.

CR So how do you actually make money? You make it from sales of work at the Nilufar Gallery in Milan?

MG Mostly through Nilufar, or private commissions.

CR Like the shoeboxes?

MG Yes, for Diego Dolcini. He's a young Italian shoe designer, who lives in Bologna, but has got a shop in Milan just off Via Manzoni.

CR You're the obvious designer to hire to do a restaurant.

MG Yeah, I know!

CR And no one's got the message yet! We're actually sitting at one of the tables you made from the green and cream laminate wardrobe doors Giò Ponti designed for the Hotel Parco dei Principi in Sorrento. When you're working with material first used by a revered historic designer, is there ever a moment when you feel you're desecrating somebody's work? Or are you happy in your mission?

MG I don't really choose super important pieces. I mean, this is stuff that would have gone to the skip, more or less. They were just doors — laminated sheets of poplar ply, white inside, green outside, nice solid wood edging. In the case of the Carlo Mollino chairs, they were from the Lutrario ballroom in Turin, and I was only given those that weren't really repairable. Ponti, Mollino, and [Franco] Albini are definitely the designers that really pushed design in those years. Albini was more of an engineer, more detailed. Ponti was very much into details too, but he was also playing with color. He was creating amazing spaces. And then Mollino, he was just totally out there. His photography [which includes female soft-porn Polaroid portraits taken between the 1960s and his death in 1973] looks very contemporary. He was an aesthete, he was someone who, whatever he did, did it with this really peculiar eye, and really tried to see it differently. He also always seemed like a slightly schizophrenic character, but maybe he wasn't. You would never see him really smiling. He was always quite serious, but that was probably inherited from Futurism. I mean, Marinetti never really seemed to be smiling either.

CR Do you smile in photographs?

MG Not always. Some people take pictures, and you really don't want to smile. [Laughs.]

CR You must get a lot of interview requests now. You draw an enormous amount of attention!

MG Yeah, but I'm actually trying to slow down a bit. It's come to a point where I feel like it doesn't give me any particular satisfaction, or I don't think it's necessarily good for the studio to be so exposed.

CR Do you think you've been overexposed?

MG Yeah.

CR Do you think that's your fault?

MG Yeah, a little bit. Recently Italian *Rolling Stone* wanted to publish some images, and I said, "No, but I'll do something in Japan when I'm there and it's going to cost you something. And you have to give us eight pages." And they said, "Yes," so I realized there are more interesting things to do with the press. You know, turn it into a project.

CR In 2008 you were designated a "Designer of the Future" at Design Miami in Basel. You had very much already arrived by then. Did it help in any way?

MG Of the four of us, two had been students of mine at the Royal College — Max Lamb and Julia Lohmann. I didn't mind, because they're friends, you know, and the people I spend time with. It was just a bit weird that suddenly they would just jump in general into the whole gallery thing.

CR Suddenly being very hyped.

MG And hype also kind of robbed them of their own existence, you know? So that's the thing of overexposure, I think. One does have to be a little bit careful. I'm mature enough to see what's going on, and I disappear off to New Zealand for two months a year, which helps. It's a good time for me to regenerate, and Francis and I constantly work, we talk about our work, and rethink, and we draw, we draw quite a lot.

CR It all sounds very ideal, bohemian...

MG It buys us some time, not having to answer emails. And I have time to go to libraries, too. I love going to libraries in weird cities. I've always loved just going to a section of weird books — I mean, mostly design, architecture, craft — just picking up books. The one I really love is the National Library in Stockholm. It's this Asplund building [architect Erik Gunnar Asplund], the round one that's always photographed. It seems like it's this place that people go to, this cathedral of knowledge and thought, and you go there and spend time there, and the quietness... It's just nice to immerse yourself in a different world like that, and discover things.

CHICAGO

JEANNE GANG

Interview by Michael Bullock

Community advocacy, sustainability, environmentalism, interdisciplinary collaboration — these may sound like buzz words better suited to a 1970s political activist than a leading 21st-century architecture firm, but they are all essential elements in the practice of Chicago-based Studio Gang. Founded in 1997 by Harvard-trained Jeanne Gang, the firm embodies ideals that may seem counter to market logic, but, post-economic meltdown, they represent a smart model for how a contemporary firm can make stylish, daring work without compromising either its politics or its clients' pocket books. Over the last few years Gang and her team have been on a roll with a number of groundbreaking projects, of which the most spectacular was the 82-story Aqua Tower in Chicago (2011), a dazzling mixed-use building that hit the headlines as the tallest skyscraper ever designed by a female-led team. It also earned Gang a 2011 MacArthur "Genius Grant" Fellowship, making her the second female architect ever to receive the prize. Aqua's unusual shape — defined by a *Flintstones*-esque stack of irregular concrete slabs — boldly adds a new icon to the Windy City's skyline, no small achievement in a town packed with Modernist masterpieces. Many new commissions have followed in its wake — including the Solar Carve Tower planned for a site next to Manhattan's High Line — and its success has afforded Gang the opportunity to realize *Reverse Effect* (2011), a long-planned book project that showcases another dimension of the firm's interests and approach by addressing a major natural element in Chicago: the river. It's a vital piece of design advocacy, offering clear solutions to complicated problems, aiming to mobilize politicians, designers, and local residents toward a unified rebirth of a vast, polluted landscape. Anyone responsible for such groundbreaking accomplishments must come across as a steely and intense personality — or so I imagined. But when I met with Jeanne Gang in her office in Wicker Park, she exuded a friendly, Midwestern warmth — a youthful 48-year-old driven by a love for her work.

Michael Bullock	There are many different descriptions of Aqua Tower: a ballerina, a mountain, rippling water… Which one's your favorite?
Jeanne Gang	I don't really have a favorite, but I like the fact that the ambiguity of it opens it up to interpretation. Someone even told me they thought they saw the face of the mayor in the ripples! [Laughs.]
MB	The story goes that you met Aqua's developer at a dinner party, and that up until then he was known for some very mediocre buildings.
JG	I never found him to be mediocre at all. In fact, he was always the one to push the project further. One of the best things about the tower is the mixed use, and that was his idea. Aqua has a hotel, rental apartments, and condominiums. Normally, there would be a certain exclusivity between owners and renters and there would be separate lobbies in the buildings between hotel and residential. But we decided together that it would be more interesting if everyone could mix in the common spaces and that's what happened — and it's amazing. Evidently, it's a favorite place to rent for the University of Chicago's business school because it's such a social, extroverted building: people socialize on the deck by the pool, there's a basketball court, a movie room, and lots of other shared spaces. There are over 750 households living there and it's created an interesting, economically diverse mix of people.
MB	What made the developer want to work with you?
JG	He wanted to give a chance to a younger firm, someone who hadn't designed a tall building before. When we showed him our two possible schemes, he immediately saw the potential in the one that eventually became the Aqua.
MB	It must have been daunting to design a high-rise with so many varying floor sizes.
JG	Well, we always knew that with the terraces moving around and the floor plates varying it was going to be hard to lay out the interior units in such a way that the living room always hit the terrace. Another concern was the thermal break: if you have a floor slab that goes from the inside to the outside it conducts hot and cold temperature. That would have dramatically reduced the energy efficiency, so we ended up offsetting that with better glass. But on the positive side we knew that the terraces would also provide sun shading, and that they would help minimize the building's movement because the irregular façade confuses the wind. And usually, when you think about stepping out onto your terrace in Chicago, you think about being blown off, but because the slabs are different shapes they break up the wind so it actually feels pretty comfortable. But we had to run many tests to find all that out.
MB	How can you even test for things like that?
JG	In a wind tunnel. Basically, you hire a company and that's all they do: wind

studies on tall buildings. You give them the design and they build the model and put pressure points on it, and then they put it in a giant wind tunnel and run the numbers on it. It really helps you decide whether you need a mass damper on the top to minimize movement, which we ended up not needing. Or you might find out that there are places on the building at the base that are too windy for comfort and then you can ameliorate that.

MB Were there restrictions for the height of the building?

JG The whole area was a planned development, but instead of prescribing a certain height we were given a maximum square footage. In the original plan they had envisioned a shorter, fatter building. So we went in and asked the city if it was okay if we did a skinnier, taller building with the same area, and they said yes. I like a thinner building — it looks better. And in fatter buildings it's just so much harder to get light and air.

MB Did you realize when you were building it that the press would run with the angle of "tallest building by female architect"?

JG Not really. Studio Gang is roughly half men and half women, so I didn't imagine it would become such a tagline for the building. I'm hoping that many more women start doing tall buildings and then it'll become a non-issue. [Laughs.]

MB I can see that it would be annoying to focus on that rather than the originality and innovation, but I also understand why it's meaningful.

JG Tall buildings are all about statistics. There are entire websites devoted to how to measure the height, which building has the highest square-footage of hospitality space versus residential space; there are many, many, many categories and there are lots of high-rise aficionados that keep track of these things. There's a guy in my gym that knows more about the stats of tall buildings than I do. [Laughs.] He'll ask me questions when I'm on the treadmill like, "Is the Sears Tower 1,700 feet, or do they count the...?" and then he'll rattle back.

MB Sounds like he has a skyscraper-stat fetish. But are these questions of gender and building annoying to you?

JG People are curious, so I don't hold it against them. I honestly don't think this is a topic that's going to hang around much longer. It seems like we're kind of past it.

MB Most of the female architects we've interviewed for PIN–UP were also very much over this gender conversation. But I also read that there are only five female-led firms in the world that could get commissions on this scale. So, while change is on its way, we're not there yet.

JG True. And as I said, people are naturally curious because they've seen architecture represented as a man's field for so long. And that's OK, but it's also not exactly the most fun thing to talk about all the time.

MB All right, I won't torture you further. Of all your projects, the Aqua undoubtedly got the most media attention. Do you sometimes feel as if there are other projects you've done that might represent your firm better?

JG I wouldn't say represent me *better* — it takes a handful of projects to fully represent someone. But even though I like designing them, our work isn't all about tall buildings. We are working with communities; we're trying to do things that are having an impact, especially for making the world more sustainable.

MB Could you give me an example?

JG I think the community center we did for SOS Children's Villages is a good example. SOS Children's Villages is an international not-for-profit and their mission is finding foster families for orphans and trying to get siblings into the same family. Not all the children are orphaned, some have parents who just can't handle them, for whatever reason. SOS has villages all over the world and our community center was for the first village in the States, here in Chicago's South Side. The center is the piece that binds the foster-care families and the SOS Children's Village to the greater neighborhood. They offer after-school classes, there are family rooms where children can meet with their parents, there are daycare facilities for the greater community, and so on.

MB Is this the project that was done with a variety of donated materials?

JG Yes. SOS is a notoriously underfunded social-service program so we — our office, but also the owner and the contractor — were trying to gather up as much as we could through in-kind donations of materials and services. That made it a real challenge to design because we couldn't really count on any one material. One day it would be there, the next day it might change to something else. So we designed a strategy to cope with this problem through Excel spreadsheets where we could plug in the different materials that we got as donations. If one thing changed it would have repercussions on the other pieces. The way the building looks now really is the result of these material donations we were given — or that were taken away from us. For example, originally this building was meant to be all brick masonry. But then we lost our brick-masonry donation, so we decided to expose the concrete, using different types of mixes. The process might be a little complicated to explain, but even if you don't know that, you just see the building and it has this rather engaging, fluid-looking wall. It's become a real anchor in that community.

MB How do people react to it?

JG They care about it. People have started to do birthday parties there, people go there to vote, all kinds of community meetings happen there. And it hasn't even been tagged, which is amazing in that neighborhood.

MB Speaking of community and neighborhoods, in your book *Reverse Effect:*

Renewing Chicago's Waterways you propose transformation strategies for the neighborhoods around the Chicago River's South Branch. Did the book come out of a city competition or was it self-initiated?

JG We've been working a lot with environmental groups, the NRDC [Natural Resources Defense Council], and also the city, asking what the future of the river is going to be now that industry has left and we have this huge swath of available properties. How are we going to re-imagine this river and make it work? Because right now it is very polluted, so it's a great opportunity to reassess it. The book shows the history of the river in a very clear way so that people can see that it's already a manipulated system. We can go in and change it again, and we should. But rather than making specific design proposals, the book is meant to provide all the kinds of information that people need to make those mental projections. Some of it is very arcane: it's technical, scientific, or policy information. But when you take all those ingredients and think about them and make a proposal, people can respond to it. It's about getting people on the same page, creating a community and saying, "This is where we want to go." In the U.S. right now everything is too divisive and polarized.

MB I see a balance between nature and technology in your work. Was your interest in technology influenced by the fact that your father was an engineer?

JG I was initially thinking of becoming a painter or an artist, but I was also always hardcore about math and science. Architecture combined these two for me, the analytical side and the more, let's say, sensitive or observant side. Growing up, I also spent a lot of time traveling with my family mainly because my dad liked to go and see big bridges.

MB Did your father design bridges?

JG Yes, bridges and roads. He liked engineering feats and he also liked places that had superlatives, like the biggest canyon, or the highest mountain. So we spent a lot of time seeing amazing landscapes and infrastructure.

MB Ah, so nature and technology were combined from an early age!

JG I guess... yeah. I always loved the fusion of dwelling and landscape. Have you ever been to Mesa Verde National Park in Colorado? *Mesa verde* means "green table," and the landscape looks completely flat. And then, when you get up to the site, you see that it goes down and there are all these Native American pueblo-type dwellings in the rock. A great co-existence! That really sticks out in my mind, more so than, say, the Eiffel Tower or something like that.

MB Was there anyone you felt was like a mentor to you?

JG I always learned something from my teachers at Harvard. And then the people that I worked with, of course. But there was never somebody...

MB In particular?

JG There wasn't anyone just like me. The person I always connected with, but never met, was the Brazilian architect Lina Bo Bardi. Her work spoke to me. She was Italian and, when she came to São Paulo, she really looked at what was around her and combined European Modernism with this much more indigenous lifestyle. She figured it out, embraced it, and designed for it.

MB In the mid 1990s you moved to Rotterdam and worked for Rem Koolhaas at OMA?

JG Yes, after I graduated from Harvard I went on to work for him in the Netherlands for a couple of years. OMA was a much smaller office at the time but we were doing really cool work. And then I came back to the States — I needed to work here before I got my American license — and I remember going to interviews and people not knowing who Rem Koolhaas was. [Laughs.]

MB Is there anything in the way you run your studio here that you brought back with you from OMA?

JG For sure! That we really devote time to research both in gathering information but also research in design, research through doing competitions, formal research, and environmental research — that's always going on independent of other projects.

MB So the research isn't strictly materials and technologies, it's also your own cultural research as well?

JG Yeah, usually when I start a project I try to fan out in all directions. So if it's project-based research then we gather, and we produce, and you end up landing on certain ideas that resonate with that project and then maybe those go forward. But then there's all this research that wasn't used for that particular project, and it turns into this kind of institutional body of knowledge. It's like building our own library.

MB What were the biggest challenges when you started your own office?

JG Surviving was a pretty big challenge — just getting paid. Although, when you're starting out you just do it. You don't even think about it somehow. I never considered, like, "If I'd stayed with a firm I would be making this much money," it was just a passion to start it up and do my own thing, and that drove it. I always knew it would happen, it was just a matter of time. But the difficulty is, of course, just getting work.

MB Did you ever differentiate between work you had to accept for money and work you made to build a vision of where you wanted to go?

JG I never thought of it like that. It was more like, if I got a project that was small, what could I do with it to make it interesting? I didn't turn anything down to start with. One of the first projects was an apartment for a friend of mine who had moved into a loft. So on the surface it was "just" a loft

re-conversion, but to me it was exciting because she was on the top floor, so instead of the typical idea of putting balconies on the façade to create outdoor space, we just cut a giant hole in the roof and made an interior courtyard. It was a feat to pull off, but it was so interesting even if it was a simple loft interior.

MB You've been quoted in *The New York Times* as saying, "An architect needs to be an activist." Could you explain what you meant by that?

JG Architects have special skills. They are able to connect the dots between different disciplines, and they're able to communicate ideas to the broader public. We are able to project what something could look like in the future, and we're all about making plans. And that is very useful. I think architects should use these skills more to push issues that they care about for the greater good. I don't know if that's activism or advocacy, but to me it's about moving issues forward that are important to all of us, and using the skills we have to make these things happen.

MB Last question: how did you meet and start working with your husband?

JG Well, we actually met at OMA, so we've been collaborating for a long time. When I came back to Chicago to start my practice, at some point I was able to ask him to join me. We work really well together — we always have — so it's great to be in the same space together.

MB How do you balance an intense practice with family life?

JG I have to admit my life is not balanced at all but I enjoy it, so it's not a burden. I like to create, to work with people. It's like a beehive, it's a buzzing beehive where we're all contributing.

MB Great! Is there anything else you would like to add?

JG No. I just want to get the pictures over with. That's the part I really hate! [Laughs.]

LONDON

ZAHA HADID

Interview by Kenny Schachter

In the two weeks I spent trying to arrange this interview, Zaha Hadid traveled to three continents and five cities — it was almost impossible to get hold of her. But after nearly three years working together, I had grown used to her busy schedule. Our collaboration started when I bought a property in London's East End and asked her to design a building for it. Despite my sometimes far-fetched schemes and, to be frank, my trepidation about Zaha's somewhat towering personality, our collaborations have become increasingly frequent. One was the Z-Car, commissioned in 2005, with a design brief that called for a truly modern, sustainable car. In another collaborative venture, we created a large furniture/ storage/sculpture object. Shaped like a twisted boomerang, it cantilevers ten feet from its base and contains a storage bin and built-in seats; it now serves as my desk. And then, in 2006, I asked Zaha to design a bespoke pavilion for my gallery, Rove, to display her fascinating paintings and editions of her models; the result, itself a sculpture, was displayed at Art Basel Miami Beach.

All told it's been a whirlwind. Perhaps the best, and only, way to describe Zaha is like mercury given form: hard to grasp, agile and elegant, but always potentially dangerous...

Kenny Schachter	Was it a childhood aspiration to be an architect? Was there any other career you ever contemplated?
Zaha Hadid	Politics always interested me — as did psychology and mathematics. I also remember wanting to be a singer.

KS Are there any lasting impressions/influences from growing up in Baghdad? Does that color the way you work in any capacity?

ZH Yes, in some obvious ways, but not in others. At that time, Iraq was progressive and liberal. This aspect of growing up in Baghdad definitely influenced me. Your question actually makes me think of a discussion I had with Alvin Boyarsky about how calligraphy influenced abstraction, and later Deconstructivist architecture. Rem Koolhaas was one of the first to make the connection, when he observed that only his Arab and Persian architecture students were able to make certain curvilinear gestures in their work — he thought it came from the calligraphy. The act of making that script — a visual and physical gesture that is an everyday movement for someone writing in these languages, but is not part of Western language — maybe encourages or allows for abstraction of gesture in other ways, or for other understandings. And I think definitely the Russians, Malevich particularly, looked at these scripts. Kandinsky — you can see this in his work. Also, one of my first memories is of the museum in Baghdad—we were allowed into the storage area because one of my teachers in school was married to an archaeologist. It was an incredible experience to see these thousands of glass vitrines, and literally millions of seals — long ones, short ones, Sumerian, Babylonian treasures. Upstairs was modest, but the basement and the storage area were amazing.

KS The distinctions between furniture, design, art, fashion, and architecture are blurring. Good thing? Bad thing?

ZH It's not a bad thing at all. Traditionally, there has always been an overlap at certain historical moments. The Bauhaus or the Arts and Crafts movement of the early 20th century are obvious examples. A lot of what we try to do is create an architecture that translates the intellectual into the sensual by experimenting with completely unexpected immersive environments. We often use smaller design projects to test out ideas, which later become incorporated in our building designs, and we are also working now on a series of projects that look at smaller environments within the whole — the kitchen we have designed for DuPont, for example. We are very concerned with making fluid spaces, where everything works together, both functionally and aesthetically, so the blurring of disciplines is good — it furthers that experiment, or goal.

KS Were you always into fashion from an early age?
ZH Yes.

KS Musicians reference art (Sonic Youth wrote an album about a Richard Prince painting); your works have been compared to Russian Constructivism. Do things like art and music truly influence your designs?

ZH You can't design — or exist, for that matter — in a vacuum, so of course. Malevich was an early influence as a representative of the modern avant-garde intersection between art and design. The liberation from given typologies and the conquest of the realm of freedom of creation offered by the world of abstract art was appealing.

KS Are you very mathematically inclined? Do you have to be to be an architect?

ZH I am. Mathematics and philosophy are very useful for architects, but not the way most believe them to be. I studied mathematics at university in Beirut before going to the Architectural Association, so yes, I have a certain level of knowledge. I think it is important for architects to have these skills. Obviously, buildings would not be built without engineers. Architects need them. But by the same token you can't just hand a sketch to an engineer and expect that they'll run off and build it. You need to know what you're doing structurally and technically in order to design any building. Maybe not always the small details, but the bigger picture.

KS You exude a Nietzschean sense of self-determination. Were you always so self-assured?

ZH Yes.

KS Is there a place for humor in architecture?

ZH Yes.

KS Could you live anywhere besides London?

ZH Yes.

KS Any thoughts on London's mayor, Ken Livingstone?

ZH No.

KS What do you hate about London?

ZH London is still too conservative in its architecture. There is also too much of a brotherhood in almost every aspect of the city. But it also has been my home for over 30 years, and I have no plans to change that.

KS You have designed shoes, are working on a handbag, have done tea sets, furniture, kitchens, etc. Is there a hierarchy of importance for you with regard to the disparate design works you are presently undertaking?

ZH The idea for a building or an object can be just as immediate as each other, but there is a huge difference in the process that follows. The satisfaction of design is that the production process between idea and result is so quick and uncomplicated compared to a building. In terms of form, though, design and architecture interest me equally — there is a useful dialogue between

the two. You might say that design objects are fragments of what could occur in architecture.

KS Black and white have figured prominently in your design work and dressing mode. Is there a wider role for color in your present or future work?

ZH Of course.

KS Is black your favorite color? I know that sounds asinine but it's still interesting!

ZH Clear, or transparent, is my favorite — it's not really a color, but then, neither is black.

KS You have crashed through the cement ceiling becoming the very first internationally acclaimed female architect. Do buildings reflect gender in any discernable capacity?

ZH I don't think so.

KS This interview is in PIN–UP, so I will briefly touch upon issues of sexuality: can buildings contain some notion of sexuality within the design (other than Norman's pickle)?

ZH What?

PARIS

PIERRE HARDY

Interview by Emily King

Pierre Hardy has a singular way with form. His shoe designs are not only beautiful on the feet and flattering to the leg, they are charismatic objects in their own right. Having arrived at shoes through an indirect route, including stints as a dancer, a scenographer, and an illustrator, Hardy conceives of fashion in the broadest possible sense, often referencing contemporary design and art in his work, but never falling into the trap of over-literal quotation. Today, the youthful 50-something masterminds his eponymous line, which he founded in 1999, as well as developing the men's and women's shoe collections for Balenciaga (together with Nicolas Ghesquière), and acting as creative director for the fine-jewelry division of Hermès (for whom he also used to design the shoes).

Hardy is passionate not only about fashion, but also about architecture and design. He was his own architect for his Paris and New York boutiques, which he made into devotional spaces where every detail is sharp and precise, and where stilettos, sandals, ankle boots, and trainers provoke desire tinged with urgency. But nowhere is his enthusiasm for design more evident than in his Paris home. Hardy is notoriously private, and it took some persuasion before he agreed to meet with PIN–UP in his high-ceilinged, 17th-century Marais apartment. Filled with rare design pieces, limited editions, and Modern and contemporary art, it's clearly the abode of a serious and knowledgeable collector — even though that's a label he himself would resist.

Emily King	Do you remember the first time you became aware of design and architecture?
Pierre Hardy	It was actually very early, when I moved into a new apartment with my parents. We lived with my grandparents until I was ten, in a very old apartment, with old furniture. For their new home my parents bought all new, modern furniture — it was the late 1960s, so it was all post-Paulin, post-Eames, that kind of aesthetic. I remember it very distinctly. It was a very classic apartment, but the furniture was brand new. I also always had a love for cars, which I shared with my father. I was crazy about cars and I knew them all by heart: the names, the serial numbers, the brands. They were the first objects that I really loved, that I recognized as objects of design.

EK Is there a car you particularly remember?

PH My father's first Alfa Romeo, a white Giulietta. It was very square with a cut in the back. It had a very strange shape.

EK An Italian car must have been quite unusual in France at that time. When I first came here, in the 1970s, I remember being struck by the fact that everyone drove French cars — they looked so different from the cars in England.

PH Yes, very different. Nowadays all the cars look the same. You can exchange a BMW, a Lexus, a Honda, a Mercedes. They have no handwriting, no outline — well they do, but it's the same for every car.

EK Do you think that's because they're all designed using the same software?

PH Yes, probably. It's a bit like football, with designers moving like players from one international design studio to another. But I think it's also a question of taste. Cars are no longer the fantasy objects they used to be, they've become more like tools. People want them to be efficient, not consume too much, and be safe — in the end the result becomes almost the same. I just worked with a car company who asked me to conceive a concept shoe, because they'd designed a concept car. We had very interesting conversations about why all these cars are built like they could go to the moon, almost like spaceships, yet can't run any faster than 70 kilometers per hour.

EK Do you own a car?

PH I have three, actually: a 12-year-old Jaguar, an old Mercedes convertible, and a very old Volkswagen Karmann Ghia.

EK And you keep them all in Paris? It's impossible to park here!

PH Yes, exactly. That's why they're all parked in different garages at opposite ends of the city! [Laughs.]

EK You had quite a complex career trajectory before becoming a shoe designer: from contemporary dance, to scenography and stage design, to fashion illustration.

PH Well, I didn't know what to do exactly. I loved lots of things in equal measure, so it was like a puzzle of different ways of expressing myself. Back then the aim of studying was not to work, but to learn ways of expressing yourself. There was no purpose, no aim or strategy, it was just pure pleasure. I still teach, so I know that it's very different for students today.

EK But how did you go from being a dancer to a scenographer?

PH At the time I was working in a company that was also in charge of the visual aspect of the show. They would always ask me to help make the costumes and the sets. It was a wonderful moment, four years of my life. Probably my biggest regret, if I have any, is that I didn't make a career in theater. It's not a frustration, because I did something else that I love. But I still think the stage allows you to invent a perfect world for a specific moment. It's a total creation, like its own planet, with everything under control. The light, the people, the movement, the sound, everything is built and designed for a specific effect. Working in fashion, I have to deal with reality — that of the women, the market, the timing — whereas the theater is like a bubble where you can create everything from scratch.

EK Were you ever interested in designing for film?

PH No, because that's another thing. You know, I'm not really a storyteller. Even in my own work I feel totally unable to tell a story. It just doesn't work. I'm in awe of writers and filmmakers for that reason, because for me to build a story, and make it believable, would be a mountain!

EK So where did you learn how to design?

PH I didn't really learn design. When I went to school, in the late 1970s, design was still a very new idea. Even the position of "fashion designer" didn't exist — you were either a couturier or you were nothing. It was the very beginning of people like Jean-Paul Gaultier. So I was just doing things that I loved — dancing, drawing, painting — and all the subjects connected to that, whether it was history of art, anatomy, or aesthetics. But I was never consciously involved in constructing a position as a designer, fashion or otherwise. There was no strategy, I just wanted to draw and to paint. I also dabbled a little bit in furniture, but it didn't work so well. But then a stylist friend of mine, who was working at Dior, asked me to do illustrations for her.

EK What exactly were you asked to do at Dior?

PH My friend had just become head of the studio and I was asked to draw the collections. She'd always known me as a fashion illustrator. But once I started, I quickly realized that it's a big step from making illustrations for fashion magazines to being in charge of an entire collection. And during that period, between 1987 and 1989, Christian Dior was probably one of

the biggest brands. If you'd asked people in the street to name a fashion brand, nine out of ten would have said Dior. It was a big, big thing, but at the time I didn't really realize that. And it was at Dior that I realized that I really enjoyed designing shoes, so I thought, "Let's go for shoes!" This might sound a bit silly, but that's exactly what happened.

EK Do you remember designing your first shoe?

PH For Dior? Of course! Well, maybe not the first one. But I do remember that it was a big collection because I had to do the couture, all the shoes for the show, and ready-to-wear for all over the world, including for the licensees. It was just enormous.

EK What were your points of reference when you started designing shoes?

PH Well, I've never worked with archives, even to this day, whether it's at Balenciaga — a brand with a lot of history — or at Hermès, where they even have a museum and a curator. I know the archives, of course, and I've looked at them, but I've not gone further than that. It doesn't work for me. I think it's better to work with the memory of what it was, which is usually very different from what it *actually* was. I believe that in order to really make these old brands come alive you have to forget the archive and just use your memory to work out what's valid for today.

EK So how would you describe your design process?

PH It's always very difficult to analyze, or to conceptualize, fashion because it escapes logic. There's no progress in fashion: the fashion of today is no more fashion than the fashion of yesterday or less fashion than the fashion of tomorrow. It's a combination of material things like, "This season it's all about red," or, "This season it's all about big shoes," or the stiletto, or flats, or whatever. There are no rules. That's why it's so complicated and so difficult to understand from the outside. When you build a house, there are some rules, but when you build a fashion collection, there is nothing, except perhaps anatomy — but sometimes not even that! [Laughs.] You have to understand the moment and the opportunity. You have to do the right thing at the right time, and the reason something might be right is very diffuse. That's why it's so difficult to speak about fashion with intelligence. It's a pure fantasy. So when I'm talking about the design of a collection I might remember the shape of the heels, the materials, some motifs and patterns; but the way the collection is built, why it has that style, that I really don't know. And I don't know if any fashion designer could really explain it.

EK Is there an era you particularly love in design?

PH I'm quite eclectic, but I love the end of the 1960s and the beginning of the 70s, in both fashion and design. It was a very dynamic era and there was a break away from previous shapes as well as in the use of materials. And there was also a meaning to the new formal language because it was about finding a new way of life and trying to express it through the design. I like that.

EK	Which designers would you associate with that?
PH	People like Charles and Ray Eames in America, or Achille Castiglioni in Italy. They were really thinking about what a modern way of life would look like and adapting their designs accordingly, even if in the end they weren't always right. For example, in fashion in the late 1960s people thought that by the year 2000 we would be going about our business in white all-in-ones. Alas, we still dress just like we did 50 or even 100 years ago. But what I like in this period is the fantasy of progress, the fantasy of the future.
EK	Do you collect design from that period?
PH	No. In fact, I don't consider myself a collector at all. For me, having a collection would be like a prison.
EK	But you own so many beautiful, rare pieces: Konstantin Grcic's Chaos Armchair and the Rock Table by Arik Levy. And I also heard you own some amazing pieces by Shiro Kuramata…
PH	All I have from him is the mesh console table that you saw in the hall. It's a very unique piece. I think there were maybe only three or four in the world. But I don't actively pursue certain objects, I just buy them when I happen to like them.
EK	What about those perforated-steel Robert Wilson chairs I saw downstairs, or the fiberglass chair in the hall?
PH	The perforated chairs are from Bob Wilson's production of Heiner Müller's play *Hamletmachine*, which I saw twice, in Berlin and in Hamburg. It was in 1989, the year the Berlin wall came down. Bob Wilson is such a funny guy. He loves to drink and eat and laugh, yet you look at these chairs and they are so serious — the complete opposite of who he is. The Roma fiberglass chair is by Marco Zanini. I bought that in auction in Paris and then I bought its twin, which is the same, but with glitter. It's so big that it's useless. [Laughs.] I love it, but more like a sculpture. It's a little bit the same with the marble Tobia Scarpa light from Flos [the Biagio, designed in 1968] that I have in the bedroom. In a way it's an anti-design piece because it's so heavy, so fragile, and it's difficult to produce. It's well designed, but is it a piece of design? I don't know. There's an ambiguity.
EK	I also noticed a collection of glass in your kitchen. Have you been building it up for a while?
PH	Yes, I used to have even more — Baroque pieces, cut glass, and Venetian glass — but I ended up only keeping the rounder pieces, the blown glass. Most of them I simply found at flea markets or little antique shops.
EK	Do you still enjoy going to flea markets?
PH	No, they're so expensive now, they've become like real shops with the same prices as in the Left Bank antique shops. And the quality there is better, even if it's not so much fun anymore.

EK Do you remember the first piece of design you ever bought?

PH Yes, it was a very minimal, white square table by the Italian designers Studio Alchimia. I was still a student and I found it in a sale somewhere here in Paris. I remember mixing it with a lot of different things: an 18th-century-style sofa, a big poster of Warhol — signed! It wasn't mine, but it was in the apartment at the time. [Laughs.] The whole thing was very 80s. My references were less about design and more about painting, actually. It was very David Hockney, with modern things and old things mixed together.

EK Had you seen *A Bigger Splash*?

PH That was my absolute dream movie when I was 18! Actually, it's not a movie, it's not even a documentary — it's pure expression. It can be quite boring at times, but you don't really care. Today things can be too designed, too well lit, over-precise, over-retouched. Everything is so clean. *A Bigger Splash* represents a very different moment, a different way of thinking and living.

EK So when you look at a piece of design, you think about it more as part of an overall picture than as an individual object?

PH Yes. I remember when I was young my grandmother lived by the Knoll shop on Boulevard St-Germain. I remember being completely obsessed with it because it seemed like a dream planet where everything was so perfect, so sleek, so beautiful, and brand new. Paris in the 1970s and 80s was full of old things; in contrast this shop looked almost abstract, not like a collection of chairs and tables, but like an installation of new aesthetics. Now I know that these aesthetics came from the 50s and 60s, but I personally still haven't reached that level of modernity. You have to live in reality, with comfort, and other people, but it is still a dream, or a fantasy, totally.

EK I noticed that most of the pieces in your home are black and white, whether they're art or design.

PH Yes, it's almost a little bit like drawing — black and white is less invasive for me than color.

EK Did you ever find yourself getting rid of color? Did you own any colorful Ettore Sottsass pieces, for example?

PH Some, but very little. I used to have a pedestal table — the very simple one with a glass square with four cylinders and wavy tubular legs [Le Strutture Tremano, 1979]. But that's it. I eventually sold it because I felt the pastel colors were too feminine for me. And also, it was quite useless. [Laughs.]

EK Have you ever based a shoe on a specific design piece?

PH I've tried with Sottsass, actually. But it didn't work at all.

EK	Some of your shoe heels remind me very much of the Daniel Buren installation in the courtyard of the Palais-Royal, where you also have your store.
PH	Yes, I love that piece. It's a real icon for me. Did you see his show at the Centre Pompidou years ago ["Le musée qui n'existait pas," 2002]? It was fantastic. It was the perfect demonstration of how you can build a world with a stripe. You can make it intimate, fun, dark, open, closed. Any possible quality of the space you create with one tool — a simple stripe!
EK	Were you ever tempted to become an artist?
PH	Me?! I wouldn't have dared! I wasn't brought up in that mindset, my family didn't have that perspective, and, frankly, my image of myself didn't let me think that being an artist was something I could attain.
EK	Is making art so different from fashion or design?
PH	Yes, I think it's totally different. My collections are not pieces of art at all. They are simply things you can wear and walk in. I hope that they are as artistic as possible, but they are not pieces of art. Maybe it's an old-fashioned way of thinking, but for me it's very important to make that distinction. In design, you have to deal with reality, with the people who will buy your product, use your product, and ultimately throw away your product.
EK	Do you find the speed of fashion at all oppressive?
PH	No, actually, I love it! I love the lightness. In a very specific moment it has to be very strong, very focused, but then it's over and it's, "Okay, let's try again." I love that dynamic. Of course sometimes it can be exhausting, and it may feel like a waste of energy. I don't do shows for my own collections, but when we do shows for Balenciaga, for example, you ask yourself, "Why all this work for a show that lasts ten minutes?" But those ten minutes are the essence of what the next year will be about, and I love that.
EK	What's your starting point for a new collection?
PH	Usually, the first thing I do is go back to the previous collection and take what was good and then twist it, twist it to the point where it will break. It's a bit like in dance when you flex, flex, flex to the point where you can go no further, or it's too far. Next is to create new shapes, new volumes for the heel. I try to experiment with different balances for the body. I don't talk about ergonomics, but I like to think about anatomy and how to show it as much as possible — or how to contradict it. I can either follow the line of the foot, follow the curves, or I can transform it into a totally abstract or graphic volume.
EK	Speaking of anatomy, I've come to notice that there seems to be a kind of game to see how far designers can go with the height of heels. If I look at the heels of my shoes from, say, ten, even five years ago, they're so much lower than my high heels now. They almost look dowdy.
PH	Yes, it's true. If you look at old magazines or fashion shows, it's incredible:

159 PIERRE HARDY

ten or 15 years ago, eight-centimeter, nine-centimeter heels were considered enormous. Now, that's totally normal. But it's just a matter of practice; women have actually gotten used to it. But 11.5 centimeters is the absolute maximum a woman can possibly wear without platforms or compensation. After that you go as far as you like! [Laughs.]

EK Is there anything you really dislike in a shoe, that you think is just the absolute ultimate in bad taste?

PH Yes, I really don't like Uggs, except for when little babies wear them. Then it's cute, or at least funny. Crocs are even worse.

EK I remember you once said that it feels weird to you when someone says they own a pair of Pierre Hardys.

PH It's a strange thing when your name becomes an object or a brand. And the first time I saw my name on a shoebox, for example, or above the shop, it was a bit of a shock. I've gotten more used to it now. But to this day, when people say, "I'm putting on my Pierre Hardys," I ask myself if it wouldn't have been better to give the collection a different name. [Laughs.] That said, I'm really happy I've found a form that people can read and recognize, because each of my designs is also like a portrait of myself, in a way, with a little bit of my heart and soul.

BASEL

JACQUES
HERZOG

Interview by Aric Chen

Architect Jacques Herzog, of Herzog & de Meuron, is a busy man, jetting the globe from one high-profile commission to another. In 2010, he celebrated the premiere of a new production of Verdi's *Attila* at New York's Metropolitan Opera, for which his office designed the stage sets, in collaboration with Miuccia Prada. And almost simultaneously, he and co-principal Pierre de Meuron inaugurated the VitraHaus, a showroom and exhibition building for Vitra that looks like a stack of extruded house structures — and which joined showstoppers by Tadao Ando, Frank Gehry, Zaha Hadid, and others on the furniture maker's campus in Weil am Rhein, Germany. Aric Chen managed to pin him down, briefly, for PIN–UP.

Aric Chen	Now that many of your most anticipated projects are completed, or well under construction, what's next for Herzog & de Meuron?
Jacques Herzog	We are working on many projects in Europe, America, and the Arabian countries. Also, since a very recent date, we're working on the Kolkata Museum of Modern Art in India, and a dance theatre in São Paulo.
AC	How has the recent turmoil in the world economy affected your practice, if at all? Not so much in terms of your business, but in terms of your thinking?
JH	In terms of business, we have been quite lucky so far. In terms of thinking, architecture has always reflected the economic reality of our societies, now and in the past. Architecture is a tough business, where the liability and responsibility of the architect plays a very important role in what an architectural practice can do and how far it can go. Architecture is therefore not an ideal medium for frills and other unnecessary things. We have always underscored this as a basis for our understanding of the business. In this sense, our thinking has always been adapted and prepared to face tougher economic times. Having said this, we reject the idea of a change in the sense that building designs look more modest, simpler, and more ecologically correct. Very often such "modest" design approaches are just disguises lacking the conceptual and intellectual rigor necessary to transform and adapt architecture into an adequate medium for our time.
AC	Are there any conclusions to be drawn from the differences in your three schemes for London's Tate Modern: your original design of 2000, your 2006 proposed addition, and 2008's revision of the latter?
JH	No particular conclusions. We clearly believe the current design is more intelligent and integrates the existing and new in a much better way.
AC	What would you propose for Beijing's Bird's Nest, now that the Olympics are over?
JH	The Bird's Nest stadium is visited every day by tens of thousands of people, like a public sculpture in a big park. We quite like that... It is open, it is public and a place to meet. There is no such place anywhere else that is so popular after losing its original function as an Olympic arena.
AC	The VitraHaus is a continuation of what seems to be a longstanding interest of yours in the archetypal, gabled house, as seen in your recent proposals for the Parrish Museum in the Hamptons and the Fondazione Feltrinelli in Milan, and also in the 1997 Maison Rudin in France. What is the significance of that archetype for you?
JH	The archetypal house is often a very pragmatic solution, but as you say, it is also an archetype, and as such of very strong iconic value. We like these two seemingly paradoxical and almost opposed qualities: the pragmatic and the paradigmatic.

LONDON

SOPHIE HICKS

Interview by Emily King

With her boyishly short hair and smart men's clothes, Sophie Hicks is widely known for her sharp personal style. She developed her fashion skills during the nine years she worked as a stylist, first as a teenager for *Harpers & Queen*, then at *Vogue*, and afterwards for Azzedine Alaïa. It wasn't until her mid-20s — with a little indirect help from Madonna — that she discovered her true calling: architecture. After a degree from London's Architectural Association, she went on to design office space, exhibitions, private residences, and shops — for Paul Smith and Chloé, among others. Her Parisian flagship store for Yohji Yamamoto is a miraculous exercise in crafted wood and folded paper. Hicks's style is subtle, quiet, detail-oriented, and elegant. Her spaces are never flashy, but always smart, and often witty. Meeting her in her long, lean mews house home-cum-studio in Notting Hill — which she shares with her boyfriend, children, and pets — I found myself impressed by her poise, determination, and sharp intelligence. But the true focus of my envy was her indoor swimming pool.

Emily King	Oh, I'm a big swimmer and I would love an indoor pool like that! How long is it?
Sophie Hicks	It's 12.5 meters.

EK Exactly half the width of an Olympic pool!

SH Well, actually it's a few inches too short, but it doesn't matter.

EK Do you swim every day?

SH I try to. But when I go to the country for the weekend I tend to miss a Friday night. But I'm careful not to miss too many other days. But the real reason the pool is here on the ground floor is because this building's on the mews and people walk right outside the window. If you have the luxury of space to spread around, you think, "Well, what am I going to do on the ground floor? Do we want to eat there, with everybody watching us having breakfast?" Then you think, "Garage?" But that's a bit...

EK Boring?

SH Yes. So my main project has been developing a façade design for a building in London, right on the street like this, where you get some light coming in and some views in and out. It should be oblique enough that you feel protected, but the wall would still be light permeable. It would solve the problem of being watched, unless of course you don't mind that. I mean, in Amsterdam for instance, they all quite like being watched.

EK The other problem with houses in London — the Victorian ones, at least — is that the raised ground floor is the sitting room. It's the nicest room in the house, but you never go there because you spend all your time in the basement kitchen.

SH Yes, which is horrid. It's much better to live laterally. In a way it would make sense if everybody could sell parts of their houses to their neighbors and chop them horizontally. [Laughs.] While my family and I were waiting for this building to be finished — just after we came back from France — I rented a mansion flat in Holland Park, and it was incredibly nice, just one rambling room after another.

EK When did you live in France?

SH When I bought this house with my ex-husband, in 2003, there was a lot of structural work to be done. While working on the Chloé shops, I got used to employing executive architects: there were so many projects there was no way I could do everything by myself, so I'd do all the design and then hand it over to the executive architect for the day-to-day management. When we started working on this house, I thought: "Why don't I use the architect who did Chloé? I don't have to stand here and check people putting steelwork in, and setting concrete floors!" Rather than stay in London, renting a big flat

that would have cost a fortune, I asked him to manage it all and took off for a year with the kids to Megève in the French Alps.

EK Surely your three children rebelled? How old were they then?

SH Arthur was about 14 then, and he took it quite well. But Edie, who was twelve at the time, said: "Absolutely no way!" But I convinced her by promising to take her horse with us and to drive her to ride every day after school. Olympia, the little one, was fine. She actually loved it. We drove there from England during a boiling hot summer, with a horse trailer, a cat, and five kittens in the car. Every time we stopped something terrible would happen. Once Edie forgot to shut the gate, and the horse escaped. But the journey was actually hilarious fun.

EK You started working in fashion quite early. I read that you edited the *Harpers & Queen* teenage issue in 1977 — you must only have been in your teens yourself!

SH Yes. It's funny, I actually just came across that issue the other day. It's absolutely ghastly, but also quite brilliant in a way. They had a very interesting features editor called Anne Barr. She'd teamed up with the writer Peter York, and he came to her with this germ of an idea about a tribe of people that he'd kind of identified, and together they created the "Sloane Ranger." ["Sloane Ranger" is a 1980s term for a particular breed of well-heeled young Londoner: see the *The Official Sloane Ranger Handbook* by Ann Barr and Peter York (Ebury, 1982).]

EK Had you already found your uniform back then?

SH I used to always wear a Claude Montana sailor suit. It had a white-linen collar, wide navy-blue linen trousers with buttons on the front, and a navy blue linen jacket with gold buttons and turned-back cuffs. It had big shoulder pads, but I took them out. It was quite fabulous and I really loved it. I used to make my mother wash and iron it overnight.

EK How did you get the money to buy it?

SH I'd blagged my way into the Montana show in Paris, and I thought, "Ooh yes, I want that!" But I obviously couldn't afford it. However there was this man, Ricky Burns, who had a shop with his mother in George Street. Ricky was an incredibly camp hairdresser-type with a gorgeous bouffant. He had one of the few shops that stocked designer clothes. I remember going in to see him and saying: "I really, really want that sailor suit, and I don't want you to sell it to anyone else. But I can't afford it!" And they were amazing: they probably gave it to me for half the price, or something.

EK Were you always a particular dresser, even as a child?

SH Yes, but my first memories of clothes are actually dreadful. My mother had a dressmaker who lived in a stinky house on the outskirts of I-don't-know-where, and she used her front hall as the fitting room. My mother would buy

white-cotton piqué with strawberries printed on it — horrible material — and this old bag used to make me sundresses that were short and triangular, like 1950s A-line with matching frilly knickers and a sunhat. And underneath these sundresses I used to have wear a petticoat to make them stick out. [Laughs.]

EK Now that actually sounds pretty cute. And when did you cut your hair?

SH When I was nine my mother left me at the hairdresser to have a trim, while she went off, probably to John Lewis to buy some more of that horrible material for my sundresses. [Laughs.] The man asked me, "What do you want me to do?" And I said, "Take it off, take it off! Off, off, off! All of it!" So he took it all off. And it's been like that ever since.

EK Most of your interviews tell the story of your epiphany, when you switched from fashion to architecture. Legend has it that you were flying a big crew out to photograph Madonna, and she canceled the shoot mid-air. Is that true?

SH Yes and no. It was more exhaustion, I think. I had been traveling with Azzedine Alaïa for weeks, working as his stylist for a book. He is absolutely lovely — and still a great friend — but he's also completely exhausting. He doesn't need much sleep, and I need quite a lot. During our trips we had all these ghastly disasters, which we now laugh about. We made a trip around America, staying in hotels with kitchenettes, cooking very stinky North African food and setting off fire alarms. It was a hilarious trip, but I got more and more tired because after every shoot Azzedine likes to go and party. He's like, "Oh, we're going to see Grace Jones, she's having a dinner!" And you'd get back to the hotel really late, completely knackered, and then, at six in the morning, I'd hear little mouse-like noises in his room next door. He couldn't order breakfast, because he can't speak English, but he'd wait, incredibly politely, until about 7:15, and then I'd hear: "Sophie? *Tu es réveillée*? Sophie? Sophie?" And I'd think, "No! I can't... Leave me alone... Yes, I'm *réveillée*. Okay, breakfast!" And after a couple of weeks of that I thought I was dead. And then fucking Madonna canceled and I thought, "That's the last bloody straw, that's it!"

EK People tend to say that you trained relatively late to be an architect, but it wasn't that late, it's just that you started in fashion so early.

SH It wasn't late, but it felt late. I was only 26 when I started studying architecture, but at that point I'd already done nine years in fashion.

EK What was it like becoming a student again?

SH It was hilarious! The Architectural Association asked me in for an interview, and they said, "Bring your portfolio." I didn't have a portfolio, so they said: "Well, you must have some sketches or something." So I turned up at the AA in top-to-toe Azzedine, and I showed them my fashion-show sketchbooks because we all used to sketch everything on the runways — you weren't allowed to take photos in those days, everything was very secret then.

EK	And once you were accepted you started working on your first architecture commissions before you even graduated.
SH	Yes. In my third year, I worked on the "Pop Art" show at the Royal Academy. We put white linoleum over the entire Royal Academy galleries. We got this cheap white linoleum and stuck it down everywhere, over the plinths and everything.
EK	Do you think your fashion background meant you were less constrained by architectural convention?
SH	I'm freer thinking, probably. I look at art a lot, and I think that helps. I do find architects are quite trapped, often — mentally trapped. It helps having been in a different world before going into architecture. Fashion is an interesting world because it captures the zeitgeist. Architecture also has to capture the zeitgeist, but it has to last a lot longer.
EK	Do you find the timeframe of architecture frustrating?
SH	No, not at all. You just can't be frustrated by it. Architecture takes forever, you can't be in a hurry. You have to see everything over a ten-year span, rather than a half-year span like in fashion.
EK	Of course there are buildings like the Barbican which already looked dated when they opened...
SH	But now the Barbican's fabulous again! Things go in and things go out, that's what's nice about architecture. It sort of hangs on in there, and comes round again. One of the reasons I gave up fashion is because I wanted to create things myself. Although it's quite interesting doing styling, helping to create a look, you're very much part of a team, which is not a bad thing, but in the end I wanted to be the key creative person.
EK	But you never wanted to make clothes?
SH	No.
EK	Perhaps there's a parallel between fashion and architecture, in that they are both about housing a body, but in two different kinds of ways?
SH	I actually can't bear "architectural" fashion. It just drives me mad when they go on about... They're always describing Hussein Chalayan as architectural, and it's just bullshit. He has some very interesting ideas, but it's often irritatingly conceptual. When Azzedine makes clothes he dresses a body to look more fabulous than anybody has ever looked before. That's what he does, it's his great art. That's why he has to cut every pattern himself, why he's an absolute control freak. He's just started allowing his senior tailor to presume to make some tiny changes and bring them down to the workshop for his approval. And he probably wouldn't admit to it!
EK	So you think fashion and architecture are completely different?
SH	Clothes have to house the body and they have to be practical up to a certain

point. But architecture is so much more complicated: there are rules and regulations you have to obey — loads of them. So you lose a lot of the spontaneity. But that's fine, because it needs to last longer. To me architecture should have an emotional impact. The person experiencing it should think, "Mmm, I feel uplifted," or, "I feel comfortable," or, "I really like the way I'm walking around this place." That's the way I approach it.

EK Do you prefer doing retail to residential?

SH I've actually stopped doing retail, although perhaps you shouldn't write that, because if someone incredible approached me... [Laughs.] Global luxury goods went completely cold after we finished the Yohji Yamamoto shop in Paris, and I'm glad to finish retail on that, because I'm really happy with it.

EK What was Yohji Yamamoto like to work with?

SH Very nice. He engages on a very detailed level as well as a general level. We had fantastic meetings, actually. The first presentation went really well. We'd done a deep study on him, his image, his thoughts, and I went off to Tokyo with a book that we'd made for him. I did a 40-minute presentation, and at the end I looked at him, and he uttered, "Fabulous!" And he's quite stern and has a very thick accent, so I thought: "Oh my God, what did he say? Have I done something wrong?" [Laughs.] And finally someone said, "I think Yohji's saying it's very nice, Sophie."

EK One of the worries in retail is that there's a shelf life. Do you know how long they'll keep it?

SH It's always a worry, yes. But it's a very good showplace for him, so maybe they'll keep it for a while. I really hope so.

EK So if that was your last retail project, what's next?

SH I'd like to design a guesthouse-type hotel and run it, so I've been searching for a site or a building in London that I can rebuild. Obviously I won't attempt to run the hotel all by myself: I'll team up with somebody who's made all the mistakes before.

EK Most London hotels are terrible, aren't they?

SH They're often kind of charmless and flashy. You know, "cool" — ghastly! My fantasy hotel is the Bristol in Paris. I used to go there once a month when I worked for Chloé. And it's fantastic; you're part of this vast machine that runs like clockwork, with incredible service. Of course it's not my style at all, but it's so lovely. I'd want to create a place where people can come and experience a city in a way that you could only experience it if you actually lived there. A hotel/guesthouse that feels like a private residence: no reception, no concierge, really, really good service, but hidden. So, breakfast is delivered to you, but put there invisibly; the bed is made during the day, someone tidies for you, but it's as if you're in your own place. And there'd be a letter or booklet, an insider's guide to the neighborhood,

which will say: "The new bicycle shop's opened up here, but the old bicycle shop's still down there. And for coffee you can go here, but, actually, a much nicer place is over there."

And in fact there is something else I would like to do: through my work for Chloé, Paul Smith, and Yohji Yamamoto, I realized that there's an absolute gap between the company that goes out and commissions a designer or an architect, and the implementation, the actual building process. The people in the companies are not usually educated in that and it causes massive problems. So what I'd like to do is to work as a consultant for brands, to help them pick the right architect, and to be there and explain to them when they're about to get something wrong.

EK Let's end this conversation on fashion. Tell me what you're wearing right now.

SH Actually, these trousers are Comme des Garçons. But when I was being photographed for PIN–UP earlier last week, I decided that I would only wear Azzedine Alaïa, simply because every time someone does a shoot with me, they always drop the Azzedine — I assume it's because he doesn't advertise. So this time I made sure I was wearing Azzedine in every single shot! [Laughs.]

LONDON

JUNYA ISHIGAMI

Interview by Beatrice Galilee

It was in snowbound London that I met Junya Ishigami, the much-fêted starlet of the new Japanese architecture set. The young prodigy of the SANAA school of look-no-hands playful minimalism is on most radars as the next big thing in architecture. His gravity-defying art piece *Table* (2005) was a shocking, David Blaine–like demonstration of his creativity and undoubted flair; and *Balloon* (2007) — a helium-filled aluminum-foil cube the size of a four-story building, slowly bobbing about at Tokyo's Museum of Contemporary Art — was equally awe-inspiring. So far he has not built much, but what he has is exciting and ambitious, like the Kanagawa Institute of Technology (KAIT), or the Yohji Yamamoto store in New York's Meatpacking District. And, unlike some of his minimalist contemporaries, he loves nature.

Dressed in baggy jeans with a Japanese motif down the side, Ishigami stooped politely to greet me in his hotel's 18th-century dining room. As the interview began, the translator poured us tea.

Beatrice Galilee	The last time I saw your work was at the Venice Architecture Biennale. You lined the entire interior of the building with pencil drawings of flowers and meticulous and naïve little architecture drawings, and outside you created a separate garden pavilion. It was a really interesting way of exhibiting.
Junya Ishigami	Thank you. I actually wanted to create architecture that could be scenery and scenery that could be architecture. Approaching the project in that way I could consider artificial and natural things on the same level.
BG	Tell me about how you started out. You were famous as Kazuyo Sejima's prodigy at SANAA. Did you follow her work as a student?
JI	I participated in many competitions at university. Sejima-*san* was a member of one of the competition juries; she invited me to work in her studio and I ended up working there for four years.
BG	And what made you leave? — it's a brave move!
JI	For some reason I had already determined for myself that I would become independent when I turned 30. I didn't have any specific reason for this... it was just something I decided for myself. [Laughs.] When I started working on my own projects, I was already 29, so for me, it was time to quit. But I couldn't leave SANAA so easily — it took about a year. Around the same time I got the university project at KAIT, which was really what made it all happen. Thanks to that, I could be independent at 30 years and six months — in a way it was perfect timing!
BG	So was the *Table* project in 2005 your first solo project?
JI	Yes, *Table* was the first project I did after I started my practice.
BG	I'm still shocked that this aluminum sheet — three millimeters thick, 9.5 meters long, and laden with vases, glasses, flowers, and food — was even able to stand up.
JI	I built *Table* as you would build a small building. Before it was set on its legs, the steel sheet was curved in a factory until it looked like a piglet's tail. I then worked out where to place the objects, each of whose weight was specifically calculated to create a flat plane. Each item was placed and arranged with very close attention to the view — how it would be seen — and to the distribution of load.
BG	And what about the *Balloon* project at the Museum of Contemporary Art in Tokyo?
JI	For *Balloon* I wanted to design a space as I would a landscape. I was interested in what sort of spaces would be created by the extremely slow movement of an extremely large object. I think I had in mind the idea of expressing something very gentle. Almost like a cloud.

BG *Balloon* and *Table* both appear very simple, but they must have been hugely complicated.

JI Yes, realizing *Balloon* was actually quite close to constructing an actual building. It weighs about one ton and stands about four stories high. It was also fairly complex because its weight, down to every last bolt, was used to create this very slow and boundless appearance. I actually worked with space engineers to calculate accurately the necessary quantity of helium.

BG And what are you working on at the moment?

JI It's a commission to improve an artificial lake. It's an industrial lake, created by a dam in the west of Japan, and it's not so beautiful right now. So I will make a new lake, and the area surrounding it will become a park. I plan to change the landscape and make it beautiful. The plan is to create a more curving shoreline with various ponds, to make everything seem more natural.

BG You seem to have a strong relationship with nature in everything you do. Why?

JI I simply like it. There's no reason. Maybe... well... my mother likes plants, very much. Maybe that's something...

BG Where did you grow up?

JI I grew up in a big condominium developed by the city; the whole area is like a new town, just outside Tokyo. It's very... well... it's suburbia. But I believe the relationship between the city and the landscape has been missing for a long time. In all my work I see it as a bringing together of architecture and landscape. I would like to explore the possibility of architecture by approaching landscape.

BG Do you think architects have been too focused on the city?

JI When architecture was part of the city, that was only for the human beings. Now architecture is not only for human beings but for many different aspects. Therefore the approach to the different values is very important.

BG What do you mean by values?

JI Now everyone accepts different values. When we talk about car design, people cannot simply design the car's shape. Some people are interested in speed, in the environment. Other people would like to travel into space. The values of each individual person vary so much.

BG What's it like to be a young architect in Toyko? Is there a lot of work?

JI The good thing about Japan is that there is a tendency to scrap and build — old buildings are often just demolished. Because of that, even a young architect can work on many smaller projects. And as long as we can get small projects it's okay, we can survive.

BG Who are your heroes?

JI Well, I went to see the buildings of Le Corbusier, Mies van der Rohe, and Rem Koolhaas in Europe when I was at university. But there is not one specific person I feel has influenced me very strongly. But I am probably very much influenced by all of them, little by little.

BG What about your contemporaries?

JI I'm not really interested in what other architects are doing right now.

BG What about other influences? Music? Fashion?

JI I like fashion, but I wouldn't say it influences my work. I really like the work of Viktor & Rolf or Alexander McQueen, for example.

BG How did your Yohji Yamamoto collaboration start?

JI My involvement with Yohji happened very naturally. I am very good friends with the husband of his daughter Limi, who is also a designer. So one day Yohji called me up and asked me whether I wanted to design the store. He already knew me, so I guess that's how it happened.

BG You often talk about space and comfort — how does your philosophy extend to your choice of materials?

JI I don't see much possibility in only using materials. The material alone cannot create an experience. When we find new relationships between materials and other things then there will probably be more possibilities. But I'm more interested in considering new relationships between heavy and light, big and small, material and non-material.

BG Would you agree that your work is often more about storytelling?

JI The story is very important. I probably believe more in the poet than anything else. For a poet, each word has a relationship but the images between each word are more important.

BG That's a lovely sentiment. Do you think poetry is easier in an art installation than in a building?

JI No. For me it is the same.

BG Would you describe one of your projects as a poem?

JI Perhaps *Table*. It has so many aspects. Why is it so thin? Why are these objects displayed on the tabletop? Why do the table and the sides of the table have these proportions? Why these proportions in this space? There are many reasons why it's like this. People say it's too thin, it's impossible; but if someone sees it in another way, then the relationship changes. Somehow you could say there is a simple explanation for a table. But all the time the images show me more possibilities, more possible relationships. So there are no conclusions in these explanations, only that different people receive this information differently.

BG Could you also interpret functional aspects of a building as a poem?

JI Yes, you can. In the KAIT, everything is very carefully considered, as if it has its own project. There are many relationships we can see, and there are many we cannot see directly, but I'm trying to show this kind of relationship in a very natural way. Everything should be very natural.

LOS ANGELES

JOHNSTON MARKLEE

Interview by Brooke Hodge

Not only are Sharon Johnston and Mark Lee of Johnston Marklee & Associates considered the best-dressed architects in Los Angeles, they are also responsible for some of the most interesting new architecture in the city, not to say around the world. Since founding their practice in 1998, the well-traveled duo has forged a reputation for sophisticated, inventive work that includes a number of residential projects from Pacific Palisades to Palm Springs, a double boutique for Maison Martin Margiela and Mameg in Beverly Hills, a holiday home in Rosario, Argentina, and the extension and renovation of a 1978 Thom Mayne classic in Venice Beach. More recent commissions in Europe include an art complex and winery in Italy, and a housing project in Switzerland. During a conversation over Californian Shiraz and some excellent cheese, Mark and Sharon spilled about everything from their humble beginnings and their love of fashion, to apertures, L.A., and the beauty of constraints in architecture.

Brooke Hodge	I've known you both since you were students at the Graduate School of Design at Harvard, but I've never heard the story of how you decided to practice architecture together.
Mark Lee	Well, it all started pretty innocently...
Sharon Johnston	[Laughs.] Love works like that!

BH	So it all started at Harvard?
SJ	Not really, although we met there. We were in different programs, but we had one studio together. It wasn't until we were both back in L.A. that things started to get serious.
ML	I was teaching at ETH Zürich for three years and was commuting back and forth from L.A. I got to the point where I had to make the decision to leave or stay for ten more years. I had lived in L.A. for 15 years before I began going to Zürich, and Sharon is actually from L.A., so when we really got together we always gravitated towards this city.
SJ	During those three years we spent a lot of time together traveling, talking, eating, and, of course, looking at architecture, and we realized that we had a synergy that we could translate into a practice, a vital collaboration.
ML	We complement each other well. I'm explosive on the inside and calm on the outside, and Sharon is the opposite. [Laughs.]

BH	I remember coming to visit you when I first moved to L.A. in 2001, and you had that space in an A. Quincy Jones building in Santa Monica. Can you tell me about some of your early projects?
ML	Well, when we moved back to L.A. in 1998 and really started establishing the practice, one of our first real projects was for the Lannan Foundation. They had been based in Los Angeles, but they'd left and started their writers-in-residence program in Marfa, Texas.
SJ	Mark and I both love Donald Judd's work, and we had already developed a relationship with Marfa people, so we were hired to do some really minor renovations for some historic houses that the Lannan owned, and that was our beginning. We did another small residence in Marfa, and then just slowly started building up a small portfolio of work. I think those projects were important because they involved a community of people and an art-historical context, two threads that have run through our practice ever since.
ML	And, most importantly, we came into contact with a lot of artists there who have become lifelong friends.

BH	You've always placed a lot of importance on collaborating with artists in your projects — recently you worked with Jack Pierson, Jeff Elrod, and Walead Beshty.

ML Yes, but at the beginning that didn't get us any work either. I remember when we came back from working on those projects in Marfa, we didn't have any work in L.A. Since we'd done work in Texas, and then a renovation project in Palm Springs, we used to tell people we specialized in hot climates. [Laughs.]

BH How much has L.A. informed the kind of work you do? I think your practice feels like an L.A. practice, but it doesn't feel like the regular ones we hear of, with the architect saying, "Oh, we took what was here with the Case Study Houses and mid-century Modern and put our own spin on it." Your practice has more to it than that. Do you think that comes from working in other environments and the time you've spent in Europe?

ML Maybe. Oddly though, our European colleagues think that our work is very Los Angeles.

SJ They always describe it as very dreamy! [Laughs.]

ML It's funny, because I think we're always marginal in a way. We're not completely detached from the center, we're aware of what's happening, but we always feel a little bit like outsiders. And I don't know whether this is a condition about L.A. that attracts us to it...

BH I think L.A. is a city where you can be an insider and an outsider at the same time, which leads to a certain amount of freedom. Outsiders can always feel at home here, because it's a city full of outsiders, really. It's not clubby in the way that New York can sometimes be.

ML By being here we really have the freedom of not being subsumed under a certain architecture culture. L.A. doesn't have the same kind of gravity and history that Manhattan has and this is something about L.A. that we always find very invigorating. I remember when I first came here, someone said, "If you want to be an Angeleno, it's a matter of decision." You can decide that you want to be an Angeleno. You don't have to be born here.

SJ At the same time, our experience in Europe influences us in a major way — the artists we like and the work we looked at, at a formative time in our careers. And now 60 to 70 percent of our current work is in Europe. There are important projects that we're doing here in L.A. and in Southern California, but just the physical effort of being in Europe — Mark is there half time — has intensified our connection to Europe. It's an interesting juncture for us. We were recently at a conference in Porto and we were the only representatives from North America. That was an interesting snapshot of how our work fits within that Eurocentric context. But even though we spend so much time there, our core is here in L.A.

BH What other influences have been important for you?

SJ When we started our practice, we really wanted to learn how to build, and that has always been very important to us. So if we had an interesting client, we would take the job. And we've done a lot of little things, but the language and kind of vernacular of building in America, of building in Southern

California, definitely influences how we think about work. Right now we're working on a housing project near Lake Geneva with eight other architects, and each architect is from a different country. We realized how much the fundamentals of space, form, and light influence us and that we don't start with the details that, let's say, a Swiss architect might imagine being the foundation of their work. And this is just because of where we've grown up, and where we live.

ML After having spent time in Switzerland and having understood the building culture there, as well as the amount of money people spend on construction, when we came back we realized that would never happen in L.A. So we tried to absorb what was fundamental from that way of thinking, but also wanted to bring back in this kind of Los Angeles way of ad hoc construction, of putting things together without obsessing over it.

BH Speaking of obsession, in addition to art, you have a very keen interest in fashion, and I think they both enter your practice in a really strong way. Not because your work is trying to be fashionable or trendy, but because it's really at the foundation of who you are and how you work.

ML I have to confess that as a teenager I actually wanted to be a fashion designer, but I think my parents preferred that I study architecture.

SJ [Laughs.] Something respectable!

BH But then you got to do a fashion store, Mameg, here in Beverly Hills. How did that happen?

SJ We've known Sonia Eram, the owner of Mameg, for a long time. I remember the day we met, twelve years ago. We were out, just dressed in dirty jeans, and we found this shop, Mameg. Mark picked out a shirt by Josephus Thimister and Sonia was like, "Oh my god, you guys like this shirt? I've got to take you to this space, I want it to be my new store!" And that's how we ended up designing her previous space on Montana in Brentwood, which then led to the new Margiela/Mameg space on Santa Monica Boulevard in Beverly Hills.

SJ Every once in a while, just at a funny juncture, you trace the lineage of connections with people that turned into projects. Sonia actually turned out to be a really obscure hinge to another important project. These guys who did a lot of the metalwork for the Mameg project had friends who wanted to develop a house, and we met them and they became our clients for the Hill House [2004], which for us is an important, seminal project.

ML I think when we started we knew that we're not the kind of architects who do competition after competition and hope that one day we'll win a big museum project. We knew our shortcomings and our lack of experience and so we wanted to take on everything, say yes to everything. Because in every project there's a lesson, and not necessarily a design lesson. We can learn a lot from the experience of construction, working with contractors, and we also wanted to find people to work with who we could travel with together.

BH It seems that you have always found clients with whom you have a definite synergy and with whom you develop a relationship over time.

ML I think, subconsciously, we're always looking for people who are willing to travel with us together through the course of one project or sometimes several, rather than finding a client who has "arrived" and wants to hire us as a trophy. We believe it's important to invest in the beginning, at the outset, with people who are building, or exploring, or thinking, at the same level as us, but who are also going somewhere. Oftentimes we know right away that it's a lifelong relationship with clients. We might start off with a kitchen renovation for them, and maybe we'll do a museum for them later, you know? [Laughs.]

BH Mark, I know you've spent a lot of time in Berlin recently, teaching as a guest professor at the Technische Hochschule. Has that had any impact on your practice, design-wise?

ML I think so. For us, not only is Berlin a Germanic culture, and in that way not so different from Switzerland, but we've also found many similarities between Berlin and L.A. Like L.A., Berlin is always promising to become something but is never quite getting there. The tension between desire and becoming is interesting. There's also a lot of art production happening in Berlin, but the financial transactions related to that are in Cologne or Munich. It's very similar to L.A., where there are a lot of interesting artists but the deals are still being made in New York. And also things are very cheap in Berlin.

SJ And Bless [the fashion label] is in Berlin!

ML And Berlin has the kind of historical layer that I like, the sense of a very recent history that's still fresh. That's what I also like about L.A., that there's a history that's still developing, it's not stagnant at all.

BH You have an impressive selection of chairs here in the office, and Mark, I know you have a great knowledge of and interest in design, and over the years you've assembled quite a collection. Were you ever tempted to design one yourself?

ML [Long pause.] Vitra actually asked us if we were interested in designing a chair. And our response was that, because we have so much respect for industrial designers, we didn't want to pollute their design world. We'd much rather have this distant, admiring relationship with them. We'd rather learn from them than try to come up with a product ourselves. So I think it's a tangential relationship that we have with design as well as the art world. For us I think architecture is architecture — it's different from art and design.

SJ We've often been asked to speak about intersections between art and architecture, and architecture and design, and I think that's a point where we diverge from a lot of our peers. There's this whole discussion about interdisciplinarity, or the blurring of boundaries, everyone spreading out, dipping into other disciplines, but Mark and I are actually contracting. Which doesn't mean that we're not carefully looking at parallel practices. But we're not trying to be a fashion designer, or an industrial designer, or an artist.

BH So you're not bringing any techniques from those types of design into your architectural work?

ML It's not an ideological thing. Sometimes it's as simple as the fact that we just don't have the budget or the right circumstance to bring it in.

SJ I think that's why for us Martin Margiela's work has always been so important. His work has been about innovating within the most basic parameters of making a piece of clothing, whether it's how the lining works, or what's inside or what's outside. Often they're very simple things, but his precise work in those areas has produced things that will be forever new.

BH So what do you get out of your collaborations with artists?

ML For us, it's refreshing to see how artists and other types of designers see the world. They come from a completely different perspective. We like to see what happens when we bring their vision and ours together, and that's why working with artists is so important for us.

SJ There's something thrilling about the kind of displacement of thinking about someone else's problem or asking them to think about ours, but without that feeling of, "You're in my territory," or, "I'm in yours." I like that idea of just being as radical as we can about the ways we can think about our own work, and our dialogue with artists is part of that.

ML It's funny working with artists, because we often hear them say, "I wish I could work like an architect, because you have all these real restraints and constrictions to work with, and we have to invent our own, sadomasochistically!"

BH Let's talk about the two projects that you're working on now for the DEPART Foundation in Italy: the Grand Traiano Art Complex in Grottaferrata, a small town outside Rome, and the Poggio Golo Winery in Montepulciano, Tuscany, which has an artist-in-residence component. You are really bringing art and architecture together in this work.

ML In a way, the Italian projects complete the full circle of our first ten years of work. When we were working in Marfa we fell in love with this whole idea of a dispersed museum, a museum that's not a single building, but that is kind of scattered throughout the city. The project for DEPART in Rome is very similar to that. It's a series of pavilions scattered throughout the parks, with some installations in the city. We don't really think about it consciously, but at moments like this we reflect about the first work and how it brought us to where we are now.

SJ As we've practiced longer and we've been working on bigger projects, it's been interesting to think about issues of form, issues of structure, and issues of mass, which we've studied at the scale of a single-family house, and how they get developed at the almost urban scale of the Grand Traiano Art Complex, the housing project near Lake Geneva, or at the scale of a large building, in the case of the winery. It really has been a series of steps, but now we're finding a new platform for the work.

BH It's a little bit as if you've developed a kind of formal vocabulary over time that you can reconfigure in a lot of different ways.

ML But it's funny how that's received in different places. When we present our work to our American colleagues, they say, "Whoa, all your buildings look the same!" [Laughs.] And when we show our work in Europe it's, "Oh, you're such a chameleon... How can you do an arch in this part and do a square in the other?"

SJ Our focus on the more abstract components of architecture that have to do with form, mass, and aperture is to some degree a conscious decision. But it also has to do with trying to get the most spatial impact within the parameters we have. So materials are usually subsumed into the logic of form, structure, and space, elements that we think are the most fundamental to making great architecture.

ML Apertures have actually been very important for us in the last ten years. I think it came out after Switzerland and we realized that when you look at books on recent architecture, you can always tell without reading the text which is a U.S. building and which is a European building by simply looking at how thick the window mullions are. So right from the beginning we decided not to let ourselves get hijacked by the U.S. window system and to design around it. Eventually that evolved into a series of work that is very abstract and massive, and the apertures became more important in relationship to the massing. It's also our way of addressing Modernism and our Southern Californian roots by finding new ways to make connections between nature and buildings and indoors and outdoors.

BH Speaking of your Southern Californian roots, you live in the Sale House, as your extension to Thom Mayne's 2-4-6-8 House is known. You designed the project and then ended up renting from the owner?

ML Yes, but we recently moved back to our condo in Santa Monica. We really liked that house and we lived there for two years, but our daughter Lilly made us move because she wanted to be closer to the beach... [Laughs.]

NEW YORK

WILLIAM KATAVOLOS

Interview by Felix Burrichter and Pierre Alexandre de Looz

William Katavolos is many things: an architect, a former painter, a revered industrial designer, an unlikely environmentalist, a mad scientist — not to mention a determinist and organicist. PIN–UP went to Brooklyn's Pratt Institute, which he co-directs, to interview this brilliant and sometimes overlooked polymath on his home turf. But it's just as hard to find him there as it is to classify the multi-faceted work of his 60-year-long career. We eventually tracked him down in the basement, where Pratt's Center for Experimental Structures is located. There he was, surrounded by a group of assistants, busy erecting a small prototype of one of his "liquid villas": a sustainable house with water-filled partitions and roof, a concept he has been working on for the past 30 years. All the research has paid off, he says, and the liquid villa is finally ready for its launch — provided sufficient funding can be found. Which may be problematic: the many ideas that went into the concept, which he calls hydronics, are not easily explained (especially in print); and, as so often is the case with people of Katavolos's high intellectual caliber, he is not a gifted salesman. PIN–UP attempted, nonetheless, to dive head on into the fascinating world of a man who, at 84, is still proudly avant-garde.

Pierre Alexandre de Looz	Is it true that you started your career as an artist, rather than as an architect?
William Katavolos	Yes, I enrolled at Pratt for painting before the war, then I was drafted out of Pratt for World War II; so when I came back [the painter] John Nichols convinced me to move downtown. John, Henry Miller, and [the con artist] Jim Moran, we all lived in a space together. We were so broke back then, whenever there was a big opening somewhere, we were always right there when the jumbo shrimp were coming out. Thanks to that we always got a fairly decent meal. [Laughs.]
PAdL	What kind of work were you doing?
WK	I painted like Pollock, but differently. I used to crimp whole cans of paint and pour huge areas of color — never used a brush. Now, I didn't know Pollock was doing this; I didn't even *know* Pollock at the time. We would see him occasionally at the Cedar Tavern holding court, but I don't ever really remember talking to him. He was morose, a very tough guy. So I had very little contact with him. Somebody warned me when they saw what I was doing, saying Pollock would knock me when he sees this. But I ended on a high note. There was an evening with [the French gallerist] Louis Carré and we wanted to get some money for John Nichols, so we arranged a big party. The whole thing was to get John Nichols's work moving. But Rothko called me over and said, "I want you to meet Louis Carré," and we started talking. He asked me, "How do you paint?" And I said, "I don't paint anymore; I stopped. I'm a designer now." But he said, "You gotta have some new work." I'd destroyed most of my work, but had given Nichols some of my paintings, so Rothko asked Nichols if he'd show them to Carré. So it was a bit embarrassing, because we pulled my paintings out when we should have put Nichol's paintings out. And of course, Louis Carré liked them and offered me a show in Paris. And Rothko looked at me expecting me to say yes. And I said, "You don't understand, I don't paint anymore." And I've never painted since.
PAdL	Do you know where those paintings are now?
WK	My father owned the Ram's Head Inn on Shelter Island, and years later at one point Nichols came out with his new wife, and we had a couple of drinks, and he said, "You know, I gotta tell you something: the paintings you left me, I sold them." And I said, "Oh, well that's fine." After all, he was paying for the studio and all that. And he said, "You don't understand, I signed *my* name on them!" [Laughs.] So god knows where they are. My wife is always looking for them, whenever we go somewhere. But the reason I quit painting in the first place is because I met Frederick Kiesler. He was doing this wonderful stuff up at Columbia, it was called bio-correlations. I used to sit in on that, and that really made me a designer. Paul Nelson as well, he even came to Pratt after a while. I think it's safe to say that Nelson and Kiesler were my mentors as a young designer.

PAdL What made them so important to your work?

WK Well, their ability to design — do you remember the very simple library system that Kiesler did? Everything about it was totally designed. Paul Nelson designed the same way. That's the kind of design I believe in. It can't just be lower-case architecture. I'll get in trouble again when I say this, but what the Greeks did in architecture just about covers Western civilization. There have been a couple of improvements, of course: the Romans created the public buildings, as we know them. But the Greeks! Just the Parthenon alone was enough. No matter how long you study the Parthenon — it's not about golden sections and the other stuff, it's just a deep, deep, deep understanding of numbers. It's a three-dimensional understanding of the number systems, of Pythagoras, etc. Later on, after it was all over, Plato put it all together with the harmonics. As far as I'm concerned, string theory is based on Plato's studies.

PAdL I've heard you were also hanging out with Robert Oppenheimer.

WK As I said earlier, my father ran the Ram's Head Inn on Shelter Island, and Einstein and Oppenheimer would always hold their meetings out there. That famous Shelter Island Conference was held there in 1947, and almost every physicist in the world showed up: Linus Pauling, Julian Schwinger, Oppenheimer, every one of them. And when I came back from the war I spent the winter on Ram Island by myself; I wanted to pull myself together. I loved painting out there.

PAdL So did you ever talk to any of these guys about the harmonics theory?

WK Well, my studio was in the basement of the hotel where they stayed. I did get to interact a little, but the security was very tight. They did a lot of the atom-bomb discussions there — they called them "weather conferences"!

Felix Burrichter But this was long before you started as a designer?

WK Yes, I didn't start designing until 1949.

FB Did any of that have an impact on your later design research?

WK Of course. I got into number research, and Richard Feynman was a number fanatic; and that was my introduction to physics.

PAdL So is design a kind of science?

WK No, it's not. It's like mathematics. Mathematics are not a science — they're a discipline, and design is a discipline. Engineering is based on science; if it fails, you're out of business. But if a designer fails, it doesn't really mean anything.

FB So how did your trajectory into design evolve into full-scale architecture?

WK I joined up with two other guys, Ross Littell and Douglas Kelley, and Ross

wanted to know how we could come up with a design system, and I remember drawing a leg system. And you could take that leg system and put it side by side, or what not. And then Ross said, "Why don't we make some of this stuff?" So we went down to the shop and started knocking out magazine racks, and book racks, and tables. And then we went out and tried to sell it, and we did have some success with it. And then all of a sudden it got serious: [the furniture company] Laverne International wanted their showroom done over on 57th street, and they asked us. It turned out to be a beautiful showroom. And one night Laverne comes over to my studio, which was also on 57th street, and says, "Bill, I'm going bankrupt — I spent all this money on the showroom, but I have nothing to show." And I felt really responsible and that weekend I designed what is now called the "new furniture."

FB You mean your famous T Chair?

WK Yes, among other pieces. Take the T Chair, for example — that was designed two hours after Laverne left my studio. There are reasons for this design, though. Lina Bo Bardi had designed a Mexican peasant chair that had three legs — and it stuck in my mind as being very smart. At the same time, Charlotte Perriand, who worked with Le Corbusier, had designed a line of peasant furniture. So all of that was on my mind, so it was easier to knock out a collection of 13 pieces in such a short time because I was building on things I'd seen before. I just tried it out in chrome and leather, and it worked! Ross came back on Monday and we started making the prototypes.

PAdL So it was a very spontaneous thing?

WK Well, that's the way I design, anyway. Take the American National Exhibition Pavilion in Moscow [1959], for example. George Nelson's office called me up one night, and they said, "Can you come in? We have a problem and would like you to take a look at it." So I came in on Friday and looked at the project, which they had been working on for over a year. And when I heard that the pavilion was supposed to go up in Moscow I said, "You're kidding me? You can't even find a screwdriver in Moscow, and you think you're gonna find buttresses?" And I told them that with Russian concrete, when you point-load it, it just explodes. So I said, "George, you got a problem! You've got to redesign it, even if it has to be up in two weeks." So we did. Charles Eames was there too, because he was going to show his famous multi-screen film *Glimpses of the USA* at the pavilion. And all he wanted to know was how he could hang his screen — because you can't hang anything from a Buckminster Fuller dome, and you can't touch the floor, but you need to come up with a system to support everything.

 So that night I went home and started drawing something up. I just guessed that given it was in Moscow, they'd have to have a weather wall under the dome, too. So I hung the whole damn thing from this theoretical weather wall, and cantilevered it out. In any case, I brought it in on Monday and George looked at it and said, "You can't do that!" But Eames was fine with it, so we sent it to the guys from Severud [the structural engineers],

and we did the engineering on it that afternoon. We ended up assembling it in Milan and then took it to Moscow, and it was there that Nixon and Khrushchev gave their famous speech.

FB So you designed the American National Exhibition pavilion in Moscow, but you also designed the Hawaiian pavilion for the New York World Fair in 1964, right?

WK Yes. But I have to say, one of the best ones was the Solar Energy Pavilion at the Salonika Fair in the late 50s, which I designed. Everything we showed then is state of the art today. We had solar furniture, solar collectors, a solar cooker, which was designed specifically for Africa.

FB How do you feel about world fairs today?

WK I don't think you can have a successful world fair anymore today.

FB But they're still around!

WK Yes, but they have no effect. The one at the turn of the century changed America forever, by innovating with European ideas. And the 1933 Chicago World Fair changed the world! I would say the Montreal Expo in 1969 was the last good one. Nothing since then has had any effect.

FB Why do you say that?

WK I think primarily because no one has had time enough to come up with something earth-shaking. In those days, architects and designers were working on ideas for over 20 or 30 years.

PAdL Did you see the show [on pre-fab houses] "Home Delivery" at the MoMA? I would be very curious to know what you think about it, because in some of the houses they're trying to integrate solar panels, wind turbines, etc. But the funny thing is that there are no ideas about pre-fabricated architecture that works with pneumatics.

WK I just read the review in *The New York Times* and it put me off that they were giving architects something like 150,000 dollars to build these structures. My instant feeling was: if they'd given me 25,000 dollars, I could change the world with my water architecture that I've been working on for the past 30 years. Although I must admit, after I saw the Lustron House 1 at MoMA, that it was a first-class idea when it appeared. Buckminster Fuller's Dymaxion House was a great idea, but nobody wanted to live in it. But everybody wanted to live in the Lustron House. It was extremely popular, and it was very beautiful.

PAdL Well, those kinds of projects get knocked — especially by architects — because they look so conventional.

WK Oh yes, but if you ask anybody in the world what a house is, they're going to draw the little slanted-roof house with a chimney and smoke coming out. So that's what sells, and that's what people want. So the guy who invented

the Lustron House was a genius. To some extent that's exactly what I'm interested in: inventing a liquid villa for 35,000 dollars that is the equivalent of Palladio. If you look at Palladio's villas, they're all self-sufficient. You have not only the kitchen, you have the butchery, you have the shoemaker, the herb gardens — it's complete, it's totally self-sufficient and totally sustainable — exactly what we need today. Except today it needs to be hydroponic gardening, it's gotta be fish-farming, it's gotta be knowledge farming, and it's gotta be fuel farming.

FB When did you first start developing this so-called water, or liquid architecture?

WK In the 50s already, when I published my essay "Organics." Back then I started thinking about growing architecture chemically. The opening of the essay was a complete description of nanotechnology, only I called it "micromation." And that's when I switched over to liquid architecture. And then I switched over to water, because it was cheaper.

FB The idea is so radical, and yet in many ways it seems quite obvious. Do you sometimes feel that you are too fast for the general public? Too far ahead for it to really catch on?

WK No. What has happened in recent years is that you win competitions — Peter Eisenman would still be a theoretician if he hadn't won that competition for the Wexner Center. In the old days, this was done through world fairs. But all that I would need in order to get my ideas out there is this: someone at MoMA or another institution to give me their garden to erect a hydronic structure. It would blossom instantly — it would take less than 30 seconds to disseminate. It would be in the backyard of the rich! [Laughs.] You know, you can't design for the poor. The poor are the most difficult clients you could possibly have, because they will actually criticize what you're doing. [Laughs.] It doesn't work. You give them a nice apartment and they'll put coal in the bathtub — they don't want to buy your program. You can work with the middle class, but it requires a crisis. You know, if one of our reactors blew, Westchester would instantly need a backyard shelter that would protect them from radiation. Now, you can't sell that to the Americans — are you kidding?! But all these houses we're developing here are radiation-proof. Just one inch of water will protect you from direct radiation. But again, you can't sell that to the Americans...

PAdL So how do you sell it to the rich?

WK Well, the rich would put this in their backyard and you would have a martini in it, and you would grow orchids, fresh fruits, exotic things, what not. But someone's got to ask me to do it, and give me the money for it. [Laughs.] But it's not a great deal of money, considering we've spent the last 20, 30 years designing and testing it. But it's never been publicized!

FB Would you label what you're working on "green" architecture?

WK I don't like the word. As a matter of fact, I call it "red architecture," but

then people immediately think of communism. But nature is actually red, it's rejecting green. The only reason you see green is because every other color in nature is being accepted, and green is the one that is being rejected. So the color of nature is the flowers, that's what nature looks like: it's red.

Let me explain a little bit how these houses work. For one, the water from the roof is slowly sucked into the system, but you always want to keep a little bit of water on the roof to maintain the pressure. But, for example, if there's a monsoon, and you're getting tons of water, the water would get sucked into the architecture and could be stored for up to a year. That would solve a lot of problems in India and Indonesia, for example. But that's just one part of what we're doing. Now, what if we begin to grow algae on the roof, and at some stage the algae is then sucked into this center chamber [points at drawing]; and at the same time we provide for a fish tank, which are usually very expensive. So it's a very holistic approach.

FB You compared your design for the Aqua Villa to the designs of Palladio. How important is the element of beauty in your design process?

WK Well, Palladio always began with the façade. The façade is what the overture is to the opera. If you don't like the overture, you won't like the opera. It has to be beautiful. Once you went deeper into these Palladian villas it became increasingly more exciting. It's a fortress, and it was designed as a fortress, and designed to be self-sufficient.

FB So are you saying that your designs for the Aqua Villas are just structure, and the façades could be whatever you wanted?

WK I think once we put the dome of the Aqua Villa up, I won't have to convince you of the façade. It's so beautiful because it's transparent, for one thing, and you're growing algae in it, which could be of any color. So yes, it has to be beautiful, otherwise nobody will want to live in it. No one wants to live in a factory!

BERLIN

FRANCIS KÉRÉ

Interview by Felix Burrichter

To the general public, Francis Kéré is perhaps best known as the architectural sidekick to the late artist Christoph Schlingensief and his "Operndorf für Afrika" project, an opera village in the middle of the savannah, 20 miles outside Ouagadougou, the capital of the small West African country of Burkina Faso. Schlingensief was never a stranger to controversy, especially in the German press, and the opera village inevitably provoked accusations of cultural colonialism. But for those who knew the soft-spoken Kéré, it was obvious that Schlingensief couldn't have found a more suitable collaborator. The eldest son of a village chief in Gando, Burkina Faso, Diébédo Francis Kéré first came to Germany in the late 1980s. After completing his high-school education in Berlin, he set his sights on studying architecture as a means to improving conditions in his native village. In 1999, while still a student at Berlin's Technical University, he returned to Gando to build the village's first ever primary school. From the beginning of his studies Kéré's goal was to work in a way that was locally specific, and the school in Gando was to become the prototype for this approach, taking into account not only readily available materials, but also cultural, social, and logistical conditions. The entire community participated in construction, carrying materials, making bricks, hoisting walls, and pounding floors. The finished building earned Kéré the Aga Khan Award for Architecture in 2004, the same year he received his architecture diploma. Since then, from his office in Berlin-Kreuzberg, Kéré has gone on to complete over a dozen further projects — including schools, housing, libraries, and community centers — in Burkina and neighboring countries such as Togo and Mali. Today, after a position as visiting professor at Harvard Graduate School of Design and with several significant projects in Europe and Asia, it may be tempting to romanticize the 48-year-old's path as a Sub-Saharan-rags-to-Western-riches tale. But Kéré's real success is his versatility in navigating sensitive cultural divides, taking the best of all worlds, and translating it into beautiful architecture.

Felix Burrichter	So how did a Burkinabé boy like you end up in Berlin?

Francis Kéré	There's nothing secretive about it! [Laughs.] It was a scholarship from the Carl Duisberg Society that brought me here. After finishing trade school I went to Ouagadougou to look for work and there was this offer to go to Germany; I applied, and got accepted.

FB Wouldn't most people from French-speaking African countries rather go to France?

FK Normally, yes. And if I'd wanted to study political science or languages, France would have been ideal. But I was a carpenter back then and had discovered that all the tools that came from Germany were good and sturdy. Everything to do with technology, innovation, and durability always meant Germany for us. So for someone working with technology, it was always a fascination.

FB What were your first impressions of Germany?

FK First, there was the flight — it was my first time on a plane and I was completely transfixed the entire time! We went from Ouagadougou to Abidjan, from Abidjan to Lagos, Lagos to London, London to Frankfurt, Frankfurt to Saarbrücken, and from there to Munich. I remember watching how everything was changing, from desert to savannah, slowly going towards the greener areas of Africa on the coast. And also seeing the infrastructure, bridges, highways... my curiosity was insane. But it was also a bit of a shock. It was another continent, another culture, a completely different economic situation — all the hustle and bustle here in Europe. And now I'm part of it!

FB Did you speak any German before you came?

FK Not a single word. But part of the program's requirement was to take six months of language classes, which I did in Munich. The German spoken in Bavaria is very different from elsewhere in Germany, but I thought it was the same everywhere and learned it down pat. And then I arrived in Berlin a few months later, and no one understood me. So I said, "Okay folks, we've got to start all over again!" [Laughs.]

FB Did you start studying right away when you arrived in Berlin?

FK No, not directly. I'd only done a trade school in Ouagadougou and was trained as a carpenter, so I didn't even have a high-school degree when I got here. But I enrolled in night school, and spent five years, every evening from 6:00 to 11:00 p.m., making up the exam. Then I started working, all kinds of different jobs, delivering newspapers from 2:00 to 7:00 a.m. During the day, it was construction jobs for the most part. Eventually it got better, and I found a job in a bookstore. But it was a long, difficult time. Once I'd finished the *Abitur*, I could enroll at university.

FB Had it always been your dream to study architecture?

FK Yes, I wanted to learn how to make more durable houses.

FB In general, or particularly for Burkina?

FK In Burkina. You know, I had to leave my village very early on to go to school because there wasn't one in Gando. It's very common in Africa for young boys to be sent off to live with host families in order to go to school. And these host families — they're often relatives — make you work really hard. Mine made me gather building materials to repair their houses. I was seven years old helping lug this heavy material. It was very hard, and as I grew older the workload only increased. After every rainy period we had to repair the houses again, and I kept saying to myself: "Why do we have to repair these houses every damn year? Can't this be done better?"

FB What were the houses made of?

FK Clay, sometimes mixed with cement. But we didn't know how to mix it properly since no one had the money to hire a trained specialist. They were rare in any case. The other thing was that, in school, we always sat in classrooms with a ceiling no higher than 2 meters — in a country where the temperature in the shade can easily reach 40° Celsius! So I wanted to know how to build houses that were better adapted to the climate and worked better.

FB But the focus of teaching at the Technical University in Berlin isn't exactly clay construction in Africa. How did you make the curriculum work for you?

FK Well, when I began university what I wanted to acquire first and foremost was scientific knowledge — I wanted to know how statics worked, how to calculate, etc. But, actually, you've touched a sore spot with your question, because what happened was that after I'd studied enough and pretty much understood how structural analysis and composition worked, I didn't want to do a final project — I wanted to go back to Burkina and utilize my newly acquired knowledge for my people. I felt that the people here at the university were too hectic and too far removed from the subject matter I was interested in. We were taught to build with glass and steel, and I didn't need that. But I had a very good thesis supervisor, Professor Herrle, who said "No, no, no, I know what you have in mind, and I've seen what you can do. I know you'll make it, just do the final thesis project. You never know. Then you'll have accomplished this part of the journey." So I did it, in less than two months, and immediately after I was hired as an assistant at the university. So it really did help! [Laughs.] But I'd also learned how to find my own method of approach and how to implement it for my goals. For example, during semester breaks, while all the others went on field trips to Versailles or New York, I would do my own research on how to build with clay.

FB In Berlin?

FK Yes. I wanted to see how Berlin is built. In the past, builders used materials from the surrounding areas, so I discovered a brickyard in Glindow, in Brandenburg,

which today is state of the art, but also produces handmade bricks for the reconstruction of old buildings. So I asked whether I could watch, and they showed me the old wells where the bricks are mixed. They had a mixing pole in the middle, turned by animals walking around the perimeter. And that's exactly what interested me, because I could translate it to Africa.

FB You've become known as the architect of Christoph Schlingensief's African Opera Village, which was also featured as part of Schlingensief's installation at the 2011 Venice Architecture Biennale, for which he posthumously won the Golden Lion. How did the two of you meet?

FK It was actually the Goethe Institut that brought us together. I was in South Africa speaking at a workshop, and they already knew Christoph because he'd been to South Africa many times before. So when I was there, everyone told me, "Man, you've got to meet Christoph Schlingensief, he's an artist and he wants to build an opera house in Africa."

FB Did you already know his work at that point?

FK No. I knew he was an artist, but that was it.

FB You hadn't been to see any of his Wagner productions in Bayreuth?

FK [Laughs.] No.

FB How did the two of you start working together?

FK We actually met in Berlin. At that point I already had construction experience in Burkina. He was very interested in it and went to visit my projects there, like the school in Gando. Christoph had a really specific idea of what the project would be, and we worked in a process of mutual acceptance and adaptation. I was the one who'd always tried to build schools, to achieve bigger things to help the development of the area, and I think that also helped him to progress his vision.

FB How did you decide on the location?

FK Christoph was extremely fascinated by Richard Wagner and by Bayreuth, by this idea of creating a festival hall on a green hill, even if he turned it into the complete opposite of Bayreuth, which is very bourgeois. But finding a place that would accommodate his ideas wasn't easy. We looked everywhere — in the country, in the city — and then one day we found this location in Laongo, about a 40-minute drive east of Ouagadougou, and Christoph said: "This is the place." You've also got to remember that he was terminally ill during all of this — many people forget this fact. Even to this day, it is not easy for me to talk about. And he knew he was dying — eventually he knew it for sure. But he also wanted to see it built before he died.

FB How much has been completed now?

FK The main festival hall isn't finished yet, but there are many, many things that are there already — residences for teachers, a school, a recording studio...

FB And everything is built of clay?

FK Partially. We also took the liberty of using other materials that hadn't been seriously considered in Burkina, like eucalyptus wood, which we used for the roofs. Eucalyptus is an invasive species and usually people just cut it down to make kindling. But I thought, "Why not give it another use?" So we developed modules that demonstrate different variations, so that people there can take over when we're done. I think that was also part of Christoph's way of appropriating Beuys's "social sculpture." I thought it was exciting how the ideas of an artist could be transferred to architecture. Christoph was also always talking about growth, so I wanted to express growth architecturally, which is how we came up with the shape of the snail for the main festival hall — a symbol of slow growth.

FB The German press was quite critical, one of their main complaints being that it was a form of cultural colonialism, as if the idea was to bring German opera to Africa.

FK Christoph wanted to bring opera back to the people, not just the upper 10,000. But, to transfer the concept all in one piece to Africa would of course open the door to criticism, and he always said it wasn't his goal. But, the criticism was also to be expected — Christoph always took a lashing for his projects. But at the same time, there was a fascination with the audacity that it took to say, "We don't need to give only food to starving people. They also need culture and art." That's what Christoph wanted to do. And the reactions in Burkina were really enthusiastic — the opposite of those in Germany. But the press has every right to criticize because it was a sensitive project, especially since it came from Germany, given the country's past. And, after all, the project was partially paid for with German public funds from the Kulturstiftung des Bundes and the foreign ministry.

FB But that's probably peanuts compared with the kind of money China is investing in Africa, no?

FK Well, Burkina has the wrong partner.

FB How's that?

FK Because Burkina is with Taiwan. [Laughs.] But China's economic power is present everywhere in Africa. Its products are cheap and cheaply made, and people buy them because they can't afford anything better. There are two sides to this coin: development and cooperation are happening more with Taiwan, because, of course, they are trying to compete with their big brother; but, China is the one that's making the really big things happen.

FB Is there any palpable cultural influence?

FK No, it's not that simple. I think the level of education and economics in Taiwan is close to, if not equal to, that of many European countries. And Burkina, with an over-80-percent illiteracy rate, is still at the beginning of its economic growth. But they are helping build up infrastructure, like streets

and big projects that the country can't manage on its own. But it's not like there are now so many Taiwanese in Burkina that everyone is eating with chopsticks. The influence of Bollywood is much bigger, for example, even though India doesn't have a big presence in Burkina. Taiwan and China have an easy time in Africa compared to most European countries. They see Africa as a big market. It supports and establishes trade, and that's what most African countries want. And unlike Germany or France, China doesn't care if the countries are run by dictators, or if human rights are respected.

FB And China also builds big streets, and stadiums...

FK Yes, massive things. And the West sometimes seems to think that people in Africa don't need these facilities. But streets are important so that a country can develop — and they cost money! Therefore, you need to watch out and not judge China so quickly. There are economic interests, but the West is looking after its economic interests as well.

FB You said earlier that your goal in studying abroad was to bring the know-how back to Burkina and to utilize simple, local resources. But now you've started working on projects outside Africa — for example, in China with Wang Shu, or in Geneva, where you're building the International Red Cross and Red Crescent Museum — does it require a whole new architectural approach? Or are you using the same kind of bricks in Geneva as in Gando?

FK What I always do is look at the location and see what's available. Burkina is a poor country lacking in know-how: that means the simplest, cheapest thing available is dirt. Geneva is located in one of the richest countries on the planet: economically and technologically, Switzerland is highly developed, if not the most developed. So I found myself in a situation that couldn't be more radically different. So we said, "OK, let's see what local elements we can use that we can find here in Switzerland." We chose to work with earth because of the museum's subject matter, which is about reconstitution of familial connections after a rupture through war or persecution under dictatorships. Earth is always the ground that we return to, so that's what the material was meant to symbolize. And so we decided to work with rammed earth as a building material.

FB Rammed earth?

FK Yes. You need specialists for it, and good molds, otherwise it won't work. But Switzerland is not Burkina Faso, and there is the money to afford it. So we went around to see if there were examples already, and we found one, a villa in Geneva, not even five years old. Everyone was excited. But when we started making the calculations we realized that a house made of rammed earth is far more expensive than one made of concrete! But we really wanted to use earth as a building material so we kept searching. And we discovered hempcrete. It's a new material that's still in development. It's like earth and is made locally, by Swiss workers who were really excited about it, and it's ecologically and technologically reasonable.

FB So how long before you'll be building a hempcrete house in Berlin?

FK Nothing concrete yet, but something will get made. There were some requests, but you need to make sure that you can divide up your time without overheating. It's not just about the number of projects — I'd rather let a structure ripen from which I can make things that I'll still like in the future. I think we're in good shape with our approach and, when the opportunity arises, I'll be there.

FB Were you never tempted to build your own house?

FK We're quite happy where we are, in our classic Berlin apartment building in Kreuzberg, a ten-minute walk from my office. They're adding more floors to the building now, so we're moving one floor below. I did think perhaps I should use this as a chance to move somewhere else, but it's so nice and calm here.

FB So how come you're not building the extension yourself?

FK Because the owner wouldn't be able to afford it! [Laughs.] If they'd asked me, I would have said: "Okay, forget about all these things that we're used to. Let's demolish everything and try something completely new."

LONDON

DAVID KOHN

Interview by Caroline Roux

David Kohn is a tall and rather good-looking redhead — one of a new breed of architects who hide their geekiness well beneath a suave exterior and excellent communication skills. I met him at Burlington House, home of the Royal Academy, where Kohn created FLASH, a temporary restaurant for former fashion designer Pablo Flack and business partner David Waddington, the boys from Bistrotheque, East London's most fashion-forward eatery. It's early evening and the restaurant is buzzing with all the right people: V&A curators, *Vogue* staffers, brand wranglers, gallery owners and their artists, dippily clad stylists and fashionistas. It's very un-London, this obsessive clan gathering, much more New York. Amid all this buzz, Kohn is having his portrait taken. In fancy clothes. Normally reserved, he is clearly enjoying his own fashion show.

Caroline Roux	So what's that you're wearing, David?

David Kohn	This is a brown-silk trench coat by Yves Saint Laurent. Isn't it great? And these trousers — I wouldn't have picked them out, but I love them. I usually wear something baggier.

Kohn runs off to change. A serious architect doing looks! He returns in a turquoise, sharply fitted, 70s-style linen Tom Ford jacket, complete with heavily machined large lapels and glaring white buttons. He's mightily pleased with himself in this pimpish jacket, grinning from ear to ear.

DK I'd never think to wear anything by Tom Ford, but it does sort of work. The Yves Saint Laurent felt smart and sophisticated, though. There was so much fabric in the coat, it looked eccentric lying on the table, and I wouldn't have thought it would look good. Did it look good? It felt great!

CR It looked as great as it felt. And FLASH, does it look as great as it feels? Are you happy with the results?

DK For me it was a test of how to work with different people and bring together all the different parts: the illustrations by Will Broome, a carpet by textile designer Rory Crichton, the paintings by Simon Popper and Alexis Teplin, and the massive Swarovski chandelier designed by Giles Deacon. You can't work with that many people and be totally ideologically consistent. For me, working on FLASH with all these other creative minds was actually a steep learning curve. They had ideas; I had to be flexible.

CR How did you get involved in FLASH in the first place?

DK Last year I decided to look at restaurant design with the students at London Metropolitan University, where I teach. So I invited Pablo from Bistrotheque to be a critic. We put together a publication of essays written on restaurant design, from Marinetti's "Manifesto of Futurist Cooking" to a Flaubert piece describing a meal in *Madame Bovary,* and a Baudrillard essay about the social critique of judgment. We also went to Vienna with the students to visit all these iconic restaurants. Hermann Czech, one of Europe's most academically serious architects, came with us — he's amazing. He's able to theorize the relationship with the client, and was always pointing out that designing restaurants is about the identity of the restaurateur. The role of the architect is simply to create a background, a stage on which the restaurant business is played out.

CR Creating FLASH must have been a gift after all that research.

DK Well, the room we were given for FLASH presented a lot of opportunities but at the same time it felt very flabby. It's too wide for its height, because it used to be twice as high. On the plus side, it had these beautiful cast-iron columns and a series of very high windows along one wall. What I'd picked

up from all those Hermann Czech lectures and all those Austrian cafés was that you should have an idea for everything — everything you touch and see, from the overall space to an idea for the spacing between the tables. I found that really reassuring.

Multiple outfits later, we realize it's late and we've missed an opening for Jonathan Meese at Stuart Shave's Modern Art gallery on Eastcastle Street. Kohn designed the gallery in 2008, after Adam Caruso and Peter St. John, for whom he previously worked, turned down the project as too small. A few days later we meet again at David's house, where he lives with his Milanese girlfriend, Margherita, who is studying for a Ph.D. in theater at Queen Mary, University of London.

CR I noticed you seem quite preoccupied with the idea of plurality, or at least against the single idea.

DK I have this lecture coming up, "The Hedgehog and the Fox." The title is from an essay that Isaiah Berlin wrote in 1953. The thesis is — he's talking about writers — that the world is divided between hedgehogs and foxes. The image of the hedgehog and the fox is from a Greek poem by Archilochus, and it says that despite the fox's cunning, the hedgehog always survives by its one defense, which is to roll up into a ball. He sees this all the way through history: there are individuals who always need to see every idea as related to a single dominant idea, and every practice as related to a single dominant practice. Dante was a hedgehog, Shakespeare was a fox. Plato, Pascal, Hegel, Nietzsche were in varying degrees hedgehogs; Aristotle, Goethe, Pushkin, Joyce were foxes. And I don't think he's saying one is right and one is wrong, though I'm curious about the usefulness of his theory for design, in promoting the idea that perhaps more architects would benefit from thinking in a more plural way and less defensively about ideas.

CR You worked for four years at Caruso St. John, architects who are known for strongly conceived and practiced ideas. Think of their famous brick house, for example.

DK Yes, except the projects I worked on with them were their most fox-like projects. Well, Gagosian [the London gallery in Kings Cross, completed in 2004] was very hedgehog. There was something very singular about that project, and of course we were working with Larry Gagosian. But then there was the Museum of Childhood [Bethnal Green, London, completed in 2006], and there are a dozen ideas that come to ground in that design, and when people go there I really think they ask: how did this get to be with this? I mean, it works, but why?

CR Which bit of the museum do people question most?

DK The most provocative part is the entrance and its relationship with the façade — it's highly decorative. The red-stone frame in the façade is in-filled with both flush glazing and a perspectival pattern of stone cubes. This suggested

that the entrance building was like a portico standing in the garden with real and imaginary depth, in the manner of Pompeian wall paintings. I get such pleasure, not out of confusing people, but from the possibility that it's pulling at many interpretations, that it's refusing to be just one thing. I enjoy many things and the possibility of many architectures being relevant, so I enjoy architects who think the same way. I've grown up with architects who really sneer at the idea of an architect designing furniture, for example. But there are different ideas to apply at different scales. We don't treat rooms the way we treat sofas. The whole idea that an interior only works with its own bespoke furniture is wrong. Looking at a lot of minimalist work I feel a kind of, "Wouldn't it be nice if you had interiors that invited furnishing?"

CR So who's the foxiest architect?

DK I really like Piero Portaluppi. I recently visited the Villa Campiglio in Milan and I was amazed. Portaluppi was interested in Frank Lloyd Wright and Arts and Crafts and more. The house exudes such a rich character, with different atmospheres created in each part, extraordinary detailing across every conceivable material: timber, metal, stone, concrete, glass. The winter garden has bronze framed sliding windows, a trellis-like *brise-soleil* in timber with copper copings; perforated brass-clad sliding doors between each room; hardwood door reveals, terrazzo and marble floors. Yet despite all of these different materials and skills, the atmosphere is one of warmth, good humor, comfort, conviviality. And I'm interested in this without cynicism. If the eclectic design process is shown to be ironic, that's a form of defense against possible criticism.

CR How does that fit in with what's happening in London now?

DK It's very rare to see new building in London other than commercial architecture. It's a 19th-century city that we're continually repairing. But in the future there'll be more theory around reuse and we'll become less preoccupied with whether things are new or not. But I'd love to work abroad for a host of reasons. I've done lots of competitions in Norway, and I think it would be interesting to work in Italy and the U.S. I lived in New York and studied at Columbia for a year. It was 1995–96, and I remember being really frustrated because Columbia was going through the beginning of its digital phase. They had paperless studios. There was no model making, no sketching. I'd come from Cambridge, on a Fulbright exchange, and I was being told to wipe the slate clean. The forms that could come out of this software fascinated everyone but I found it completely depressing; and it was all without material! It would be something seamless and incredible that could work at any scale. Okay, but how do you build it? I felt that there was very little space for a discussion about the social, political, and cultural implications.

CR So if Columbia was a disappointment, what about New York?

DK New York was fantastic. I lived for half the year on Riverside Drive, up near Harlem, and for the other half on Renwick Street, off Canal Street by

the Westside Highway — it was incredible. There were four of us and you could do anything there. There were loads of small clubs and bars then, they'd spring up every month. Avenue A was as far as exciting New York life went. It's funny to think you can walk to the end of Alphabet City and find a nice restaurant. Then you'd walk to the end of Eighth Avenue, and it felt like the edge of something. People were opportunistic and it felt very free. Cambridge was very dull after that.

CR After working for Caruso St. John, your first independent project was Stuart Shave's gallery, completed in 2008. Now you're designing a house for him in Norfolk. Stuart has described himself to me as a "hobbyist architecture enthusiast," but I have a feeling he's more entrenched than that. For a start, he invests in great design — he has a beautiful Jeanneret desk from Chandigarh in his gallery office.

DK He's become almost obsessive. He knows all the new architecture-blog sites. He sees these commissions as opportunities to find out about things and enjoy them. The more divorced an end-user is, the more the architect has to create that dialogue artificially. You can end up with a responsibility to someone you'll never meet. But Stuart's involvement has also meant that his taste has changed a lot. I saw him this morning and he freely admits that he's moved from a rather minimalist position to a more eclectic architecture. At the beginning I'd show him things like Lina Bo Bardi's houses, where it's all about background and landscape, and he was talking about John Pawson. Originally half the house had a patented super-expensive Swiss glazing system. But gradually it softened and, two years on, we have a Crittall system [a homegrown system, designed in the 1930s and still popular in British domestic and light-industrial architecture]; so the building is now referencing different technologies from different periods and playing with ideas of domesticity. Half the house was a huge void before — Stuart wanted this long concrete bench and an island kitchen; everything was objectified. Now there are two brick volumes, all exposed and painted white. The living room is still huge, but smaller than it used to be. The architecture is about the things happening in it, the animation of people, furniture, and art.

CR Do you own any art?

DK I have one piece of art: it's a drawing by Ernesto Cavallano, which I bought with Margherita. He's a New York–based artist and I'd been following his work for a while and waiting for a piece to come onto the market. I appreciate the craft of it; it has a heavily illusionist quality; it's figurative and abstract and moves between the two in a way I find compelling. The series comes from a love story about this couple who meet and are torn apart, and she turns into a space ship and he turns into a tree. It's a bizarre story.

CR Did Stuart advise you on buying it?

DK Err, he actually doesn't really know about it. I got it from White Cube...

BERLIN

HANS KOLLHOFF

Interview by Carson Chan

Hans Kollhoff may well be Berlin's most reactionary architect, a badge the 66-year-old wears with pride. His resolute historicism and trademark aspersions on Modernism have earned him the enmity of other architects and the German press alike. His teaching colleagues at ETH Zürich were naturally suspicious of his retro ethos: at best they thought his studios on Classical architecture frontloaded young minds with irrelevant and outmoded design ideas; at worst he was an agent of regression, perniciously undoing all the progress in architectural form and function brought about by a century of development. And indeed at last year's Venice Biennale, Kollhoff showed off his former students' traditional designs as if to herald a new era of Classical restraint and harmony that he and his recruits will usher upon the world.

All this may seem surprising from a former classmate and colleague of Rem Koolhaas's, but for all their reactionary posturing and dignified sobriety, Kollhoff's Classical designs are less about nostalgia than they are a humanist attempt to recuperate and project a rich cultural heritage into an ambiguous, showy, and shoddily constructed present. And the historical image of the city Kollhoff fabricates is more influenced by collective imagination than first-hand experience. Among contemporary buildings, Kollhoff's architecture stands out for its concreteness and adamant claim to permanence — the most solid construction possible today, by his own admission — even as the buildings themselves tend to blend into the background of the city. Together with his partner of 29 years, Helga Timmermann, Kollhoff has become the poster boy for critical reconstruction in Berlin and is responsible for some of the city's most definitive post-reunification urban projects, including the eponymous Kollhoff Tower (1999) at Potsdamer Platz, the master planning of Alexanderplatz, and the anticipated reconstruction of Karl Friedrich Schinkel's Bauakademie (first realized in 1832–36). PIN–UP sat down with Kollhoff, asking him to account for his singular and controversial position, take stock of his Modernist past, and prepare us for what the future world of the past might look like.

Carson Chan	In 1973, after studying with Egon Eiermann at the University of Karlsruhe, you went to Cornell University to study architecture with Oswald Mathias Ungers. You returned to Berlin in 1979 and started an office together with Arthur Ovaska, who also studied and worked with Ungers. Designs the two of you produced together at the time would be considered very much within the language of Modern architecture. Then, in 1989, the year the Berlin Wall fell, and the year you and Ovaska went separate ways, your designs took a markedly more Classical or historicist turn. Why?
Hans Kollhoff	Arthur and I had our office in West Berlin, which was really the periphery of pre-Wall Berlin's historic center. Being there was exciting: we felt we could do whatever we wanted, and we really experimented with modern forms. The destructive powers of war had left pieces of buildings standing in the vast landscape. It was thrilling, like finding pyramids in the forest! This changed after 1989. You have to remember that at Cornell, Arthur and I were not only taught by Ungers but also by Colin Rowe. Rowe's view was that as architects we would be able to urbanistically reconcile history with modern convictions in architecture. When Berlin reunified, I found myself no longer operating on the periphery, and the problem became one of dealing with a city's historic center. Projects like Friedrichstraße 119 [1999], or the Alexanderplatz and Potsdamer Platz projects were for the center of the city. If you've seen Wim Wenders's *Der Himmel über Berlin* [English title, *Wings of Desire*], you'll remember seeing Potsdamer Platz as this no-man's-land and the actor Bernhard Minetti asking, "Where did Potsdamer Platz disappear to?" One was tasked with designing the center of a completely destroyed city
CC	Some would argue that building on a no-man's-land or tabula rasa would afford the architect a greater degree of freedom. In a sense, you could have designed whatever you wanted without the physical control of the past — you had the opportunity to define a new era for Berlin. What was the reason behind making historic-looking buildings?
HK	I'm not interested in designing historic-looking buildings, I just want to pick up the thread of tradition in architecture and urbanism and develop it further. To the superficial eye that might look historicist. In some ways my work is a reaction to the various attempts of architects and planners to erase even the structures which the war had left in order to build *cités radieuses* like the Hansaviertel or the Märkisches Viertel or even the housing mega-structures in East Berlin, all of them nightmares to live in. The notion of what a city should be was lost: society was drifting through open space, among ruins and plants. Instead of having another "vision" of this kind I decided at some point to continue building according to principles that brought our beautiful European cities about.

CC So you wanted to reverse this trend by designing in historic styles?

HK Again, I don't care about historic styles. The city is related to society, and not just today's society, but also the societies of the past who built those cities, houses, and spaces. A city is not the product of individual invention; it is the architect's task to treat what has been inherited with respect, to develop it further. We don't need to start designing every Monday from scratch.

CC It is one thing to advocate for architects not to be divas and not overly impose themselves onto the city, but does that necessitate reconstructing entire cities, like Dresden or Warsaw, which were both heavily bombed during World War II? To the casual observer today, they both look as if they were untouched. The first time I visited Warsaw, I had no idea the Gothic and Renaissance old town center was completely reconstructed in the 1970s and 80s, based on paintings by Canaletto. The historical fact that 90 percent of the old town was destroyed has been erased. Walking through it, there is a sense of old Europe, but the moment you walk into one of the buildings you realize it's all modern concrete construction.

HK I understand the confusion between rebuilding versus the design and construction of new buildings is a problem, but we have to consider both as options for what we can do today. I don't differentiate between architects that reconstruct destroyed buildings and those who design new ones — both are authentic. For Inigo Jones, Palladio was the best architect in the world; that Jones designed Palladian buildings was a very new idea in 17th-century England. Similarly, when Palladio uncovered Roman ruins and decided to adhere to Vitruvian laws of Classical architecture, this was breathtakingly new in the mid-16th century Veneto. If you take a critical look at the last 100 years of modern architecture, you cannot avoid realizing that there has been a decay of the urban coherence, and a tremendous decay of architectural thought and practice. The building we're in now — my studio — is a renovation of a 200-year-old building and it's far superior to most buildings constructed today. Why did we renovate it and not raze it? Because it was built to a very high standard, there is a refinement to its proportions, and it stands for a long tradition of craftsmanship and local heritage. It's from a time when architects didn't only think about individual design. I have a sense of well-being when I see this building among other prewar buildings on this street. Our societies, all over Europe and North America, are demanding historic reconstruction. Why? Because they hate a lot of things we architects today believe in and impose on them.

CC Respecting history and tradition is great, but I'm wary that we've become selective of the history we want to address. Many people in Berlin grew up in the GDR, in socialist housing and Soviet-style urban spaces. For them, Soviet Modernism is what their heritage, their homes, look like.

HK Well, I think most East Germans miss their prefabricated social housing not because they think it was beautiful, but because it was cheap. If you

ask them what environment they prefer, I'm sure they will tell you they like traditional architecture more. Most of them would like to live in Prenzlauer Berg, if they could afford it. And Prenzlauer Berg was a 19th-century speculative housing development, nothing special at all.

CC I'm not talking about the price of rent, I'm saying that Modern architecture has become, for many, more familiar than Classical forms. The argument that reconstruction of buildings that used to exist will give people a connection to the past only holds up if people have grown up with those buildings. There are generations that have grown up with no living memory of buildings destroyed in World War II. In Berlin, the Baroque Stadtschloss that will be reconstructed is more alien to many than the Soviet-era Palast der Republik, which was built on the site of the Schloss and demolished just four years ago.

HK Yes, but the polls show that people in Berlin want the old city back. They have never seen it, their parents have never seen it, then why would they want it back? As Aldo Rossi explained, the city and its architecture is not just what's physically there, now or historically, it is also the image we memorize of it — an image communicated through film, literature, music, or pictures. Young people like the image of old Berlin. But let me be clear: if we were better architects today, then people wouldn't be asking for the past. What we're doing today is to a large extent miserable, especially some of the things PIN–UP publishes, like the architect you interviewed for the Berlin issue.

CC Are you referring to Jürgen Mayer H.?

KH Yes. I've recently been to Seville and I saw that building he did there. I tell you, in 15 years that building will be gone. It will collapse and nobody will even have the money to dispose of it. Have you been to Seville?

CC I haven't, no.

HK When you go there, you will see Jürgen Mayer H.'s building and think about the sad story of an old city and of a proud society called Seville, that today feels it needs something like that to tell tourists or investors, "Look, we're still here!"

CC Yes, that seems to be the message.

HK It's a sad, sad story.

CC It's called the Bilbao effect.

HK Yes, and Frank Gehry's Guggenheim Museum in Bilbao is even worse. More accurately, you can call it the Guggenheim effect: the whole idea of architecture as a P.R. instrument started with Frank Lloyd Wright's Guggenheim in New York. By definition, P.R. solutions, unlike buildings, only need to work for a short time.

CC But we shouldn't forget that many Classical or traditional buildings were made for P.R. reasons, too.

HK Yes, but they were made primarily for some other reason than P.R.

CC What about the monument to Vittorio Emanuele II in Rome? It was designed in the 1880s to "P.R." a unified Italy, but urbanistically it sucks.

HK Yeah, well, it's not my favorite building either.

CC But is it so bad that some buildings are designed specifically to draw attention to themselves and to the contexts they operate in? In general, I find that people have opinions about music, they have favorite movies and books, but they don't think about architecture all that deeply.

HK Really? I think the public thinks about architecture too much! Building as P.R. spectacle works in capitalist societies that are based on mass consumption. It all has to do with selling something — selling magazines, shoes, chairs. Zaha Hadid designed a building for Vitra not because the furniture maker really needed a new building; they wanted her to design an image that will travel around the world, and with this image, Vitra can sell more chairs. For me, this has very little to do with architecture. Wealthy people in the past commissioned architects to show off their wealth, this was P.R., but it was one reason among others and usually not the most important one. Today, image-making has become the dominant aspect for what we call architecture. This changes our cities into shopping and entertainment centers. It seems life is nothing but buying and selling.

CC To antagonize you some more: what if some of today's architectural P.R. strategies became tomorrow's vernacular?

HK You're kidding! They won't even exist in 20 years. They'll be in the garbage dump before they can stimulate any memories.

CC But you yourself have quoted directly from historical buildings that were built as P.R. projects: the Tribune Tower in Chicago and the American Radiator Building in New York [both by Raymond Hood and John Mead Howells, 1925 and 1924 respectively] reappear in Main Plaza [2001], a high-rise in Frankfurt. There was huge controversy when Howells and Hood unveiled their neo-Gothic design for the Tribune Tower — it was kind of a scandal in its day!

HK But look at how it's built: it's a serious building. Go there and knock on it — it's solid, it's the thing itself, not just the image of something else. Most architects today build images that collapse before their first renovation. The Tribune Tower is a fantastic building that will stand forever like the Egyptian pyramids. But most of the buildings which have been constructed during the past 50 years will decay in the timespan of one generation. Concrete crumbling, steel frames rusted, aluminum windows falling apart, Styrofoam covered with a plastic skin instead of a solid stuccoed wall, silicon in every joint and corner. Disgusting. You cannot neglect how things are made,

regardless of how they might appear from a distance. That's the difference between architecture and stage design. How we treat architecture and the city today is symptomatic of a society that is not even able to preserve its heritage and that seeks design strategies to counteract individual sadness. It's like buying Gucci to feel better.

CC What you mean is that instead of healing society, architects today contribute to the cosmetic cover-up of its problems?

HK Yes. And that's why people like you go to Bilbao, in order to proudly tell their friends they've seen Bilbao.

CC Have you been to Bilbao?

HK I haven't, no. I won't go there. I can see in the pictures what it is.

CC Something that has often fascinated me in your work and teaching is the notion of tectonic mastery, or the idea that there is a fundamental relationship between the human body's movements and proportions and the form and material of buildings. Walking through your Walter-Benjamin-Platz project in Berlin [1995–2001], one gets a sense that the phenomenological experience of architecture and public space is something you thoroughly consider. How do you teach your students this sensibility towards the body and space?

HK Well, to answer your question, we first have to ask, "What is architecture?" With today's technology, we can build almost anything we can imagine, but if the idea is to build architecture and not just an interesting object we need to consider some fundamental issues. Architecture, first of all, is not art in the sense that the individual genius simply imagines something. Architecture essentially is concerned with providing a home for the individual and simultaneously with establishing the public realm. There is a tension between the individual and the community that calls for expression, above all in the façade of a building. The façade tells you something about the owner of the house and his relationship towards society. You must take into account how the house relates to other houses next to it and across the street. This is how cities are made, and I love cities. I love the European city. That's why I became rather egoistic in judging modern urban developments. I don't feel comfortable there. I feel well in beautiful landscapes that architects haven't messed up and in parts of the city where there is a sense of permanence, of refinement from generation to generation over hundreds of years. I know that many people feel the way I do, and it is for those people that I design buildings. I try my best, and I'm glad you like Walter-Benjamin-Platz, but if I had built it a 100 years ago it would have been much more solid and more refined as well.

CC I knocked on the columns and they seemed pretty solid!

HK Yes, as solid as they can be today. Ideally we would have preferred natural stone.

CC Speaking of the columns, I noticed that they were very similar to the ones you used for the office building you designed in Maastricht [De Colonel, 2001]. You speak about being sensitive to the specificity of location, but one often finds very similar forms in many of your projects. Is there a more general European identity that you are referring to? There is a certain lamp you use in almost all your arcades and colonnades. How did this design come about?

HK It's a lamp that doesn't want to be more than just a lamp; it's a generic lamp that people know from many different places, and if you find a good lamp, there is no need to design a new one. I also love chandeliers. A chandelier is about light and atmosphere created by light, and I don't know anything better than a Venetian chandelier. We have all sorts of lighting designers and magazines devoted to artificial light and lighting design. I've been looking through them for years and nothing I've seen comes close to the quality of a good Murano chandelier and the light it gives. Maybe Bohemian chandeliers come close, but there are just these two.

CC How about the columns?

HK The columns at Walter-Benjamin-Platz came about because we needed two colonnades to flank the public space. The buildings kept growing during design, and the space in between kept getting narrower, so we carved out colonnades to make the public space wider. You need certain proportions between the buildings and the surface in between to make it feel like a public square and not a wide street. You don't find colonnades in Modern architecture, though colonnades are an important element in urban architecture. They are more than just covered walkways: they are about the proportion, the relationship of the column to the width of the walkway, to the spacing of the columns themselves, and above all between the column and your body. That's it, that's architecture!

CC You once described how simple architectural gestures can communicate ideas. Are there limits to what buildings can express?

HK There are no limits.

CC Can you express hope through a building? Fear?

HK Of course you can — you can express everything! Until the advent of Modern architecture in the 1920s, architects used an established set of tectonic elements that were developed during the tradition of architecture. They didn't simply belong to styles as Le Corbusier wanted us to believe. You could play endlessly with these architectural elements, you could combine them, play with their proportions, treat them sculpturally, and transform them into ornaments — but always within a tectonic logic. There was no tolerance for fooling around. Schinkel wrote manuals for architects and craftsmen, explaining how to make a building brutal, light, cheerful etc. He called it morphology. Working with Mathias Ungers, I learned what morphology is all about. Ungers, in the end, was more interested in abstract

things — boxes and squares. Like many of his generation he didn't succeed in escaping the prison of Modernist beliefs.

CC Boxes and squares can express things too.

HK Yes, of course, but after a certain time it becomes a little boring. You find yourself trapped in a cage of squares.

CC Communicating complex ideas through form is a tricky thing. What would you say Frank Gehry was trying to express through those curves at the Guggenheim in Bilbao? Or take Daniel Libeskind's design for the Jewish Museum in Berlin: there is an unheated, unlit, full-height room with a little window in the top corner; it was supposed to express hope, but apparently many people saw desperation.

HK Libeskind is not serious, the room simply is not communicating what the sign wants you to understand. Architecture is a language in its own right. Whenever there is a sign, something is wrong architecturally. Libeskind puts up these signs like, "This signifies hope," without even a hint of irony. Frank Gehry, on the other hand, develops the architectural form with what at Cornell has been called trash models. Basically, it's about gluing bits of cardboard and paper together with wires and all kinds of other things to achieve an interesting object — architecture through bricolage. I like that very much. In that sense I admire Frank Gehry's work, even if it might be the opposite of what I'm interested in.

CC As an artist? I thought you didn't like Bilbao.

HK Also as an architect, as long as space and function are a coherent whole. This is where Bilbao seems to fail, like Frank Lloyd Wright's Guggenheim in New York. If you make a museum space for paintings, you cannot suggest a curved wall. Gehry seems to have accepted too many compromises in Bilbao. He makes boxes wrapped in curved shapes. This is where I start to criticize.

CC You and Rem Koolhaas were both Ungers's students at Cornell, but you took very different paths afterwards. In a way, Koolhaas seems to have continued on the path that Ungers paved out; his Dutch Embassy in Berlin, for example, is very much about fitting into an urban context and about situating the building through sight lines. These are lessons from Ungers.

HK Rem and I had different interests. He was always more into the scenographic aspect of architecture, organizing program as if it were a movie, thematically, visually. I became more interested in the physical aspect of architecture and how it performs in the city. I see the Dutch Embassy and I ask myself, "Why doesn't this building have a façade? Why are people forced to circulate through it, every day, in such a dramatic way?" Somebody who works there is probably getting bored and annoyed with this path that takes you around and around. Why not make a normal corridor as architects have done since ancient Egypt?

CC Pretend you are Rem. How would you defend yourself against Hans Kollhoff?

HK [Laughs.] I understand Rem very well. I know what he's up to and what is driving him. There are some moments when he reflects on what he's doing in a curious, unpredictable, and stimulating way. There were periods when he wasn't happy with the quality of construction, and there are periods when he wasn't very happy with how society ignores the kind of architecture that he stands for. The same also happens to me. I sometimes think, "Why is this society so stupid to spend vast amounts of money on crap?"

CC We've spoken a lot about the past. What is the architecture of the future for Hans Kollhoff?

HK The architecture of the future is the architecture of the future — I hesitate to become overly optimistic. But I can tell you one thing: if you care about the future, and your children's future, you won't continue inventing strange images.

VENICE

REM
KOOLHAAS

Interview by Francesco Vezzoli

In the world of architecture, Rem Koolhaas is as close as there is to a household name. Since co-founding the architecture firm OMA, in 1975 the former scriptwriter and journalist has left his mark on virtually every aspect of architectural discourse. His books and research tomes are staples at architecture schools around the world, and OMA's designs have repeatedly challenged established architectural archetypes. Sharp-witted and possessed of an almost encyclopedic knowledge, he is in high demand as a speaker, drawing crowds more akin to those of rock concerts than university lectures. So who better to go *mano a mano* with architecture's rebel superstar than Francesco Vezzoli, the 40-something Italian artist who has extensively investigated the world's collective (and his very personal) fascination with celebrity, in all sorts of media, including film, painting, photography, and even needlepoint. Vezzoli and Koolhaas have known each other for years, sharing close mutual friends in the fashion designer Miuccia Prada and the late Herbert Muschamp, architecture critic of *The New York Times*. But it wasn't until PIN–UP invited them for an early morning breakfast in Venice that they found time to have a more personal one-on-one. On a quiet terrace overlooking the Grand Canal, Koolhaas and Vezzoli took a break from the hustle and bustle of the Art Biennale to talk about the nature of friendship, different layers of judgment, and the importance of passing on knowledge to new generations.

Francesco Vezzoli	**Herbert would have loved to know we're having this conversation in Venice. It was his favorite place.**
Rem Koolhaas	**However, the city is very different now from when Herbert was here...**

FV Yes, but he would have loved anything that put Venice back on the map. I guess Venice was his idea of multiculturalism. Like at the moment, during the Biennale.

RK Our relationship was complicated: since he was a critic and I'm an architect, our friendship was never official, it was always something in between. Instead, you had a kind of more complete friendship with him.

FV It's true. But Herbert had a larger-than-life personality. I always feared and suffered his intellectual judgment. Had he disapproved of somebody I'd had dinner with, he wouldn't have talked to me for two or three months...

RK Have you always been attracted by these extreme personalities?

FV I guess so. I think it comes from my childhood. All my parents' friends were serious academics and professors and, at their own small provincial scale, they never took my creativity as a child seriously at first, and then my teenage desires of escaping and finding my own way.

RK So you were looking for new parents who would approve of you?

FV Yes, I think that created in me the need to seduce and conquer the complicity of people who belong to older generations.

RK Is it the same now or has it changed over the years?

FV Recently, I must admit I am exhausting this kind of desire. I'm starting to feel that I have already met all the important people of the older generations who were really significant for my range of ambitions. I've collaborated with great thinkers like Gore Vidal, the most glamorous icons of the past like Helmut Berger and Marisa Berenson, the most renowned movie directors like Lina Wertmüller and Roman Polanski...

RK Is there someone you haven't met yet?

FV Actually, I've never had the occasion to know Pedro Almodóvar, who is probably my favorite living director. But I don't want to spoil the pleasure of watching his movies with innocent eyes.

RK What is your relationship with younger generations?

FV Well, recently I've made a point of only hanging out with people who are at least ten to 15 years younger than me. In a way, I learnt this from Herbert as well. And I guess he got that from a wide range of people from his past, like Andy Warhol or Diana Vreeland.

RK There is one thing in which my and Herbert's generation was very lucky:

we've never been obsessed with what people thought of us. We didn't feel that anyone was judging us like our parents. We didn't live our youth with that kind of pressure, fearing the parental judgment.

FV Is it because you are the generation that for the first time went either politely, or aggressively, against the rules of your fathers?

RK From my experience, it was just because I was very independent from the beginning. But for my generation, it probably came from before. We were born close to the war, and after we lived in a period of anarchy, when even parents weren't really interested in judging. They were all drowned in a very unstable environment, living through incredibly radical innovations. The opinions were different and ever changing.

FV In my country that was even more evident. Italy was coming from fascism when almost everyone was somehow linked to that dark power. So, for the next generation, that of my parents, it was easy and inevitable to go against their fathers. Whereas the kids of my generation have generally never thought of fighting them. On the contrary, looking at the city where I was born, most of my schoolmates decided to follow in their parents' steps, doing the same job, having very bourgeois marriages...

RK Maybe somehow that is the ironical effect of forgetting history and all the differences between generations...

FV In my experience the generation after mine seems to be uninterested in the judgment of those before them. They have almost no sense of respect or fear for the older generations, their achievements, or their power. For me, it's a very awkward attitude as I was educated to look up to the past, to listen to and learn from people who are more experienced than me.

RK Don't you think your attitude of respect could be a sort of tool? A way to know them to the point you can undermine their power and put it behind you?

FV Well, I think it's more of a research method. As a child, I wanted to be a journalist. Somehow I have fulfilled that aspiration, as that has been the nature of my work as an artist for a long while; sometimes I feel as if my older works were just glossy profiles of people I have deeply admired...

RK There's clearly more than that. In your work you openly over-invest in taking things seriously, to the point where it almost becomes a sort of criticism. It makes you really realize where the strengths are and especially where the weaknesses lie.

FV Well, I can't say I've found out what your weaknesses are yet! I have never seen you betray yourself. And Herbert always spoke greatly of you. That's the only problem I have with younger generations: that I don't see anyone being as courageous or radical as people like you, or Herbert, or, talking about fashion, Miuccia.

RK Well, it's not that true. Architects work with younger generations. In my

office there are a lot of incredibly young people. So, if you look at what we are doing, it's very difficult to say which generation is talking. It's not purely my voice, it's more of an orchestration.

FV I understand, but what I was trying to say is that when I see a young voice emerging, I notice, most times, there is a tendency towards reactionary concepts. And that involves many fields, like fashion and art as well.

RK I think this is probably due to the times we're living in more than to the younger generation per se. This is not exactly a time that encourages confidence or challenges. There is very little appetite in the world for courageous ideas. Almost none, I would say.

FV Somehow I'm more forgiving about an architect's lack of courage, since he has to deal with such a broad range of people from politics and public administrations, both of which are notoriously unsophisticated. On the contrary, I don't justify young artists for their lack of edge. They should keep up with a past when artists were really wild.

RK I don't think it's only a matter of courage. The current political situation is so bad that there is not even the possibility of perceiving something as courageous. So there is no difference anymore.

FV Do you think this applies to any field of creativity?

RK I'm afraid so. Generally, there is no sophisticated perception or layered system of judgment.

FV Don't you think that this has to do with the younger generation's serene obliviousness to the past and its weight?

RK No, mainly because they aren't taking decisions and making the difference yet. At the moment, in every country, on every continent, the power is in the hands of older demographics. In America, the culture world is represented by people in their 70s and 80s; in Europe, it's about people in their mid 40s and mid 50s; in Asia, people between 25 and 35. So I cannot say that younger generations in their obliviousness are responsible for this kind of situation. However, I agree that the new voices appearing on the horizon are not manifesting a critical challenge.

FV I strongly feel this lack of edge especially in the generation of 30-year-olds, above all in fashion and art. No bravery, or vanguardism, or consciousness of the past.

RK Could this be a deliberate choice?

FV I think they're simply like that. I noticed that my young friends look at art mostly through Google: an endless flow of images, without any critical hierarchy. It goes back to what we were talking about at the beginning of this conversation, the meaning of belonging to a generation which usually keeps an eye on the past. I always think, "What would the people who I look

up to say about my work? What would Herbert say?" It seems there are a lot of people who don't worry too much.

RK It's just that we always put ourselves in a historical perspective with regard to our profession, while younger generations don't do that at all.

FV Have you ever asked yourself, while you were working, "What would Herbert think?"

RK No. At least not while he was alive.

NEW YORK / MILAN

DANIEL LIBESKIND

Interview by Horacio Silva

Daniel Libeskind erupted on the scene in 1989, when he was commissioned to design the Jewish Museum in Berlin. Since then, the Polish-born, New York-based architect has been the active force behind an impressive variety of projects, ranging from master plans for colossal civic centers — most famously the rebuilding of the World Trade Center site — to delicate home accessories. PIN–UP chatted by phone with the ultimate formalist, who was stranded in Milan due to the volcanic ash cloud.

Horacio Silva	Hello, sorry to hear you're stuck over there! I wanted to check out your pristine studio for dust bunnies. You had a few new projects being shown in Milan, no?
Daniel Libeskind	I have a lot of new projects. A number of master plans, a high-density housing project, a park, a skyscraper, a museum of contemporary art... But, yes, in addition, I've been doing furniture pieces.

HS Did you show that coffee-and-tea set for Sawaya & Moroni?

DL Yes, that was also on show. Plus two chairs, one called Altair, which is a stainless-steel chair, and then a kind of more classic architectural chair called the Torq.

HS How do you name your projects?

DL Torq is actually based on the project I'm doing for the Museum of Contemporary Art in Milan, which involves taking the Leonardo figure inscribed in a circle and square and projecting it in a very unexpected, oblique direction. And I actually got the name Altair from my son who is a cosmologist. It's one of the double-rotating stars, and the chair is actually kind of a structure that has a double rotation. So that was a proper name for that one.

HS I was going to ask you what your children do.

DL Well, one of them is a historian. He works for an international NGO that deals with genocides, Holocaust denial, injustices in the world, and which happens to be based in Berlin and is called Task Force for Holocaust Genocide. So he's a political person with a very broad, philosophical grasp of reality. And my other son is a cosmologist. He's actually a computational-theoretical cosmologist.

HS No offense, but that sounds sexier than being an architect.

DL Well, he's basically a mathematician, not just somebody who is looking at the stars. He's working in cosmology in terms of black holes and galaxy formations.

HS And your daughter?

DL She is finishing her junior year at Harvard. She's an artist, and a scholar, and a wonderful person. So all three kids are thriving.

HS Would you have balked at their turning to architecture?

DL I think my wife forbade them when they were younger ever to consider it!

HS Let's back up a little, and talk about some of the large-scale new projects that you're working on, like the Creative Media Center in Hong Kong, and the Yongsan project in South Korea. Some of these huge undertakings are a far cry from your experimental beginnings.

DL Definitely.

HS How have you changed? Or is it the same thinking process for you?

DL Well, let's see. Yongsan, in Seoul, is probably the largest master plan in the world. It's in the center of the 600-year-old historical city, which is one of the greatest metropolitan, dense centers in the world, and I'm creating a new 21st-century city in every sense. So, of course, that's very different from designing a chair. But even though it's different, and different experience is needed for it, it's not so different in terms of the creative process. The micro and the macro somehow link up in the creative process, but it's a different kind of effort. With a city you have to digest so much information, so much complexity, and at the same time still do something which is at the heart of the world and not just science.

HS I read an interview in which you said that as an architect, you don't really come into your own until you're in your 50s.

DL Well, that was certainly the case for me. I was a late bloomer because my very first building was the Jewish Museum in Berlin [1989–99]. I'd never even built a small addition to anything before that, certainly not a whole building, so I started kind of late because most of my colleagues had already had their practices for double the amount of time. But I've been very fortunate to work in a different kind of path for architecture.

HS Does this mean that architects have a prolonged adolescence?

DL Maybe. But I think that, more than anything, it buys you the time you really need, because architecture is much more complicated than just creating a technical consumer object. It's about the complexity of life, history, tradition — things that are not really obvious. So I don't know about arrested development — it's just a different path. It's a Zen path instead of the industrial path.

HS Don't get all Zen on me!

DL I say "Zen" because the fact is that it's not following a path. It's actually not following any trace that is ahead of you, it's following something different.

HS The one thing that hasn't changed along this path seems to be your working constantly with your wife, Nina. Has that been the case since day one?

DL No, only since I started the practice in 1989, when I won the competition for the Jewish Museum in Berlin. I turned to her and said, "I'm not doing this alone — join me." And her words were, "Well, I've never been in an architect's office," and I said, "The same thing is true for me."

HS Describe the division of labor between the two of you, and what each brings to the party.

DL She's not an architect and consequently brings something completely unexpected in an architectural setting, which is, let's say, a regular person's perspective. I can be showing some incredible drawing, and she goes, "I don't understand why you think this is incredible." [Laughs.] She's been in politics and has a totally different personality to mine.

HS Because you work so closely together, do you ever feel like you're running a mom-and-pop shop?

DL No, because we don't really work like that. We are opposites in every way. When I see something black, she sees white. When I say something is great, she says it's horrible. So it's a very critical, and perhaps crazy, relationship.

HS It's interesting that you're so different and yet you dress and look alike.

DL [Laughs.] That may be after living together a long time, you begin to sort of share certain things other than the oppositions that define your relationship. But the important thing is we share the same values and aspirations, and we love each other. So that's really a privilege. I know a lot of couples that work in architecture together, but the wife is usually relegated to the position of managing the office, or doing something in the back of the house. Nina is not in the back of the house. She's a tremendous force.

HS Tell me, what's the typical Libeskind family uniform today? All black with a culture-vulture leather jacket?

DL I'm just as I always have been. But, yes, the jacket is my kind of uniform. But I wear what I do for practical reasons and because I travel a lot. I mean, I can get stuck in unexpected places, like I am now in Milan. I just dress for what I think is functionally and aesthetically the right thing to do. It's not different from the Hassids: I get up in the morning and know exactly what I'm going to wear! [Laughs.]

HS Aside from the Central Casting uniform of the über-architect, you also wear the cloak of the arch formalist with little regard to space and nil interest in floor plans. How does that label fit you?

DL Not at all, it's completely invalid. You know, if that was true we would not be building the thousands of different apartments, and practical things in different cultures, whether in Singapore, or Milan, all with high levels of expectations. This is not just about giving shape to a large-scale object, it's really creating a new setting for life, a new sense of space. So for that you have to be very practical. I'm a pragmatist, but I love doing the handcrafted sort of work. I'm doing a very small house in Connecticut for two art lovers, and there I'm designing everything, including the kitchen sink, the faucets, the built-in furniture.

HS How do you find adjusting from something of such an enormous scale in Korea to a more sort of human, habitable scale for private residents?

DL I think they're not different. They have to fall together because it is about the human scale, not just an object or a physical entity. It is about human beings — a spirit, a human sense of desire and perspective, whether small or large, that is at the source of all our endeavors.

HS The Berlin Jewish Museum seems to be the bookend from which we start reading your career. Do you ever get tired of becoming the go-to person for

all kinds of religious memorials?

DL No, it just happened because that was my first building, and my second building was the Felix Nussbaum Museum [1995–98], which houses the works of a dedicated painter who perished in the Holocaust. My third building was the Imperial War Museum in Manchester [1997–2001]. So early on people said, "Okay, this is a person who does museums." But later on, I was able to do other kinds of projects, residential, mega shopping things, office buildings… architecture as a whole.

HS Are you religious, though?

DL I'm not religious in the institutionalized sense of the word. But, yes, I think life is spiritual. It's not just about the obvious and I think that is shared by all human beings, whether they're in China, India, Europe, or Africa. We all share that same perspective on the greater reality.

HS By all accounts, you're quite the polymath. You're very well read, you're a prolific illustrator, you've written books of free verse, and, of course, you're a musician. It's well known that you were a virtuoso accordionist and part of an American-Israeli musical competition that made stars out of people like Daniel Barenboim and Itzhak Perlman.

DL Yes, yes, it's true. I have had several different lives, but they're all interconnected. I often think that I didn't really give up music. Even though I'm no longer a virtuoso performer, music is a very important part of what I do in architecture — for example, my interest in the acoustics of space, which I first used in the Jewish Museum in Berlin. The whole void was really designed as an acoustical space, completing a Schoenberg opera which was never completed. And I'm fascinated with acoustics, in the greatest sense that it goes beyond the mathematical purity of music. It's like architecture, in that it's an emotional communication from one soul to another soul. So, yes, it's all interconnected.

HS Have you ever been tempted to christen a musical venue with the accordion when no one was looking? Come on, you can trust me, I'm a journalist!

DL The truth is that I played with great classical musicians, and I played classical music with the accordion to the limit of the instrument. Isaac Stern, who was the juror of the competition, told me, "You know, you have exhausted all possibilities on this instrument. There is nothing more on this particular instrument and now you have to change to the piano." So I chose a field which can never be exhausted, in which you can never become just a virtuoso. It's a field that is always greater, the more you go into it. And so perhaps architecture is a perfect set of things because it's so many complex relationships through things that I love to do.

HS Do your buildings fill a performative gap for you?

DL Well, I think they have to be performances themselves, and they're also constructed, and if you think of a drawing, and orchestration of a drawing,

and how a drawing for a building comes to life with hundreds, thousands of workers who make it happen, it's like the culmination of a performance.

HS Maybe you could take your multidiscipline approach one step further and become the first big-name architect on "Dancing with the Stars"!

DL [Laughs.] I'm a very poor dancer. Not to change the subject, but you're right, the buildings may fill that void for me. That's the stage, that's what you're going for. You're not there, it's the building that's there, the city is there, the streets are there. It's the echo of the performance that resonates with the person on the street.

HS Now, if I'm not mistaken, you live in a flat pretty much overlooking Ground Zero.

DL Very close, and our office is on the other side so, from south and north, we see Ground Zero all the time.

HS Is your home very sparse, or are you a secret Laura Ashley, country-home type of decorator?

DL It's got a lot of books, and a lot of other things. But in terms of space, it's sparse, yes.

HS So you're not throwing scattered cushions all around the place?

DL [Laughs.] I had to give in and allow two cushions that my daughter snuck into the house, but that's where it ends. We have no patterns.

HS What does New York actually mean to you?

DL Remember, I was an immigrant to New York. My parents were hardworking New Yorkers, my mother in the sweatshops, and my father was a printer. I grew up in the Bronx — Manhattan was only for tourists — and it wasn't easy. But for somebody who lived under a totalitarian Communist regime, coming to New York, with all its opportunity and fantasy, was like coming to the Promised Land. Believe me. I don't think it's possible to separate that idea of New York from my view of the world.

HS Well, obviously the big pink elephant in the room is the World Trade Center project, and I researched this a lot, and I have to tell you, it is about as complicated to decode the Da Vinci Code. It's surrounded with so much obfuscation.

DL You're right.

HS What actually happened, in a nutshell? I don't want to revisit a lot of old ground, but I wouldn't mind some clarity...

DL Yeah, here's the clarity. I'm the master planner of the site. There are many parties involved. There are the families of the victims, there is the Port Authority of New York, which is a mammoth organization run by both the Governor of New York and the Governor of New Jersey. There are, of course,

private investors with their own architects, there's PATH [Port Authority Trans-Hudson], the MTA [Metropolitan Transportation Authority], so it's a very complicated beast. Also, of course, it's highly political and emotional. As someone who is in charge of the master plan, all I can tell you is it's pretty darn close to the original. Nothing is easy in life, and you have to be able to compromise and recognize so many different interests, and attempt to steer the project exactly where you want it to be. So a lot of things are ongoing. The memorial is going to be finished by 2011, the Freedom Tower, as they call Number One World Trade Center, is going to reach its apogee probably in 2011 or 2012, somewhere around that time. Tower Number Four is under construction. The Memorial Plaza is being constructed. The slurry wall, which is part of the museum and was part of my initial idea, is under realization. Of course, it's not an easy project because the market right now is pretty poor, nobody is building five huge towers right now, so it's slower in some aspects. But it's definitely underway, and I'm very, very optimistic that it's going to be a fantastic project when it's completed.

HS I think the misperception out there is that you actually won the design for the tower, and that it was taken away from you.

DL It's completely not true. There is a problem: if you do a beautiful rendering, people think that the whole thing is going to be built exactly like that, but actually it's only a master plan. And, in fact, you know, originally it was not even a competition, it was just advice to the Lower Manhattan Development Corporation, and because it was so echoed, and resonated with the public, they really went with a master plan. And of course it's challenging, but I'm absolutely committed to it. I didn't grow up in the Bronx for nothing: I'm not a person who throws up his hands and says, "I give up!"

HS It sounds more like it's been an exercise in frustration as much as in creativity...

DL No! I don't think you can say that... If you're going to be frustrated, you'd better not be in this field. This is not about doing some nice drawings and saying, "Go ahead and build it!" This is about fighting for what you believe in. This is a marathon, not a sprint, and it's about being able to work with others. It's not about being the prima donna. You have to reach a consensus. We used to argue over huge matters and now we are arguing over inches of public space. But my task was not just to design nice buildings; it's really about the symbols above the site, about the meaning of the site, about the light of the site, about bringing together the memory, and also a fantastic foundation for 21st-century New York.

HS I imagine you have some very definite opinions about conservation, especially given that some of your projects, like the Denver Art Museum [2000–06], have been extensions to existing buildings. How do you feel about someone like Prince Charles, who is obviously against those kinds of juxtapositions?

DL Well, I cannot defend Prince Charles. But I can empathize with the fact

that it's important to recognize the importance of tradition in architecture. The city is not a tabula rasa where you start from zero. There are layers of importance to be communicated in the language of architecture. In the San Francisco Contemporary Jewish Museum [1998–2005], maybe 90 percent of my work was behind the beautiful façade of the city's old power station. But I didn't do a kind of mock nostalgic reconstruction of the station, with its industrial architecture, but cut through it, and at the same time recognized the importance of the light, the industrial heritage. So I'm not interested in nostalgia, but I am interested in history.

HS Tell me, which is the one that really got away? Is it the Spiral at the Victoria & Albert Museum in London?

DL Well, I wouldn't say it got away from me, it got away from them! And I would have never been able to build the Royal Ontario Museum [2002–07] without having had the experience of designing the V&A Spiral.

HS You're now building a tower in Warsaw [Złota 44, begun in 2005]. How does it feel to be building in the country that you left when you were very young?

DL It's exhilarating. When I came back to Poland after so many years — and for many years I did not want to return to Poland, I had such bleak memories of it, as did all my friends — I discovered a different Poland. I speak the language and I love Polish culture and so on, but I grew up in another, dark time in Poland. You know, we were Jewish, we were not assimilated, and the situation wasn't easy. So coming back to a new Poland, which is now rid of the ghosts of Stalinism and Communism, where young people have realized there is something free in the country, and the country is once again breathing, is fantastic. By the way, I'm building this building right across from the Stalin Palace [Lev Rudnev et al., 1952–55], you know, the so-called "Gift of Stalin" to oppress the Poles, the Poles of culture. And it's also very close to where my mother lived. So it's a strange, but interesting, return. It shows that nothing in history is predictable.

HS Speaking of history, what was it like working with Richard Meier in the 70s?

DL [Laughs.] Well, Richard Meier is a great architect, first of all, and he was also my teacher in school. But I didn't last long in his office. At that time I was young and impatient, and I thought it was all just too formulaic, and I left, for better or for worse.

HS I can only imagine the intellectual jousting that would have gone on there!

DL [Laughs.] You don't know the half of it!

HS I interviewed him not long ago, and surprisingly he dropped his guard in a way that I have to say was sort of strange. We ended up talking more about tennis...

DL Amazing! Well, you know, scratch a famous architect, and somewhere you might find a real human being.

LOS ANGELES

GREG LYNN

Interview by Felix Burrichter

Sometime in the mid 90s, Greg Lynn coined the term "blob." It was an attempt to define a new kind of process in the making of biomorphous architecture, the kind one could only envision with the help of 3D technology. While in theory Lynn remained the uncrowned king of the blobosphere, other firms had caught up with his ideas and actually went ahead and built them, making Lynn one of the best-known architects of the noughties with almost no buildings to his credit. But to say that others carried out what Lynn was only able to talk about is a misconception: in fact, while many picked up on the formal aspect of Lynn's theories, they realized them with conventional building methods — something that has never interested Lynn. What he strives for is not just formal innovation, but also new ways of building. It is therefore unsurprising that in recent years he has looked to industries that have been quick to integrate new technology — car manufacture and, more importantly, naval architecture — to see how their innovations might be used in the construction industry. Technological ingenuity is present in all his recent work, which includes an apartment building in Valencia, Spain with an anodized aluminum façade, computer-generated designs for furniture made out of robot-cut recycled children's toys, and an actual boat commission for a client in Abu Dhabi. Indeed, Lynn is a passionate sailor, known for spending every free minute on his own boat, the *Kraken*, which is berthed in Marina del Rey, not far from his office in Venice Beach. PIN–UP met up with Lynn at 8:00 a.m. on a Tuesday morning after a long weekend of sailing to talk about his passion for races, Los Angeles, the house he and his wife will never build, and why it might be time to move south of the border.

Felix Burrichter	So did you win the regatta last weekend?
Greg Lynn	The race? [Laughs.] You know, there are three kinds of races. First, there's the America's Cup, where you design your own boat, but it has to be designed to fit a certain rule. It is the most expensive, but that's also where all the cool materials, shapes, and technologies are generated. Then there's design racing, where one manufacturer builds, let's say, 400 boats around the world, and you're not allowed to change anything on them, so it's a level field — and then you all race against each other. And then there's handicap racing, which is what we did last weekend. All the boats are different, and what they do is measure every single one — how much it weighs, how big it is, how much sail area, water line — and then they put it into a matrix and assign you a number. For example, my boat has number 84. Another boat might have another number, let's say 60. So for every mile we race, they owe me 24 seconds. So what we did last weekend was a handicap race. And we were the fastest boat anywhere near our size.

FB Congratulations! So who goes on the boat in a race like that?

GL Well, I've been sailing all my life, but I only bought my own boat a few years ago. So in the beginning, it was always just friends and colleagues, like Kivi Sotamaa, Casey Reas, Heather Roberge, Jason Payne — mostly architects.

FB What is it with architects and sailing?

GL Well, other than Kivi and Casey, most people just came onboard for the social aspect of it, not so much for the sailing. But as we got more competitive, I started to bring in more competitive sailors, and most of them are naval architects or sail designers, so I guess there's still a very design-heavy component. But it's becoming less about the fun, and more competitive.

FB Have you raced Frank Gehry, who's also an avid sailor?

GL I would never race Frank. But he's become one of my best friends, actually, because of sailing. If we're both in town, we always make sure to go out for a few hours once a week. But we mostly talk about work... [Laughs.] Also, he doesn't really enjoy racing, he just likes being on the water.

FB It seems sailing is also rubbing off on your recent work. Last fall you designed those giant crystal sails for Swarovski, and now you're designing a boat for a client in Abu Dhabi. Have you found your true calling in naval architecture?

GL No, no, no! But there is something that I've been drawn to ever since I saw these big 3DL sails [3DL technology was developed by the company North Sails in the early 90s: 3DL sails are thermo-molded as a unitary membrane on a full-sized three-dimensional mold] in a Prada ad about ten years ago.

They had an America's Cup campaign, and that was the first time they were using the "load-path" sail technology. So I called the people at North Sails and went up to visit their factory, and it got me thinking about how technology like that could be used for furniture, or an interior-design project. And the more I looked into it, I started to realize that the square footage on a super-high-performance boat cost the same amount as a super-low-performance building or a house. So I was interested in getting into that world and figuring out how they do that. But in the process, my passion for sailing also got reinvigorated. And now we're doing these boats for a client in Abu Dhabi, and I'm working on them with these great naval architects in Long Beach, Tim Kernan and Frederick Courouble. They're kind of the best young American naval architects and boat designers. So I like talking to them, seeing how they model, seeing how they test materials, seeing how they build, seeing the materials they're interested in... That's the part I really like. In the end, designing the actual boats, at least formally, might not be that different than designing a building. And they take about as long as a building — sometimes production can take up to five years. It's kind of a slow burn. First you have to design them, then marketing is a big deal, you know, tooling is really expensive, so they gotta make sure it's going to do all the things they want it to do before they invest in all the tools.

FB Besides the Swarovski Sails project, what material aspects of the sailing and boat world have you been able to apply to your architectural practice?

GL Well, there's a basic principle. Let's start with a very simple idea. There was a paradigm of construction where parts and pieces were put together mechanically. Whether it was dowels and pegs, welds, bolts, whatever, you would assemble parts, find where the edge is, and where things would align, and then mechanically attach them. What's happened with aerospace, automobiles, and boats is that they have acknowledged conceptually that glue, or what you would call a matrix, like resin, is the way to put things together. But it has big aesthetic, spatial, and formal consequences, and the building industry is still about glue, double-stick tape, and laminates. Whereas in the other industries, they recognize that there's a shift in paradigm. For example, in the boat world you use aluminum and titanium, with carbon fiber and dynamo fiber. You make a mold, you put it in a bag, they vacuum pump resin through it, or heat it up in an oven. So everything's just cooked in a bag and held together with glue and resin. No bolts, no screws, interfacing surfaces. And that lets you put things together and take them apart differently, lets you transport differently. It also gives you a sense of lightness. For example, in the Bloom House [Venice Beach, 2009] a lot of stuff is molded and formed with heat and pressure, like the bathroom and kitchen which are made of Corian, or the lantern, which is also made of resin. But it's not a process that is germane to boat construction, nor to airplanes — they're all made of glue-laminated composites. So that's really what I'm interested in for architecture.

FB So your interest in building is rather different from the traditional brick-and-mortar approach. Is that why, as an architect who is so widely recognized, you've built so little?

GL Well, how can I answer this without it coming out the wrong way... You see, very early in my career I got to do a very big building that was very unconventional in its brief: a Korean church on top of a factory [Seokwang Korean Presbyterian Church of New York, 1999]. There was no precedent for it, so you couldn't just go to the last one and make it better, you know? [Laughs.] But the way it was built, and its expression in materials was super conventional — just mass-produced elements, mass-produced construction systems, and all that. After that project I decided I didn't want to do that anymore. Because for me, whether it's a boat, a building, or whatever, it's only fun if there's some level of innovation in how it gets built, and in the materials, the finishes. I try to do that with all of my projects, whether it's product design, like the Alessi collection that was made of titanium, or the Ravioli Chair for Vitra, with its one-piece 3D knitted cover. I always try to find a way to think about the materials, the construction, and the design so that it all synthesizes and does something new. I think the building industry is very much ready for that kind of thing, but the way that contracts, timelines, and budgets are set up, it's very tough — it takes a long time.

FB How did you solve that dilemma when building the Bloom House?

GL It was very bespoke, I guess. The design for the site was literally taking the maximum envelope in every dimension and blowing up a balloon inside it. Massing and shape, and also cladding, were maybe not so much of an interest. It was more inside out. I wanted to take some of the stuff we've done for exhibitions, or our industrial-product projects, and bring it into the scale of a house. So we had to work with Dupont to figure out how to formalize the Corian, and that took about a year and a half just for research and development. And then for all the construction of curved walls, we had to prototype them. So the whole thing took a lot longer than usual. We couldn't possibly have done the Dupont research and development ourselves, but we were very involved in the construction and fabrication. We didn't just do drawings and give them to somebody to figure out how to build them — we had to bring Dupont and all these people into the process, including Bill Kreysler of Kreysler and Associates in Sonoma County, who made the lantern. The contractor didn't really do anything — we just gave those people 3D files and prototypes, the pieces were made, and when they arrived on site the contractor just had to install them. Nothing was built on site.

FB I suppose to operate that way you really need a client who is not breathing down your neck?

GL Oh no, the reverse, actually. You need a client who is super involved and understands it all, and who is also interested in those things. One of the owners, Jackie Bloom, actually worked for me for over twelve years. And her husband, Jason, was probably at the fabricators and the factories more

than I was. So I think it takes an investment, an interest, and passion on the client's part, or else this kind of project doesn't work.

FB And what happens when you're your own client?

GL Yeah, I tried that and it didn't go well. [Laughs.]

FB I assume you're talking about the Slavin House, the house you've been planning for you and your family since 2005? What's happening with that?

GL Well, my wife [Sylvia Lavin] and I share a lot of ideas and interests, and on some levels we work really well together. And we were very, very close to starting construction. But then we both realized it was going to be a recipe for disaster. Sylvia is too much of a closeted designer to have me design our primary residence! [Laughs.] So it's going to remain a hypothetical project. But there's also something nice about not having to live in my own showroom, living in a house I designed, sailing on a boat I designed... I remember when I was 17 and I went to Paris to see all this Corbusier stuff. I was outside of Jacques Lipchitz's house [Villas Lipchitz-Mietschaninoff, Boulogne-Billancourt, 1923–25], taking pictures, and then this woman comes out, who I assumed was Mrs. Lipchitz, and she asked me whether I wanted to see the interior of the house. So I went in thinking it would have Lipchitz sculptures everywhere, and Corbusier paintings and what not, but it was all Biedermeier furniture, Indian carpets, all kinds of weird art, just a mishmash of everything. But it was a super-cool environment, and it really impressed me.

FB What does the house you live in now look like?

GL Well, the house we were going to tear down to build the Slavin is actually a great house. It's a Sears Roebuck house from 1904 — and it was ordered by telegraph, and specifications were sent in the mail to Chicago, and then the whole house was built in a factory, put on a train, taken to Venice Beach, and popped up in probably less than a week. So what everybody says is the future of architecture actually already happened over 100 years ago. And as a factory-made thing, it makes it a very cool house to live in, because that's what I believe in. So it's full of history, and of toy-furniture prototypes, and of my family — it's a nice mix, and I get very inspired by it.

FB Speaking of history, I was surprised to read in an article that you're also something of an art historian?

GL What? No, no, no, no! [Laughs.] In fact, I'm always embarrassed by how little I know about architectural history. I have a philosophy degree, but beyond that it's always been design and architecture. The little architecture history I know is because I pick it up from people like Sylvia. What's always amazing to me is the depth of knowledge of architectural history of the mentors I've had in my life, the people I respect the most, like Peter Eisenman, Bob Stern, or Frank Gehry. And when I look at people of my generation or younger, I'm just so embarrassed about how little they know. They'll know Corbusier,

and Mies, but they won't know in any depth anything about who, say, Giulio Romano is. I actually think it's a little problematic. So when I teach I really try to start with a kind of historical precedent. For the last year we've been working on Ledoux, and before that we worked on Bernini. And 99 percent of the students have never heard of either of them — and this is at Yale University! So, sadly, history in architecture doesn't have a lot of traction right now.

FB Let's talk about your own history. How long have you been in L.A.?

GL Almost 13 years. I came here from Hoboken, New Jersey, actually, where I was renting a four-story brownstone that I got for very little money. I was just out of graduate school, and Hoboken was this super cool place with this bar, Maxwell's, and I was right across the street from there. I was also working for Peter [Eisenman] for a while, and teaching at Columbia. So it was a great setup. But at some point, I felt like the gravity was moving west. What was happening out here was so inventive and innovative, and there was a great creative climate out here. All the magazines and galleries and schools were still back east, but there was a lot going on out here. But ironically, I was just saying the other day that we need to come up with a five-year plan to get out of L.A. because it's turning into New York. The indicator for that is when you get around two or more architects together and you listen to what the conversations are: it's become very banal shoptalk, about patronage, work — it's been a while since I heard someone with a really good, new idea. L.A. has been an alternative, interesting place for the past 20 years, and now it's starting to stultify and turn into something more official. So Sylvia and I are looking for where the center of gravity is going to move next.

FB Will Greg Lynn Form be operating out of Mexico City in the future?

GL It's funny you should say Mexico City because Sylvia and I were just talking about the fact that it's time to look south. Europe is also going to get interesting. This recession is actually great for design culture in general, and the world of ideas. Especially when it hits Europe, it's gonna get rid of a lot of the fat. It's going to destroy a lot of big corporate firms, and it's going to make young people... Instead of trying to emulate Norman Foster, or whomever the young people are trying to emulate, it'll make them emulate a young Rem or a young Zaha. There is a mid-generation there all over the world that is pretty boring. And it's because everything has been so easy.

FB So you're seriously considering moving your office south of the border?

GL Well, you know, all the architects are talking about getting into Brazil now, because the economy is really good, and there's a lot of building going on in Brazil over the next few years. I know all the big corporate firms are opening offices down there, like KPF and SOM. And all the developers like Hines or Tishman Speyer, are going. And they're bringing their architects down with them. But Brazil might be a little too far south for me, though. And Mexico City doesn't have an ocean, so I guess we'll have to think it over again. [Laughs.]

BERLIN

NIKLAS MAAK

Interview by Michael Ladner

Niklas Maak is one of Germany's leading art and architecture critics. Co-head of the *Frankfurter Allgemeine Zeitung*'s arts section, he is a prolific contributor to architectural discourse in the academic as well as the journalistic sphere, and formerly taught architectural theory at the Städelschule in Frankfurt. Born in Hamburg, Maak studied architecture, philosophy, and art history in Paris, before moving back to his hometown to write a doctoral thesis on Le Corbusier. Recently Maak stepped out of his critic's shoes and into those of an architect, remodeling a quaint dacha-in-shambles into a weekend home for himself and his family. Located on a lakeshore in the village of Sacrow, just outside Berlin, the building was almost a ruin when he bought it in 2009. Its transformation has been a long, but enriching process that has led Maak to consider the wider implications of why suburbia looks the way it does, what impact the scale of personal space can have on the world at large, and how the public realm might differently relate to our individual, private spheres. PIN–UP discussed all this and more with Maak when we met him in his own little corner of paradise down by the water's edge.

Michael Ladner	How did you find this place?
Niklas Maak	We came to visit friends here in Sacrow, and they told us about this "unsaveable" house from the 60s. We immediately went to look at it. It was wet. It was moldy. No one wanted to buy it because it looked like trouble — you could punch through the wall — and people who have real money don't want to buy a 70-square-meter house, they want a 200-square-meter one, even if it's only for the weekend. Another problem was all the building restrictions. The planning authorities said: "There has to be a house on the ground all the time. You have to have three walls standing at all times because that defines a house. You can tear down one wall and build it up again and then go on like that."

ML These are the rules of the city of Berlin?

NM No, the city of Potsdam and its nerve-wracking bureaucracy. They also said, "You can't use the roof as living space. If you use the roof, you lose the permit." So I asked them, "If you are so concerned about the roof, why don't we do a flat roof instead, with solar panels on it?" You know, for years I've been writing articles criticizing people who commute in cars between the countryside and the city. So I thought, if I'm going to do this, the project needs to be a complete concept for me. So I talked to this guy who works for Tesla Motors, an electric-car company in California. I asked him if he could calculate how many square meters of solar panels one needs to commute 10,000 kilometers a year in an electric car — the answer turned out to be 38. So now the solar panels not only power the house, but also cover the emissions of the car that brings you here.

ML Did you use your knowhow from studying architecture when redesigning the house?

NM I did all drawings for the house myself. My first semester studying architecture [at the Ecole Nationale Supérieure d'Architecture de Paris-Belleville] was about the relation of interior spaces to exterior spaces, and about inversions and porosity, and the question of reframing the idea of a wall. It helped me in redesigning the Sacrow house because of all the restrictions I had. The outline of the house was set, but I was able to repeat the shape of the solar roof as a narrow terrace running around the house. This enlarged the house and there was a more deliberate and porous relation between inside and out. Introducing a skylight was interesting because the house is so small that once you walk in you immediately feel you're outside again. It has some weird inserts of California Modern and Japanese Engawa. All I really needed was a structural engineer — I found a great one; he's East German, and he was very good with the East German authorities.

ML Which must be a particular kind of art in itself...

NM Absolutely! And he was a genius at talking all my ideas through to the authorities. The only problem was that he normally builds very conventional suburban houses. For example, he'd never done a flat roof before — it felt like building the first Le Corbusier villa in the 1920s in southern France, where people had never seen a house with a flat roof. You really had to explain everything.

ML Why had he never built a flat roof before?

NM Because they make more money if they use prefabricated materials from all these building companies. It's the building companies that really push people into very dodgy aesthetics. When you drive through suburbia you think people have no taste at all, but it's not necessarily true. They have no choice at all. This lack of choice is rooted in the economic and, if you will, capitalist rationalization of the building process.

ML With only 70 square meters your house is comparatively small. I read recently about the tiny-house movement in America, which is about houses that are only 30–40 square meters big.

NM Yes, I've heard about that. I think these movements present an opportunity to rethink the idea of the house. How much inhabitable space do you really need to protect your individuality? How can we also create social structures? How can we densify social spaces by giving great new form to social experience? SANAA's Moriyama House [Tokyo, 2005] is an example of how the densification and the reduction of the scale of private space can be seen not just as a reduction or loss, but as a chance to rethink the idea of micro communal spaces.

ML I think there's a fundamental misunderstanding that minimalism is about subtraction, or loss. That's something people also misunderstand when they consider domesticity.

NM The whole idea of outsourcing some functions to the public sphere is very interesting. In Paris most flats are so expensive and small you just can't cook for twelve, so you go to a restaurant. So the whole idea of a vivid public realm is also connected to the restriction of private space to strictly private use. You use your apartment to sleep, maybe work, but then you go out in the street and use the streets as part of your daily living room.

ML As a critic, what does it feel like stepping into an architect's shoes?

NM It's special because if you're writing about architecture and conceptualizing architecture on a theoretical level, you're always thinking about possibilities. With this house I was suddenly confronted with restrictions that were so narrow that you could hardly change the size of a window. So that was the ultimate challenge for me. I kept in mind successful avant-garde projects like the Moriyama House, where Ryue Nishizawa created — against all odds and in the face of very narrow restrictions — something that is completely unique.

ML Did the experience make you look at architecture in a different way?

NM No. But what I really understood was the impact of the power structures in the building industry.

ML Do you intend to bring that to light as a writer?

NM Of course. I think what's lacking in architectural discourse is a theory of the political and economic impacts, the very material basis of things that to us appear as merely aesthetic decisions, but which are really economic decisions. I think that one should reframe architectural theory from the standpoint of analyzing the material situation, the impact of power structures on building decisions.

ML This sounds like it could be a treatise.

NM In rethinking the idea of private space — defining a minimum that is necessary for your personal life — you also tend to rethink the idea of public space and what it is for. You can argue that someone who is sitting at home emailing, Skyping, or chatting on the phone is someone who is public at that moment, and that if that person wants to escape this overwhelming social experience on the phone, or on the Internet, he or she can go to a public square, which can be pretty private in comparison. This could have a very productive impact on the definition of private space and public experience. I think the bigger theme behind the small-house discussion is the question of how we can reframe the public realm and public rituals. The whole re-investigation of public space as a political space in Egypt during the Arab Spring, or by the Occupy movement, was very valuable. A social energy was created out of public spaces that actually changed political systems. Despite all claims to the contrary, it's not true that the decision-making process has gone from the public to the virtual realm. So it may be a long path that leads from a small house to a big movement, but it's tied together by the reframing of the idea of privacy and the idea of being in public.

ML Between the political-economic system, the architect, and the consumer, how do you enact change? On the one hand you have to make people comfortable living in a semi-shared space, or in a smaller space in general, but on the other you have to convince the building industry to be open to such ideas.

NM We must profoundly rethink our idea of private lives and of housing, but there are no models available to a broader mass of people. You have an architectural avant-garde, but there is no link to the building industry. And the building industry is not interested in these models. In fact, I don't believe they're even informed about them. That's the role of architectural criticism, and of popular architecture magazines. This is why in the *Frankfurter Allgemeine Zeitung* we try to show models like the Moriyama House, or buildings by Sou Fujimoto, and to tell people that private space can be organized like that, and that a house can look like this, and that it's livable.

ML What do you think about the architectural landscape of Berlin since the reunification?

NM A friend of mine once said, "Maybe Hans Stimmann [Berlin's director of town planning between 1991 and 2006] saved Berlin from some of the worst developments in European city planning, but he surely also saved it from the best." I think that's very true because there were two phenomena after 1989 in Berlin. Stimmann had a very special idea about the European city, which was rooted in 19th-century urban planning. His idea was to restrict building height and to recreate the image of Berlin's historic *Blockrandbebauung* [perimeter block development] in order to close all the gaps, whereas a Modernist city usually consists of free-standing buildings that don't interact. He wanted to have an *alignement*, as the French say, to recreate the vivid atmosphere of 19th- or early-20th-century Berlin. Which didn't work of course. For example, if you look at photos of Friedrichstraße in the 1920s, there were flickering neon lights, there were façades popping out, pushing inwards, it was very overloaded and very lively. But if you look at it now, it looks terrifyingly polished and reduced. It's kind of a non-functioning minimalist pseudo-Modern version of the old city, with every building looking like a kind of a purified zombie version of what used to be there. There are these touching photographs of Friedrichstraße from 1929: the street is completely overcrowded with people and cars, with kids playing in the courtyards and people selling things on the street. And many of these dealers and shop owners were Jewish. So, you know, you can't recreate that just by copying their houses.

ML You said there were two phenomena — what was the other one?

NM This generational group of architects who are close to Stimmann not only built Friedrichstraße, Pariser Platz, and Potsdamer Platz, but they also invaded every void there was. There was this kind of collective agoraphobia in Berlin, a compulsion to fill every gap with houses. I think all these voids and these empty spaces and these deserted areas could have been a chance to rethink public space. It's basically a missed opportunity and a disaster. Then again, Berlin always functions very well when it comes to dealing with failure. The Palast der Republik is only one example. Towards the end it was just a monstrous ruin right in the center of town, but there was all this cultural programming happening there, which was uniquely Berlin. Even the Centre Pompidou couldn't offer the kind of variety of spaces and opportunities for cultural use that the Palast der Republik did.

ML Now that the Palast der Republik has been demolished, is there anything that could serve a similar function today?

NM I think something like the Küchenmonument is a fantastic thing. It's an inflatable structure invented here in Berlin by the architecture firm Raumlabor. It pops out of a container and folds out with the help of high-pressure air. Once it's fully inflated it's about 200 square meters big and can hold up to 100 people who can have dinner there, or discuss things, or have

a dance party. You can transport it with a little truck pretty much anywhere in the city and blow it up for a night, and it creates an instant urban space. So you create a kind of guerilla urbanism that exists despite the official architecture, and not because of the official architecture.

ML Where do you see Berlin going in the future, architecturally?

NM For sure, an era is over. The interesting question will be, what will happen to the last remaining voids that were left by this generation of urban planners? For example, what will happen to Tegel Airport after it closes? What will happen to Tempelhof Airport? Maybe you could create a whole village or a whole city quarter that functions totally differently from what we know. Tempelhof is the unique case of an inner-city void that is absolutely undefined. It would be the perfect battleground for different ideas of the city of the future. What I would really hope for is an international building exhibition on that very site that would dig as deep as possible into the question of public and private space, of collective experience and possible architectural frames for it.

LONDON

PHILIPPE MALOUIN

Interview by Caroline Roux

Philippe Malouin and I have crossed paths on many occasions — sometimes at design shows around Europe, at others in the small East London pub most favored by the city's arty gays and their dogs, the Nelson's Head. For this interview, we convened in Hackney Wick where, in its new, post-Olympic condition, you can now find cafés that serve pistachio-and-rosewater cake. Philippe arrived in black shorts, T-shirt, and plimsolls, exuding, as usual, model good looks and effortless friendliness, all helped along by his charming French-Canadian accent. But then, Philippe has plenty of reasons to be cheerful, for from a professional point of view, 2012 has been his best year yet: he was honored as one of W Hotels' three Designers of the Future; he has a newly commissioned piece in Swarovski's "Digital Crystal" exhibition at London's Design Museum; he designed a pop-up café for Artek during the London Design Festival in September; he has a growing band of private collectors clamoring for his work; and his interior-design business, Post-Office, which he runs together with colleague Will Yates, is attracting jobs with budgets that exceed 5,000 pounds — finally the perfectionist in him won't necessarily eradicate all the profit. Philippe was trained to think industrially, and he is adamant that he is a product designer and not an artist or a stylist. He studied at the Design Academy Eindhoven, where narrative and decoration are among the fundamental design values. But it's his earlier industrial-design education in Canada that colors his work, as he applies a love and knowledge of materials and process to an idiosyncratic range of products and some intriguing interiors. An interest in decoration and narrative does, however, seem to come across in the cultivation of his rather remarkable beard...

Caroline Roux	Well, Philippe, the first thing many people notice about you is your lustrous beard. And people say, "You know, Philippe Malouin, the designer with the beard." Is it an important part of your life?
Philippe Malouin	[Laughs.] I don't know where my beard obsession comes from, but yes, I guess it is important. Perhaps it stems from being Canadian, and an equation of the beard with being adult. I just grew one as soon as I was able to.
CR	When was that?
PM	Five years ago it became thick enough for me to grow it, whereas before it would have been really patchy and awful. I was 25.
CR	How do you look after it?
PM	I don't really do anything much to it except go to a place every three weeks called Rocket — it's a barber's shop in Hackney Road, and there's this guy Steve there who trims it. When I used to try and trim it myself, it would look awful. Steve is really good at trimming my beard. He had one himself for ages, but he doesn't anymore.
CR	Why do you think they've become so fashionable? I mean if you walk around Shoreditch, it's basically the bigger the beard the better.
PM	I think it's an idea of projected masculinity which is kind of funny because, you know, in Shoreditch five years ago, when I arrived in London, the look was painted-on skinny jeans, plimsolls, and malnutrition. I don't think anybody got laid during that period. So maybe some people thought it was time for a change?
CR	Let's talk about the pre-beard Philippe, then. You studied at the Université de Montréal, is that right?
PM	Yes, two years of industrial design. I used to design gas reservoirs for Bombardier trucks. I know all about the structural resistance of materials, how to calculate the size of a wood beam to support x amount of materials, how to make detailed technical drawings. That's the basis of being a designer for me. I worked like a maniac in Montreal because if you get straight As for two years, you get a grant and plane tickets to go to Europe. So I got to the ENSCI [Ecole Nationale Supérieure de Création Industrielle] in Paris. And once I was there, I got selected with a few students to work at Hermès for one semester, which was amazing. It's a company where everyone's input is important and taken seriously, there's a giant social engagement. They made sure we knew the names of everybody who works there and they spent a whole day showing us how a Birkin bag is made — step by step by step by step. You know, you would imagine the people who work for Hermès to be very chic and fashion-y and difficult, or flaky, or arrogant. But they were down to earth, completely obsessed with what they did, and they just gave us free rein and supplied us with amazing butter leathers.

CR When was that and what did you make?

PM Let me think... 2006. And I made a bag that would extend as you put things in it, like an accordion. At first it would be very, very flat, like a pouch, and then it would eventually turn into this giant escargot.

CR And what was Paris like overall?

PM Super expensive! I was so poor. I saw pictures of me recently from back then and I was literally 15 kilos skinnier. I was starving the whole time, and emaciated. I'd won a bursary to go there — 4,000 Canadian dollars, that's like 2,000 pounds — and that's all I had to live off, and it really wasn't enough. After that I did an internship with Frank Tjepkema in Amsterdam who has a studio called Tjep. He used to do a lot of work with Droog — he did that vase called Do Break, which was made of porcelain lined with PVC: you could throw it on the floor and the porcelain would shatter into a craquelé pattern without the vase breaking. It was quite a famous piece. It was Frank who said, "Let's get you into Eindhoven." School had already started, but Frank sent me to meet his friend Bas van Tol, who is head of the "living" department at Design Academy Eindhoven, and I got in.

CR How much did you learn at Eindhoven? The college has become quite a brand these days, so to what extent is that a disadvantage or an advantage?

PM I don't know about the brand, but the teachers included some of my idols, such as Wieki Somers. She's a truly, truly amazing designer, and not the Dutch stereotype — she's not about the decorative thing. She's very creative, she keeps reinventing, re-thinking, coming up with new ways to approach the problem.

CR What are your favorite Wieki Somers designs?

PM I love the really old stuff that she did for Droog, when she made these very simple pieces of furniture that were built like cigar boxes ["Extended Cigar Box" series, 2001]. She made them with local people who did actually make cigar boxes at the time, and looked at their model of production, which was really artisanal. Many people just stop at what these pieces look like because they can appear tongue in cheek, but they're really more than that. And I also love the cloakroom she did at the Museum Boijmans Van Beuningen in Rotterdam [Merry-Go-Round, 2009]. It's based on mining from a long time ago, when they used to fill a basket with coal and winch it up to the surface.

CR What was it like living in Eindhoven — I guess there aren't too many distractions to take you away from your studies? What do people do there? Drink? Get suicidal?

PM It's pretty awful. The highlight of the two-and-a-half years was when the Brazilian band CSS came and played. That really was the highlight. It so was boring, you just worked all the time. People throw house parties and there are cliques: the French clique and the Dutch clique. The Dutch had no sense of humor — or a very different one from mine anyway — and the French just

spoke French the whole time, even if half the room was Dutch or English, they'd keep speaking French. I'm French-Canadian, so I'm francophone, but so not French!

CR When you graduated from Eindhoven in 2008, it was the "design art" moment and it really seemed like that was a very significant direction for design, though the excitement around both collectible and narrative design has proved to be quite short-lived. Did it affect the way you saw yourself as a designer?

PM No, not at all. And I think people got bored of it. It's funny because Li Edelkoort [then chair of Eindhoven] even said that she liked the fact I didn't do "Dutch design." I'm a product designer, not an artist. Okay, I got picked up by galleries after graduation, but that wasn't the point.

CR Apart from designing products you're also director of interior design firm Post-Office, and one of your first projects was the interiors for design website Dezeen's offices here in London. How was that?

PM A fucking nightmare! Only because we had, like, 5,000 pounds to do it. It's a good space though — two stories, an old doctor's surgery. We created a wall of curtaining in gold-foil-coated polypropylene, ordered from China because that was cheapest, and we had to hand sew it — all 15 x 3.5 meters of it! It's fire resistant, thankfully, and it helps heat the downstairs area as the sun hits it at an angle and reflects warmth, and it gives a lovely tinted light, casting a glow across the studio. Before that we did the showroom for Six, the fashion agents who represent B Store on Savile Row. It was a really noisy space, so we decided to line all the walls in soundproofing foam that we had laser cut in Germany. We were really specific and calculated all the angles. The budget for that was more like 20,000 pounds, but I think we made 500 pounds profit in the end. [Laughs.] When you're starting out, you want each project to be as good as it can be, so you'll sacrifice the money to make it perfect.

CR More recently you completed something for Touch Digital, didn't you?

PM Yes, we did a really big office for Touch Digital in Shoreditch, who do all of Tim Walker's photo retouching, as well as work for Dior, Chanel, and others. They are kind of a big deal, actually, and it's the thing I'm most proud of so far. Touch Digital is all about light — letting light in, and letting light out, and about photography — and the problem with the old studio was that it was really dark, because everyone was retouching on screens and needed to block out light. So we made freestanding booths with louvers so that people can shut themselves off if they want to, but reopen these cubes to be social and in daylight when they're done. And they are really happy with the result. It's just very simple finishes, and the need to absorb noise in certain places influenced the finishes we chose.

CR It seems to me that your work is incredibly material based and that the choice of materials is the fundamental starting point for a lot of your

projects. Your concrete bowl, for example, which comes in four segments that fit together — it's concrete because it can be cast and polished, a humble material elevated to create a product with finesse.

PM We try a lot of things out. I like to mix manufacturing processes with materials or to use an unexpected material and a manufacturing process that you wouldn't necessarily expect either. Like the bar we just designed at KXFS, a temporary bar and restaurant in Kings Cross. Again, there was not much of a budget, so for the bar itself we stacked two tables together and added a bench on top. Then we just clad the whole thing with pink, individual ash batons. It took three days to install because it needed to be perfect. Now it looks like a very fancy giant fence. Each component was hand dyed in our studio, one by one, and each bit of wood took about half an hour because of polishing and waxing. Basically, there were six processes to get it to that state. So now we need to apply the whole process to something else. I'm working up a collection of furniture using the same idea.

CR You make a lot of stuff in your own studio, like the Yachiyo Metal Rug [2010] for example. Did six people really work on it?

PM Six people, for three months! We started making samples of a chainmail rug and discovered this fantastic Japanese twelve-in-two pattern. No matter what we did, it always formed a hexagon, and the hexagon was going to get bigger and bigger and the geometry was always perfect, and that's why it has this perfect shape, because its angles are 30 and 60 degrees. I became really obsessed with the idea, and just pushed it and pushed it. It's virtually indestructible. It could last many lifetimes. But it did also take thousands of man hours.

CR Where is it now?

PM It sold for a lot of money — a big contribution to the deposit for the flat I'm hoping to buy in Hackney. It was bought by a private Italian collector who is amazing. It's so easy to think that art collectors are just people who are richer than we are, but this woman has an incredible knowledge of the arts and of design, and I felt so happy to sell something to her.

CR What else is in her collection?

PM Everything you could think of. When we were there, 100 individual David Shrigley sculptures — little mini cast pieces — had just been delivered. I was like, "I've just seen these at the Hayward Gallery," and she's like, "Yeah, I really like them, they're really fun, and I like the process," and I'm like, "Ahhhhh!" There are Franz West pieces...

CR Where does she live?

PM In a beautiful apartment on the Embankment in London. They are extremely down-to-earth people and super simple in some ways. But they have impeccable taste at the same time and now I'm part of their thing and don't feel worthy of it.

CR	Well, 2012 has been a pretty good year for you: Designer of the Future, Artek, Swarovski, not to mention the special pieces you did for Kvadrat earlier this year in Milan. It seems like you're moving onwards and upwards.
PM	It's not like I get fan mail! [Laughs.] Just last year, when I went home for Christmas, my mum had to pay for my plane ticket. Then I came back in January and there was just so much stuff, both for myself and for Post-Office. The Kvadrat show, for example, was very exciting. We made stools composed entirely from Kvadrat material that is rolled up super tensely, so they are all glue and textile — there's no metal. We just made giant sausages out of the stuff that we rolled up. And working with Artek was a highlight — I'm obsessed with that company. I guess I should be saying Alvar Aalto more than Artek, but also [Ilmari] Tapiovaara. It's about the quintessence and longevity of their design. I'd love to design a piece for Artek, though I guess what I like is that they don't produce much new stuff, and their whole brand is about things lasting forever. Everything I buy for my house, I plan on having forever. I don't believe in fashionable, replaceable furniture. I really hated the 90s, when people tried to make themselves into design stars by wearing pink suits and were churning out a trillion injection-molded plastic chairs that were just horrible to begin with, and would end up in the landfill. I dislike that kind of consumerism and Artek is the antithesis of it.
CR	If it's not going to be Artek, who else would you like to work with?
PM	Well, Cappellini would be fantastic, just because of the amount of leeway they give their designers. I also have a project I would like to show to Moroso. And when it comes to lighting it has to be Flos, to follow in the footsteps of Castiglioni.
CR	And what's the one piece by somebody else that you wish you had designed?
PM	The basic three-legged stool by Alvar Aalto, which is a stackable piece of genius. It doesn't get better than that!
CR	What's your own home like?
PM	It's really a cliché: it's a big loft right in front of Clissold Park, completely white, with a painted concrete floor, and bicycles hanging on the wall. It's very simple, it's utilitarian. And I own an insane amount of Eames furniture — I have a dealer whose name I will not divulge!
CR	And you live there with...?
PM	My boyfriend of three years, Mr. Alex Mercer. He's an assistant director, working in movies and television. He worked on that film *Weekend* that came out last year, and he's currently doing something with David Tennant for the BBC.
CR	Does he have a beard?
PM	Of course he does! But it's a bit smaller than mine.

NEW YORK

PETER MARINO

Interview by Horacio Silva

Peter Marino is busier than a one-armed fan dancer. When PIN–UP met him, the New York–based architect was juggling an impressive list of major projects, including a high-rise condominium on New York's Upper East Side, Sotheby's new headquarters in London, a hotel in Abu Dhabi, and an office building in Mumbai. The undisputed king of retail, Marino was also working on the new Louis Vuitton tower in Tokyo, as well as on flagship stores for Christian Dior in Moscow, Chanel in Shanghai and Dubai, and Ermenegildo Zegna in Hong Kong. Not that success has gone to his head: he was just the same as ever when PIN–UP caught up with him in his Manhattan office — a divinely loquacious and irreverent diva in leather.

Horacio Silva	The massive David LaChappelle photo of you in head-to-toe leather in your lobby is quite a statement, mister!
Peter Marino	Well, I am very shy. [Laughs.] You know, David and I knew each other from the Warhol days, when we worked for 100 dollars a month, or whatever it was. I lost touch with him when he moved to L.A., but we reconnected when he came back to have a big show at Tony Shafrazi's. I told him how my whole life I was thinking I'd have Andy Warhol do my portrait and then he died. So I said, "Darling, before you die, let's do a portrait."

HS How was it working with him?

PM I'm glad I did it, but it really was a lot of work. He's such a perfectionist and nothing is ever right. I spent eight hours raising the bike or my feet a quarter inch at a time to get just the right angle. At one stage, I was standing on blocks and looked like a biker ballerina on points.

HS Very dainty. Actually, this is as good a time as any to talk about leather. I've read many interviews with you, but the weird thing is that even when a portrait of you in leather accompanies the story, it's still like a big pink elephant in the room. It's just never addressed.

PM You think? I've never thought about it much but I'm happy to talk leather! For me, it really started when I got back into bikes in a big way about ten years ago. The first thing you learn is to make sure you wear the appropriate clothing. You have to make sure you have the thickest leather jacket and pants you can find because one day you're going down. And yet I see all these idiots on their bikes dressed like they're going to the gym. A very good friend of mine was on his bike and got clipped by a motorist. And because he was, like, being free and riding in a T-shirt, his arm permanently looks like...

HS A war wound?

PM Exactly. If you go down on your bike on a bare arm, it isn't pretty. So I really did it as this sort of protective mechanism for biking. And in time, it became a large part of my persona.

HS So you're telling me it's more a lifestyle choice than a sexual one?

PM Uh-huh.

HS But you can't be oblivious to the sexual connotations. Hello, S&M?!

PM I wouldn't know about that. [Winks.]

HS Okay... Say I believe you (and I don't!), it's still an interesting comment, albeit accidental, about being an architect and always being submissive to the client.

PM Totally, I see that. Trust me, architects are forever bending over for the

client. But, if anything, for me it really is more about being a black sheep in this profession. Just ask other architects about me. I'm just not "rah-rah" about the profession. As a matter of fact, I'm usually mouthing off about what idiots architects are. I have no sympathy for them.

HS What in particular don't you like?

PM I don't like the way they protect themselves, and I don't like all that business of the way they speak. Archi-speak makes me want to vomit.

HS It can be very impenetrable...

PM It's retarded. You know, nothing is flush in architecture — it's "co-planar." Clients don't talk like that, so could you please stop it? And I don't let my staff talk in archi-speak. When they arrive, they're all excited, with their Yale and Harvard archi-speak, and I go, "Guess what? We just talk normally here."

HS What else galls you about your calling?

PM Don't get me started. The profession has all these cultural overlays that are truly repellent, especially the way it exploits the young. And it's so annoyingly intellectual. The truth is I'm just about the way it looks. I don't brand myself as an intellectual architect; I'm a visual architect. I remember reading a review once by a *New York Times* writer. What's the fellow? He's passed away now...

HS Herbert Muschamp?

PM Yeah, Herbert. He was so great. He was writing about a Rafael Viñoly building in Tokyo and he just came out and said that it's beautiful, that there was nothing else to add. And for me, that was such a valid thing to say, even though, in the world of intellectual architects, you're not allowed to discuss whether something's beautiful. You just have to ask whether it works *intellectually*. "Do the transparencies, you know, co-align?" They're such insecure mongoloids. Why would anyone talk like that? Architecture is really a sad-sack world. We pay by far the highest insurance premiums in the world. I mean, triple what doctors pay, okay? The American Medical Association is so out there, screaming on behalf of doctors, but the American Institute of Architects can't even afford a lobbyist in Washington. And, you know, we are the only people in the world who have lifetime liability. Did you know that you can sue the estate of an architect 50 years after he's dead if you trip on his stoop? Where are all you fucking geniuses who went to Yale and Harvard? Is anyone pushing for legislation that makes even a little bit of sense? Consequently, the profession has embraced a gallows sense of humor. Everyone talks about being such losers. I don't want any part of it.

HS Hence the leather?

PM Well, it's definitely a way of being contrary and distancing myself. Actually, I have a funny story. The other day I was walking out of my doctor's office,

who is amused by my physical presence, and he asked a female patient of his, who turns out to be a rather prominent New York art dealer, to guess what I do for a living. Her first guess was choreographer. No. She then said fashion designer. Which, you know, is a pretty good guess. And then the third guess was actor. When I told her I was an architect, she said, "Well, that's the best disguise I've ever seen." [Laughs.] But I'm not going to stand there in cheap khakis to play the role of an architect.

HS Where do you get your leather from?

PM I get a lot of it made. These pants were made for me in Paris, by Dior. And they've done some coats and pants and all sorts of stuff for me. I saw a great piece at the Z Zegna show, a beautiful black wool jacket that was very, very long. So I said to Mr. Zegna, "If you can make that in black leather, I will wear it." So they're making me one.

HS Do you have any authentic biker gear?

PM Tons. I guess these [pointing to pants] are a little recherché! [Laughs.] But there are great leather shops that I go to in London and the Village. I also get stuff from catalogs.

HS What do you ride?

PM A lot of things. [Laughs.] I have a Harley Davidson Night Rod Special and a Dyna Low Rider. I have a Triumph Speed Triple to ride here in town. And I've also got a Ducati Monster.

HS What attracts you to bikes?

PM I like the speed, I like the noise, and I like anything where I can get out of myself. When you're on your bike, you are so focused on not dying. I'm not thinking about my architecture projects in China, or about a project in Moscow that's a month late, or, you know, about a construction death in New York. I'm a very intermediate rider so I'm also attracted to the idea of getting really good at it.

HS You said that David LaChappelle was a perfectionist, but by all accounts so are you. We've been meaning to play tennis for ages so I did some reconnaissance on your game. According to the people in your office, you are incredibly competitive and have a trainer all the time to do drill after drill.

PM That's all true. I am highly competitive, and it makes me crazy. The truth is I don't really care if I win; I just want to do the perfect stroke. Look at Roger Federer — he is so wonderful and graceful to watch. And then you see people like Rafael Nadal, who just plays like a gorilla. What's the point?

HS How does that quest for perfection affect your work?

PM It's very painful. [Laughs.] It's sort of like having a permanent toothache because, even if you've done a job to perfection, you have to deal with

the mongoloids who then have to build it and they're not always on the perfection team. And then you've got to convince the clients that they need to pay for perfection. It's hopeless!

HS You're ridiculous. You must find it tough to let a project go.

PM Are you kidding? I never let go! [Laughs.] Never. The word "retentive" was invented for me.

HS So you follow up with memos about how they should live in your space?

PM Nonstop!

HS You do? I was joking...

PM Oh, I'm terrible. Lawyers' letters like you wouldn't believe. You know, "Please remove my name from that project, since you just changed that door." [Laughs.]

HS You've been an architect for 30 years, but your focus of late has shifted radically to large-scale architectural projects. How did that come about?

PM Architecture is the perfect example of a catch-22 profession. You're a new architect, you haven't built anything and you haven't worked anywhere, so nobody wants to hire you. So I started off doing private homes, which is the easiest work to get as a young architect. And it was great because I was lucky and my first three clients were Andy Warhol, Yves Saint Laurent, and the Agnellis. That led to a lot of work — and press — but they were homes. And being an architect can be like being an actor: once you've perfected a role, no one's going to let you break out of it. If you're Herzog & de Meuron and you do some good museums, then you do museums the rest of your life. So breaking out of residential was next to impossible. I didn't get a nonresidential job till Fred Pressman called me in 1985 and said, "You know, we're looking for a designer for Barneys."

HS He actually ended up being your yenta of sorts.

PM Absolutely. It was through him and the Pressman family that I went to Europe and started attending fashion shows. As a result, in the mid to late 80s, I met every single major designer because Barneys was carrying them all. And I ended up working for many of them.

HS So you went from scatter-cushion queen to retail king.

PM Yes, and did nothing but retail for the next 20 years! Then, finally, in about 2000 or 2001, I got hired to do the presidential suites and the Ty Warner penthouse at the Four Seasons, the I.M. Pei Hotel in New York. It's interesting because by the late 80s/early 90s, if you were a fashion brand and didn't have a name architect, nobody took you seriously. But for the most part hotels were done, and I guess they're still being done, by super-hideous commercial firms from South Africa and Columbus, Ohio, or wherever. And they just turn out these hideous hotels, all of which look the same. I have

to say, there are a few coming up that are sort of gorgeous, especially in Germany, but it's a nascent concern because the market hasn't demanded it. Up until now, the market demanded, you know, the beige-marble paradigm of the Four Seasons, until Four Seasons really tripped up and started making the same building that they were building in Ohio and putting it in Marrakech.

But the Four Seasons was a very good foot in the door for me. All of a sudden, I became considered for hotels. Then, in about 2002, we got hired by the Aga Khan to do the Yacht Club Costa Smeralda in Italy, which is part shopping mall, part 40-room hotel, and part private club. It turned out that eleven of their key members had already had their houses done by me. Again with the residential! [Laughs.]

But, yeah, certainly the scale of the projects has upped dramatically in the last few years. Now we're getting endless hotels, and once the fashion brands started building buildings — Vuitton gives me buildings, Chanel gives me buildings, Zegna gives me buildings — that gave us a big portfolio of completed buildings, which in turn led to more work.

HS Given that you build all these temples to luxury, you're a good person to ask to define luxury today. I mean, everyone hitches their wagon to "luxury" — it's the most trite, overused word.

PM I so totally hate that word. But I don't know if luxury is any different today than it's ever been. What I think happened is that after World War II we entered this era of simply hideous "brave new world"-style engineering, and luxury became synonymous in the public imagination with decadence. But luxury is not the Sapersteins doing Versailles in Los Angeles. That's Sponge Bob Square Pants — it's a cartoon, a joke. A gold Louis XVI bathroom is not luxury, it's vulgarity.

But the truth is, I don't have a problem with modern architecture being luxurious per se. Many modern architects do. A lot of them think you're not really modern unless you build in concrete; no, that just means you're good at parking garages! [Laughs.] Just because I like a very bare aesthetic doesn't mean it can't be made out of some absolutely gorgeous material. I think the most luxurious thing in the world was the Barcelona Pavilion. What is more luxurious than perfect proportions, perfect aesthetics, and wide-open spaces punctuated by the most perfectly placed pieces of green marble?

HS A lot of people may not know that you're an avid collector. What kind of stuff tickles your fancy?

PM I collect art, photography, rare books, antiquities, 19th-century American silver, porcelain.

HS Was collecting porcelain a hobby passed on by Warhol?

PM Yes. I think a little of his obsessive-compulsive collecting disorder rubbed off on me. I started with cookie jars, of all things, and as I got more money

that morphed into porcelain. I still have my original 120 cookie jars that I would get with Andy at flea markets. And I have a huge collection of 19th-century porcelain, which Andy hated because it was Victorian, which he considered the most disgusting thing in the world. [Laughs.]

HS How did you meet him?

PM I was in college at Cornell, and used to drive to New York every weekend, and a fellow called Ed Wall, who was in my architecture class, basically brought me to the Factory.

HS How friendly were you?

PM With Andy? Pretty friendly. I mean, I was friends with him from 1970 till he died in 86. When he bought his town house, he hired me as the architect. And when the Factory moved, from 33 Union Square West to 860 Broadway, I was also the architect. Andy basically put me into business and hooked me up with a lot of people. There's a funny story of him giving me the first check. Andy, who was notoriously cheap, gave me a check for 150 dollars. I was so excited because my rent was like 111 dollars at the time, and I knew I could live another month without being thrown out. [Laughs.] And he said, "If I were you, I wouldn't cash the check, because someday my signature's going to be worth so much more than that." I just thought he was scamming, but he was right.

HS What was his taste in architecture like?

PM Andy's favorite periods were ultra-modern, Art Deco, or the aesthetic of early, early, early America. He had a great knowledge of early American furniture, and for me it was so fascinating hearing one of the world's leading modern artists talk about that kind of thing. I would say, "Isn't that a bit granny, Andy?", and he'd say, "Yes, it's totally granny!", all excited. Do we care if it's granny if it's great? You know, if you go to modern architectural school, they put such horse blinders on your aesthetics, telling you what you're allowed to like and what not to like. Andy removed the blinders.

BERLIN

JÜRGEN MAYER H.

Interview by Carson Chan

In architect years Jürgen Mayer-Hermann is, at only 47, a child. As it happens, he also counts among the profession's current *enfants terribles*, designing in the face of prevailing tastes and conventions. In 2011 the architecture community watched in jealous disbelief as his firm unveiled the gargantuan Metropol Parasol — the largest wooden structure in the world — which has transformed several blocks of central Seville into a fecund hub of civic activity. More often than not, designs of this type remain unbuilt, relegated to a hard-drive mausoleum for stillborn fantasias, but somehow Mayer manages to make his utopias reality. He began his practice, J. Mayer H., in the ideological free-for-all that was mid-1990s Berlin. From there he constructed a vision of unmitigated optimism, choosing futurism over fears of the ecological unknown. To many architects, his buildings, his practice, and his success are confounding. But as more and more of his creations become part of lived reality, a question arises: if architecture does indeed shape the way we live, what would life be like in a J. Mayer H. world?

Carson Chan	Your first passion is art. When did architecture take over?
Jürgen Mayer H.	I've never been interested in the closed definition of disciplines. It's more the blurry boundaries that catch my attention. I still have this old book about 20th-century art and architecture in Stuttgart that my parents gave me, and I became obsessed by an image of Erich Mendelsohn's Schocken department store from the late 20s. As a teenager I was into art and drawing, and buildings became a fascination when I saw works by Richard Serra and realized the relationship between art and architecture could be seen as a question of scale. Basically, I wanted to make something that people could walk around and through. Architecture just seemed to be a logical choice, so I enrolled at the University of Stuttgart. German architecture education in the 80s was very much about how to become a real architect, but at Stuttgart I was also opened up to architecture's cultural dimensions, to materials, the senses. From there I went to Cooper Union in New York, where the dean, John Hejduk, pushed for a lively discourse, clashing ideas and positions for the pursuit of a new architecture. John tried to bring out a personal position towards architecture in his students, and later, when I went to Princeton, Liz Diller, Mark Wigley, Beatriz Colomina, George Teyssot, and Alessandra Ponte helped me zoom out and see things through a larger social lens.

CC You make very idiosyncratic forms. Would you say this sprang from your Cooper days?

JMH Cooper was definitely an eye-opener on that level. I remember I was given the Book of Genesis and asked to make architecture from the Noah's Ark story. How do you make architecture from a narrative? After struggling for two months, I had a breakthrough. I analyzed the text through modern-music compositional techniques and out came multiple mutations and deformations of a grid structure, all gradations from orthogonal frameworks to smooth organic systems. My discovery wasn't about how to make forms, but that cultural expressions are not necessarily opposing entities — that everything is in dialogue with everything else.

CC Tell me about your obsession with Conlon Nancarrow's music.

JMH I remember hearing Conlon's music on German radio in the mid 1980s, just before moving to New York. I was completely puzzled by it. It was music composed for the player piano, and it sounded completely alien. I didn't catch who the composer was and this was before the Internet, so when I arrived in the States I went to the American Society of Composers, described to them what I'd heard, and they identified Nancarrow for me. What is so fascinating is that player pianos are controlled by huge rolls of perforated paper: where there is a hole, the piano knows to play a specific note. It's a machine that

allows information to be translated into the experience of music. It is a kind of pre-computer music. A friend at Princeton's music department knew Nancarrow, and in 1993 I made a trip to visit him in Mexico. Usually I don't want to meet people I really respect for fear of disappointment, but I really wanted to see where he worked and lived. It was magic to see a place where music gets punched! We had lunch with his wife and son, and sat in his studio listening to his perforated paper rolls, and he gave me a sketch roll of one of his compositions.

CC Is the nerdy Jürgen, obsessed with obscure contemporary composers, the same one that compulsively collected data-protection patterns like those you find inside bank envelopes?

JMH Well, the interest in data-protection patterns came a little later. What you're hinting at is my interest in repetition, iterations, and patterns. I'm not only interested in these topics visually, but how they suggest ritual, conformity, and social contracts on how to behave. Think about Conlon Nancarrow — the composition is precise, controlled, tight, but the sonic results are mind-blowing. Now use this to think about, say, the weather, tourism, fashion, and we start to see how through patterns we can understand the complexity of society's inner workings. Technology, and the human experience of it, is important to both Nancarrow's music and the data-protection patterns.

CC The experience of patterns is something you've explored more through art installations, right?

JMH Well, I've always been thinking simultaneously through art. I made an installation at Storefront for Art and Architecture called "House Warming" [1994] where I put temperature-sensitive surfaces on walls and furniture — like those Hypercolor T-shirts from the 80s, but made into a room interior. When you sit on the chairs, your body heat changes the seat's color, revealing what's beneath your clothes. The architecture quite literally exposes something of its user.

CC Okay, that's scary, but I like that it's also unabashedly perverse. Looking at the Sarpi Border Checkpoint on the frontier between Georgia and Turkey [2011], or the Cumulus building at Danfoss Universe in Denmark with its mutant-half-pipe silhouettes [2007], I'm thinking that the production of perversity is basically a technique in your practice. The first time I saw images of the Sarpi building, I took it as a dare. It was like you were saying, "You didn't think we were going to go through with this? Well look at this, we just did!" The building has all these gratuitous curves, these seemingly irrational gestures.

JMH Why do you think these kinds of forms are not allowed?

CC Of course they're allowed, who's going to stop you! But you agree that it's completely contrary to received tastefulness in architectural design. I think that's what's so powerful about your forms. They're presented as challenges

	to other architects.

JMH Sure, but I would say that our shapes are more nuanced than that. Look at Cy Twombly's paintings and drawings. I was completely obsessed with how he de-trained his hand. Some of his work, you can say, is kind of kitschy, but it was as if he was producing drawings that wouldn't be made by someone who went through a couple of educational processes. It was never childish, but he was determined to untrain his training. That's a quality I also see in both the border station and the Danfoss project. They're about trusting the initial impulses of design. You look at your sketch and think, "Well, actually we don't have to go for more, we can just try to see if this works." For the border station, I wanted to question the idea of a border being a perfect linear divide between two sides and to pose it as a place that encapsulates space. I drew an undulating curve that had these pockets and folds of space. We designed a border station that could be used as a meeting place: there are rooms there that one can rent out for conferences, there are viewing platforms, and so on. Basically, these programs were produced by a simple diagram — a straight line becoming undulated.

CC Would you say that provocation is part of J. Mayer H.'s modus operandi?

JMH I would rather go with irritation, which is subtler and slower and goes down deeper. That also includes irritating ourselves. In retrospect, of course, these projects seem to be clearer than when we were developing them. It's a very messy process. It's trial and error. You're constantly uncertain and filled with insecurities. There is always a moment when it feels right, and this is a moment when intuition rather than rationale takes over. What is maybe the greatest discovery after 15 years of production is that I feel like I can trust my intuitions.

CC If you're creating irritation, when it feels right is also when it feels wrong, no?

JMH Things can get so bad, so ugly, that they loop around and become good. Sometimes when we get so off track, we discover completely new potentials, and this feels right. Design is something that is beyond arguments and justification. Ideally, at some point, I don't want to have to answer questions anymore. The work will just exist and there won't be any why or how.

CC Your designs recall for me a vision of the future from the past — a time when thinking about the future was still exciting. What does architecture have to say about the future? By and large, architecture today is stuck in a holding pattern, waiting for something to happen, waiting to respond. Your work escapes this. Much of it has the same look and hyper-optimism of "The Jetsons" — the extravagance of the forms points towards the extravagance of thinking towards utopia. "The Jetsons" came about at the same historical moment as Disney's Tomorrowland. They had these rides at Tomorrowland where you could see what the world would look like in the future, and all the buildings there had unconventional shapes. Outlandishness of form indicated that this was a world that existed beyond the trajectory of how

the world was then developing.

JMH Hey, my personal little theory is that we're all constantly reworking our childhoods. For me, creativity has a lot to do with recovering a lost innocence. That, and also that I went through architecture school in the 1980s and 1990s — I'm possibly reacting to the backward-looking frames of Postmodernism and Deconstructivism. As a society, we're definitely looking at the future again, but always in terms of responsibilities, cautions, and potential catastrophes. I refer back to this moment in the past because there was this excitement, energy, and risk of discovery. I like to think of our buildings as a trailer to a future that might not happen, but which is completely possible.

CC Were there many Panton chairs in your childhood?

JMH No, no, I'm more taken by the Swabian style of 1970s architecture. People used a lot of brown anodized façades, and there were many 45-degree chamfered corners, often applied to office buildings. I don't know why, but I was fascinated by this style of architecture. It was also a moment in architecture that welcomed rethinking of the boundaries between interior and exterior, that both can be seen as landscape. I saw all these houses back then with sunken living rooms, central fireplaces, split levels, and so on. It was a moment when even non-architects were questioning how to live and how they wanted their home to be. Today we standardize everything to ensure a good resale value.

CC You put sunken living rooms in your new apartment building in Berlin! But could chamfered corners and interior landscapes bring back this dynamism to society? Is it not just an aesthetic solution? Are we confusing how things work with how things look?

JMH At least it's a starting point. Look at Claude Parent's work with oblique surfaces, where spatial configurations were culturally or socially charged by challenging certain ideas and conventions about how we live. I think the chamfer is one way of looking at a different possibility, going away from a tectonic understanding of space towards an open-envelope way of seeing space.

CC Unlike other offices today that have established a strong stylistic voice, J. Mayer H. has made almost no bread-and-butter projects. You seem to have gotten your way every time, no?

JMH It wasn't a choice — it's just that we never got a so-called normal job. In the competitions where we tried to design to please a jury, we never won. We always won when it was something different. The town hall near Stuttgart [2002] was a lucky moment where the jury and the client liked the project. I would say this project opened up my practice into the way it is today. My interest in patterns is there, interactive technology is there, complex spatial and sculptural ideas are there, referencing 70s materiality is there. We've been through so many proposals and competitions that, in the end, it

only makes sense if you do something you believe in and want to spend the next three to five years working on.

CC Berlin is not the most architecturally ambitious place in the world. Why did you choose to settle here?

JMH Berlin became interesting as a home because after I finished school in 1994, I had no work opportunities in America. I'd really wanted to work for Diller & Scofidio — Liz was my thesis advisor at Princeton — but they had just one employee at the time and the position was already filled. A bunch of architect friends were moving to Berlin and saw the capital as a test bed for new ideas. Architecturally, almost everything went kind of wrong for the city from then on, but it's still a great place to work and to be around creative people. That my work never resonated with politicians or clients here has now become an advantage, since it forced me to develop an international career.

CC It's what people say about the art scene, too — there are so many great international artists that live here and work here, but don't often show here. Berlin is kind of an incubation tank where people can test ideas, and then realize their potential elsewhere.

JMH It feels somehow like living under cover, like living a camouflaged situation. Even my place here, my apartment, feels like a camouflaged situation rather than showing off. I think Berlin is similar. It's the producer, the lab, the studio — ideas get condensed somewhere else.

CC So if we contextualize your practice internationally, rather than just in Berlin, who would you say are your peers? What lines of thought in architecture are you sharing?

JMH I never know how to answer that question. Let's just say I share many interests with my many friends from around the world. Relationships these days are always blurred — you work with friends and you party together. This is the norm now, right?

CC Well, what I was trying to get at is my perceived lack of a collective voice in architecture today. The Modernists were all sitting around in living rooms dreaming about the future, their role in society, and staking their positions. Why aren't architects today saying, "This is what we believe"?

JMH Why do you expect that from architects? Would you expect that from artists?

CC It comes from a romantic view of architecture being something done out of a sense of social responsibility. It seems, more than art, to be something that confronts the general population on a daily level, and which therefore probably requires more consensual thinking between other architects, engineers, and planners. The image of all these Modern-architect guys sitting together saying, "We agree on this," is the image of collective development, no?

JMH Were the Modernists successful in that way? Actually, I'm happy that it

doesn't exist anymore. I don't believe in a men's club that finds the solution for the world. I think that it's healthy that architecture practices operate in a kind of acupunctural way, where everybody does their own projects and individually tests the possibilities of the discipline. I'm interested in the variety, in different solutions, rather than the quest for one method that solves it all. That's actually a scary idea. We don't always have to find consensus.

CC Are you the kind of architect who aims to make your clients happy, or would you say you're more disagreeable?

JMH Buildings only happen if there is an affinity between at least two people, the client and the architect. We very much listen to our clients; we're not difficult architects to work with, and we like to be pushed and pulled. We're chosen because of our projects. We need clients with curiosity who see architecture as an adventure into something unseen. And so far we've been very lucky.

CC Metropol Parasol in Seville, your largest, most complex project to date, was the result of a winning competition entry, and it's impressive that the final structure looks so similar to the initial renderings. Did you enter the competition thinking that a giant wooden amoeba-mushroom canopy would win? Or did you enter the competition to make a statement?

JMH Seville kind of just happened to us. Around October 2003 we had just won a competition for a master plan of Potsdam, but the client kept pushing back the date when work should start. I had all these people in the office with nothing to do. A friend from Seville told me about the competition and, with time on our hands, we decided to do it to test some ideas. Very early on we made this kind of cloud-on-legs thing that is the building today. It was about the shadows the structure would cast, and it was a reference to the huge trees typical of the plazas in Seville. There were ten firms that made it to the second phase, and I was really surprised that we were one of them. The competition was all online, very public, and, when we saw that our project was so enthusiastically discussed in the blogs, we became very energetic to push ahead. In hindsight, I see many echoes of the Noah's Ark project from Cooper Union. Here too, I thought about how regulated structures and organic forms come about together.

CC It was completed just a year ago, so it must be amazing to see how the scheme has taken on so many different roles and functions already. It's essentially an observation platform that provides shade, but when the protests against austerity measures in Spain took place there, it really became embedded in civic life on so many levels. In some images, it almost looked as if the crowds were protesting against the structure itself and the expense it represents.

JMH Sure, it was the general dynamic in Spain then, but people are starting to see that Metropol Parasol was not only an expense, but that it's also an economic stimulator, an investment in the future that already pays back. The businesses around it have seen a 30-percent growth in sales. It's also been incredible to

see how it has been enmeshed in many iterations of public life from the very Catholic Semana Santa to the Gay Pride parade. For the austerity protests, it became a campground, a forum for public discussion, and a temporary concert venue. I think that it has already been in four music videos and a Spanish thriller movie. For some reason, it was on the poster of the cartoon festival, too. To see how people take it on, make it their own, use it, transform it, play with it, identify with it — this is the most rewarding part of being an architect. It's a great payoff after eight years' work. Might I add that we have the former mayor of Seville to thank for this — he pushed it through so many hurdles.

CC You've had the mayor of Seville as a client, and now the president of Georgia!
JMH Well, let's say the government of Georgia.

CC I heard you were personally invited there by President Saakashvili?
JMH So, Metropol Parasol was published in a book that the president saw, and then they invited me for a discussion about a project in the center of Tbilisi. This project never happened, but a discussion started and, little by little, we started working together. Except for the airport in Mestia [2010], most of the projects have not been for building types one normally associates with great architecture. We've been making highway rest stops, and of course the border station you mentioned earlier. These projects have been exciting because we're bringing a quality to spaces that aren't usually seen as having potential. I would rather do a sewage system than a memorial.

CC The Georgians have commissioned so many projects. To date there are, what, 15?
JMH Yeah, something like that.

CC Seeing your Georgian projects sprouting all over makes one think that the Jetsons' world could actually become reality. It's amazing to think that these forms that we don't see in conventional building today could soon populate a large part of one's visual environment. You said that architecture conditions the way we behave. How would we behave in a J. Mayer H. world?
JMH Form is not necessarily only what you see. It is a demarcation between two conditions. So, metaphorically or not, people would hug and poke the walls. Think about the "House Warming" project. I loved that people touched the walls with their bodies, that sitting down was about leaving a physical trace, something personal, that architectural surface becomes a temporary projection of its users. Grasping also means understanding. Bringing your body in contact with another surface brings about moments of simultaneous clarity and confusion.

CC So this is a world where people are sensing, touching, and grasping their surroundings and each other all the time?
JMH Yes.

LOS ANGELES

THOM MAYNE

Interview by Katya Tylevich

I should have brought a Bundt cake. Thom Mayne has just moved his firm's office from Santa Monica to Culver City, and here I am empty handed, save for my tape recorder, which seems an uninspired offering for an architect of his standing. Mayne has never been busier: between his multiple intercontinental projects and competitions, there are lectures and symposia, copious awards to collect (which have included the 2005 Pritzker Prize), tentative bocce-ball matches, and also the President's Committee of the Arts and Humanities, to which he was appointed in 2009. (In the ceremony photo he is, at six feet seven inches, the only person taller than First Lady Michelle Obama.) Mayne's firm, Morphosis, is multi-tasking on several major projects right now, among them the much-talked-about Phare (lighthouse) in the La Défense district of Paris, a sustainable skyscraper, wrapped in a double skin, that edges in height toward the Eiffel Tower.

Mayne and I sit down at a small table beside his desk, which is located in the same big room as his employees. It surprises me that he wants to talk "in public" like this. We discuss the high hopes and low points of Morphosis (now 60-plus people strong), which Mayne started in 1972, the same year he helped found the Southern California Institute of Architecture (better known as SCI-Arc). At one point in our conversation, he calls himself "insatiable," an appropriate adjective for a man who comes to the office in the middle of the night expecting to see people working. Not that he's a slave driver: his ideal architecture atelier would come complete with a personal chef and on-site guitarists. Something to think about as Mayne oversees construction of the new Morphosis office, in progress just a few steps from the temporary H.Q. where we meet.

Katya Tylevich	Welcome to your new neighborhood!

Thom Mayne Right. My car doesn't even know how to get here yet! I've been in Santa Monica my whole life, so it's a bit of a jolt. For me, working and living are contiguous: I'll be at the office, leave for dinner, zip back to work, leave again, come back later — someone's still here working at four o'clock in the morning. Now it's a 40-minute roundtrip, instead of ten. That's a little tough.

KT So why did you leave Santa Monica?

TM Well, Santa Monica used to be fantastic, when SCI-Arc moved there years ago. It had all of these industries, where we could make anything in the world, cast metal, carpentry of every type — it was an amazing community. Now, slowly, Santa Monica has turned into Orange County. It's mostly the music, film, and T.V. industries, and the neighborhood keeps increasing in cost. Plus, the 405 Freeway is like a DMZ: it can take 15 minutes just to get on the on-ramp. So you're bound to become a Westside person in Santa Monica. We'd given up going downtown. I mean, I'm on the faculty at UCLA and still connected to SCI-Arc, so whenever I had to give an introduction or go to a lecture in the evening, I had to leave the Westside at 3:30 p.m. by beach, and bring my work with me to a café en route. But for our new office here in Culver City, we found a site right next to the new metro station exit. How many people get that in L.A.? In three years, I will be riding my bike seven blocks through Santa Monica, leaving it at the station, and then coming here by train. We're immediately going to give everyone incentives to take the metro. Slowly urbanizing the city, right?

KT What are you plotting for your new office right now?

TM Oh, we're going to make it a real L.A. scene: a garden, full-grown trees, swings, a fireplace, a bocce-ball court. I've thought about it for a long time. I'm going to actually make a real environment. It's going to be very simple, and in some ways, very non-architectural.

KT What does "non-architectural" mean, coming from an architect?

TM It means a high-tech loft space, a studio space. I don't want the new office "designed." First of all, my design keeps evolving and I don't want to lock myself into a particular idea. Second, this is where we make work, it doesn't itself have to be a piece of work. It will be a neat, clean, and highly serviced big white loft.

KT I heard rumors you're installing a pool in the office?

TM It's possible. Someday. [Laughs.] You know, my first job out of college was at Gruen Associates and they used to have an office in Malibu, way up in the mountains. It was so isolated that they had a chef provide them dinners, and they had tennis courts and a pool. It was a very elegant, appropriate

way for architects to work — a really civilized existence. I've also spent time in Switzerland, and there were several studios there that came with a guitarist and a cook, and so on. That, to me, is the classic atelier. At the beginning of the century, that's what architecture offices looked like. It got very corporate in the 70s, 80s, and 90s, but architecture used to be a hybrid between art and the business or "real" world. Without question, that hybrid is what attracted my generation of architects.

KT Do you consider yourself an L.A. architect?

TM People are going to say that. And to some degree, I guess I have to say it too, because I've made my career here, and a lot of my work could only be based in L.A., where there's a more relaxed attitude toward experimentation, and a benign climate, which allows for buildings that aren't so highly pragmatic in dealing with extreme weather. But I came to L.A. with my mom, when I was ten years old, because my parents got divorced. I'm an East Coast kid and much more of a New York guy than an L.A. guy. I'm direct and I say what I want. L.A.'s a Midwestern town, politer. I like confrontation. I'm an urban person. I do love L.A., but I don't connect to it like I connect to New York. That's my home, whereas L.A. is more a base of operation.

KT How does L.A. rank as a professional home?

TM For young architects here, there's a huge amount of work at a small scale — like residential work, for example — that can be very open to innovation and research. But on the next level there's nothing. Nothing at all. In 1997, we got the high school here — Diamond Ranch — but with that came Toronto [University of Toronto graduate-student housing] and the Hypo Alpe-Adria-Bank in Austria. That was the beginning of my practice, really, in terms of the scale of work that I looked forward to. It kept moving in that direction, and now, save for one project [Emerson College Los Angeles Center], we have just about no prospects in L.A. Our focus is now on Paris; we just finished one project in Shanghai [Giant Group Campus], and we're starting another in Beijing. Even in a city as large as L.A., it would be impossible to think of a practice as being "regional," unless it was very small and specialized. The point is, today architecture is an international practice, certainly for my generation.

KT Why do you make that specification?

TM L.A. had very good architects, like the Case Study House gang. They were the people I worked under, like Gregory Ain, Pierre Koenig and Craig Ellwood. They were fantastic teachers. And of course you had Ray Kappe, and your Schindlers, Neutras, and Wrights. But in my generation, the architecture shifted to a global interest. We were being published globally — not even for built projects, but for our conceptual work and research. It's funny, in 1980, *Domus* published a photo of a group of us on the beach: Craig Hodgetts, Robert Mangurian, Frank Gehry (with black hair, looking very young), Eric [Owen] Moss, myself, and my partner at the time, Mike Rotondi. Around

that point, somebody coined the term "L.A. School." And, really, I didn't even get it. It was just my life. I was 28 years old when I was involved in starting SCI-Arc. That was 1972 and we, the young architects, were invited everywhere: Europe, Japan, Thailand. It felt like the beginning of a culturally globalizing architecture, and my whole life has been like that. I was just at the Architecture Biennale in Venice and the joke is always that it's "one-stop shopping" — you see all the colleagues you've had an ongoing relationship with for 40 years. I'm 66 years old now, I started when I was a kid, and I'm seeing the same people I've been hanging out with through all these years of symposia and conferences, lectures, and various types of competitions. Maybe we see each other only every two years, but we sit down together and it feels like it's only been two hours.

KT You make it sound unbelievably friendly! Surely, not everybody feels the camaraderie?

TM Sure, there's a certain amount of competition, but I would have thought... Well, I don't really compete against anybody except myself. My demons are my own limitations. Anyway, every discipline has the same issue. You must be competing against other writers, other journalists, at times, but you also have a huge amount of connected tissue with each other, precisely because you're engaged in the same activity. You share emotional and intellectual characteristics, which bring a certain amount of closeness. Sometimes you lose some, and it's difficult and it really hurts, but you get over it, and you move on. There are other times that you get what you want. You learn to deal with the competition because you realize it's going to be with you your entire life. What's the alternative? Have no friends who do what you do? That's stupid.

KT Is this a lifelong philosophy of yours, or one developed over time?

TM One of the things so unusual to L.A., and SCI-Arc in particular, and now to UCLA, is that academically and professionally there's always been an incredible diversity of characters. Because of that, it's been volatile at times. Personally, I've been in sessions where you'd think we were going to kill each other — screaming and profanities — but somehow, that same evening, we'd be out drinking together. We'd resolve it. You can separate the issues from your own broader friendships. That's healthy. And SCI-Arc was an incredible place to grow up. It had a huge influence on me, there's no question. We were really engaged in asking the question: what is architecture?

KT It doesn't seem you ever left the academic world, despite your office's growing the way it has.

TM Actually, this office is deeply connected to the global academic world. We continually have students here and classes, people visiting from all over the world. We also create a great output of ideas — not just buildings, but also drawings, and objects, and books. Some work realizes our desires, and other work articulates our desires, in a different way. I like wearing multiple hats.

KT How do you find the time to wear them?

TM I have a pretty big appetite. I couldn't possibly work on just one thing at a time. If one project got all my focus, I'd go crazy. I need more. Also, cross-referencing is incredibly important to me. Sometimes, we're working on one project only to realize we're heading someplace more relevant for an entirely different project. Architecture is interpretive and extremely complicated to grasp, and you don't know toward what end you're working until you finally arrive there. I never start with a priori ideas. I start with questions, and I really enjoy the serendipity of that process. Plus, concentrating on a single work is difficult, emotionally. You get stuck. When you're working on multiple projects at a time, you have one that's going great and another that isn't, but they're at different stages. It's better that way, psychologically. You go home thinking, "Fabulous day on this one, even if we have to start from scratch on that one." It's more balanced that way.

KT So workaholicism is a mood stabilizer?

TM I don't know. If I don't have at least four projects in my life, I'm horrible. My family thinks it's hilarious. My wife [Blythe Mayne, who until recently served as CFO and "all-purpose advisor" at Morphosis, and still maintains an interest in the firm as owner] and two boys know when I'm in a bad mood. I just... I get down. I have to make stuff. I have to do something constantly, otherwise I'm unhappy. Right now I'm working on three-dimensional paintings, which I think aggravates the office because they think it's taking my energy away from real projects. It's not. Some of our projects are a little too pragmatic for me, and I'm upset because I have much bigger ambitions for them. But with these drawings, I can go wherever I want. They're ideas — they're not loaded with pragmatics. I need them. I have to go home every day saying, "I've got another thing in the works." I'm insatiable that way.

KT Were there times in your career when there just wasn't enough in the works, and you truly felt unsatisfied?

TM Of course. 1990 was a horrible year. I had 30 people and lost all of my work. Some of our projects, which I thought were among our better works, never got built and it was really, really tough. What happened then with the economy is exactly what's happening now — the real estate heated up, we had three big projects in Japan and one here, all Japanese clients, and then it all stopped in one week. They called it off: stop, stop, stop. And I had to let a huge amount of the office go. We kept about six people. We were supposed to start a school here, and it kept getting delayed, delayed, delayed, for an entire year. But by instinct, I couldn't stop. I ramped it up. I moved my office, built a new one (the one we just left in Santa Monica). People thought it was crazy. Well, it brought a ton of money to the office when it was broke. I did five books, five monographs, computerized the office, did a whole series of drawings that I later sold — which saved my ass. I was selling drawings that entire period to pay my rent. And I did a lot of artwork. Those two-and-a-half years were really tough for me, they were tough for my family. But I

look back now, and those were two-and-a-half years of the most creative work that I've ever had in my life.

KT Because you were competing with yourself?

TM On quite a few different levels. In architecture, you have to be able to initiate your own work and somehow create your own life and history. No one else is going to do that for you. Now, I tell architects who are in the same position I was in 20 years ago: "Do your creative work, do your research, stay alive, and use it. Because when you're really busy, you complain that you haven't got time to do the things you want. You don't have work now, so do everything you want to do, and be ready to go full speed when things happen again."

KT Has your competition with yourself changed over the years? To use your term, have you "ramped it up"?

TM I'm never quite comfortable with what I do. I'm always quite critical of it, although my self-criticism does go in different stages. Maybe now I am more comfortable than I used to be. I have an incredibly powerful office, and I recognize I'm working with a huge amount of talent that I put together. They're insanely dedicated. Come here any time of the night, and there will be people here. Come here on Sunday at five o'clock in the afternoon, and I guarantee there will be someone here. I get crazy people. Most people work to live, but architects live to work. This is an absurd profession. If you're just looking for a job, I can't imagine anything stupider than being an architect. It's something you have to absolutely love doing. It requires a huge, huge commitment, and it's tricky to negotiate the rest of your life.

KT So how do you negotiate the rest of your life?

TM I keep it simple. I have family and work. And that's it! [Laughs.] And I'm also very much influenced by my European friends: I take time off, I take real vacations. It's critical to leave at times. As with any art form, you do actually have to be living in that world to be interpreting it — you have to be a part of it, interested in it, engaged. You can't be buried in the studio. In essence, I think architecture is a social and political art.

SEATTLE

ROY
MCMAKIN

Interview by Michael Ned Holte

Roy McMakin loves making objects — especially functional ones — which explains why so many people consider him an architect or a designer. But whether making a house or a chair, he sees himself first and foremost as an artist. The notion of function has always been slippery in the art world, but that's the slope he slides on. Besides furniture and houses, his output over the last 30 years has included sculpture, photographs, drawings, and landscape projects. His work plays not just with function but also with scale, perception, language, desire, time, and memory. After studying in San Diego, McMakin moved to Los Angeles, where he opened a store, Domestic Furniture, and garnered lots of attention for his objects and interiors. His progress up the West Coast continued in 1993, when he moved to Seattle, where he now oversees a modest architecture office and Big Leaf Manufacturing, a sprawling shop producing his Domestic Furniture line. But success has done nothing to diminish McMakin's soft spot for abandoned furniture encountered on the city streets.

Michael Ned Holte	When I was in Seattle a year ago, you were very enamored of a green dresser you'd found on the curbside and photographed. Have you found any great objects recently?
Roy McMakin	I don't know where this came from, but over the weekend I was thinking about a way to describe the stuff that sort of rises to the surface in my life and many people's lives, the objects that you choose to want to look at and have around. And it occurred to me that a fabulous name for a vintage secondhand store would be "Cream of the Crap." I guess I'm saying there's always some object that gives the illusion of somehow making things better and either kind of clarifies something in my life, or feels like a treasure in a treasure hunt, where something is hidden away and lost, and then I discover and see the transcendence within the object. So I think it's more like, "What is the object of the week?", you know?
MNH	Yes, I do. And when you photograph them from all four sides, and from above and below, is that a way to clarify the object further?
RM	With the photographs you mentioned, I think I was trying to use a certain kind of veiled obsessiveness to say: "Here is this thing that I find fascinating, and I'm showing you that it's fascinating, but I can't, completely. As much as I try to capture my fascination, there's a doubt in my mind whether I can do it, even if I show you every speck of it. Are you able to see what I find fascinating?" I mean, that's one way to read the whole project.
MNH	We've talked previously about your objects as a kind of portraiture. In 2000 you made a piece titled *Two Chests, One with no Knobs, One with Slightly Oversized Drawers*, which is one of my favorites. One chest was a sort of blank, mute conundrum; the other was an empty skeleton with six white-faced drawers stacked neatly but uselessly nearby. You confided to me that the working title of the piece was *Self Portrait*, but that you chickened out and changed the name when it was done. More recently, I saw a dresser you made with one small drawer that didn't quite fit right and sits on top of the dresser, but the piece is otherwise normal. Is that piece a new self portrait?
RM	The new one, if it is a self portrait, shows that I view myself with increased functionality in the world because every drawer but one actually works. It's functional, and I sort of intend for it to go out in the world. A person could put their socks or whatever in the drawer. It's a lonely drawer, yet the face of it is painted a very bright white, and the rest is a slightly creamy, slightly darker white. So the drawer kind of glows. I guess you could say it's a slightly more psychologically healthy self-portrait.
MNH	That's how I read it.
RM	I'll tell my therapist!
MNH	Your body of work comprises houses and other buildings, furniture,

sculpture, lamps, photographs, and even performance, but you prefer to think of yourself as an artist. What's at stake for you in that definition?

RM I don't know if it's about what's at stake. I feel like "artist" is more accurate, and when I've tried calling myself a designer or an architect, it doesn't feel like what I do. I think that all of this is predicated on what other people choose to call these different professions, and I guess you could say that designers and architects deal with the same issues as artists do in terms of expressiveness and meaning and all those kinds of things. So it might just be that there's an inaccuracy with these existing labels. But there's nothing particularly special about being an artist versus these other things. I like to do sculpture, and I like to do drawing, and I like to do photographs, and I like to do houses and furniture. So it feels like the right label.

MNH You were a student of Allan Kaprow's, who for much of his career espoused a blurring of art and life. Is there a way in which a chair — and I'm thinking of your chairs in particular — might be seen as part of that blurring?

RM Yeah. I think when I left U.C. San Diego and my education with Kaprow, as well as with people like Manny Farber, the initial way that I wanted to put furniture out in the world was conceptual. I was trying to make the next statement after Scott Burton, who was an artist doing furniture, though it was always clearly meant to be seen as sculpture. Whereas I felt my objects were in fact pieces of furniture, and while it was conceived as an artwork, it was still a chair. And I still feel this way. I was very focused on a kind of everyday looking at the world, which I absolutely think came from Allan Kaprow and the blurring of boundaries.

MNH When you lived in Los Angeles, you designed furniture for "The Tonight Show" with Jay Leno. Were you thinking about that as an opportunity to exhibit your work in a domestic situation, by having it on millions of T.V. screens, or was it really just a gig for you?

RM I think during the time I had the Domestic Furniture store in L.A. I became very focused on the business side of things, survival, bringing work in. But I also saw opportunities to explore the circumstances and experiences of creating objects. I think it's really interesting to make things and see them out in the world. But in hindsight, I think I was kind of reckless or careless in terms of how the world saw what I was doing. If you look at Kaprow, he was pretty careful about the way his performances existed. I was less careful, but I look at the tons of things I did in those five or six years as an education in how objects come to be in the world.

MNH It always seemed you were more interested in the details of an object than its future context, lavishing lots of attention on a knob or the way two pieces of wood join together rather than thinking about how the thing's going to operate once out in the world.

RM Well, I think that was indeed the case, and I trusted that the objects would stand on their own as being interesting or not, and I think they were.

In San Diego, where I'd gone to school and lived, I was well recognized as an artist. And yet when I moved to L.A. and started Domestic Furniture, there were two audiences. One was the entertainment industry, and the other was the art world. And the art world didn't really know my prior work, so they saw me as a designer they found interesting. There was no sign hanging on the door saying, "This store is a conceptual art piece." I would argue it was interesting, in a charming, folk-arty kind of way. But I think it might have been smarter not to just assume everybody can read things quickly. That's been a criticism I've gotten over the years: that I attribute too much understanding to people, and don't see that, faced with the whole breadth of what I'm doing, they can't make sense of it, and that I should help them understand things a little better.

MNH You moved to Seattle in 1993. What's changed for you since leaving Los Angeles, besides the weather?

RM Well, I left L.A. for a few reasons. I'd been working with a variety of shops to build my furniture, but I realized I wanted to have greater control over its production and to get more deeply into the issues of craft. Ideally, I wanted to find a group of people I could work with for a number of years, who would explore my ideas with me, help me realize them, and add to them. I realized Southern California wasn't really a good place to do that, because there really weren't as many people interested in it as there were in other places. I selected Seattle for that reason, its being an area where wood and trees are part of the economy. All of those expectations have been realized here in terms of the way I work, and the shop I have, and the way everything is produced.

MNH I noticed you recently completed a shoe store named Rock, Paper, Scissors. The dominant color is gray, which you have often used. Do you see gray as a kind of signature?

RM It's funny you noticed that little shoe store, which is a tiny project that came about through Ian Butcher, who runs the architectural side of my office. It was fun, actually, because it was an inexpensive, very quick thing that Ian mostly ran, and an experiment with me giving some key direction, but kind of delegating a lot. And I think it was successful because everybody was happy with the process. I think gray is a wonderfully useful color. Or lack of color. The reason we put it in the shoe store is so that it drops away and shows off the white or the colors of the shoes. But I think it also has a really strong associative, emotional read. Certain things you remember in black and white or in gray, and some things you remember in color. Sometimes objects I make, or even houses, come out of the black-and-white memories, not the color ones.

MNH For example, the piece you did in 2003 called *Lequita Faye Melvin* — which was your mother's name — comprising 19 pieces of furniture from your grandparents' house that you re-created from memory. Could you talk a little bit about how memory operates in your work?

RM Well, memory was really the starting point for the pieces I did when I was first conceiving furniture over 30 years ago. My fascination with stuff — the topic we started with — started really young in my life, initially in our basement. We didn't have a lot of money, but we had a few odds and ends in storage. I thought of these as special pieces of furniture — cream of the crap, I guess — and I would bring them upstairs and put them in my room in place of my little bedroom furniture.

MNH That's perfect!

RM I also had a fair amount of discretionary money as an adolescent because I would sell these paintings of landscapes and stuff like that, and I would use that money to buy furniture. We moved around a lot when I was a kid. I don't think I had a sense of the past anywhere we lived, so I think I was trying to find or create some sense of past. When I started designing furniture, my explicit aim was to create pieces where time is ambiguous, so when people saw a piece they would be confused as to what point in time it was made, and if that ambiguity stayed with it as it moved into the future it might actually transcend style and exist outside of time. That led into my sense of architecture and the houses I do, with my feeling that if you can stare memory and time down hard enough, then you might have a chance of potentially transcending them.

MNH You showed me a ton of drawings you've done, but I sensed that that was really the tip of the iceberg. And, coincidentally, today I just received a really beautiful little book by Ron Padgett, a collection of poems he found but didn't really recognize as his own, although they must have been because they were in his handwriting. And I love that idea so much. Are there, in a similar sense, any "chairs I guess I made"?

RM I think in a lot of ways drawings are sort of like poems, and I think there are things that certainly surprise me. And when I look through them, instead of their coming back as a fully formed memory, they come back as more of a dreamlike thing, like, "Oh yeah, that..." Like, sort of remembered, but also sort of fresh. I didn't really focus on the drawings until about four or five years ago. I kept them, but I didn't really think about it, so when I see them now, they kind of evoke this sort of intense longing that I like. There's this furniture or this sculpture that I'm just so longing to have in the world. But it's expensive to make things, and how do you get all these things out in the world?

MNH Drawing is faster.

RM Drawing is really fast and really cheap. When I'm caught up in the stresses of maintaining a shop and making sure there's money to keep it all going, I have this fantasy of just doing drawings. It's just a kind of longing, you know, a fantasy world where I just sit in my calm, quiet, little life and make a drawing. And then I make another drawing, and then I make another drawing. It's all perfectly satisfying, you know? It's fully contained and has everything I need.

MNH You mentioned Manny Farber earlier and, because he passed away last year, I thought I would ask what you learned from Manny.

RM Well, I don't know if I fully know everything I learned. It sort of reveals itself in time, like any good education or any good teacher. But one thing I think I learned — and this happened beyond school, because I became friends with Manny and his wife, Patricia Patterson — was how to live, how to fill your time, how to make meaning. For me, it's a matter of trying just to show people the stuff of life around you, this cream of the crap, and to show the kind of love that can exist in life.

MNH That's a nice full circle.

RM Okay. Good.

RICHARD MEIER

Interview by Horacio Silva

Richard Meier needs no introduction. The éminence grise of neo-Corbusians is so culturally pervasive that he was recently name-checked on that loftiest of forums for architectural discourse, "The Real Housewives of New York City." A Pritzker Prize–winning rationalist's rationalist, Meier is also known for a prolific oeuvre that includes everything from major museums and civic commissions to luxury condos that have become as famous as their residents. Though he is now in his 70s, and walks with a slight limp, Meier has lost none of his intellectual curiosity or joie de vivre. PIN–UP caught up with him at his midtown practice, where he was nursing a visibly wounded hand.

Horacio Silva What did you do to your hand? Don't tell me it was a freak bowling accident!

Richard Meier No, no. Equally embarrassing though. I asked my housekeeper to leave something out for me to cook for dinner. So she put some oil in a pot and left everything ready for me — all I had to do was, you know, turn it on and throw in some chicken or whatever. But typical of the way I cook, I turned it on and then sat down to watch the news on television. Then I got up and I said, "Oh, gosh, I'd better, you know, do something here," so I put the chicken in and the hot oil splashed all over me. I can't turn on the stove without something going wrong!

HS You've designed enough restaurants by now to be fed for life. Remind me, was 66 in TriBeCa your first?

RM Yes, 66 was the first. I used to love that place — it was fabulous and the food was great. And even though they insisted I sit at a private table most of the time, I really liked sitting at the long communal table.

HS How very mid-90s Asia de Cuba!

RM I know, but it's fabulous to sit down and talk with absolute strangers. It's one of my great pleasures.

HS I imagine conversation with strangers comes easily to you. You've been a presence on the New York social scene for a while.

RM Well, I like to know what's going on. I mean, I do go to things and then wonder why. But I'm naturally curious. And, if I'm not working, you know, why go home and watch the news?

HS So it doesn't bother you being occasionally called a society architect or a latter-day Stanford White?

RM Not in the slightest. Stanford White, from what I've read, had a pretty active, rich life and he was also a great architect. A couple of weeks ago I was in the Racquet Club he did on 54th and Fifth. Beautiful place.

HS Does the dialogue you have with people in a city as diverse as New York inform your work in any way?

RM Not really. What's important to me, which informs everything we do here, is to ask the question, "What is the nature of public space?" How do people come together, and how do you make a place where people want to meet friends or other people? And I think that's what architecture is about. It's about bringing people together in an environment where you feel uplifted.

HS Do you see that successfully happening in New York?

RM Generally speaking, I think architecture is not high on the agenda in New York City. I don't go to clubs, so I can't shed light on that aspect. But let's

look at cultural events in the city. People go to cultural events not only to take in what's showing but also to meet other people. If you go to the Metropolitan Museum on a Friday night, which I did recently, you wouldn't believe the number of young people who go there to see a show and then have a drink and meet with friends — it's a great scene. I think it's fabulous when a private cultural event gives way to a public social event. But, in answer to your question, I don't think this happens often enough. I guess that's what makes my job exciting, knowing that possibilities to improve the city still exist.

HS Are there any areas of New York's development that you lament? I was walking through the Meatpacking District recently and — maybe because I'd just come back from Miami — I found it hard to know what city I was in.

RM That area has lost a lot of the charm that you associate with New York. I've never seen so many ugly buildings and boutiques in one place in my life! I don't know who shops there, but obviously many people must, because they wouldn't want to build there otherwise. But the great thing about New York is that it's always changing. I had dinner with my daughter on the Lower East Side a couple of weeks ago. You can't believe how crowded the streets and restaurants were. I don't know where all those people come from — they can't all live there — but it was packed. Even five years ago that wasn't the case.

HS On the subject of restaurants, why do you think that contemporary food, like a lot of the arts and cultural pursuits, has borrowed so many elements from different cultures, but that architecture remains so one note and white bread?

RM Oh, boy, that's a good question. I think architecture is about making space that works on a human scale. It's not about interpreting culture. I don't know whether Modernist architecture actively resists non-Western cultures and, like I said, I don't think that's what architecture is about. But certainly the results suggest that there isn't that kind of dialogue between cultures that exists in other endeavors. Of course there is the odd flourish you can introduce with the use of materials, textures, and color. Those things can come into play, and reflect certain cultural influences. But at the end of the day, it's still basically about making space.

HS Since you brought up the dirty M word, when was the apple-falling-from-the-tree moment? At what point did Modernism make sense?

RM Well, I don't think it was ever a question. It never occurred to me that things should be anything other than contemporary and modern. We live in a modern society. We live a contemporary life.

HS You and a group of others were posited as combatants in the war between the whites versus grays, or Modernists versus the Postmodernists. Who won?

RM Well, I don't think there was ever a contest. [Laughs.] The grays just disappeared. By sheer force of will, the whites won.

HS Just as well for you — you've peddled more white goods than General Electric. What does white mean to you?

RM Well, ironically, it's about color. You know, white reflects all colors and allows us to perceive them more clearly. And white is constantly changing. This room, if you look at it now, in this twilight, is a different white than it was three hours ago, when the sun was out.

HS I was looking at an at home with you in a recent issue of a shelter magazine and, other than its being white, I was surprised by your personal living environment. For one, I didn't expect you to be living in a pre-war building. How different would you say your homes are from the unrelentingly Modernist aesthetic that most people associate with you?

RM I think it's probably more cozy and a lot more cluttered than people would expect. The problem is that over the years things accumulate, and I'm not very good at throwing things away.

HS So you're the missing Collyer brother.

RM [Laughs.] Absolutely, it's out of control! Every weekend when I'm home, I say, "What can I get rid of?" But there are stacks of books everywhere.

HS I notice the Frank Lloyd Wright book, which reminds me of a quote of yours. I'm sorry if I'm bastardizing it, but it was something along the lines of your thinking he's right even though he got a lot wrong. So humor me: in the year of Wright's centenary, what do you think he got wrong?

RM Well, when I was a student, I read everything I could get my hands on about Wright. And in fact, when I was at Cornell, Frank Lloyd Wright came to give a lecture and seminars, so we were following him around. And after I graduated, I spent a weekend as a guest of the Kaufmans at Fallingwater. Not long after that, I was working on the design of my first commission — a house for my parents — and, as you know, Wright talked about the extension of space, interior to exterior, and how the building should be organic and relate to nature. So I designed this house with brick walls which began in the living room and extended out into the garden. And dividing it were big sliding glass doors and a big glass window. And the floors were in stone, which extended outside as well. When I finished it, I remember thinking, you know, the inside is different from the outside. The minute you put a glass wall up, you enclose that interior space. Even though you can see through it, there is no extension of space. The glass is a membrane, as much as the brick wall is a membrane. And the building weathers differently. The brick wall on the outside has a little bit of moss and algae on it, but the brick wall on the inside stays pristine. This whole idea of architecture being organic is false, because the minute you build something, that's it. It's static. It doesn't grow. So I said that, much as I love Wright, Wright is wrong. And the next house I worked on, which was the Smith house in Darien, Connecticut [1965–67], I did completely differently, as a manmade object sitting on the ground, reflecting nature, enhancing nature...

HS But not trying to masquerade as an extension of nature.

RM Right! I'm thankful to Wright for enabling me to understand the relationship between the manmade and the natural, and how there's a dialogue that's created between the two.

HS Let's just change subject here a little and talk about your most famous work, the Getty Museum in Los Angeles, which you finished ten years ago. It's the kind of commission that most architects can only dream of. Looking back at it now, was it a curse or a blessing?

RM Well, it was twelve years of my life, spending two weeks of every month in Los Angeles. I enjoyed doing it, and every time I go back I'm just awed by the fact that it's there. And it's continued to have enormous numbers of people visiting every day, so I'm very proud of having been part of that. But, you know, it certainly wreaked havoc with my life at the time.

HS How so?

RM Well, my kids were young, and every time I talked to them on the phone, they'd say, "Daddy, where are you?" Being bicoastal isn't everything it's cracked up to be, at least it wasn't for me.

HS Is it like looking back at a long-term relationship that didn't work out in the end?

RM Well, I think it worked out in the end, as far as I'm concerned. But it was a difficult, long-term, long-distance relationship.

HS Is there anything you would have done differently?

RM Oh, I don't think so.

HS Not the gardens? You did get a bit of flak over those and famously fought with the landscape artist Robert Irwin.

RM Well, I did what I could. Maybe someday it will be changed to be more in line with what I had in mind. But it's seriously in the past.

HS There's an almost universal valentine that goes out to you after the completion of a project. I say this not to be fawning, but to bring it up as a counterpoint to those times when it doesn't go down like that. And one of them, obviously, is the Ara Pacis in Rome.

RM Well, the most visited place in Rome today is the Vatican, closely followed by the Coliseum. And the third most visited monument is the Ara Pacis. It's a huge success, and that brings me no small amount of pride.

HS But it must have been hard not to be hurt by some of the reactions to it. *The New York Times* critic said that the project was insensitive to the history of Rome and that it reinforced "the cliché that all contemporary architecture is an expression of an architect's selfimportance." Ouch!

RM Of course it hurts, but you learn to become pretty thickskinned and to

accept that others are entitled to their opinions, even if you obviously don't agree with them. And you know it wasn't just the critics that went on the attack; I mean, let's just say that in Italy they've really got some interesting politicians. There was one man, who shall remain nameless, who was running for mayor. He called me up and said, "Mr. Meier, I want to come and visit you, because I made some statements about the Ara Pacis and I'd like to talk to you." So we made an appointment and he came to New York and he sat in the conference room and said, "The purpose of my trip is to ask you to change your design."

HS Okay...

RM So I said, "Well, what exactly should be changed?", and he said, "It doesn't matter. Anything. You have to change something." I said, "Why?" He said, "Because I said I would make you change something, and I need to be able to go back to Rome and say that Mr. Meier will be changing something." I told him I didn't know what to change. So he left and went back to Rome and held a news conference. He said, "Mr. Meier's a very stubborn man. I went to New York and asked him to make changes, and he wouldn't change anything."

HS Is that what started the whole kerfuffle with the current mayor, who is pushing to have the travertine wall you created around the Ara Pacis torn down?

RM I really do think so. A big difference between Italy — come to think of it, Europe in general — and America is that architecture has political overtones, and politicians get involved. I can't imagine Mayor Bloomberg going out and saying, you know, this or that shouldn't be built. He leaves it to other people.

HS No, he just likes to get involved with town planning when he can't have his own way with, say, congestion pricing.

RM Right, right. But he doesn't say, "Gee, you know, wouldn't it be great if we did a public monument on the West Side Highway?" But in Europe, and in Italy especially, every politician has projects or things that they're either for or against — it becomes a political battle sometimes. Also, although I don't know this for a fact, being an American working in Italy probably had something to do with it as well.

HS How adept a politician does one need to be to become a successful architect?

RM [Laughs.] Well, I don't consider myself a particularly good politician. But I have been involved in politics, or with politicians, in order to get things accomplished.

HS What happened to the plans for the Beethoven Museum in Bonn? Will it be built in the end?

RM You know, we still haven't heard whether we won the competition. I don't

know what's going on. We heard it's down to three or four architects, so no news is good news I guess.

HS I imagine it's a project that's close to your heart as you're a very big music fan.

RM Yes, with a soft spot for Beethoven, but I don't know if that's going to do the trick for us!

HS To what extent do your many extracurricular activities influence your work?

RM Let's see. I really like to play tennis, but I can't imagine how it influences architecture.

HS Hello! Obsessive grids!

RM [Laughs.] There you go! What else? I guess it's also a game of angles. Like architecture, it's unpredictable and requires you to keep your eye on the ball. And there are also the forces of nature, like the changing of the light. So I guess they're more similar than I thought.

HS Are you and your cousin Peter Eisenman still obsessively following the Jets?

RM I love watching football, but I'm not as obsessive as Peter. He's what you'd call an avid sports fan. [Laughs.]

HS You don't do fantasy leagues?

RM No, I don't go there. He really goes out of his way, to Rutgers games and god knows what. I like to watch football on television, so if it's not a good game you can turn it off.

HS Even though I'm told you've been seeing the same person for a while, over the years you've been portrayed in the media as a lothario of sorts. So you're as good a person as any to ask: why do so many women find architects sexy?

RM I think the jury's still out on that one, but I'll take a guess and say it's probably because they don't know anything about architects!

SÃO PAULO

PAULO MENDES DA ROCHA

Interview by Felix Burrichter

Paulo Mendes da Rocha is a living architectural icon. The octogenarian Pritzker Prize winner, who looks and acts far younger than his age, has always had a way of teasing rare spatial poetry out of exposed concrete slabs, whether in early projects such as the dramatic gym for São Paulo's Clube Atlético (1958), the Brazilian Pavilion at Expo 1970 in Osaka, Japan, or in later works such as the São Pedro Apóstolo chapel in Campos do Jordão (1987) or the Museu Brasileiro da Escultura in São Paulo (1988–95). But, as he is the first to point out, while he may be a master of poured concrete, he's also proven himself with many other materials, not least with the thoughtful renovation of São Paulo's Pinacoteca do Estado (1993–98), a Neoclassical building from 1900 that he beautifully stripped down to its structural brick, and which earned this passionate whiskey drinker the 2000 Mies van der Rohe Award.

With such a legacy of landmark buildings, and at least five large-scale cultural projects currently underway (including in Lisbon and in his hometown Vitória, as well as a collaboration with Marina Abramović), one would expect Mendes da Rocha to employ a considerable staff and maintain a representative office in one of the better parts of São Paulo. So imagine PIN–UP's surprise at discovering his single-room office on the fourth floor of a dilapidated Modernist building in Rua Bento Freitas, a thoroughfare best known as the main drag for transsexual street workers and a favorite haunt of the city's drug mafia. But just like everything in Mendes da Rocha's career, the location of the office — where he works with only his wife and secretary — is an exercise in pedigreed humility. A natural-born storyteller, Mendes da Rocha affects a serious demeanor that is punctuated by cheeky grins; after a quick tour of the office and a walk-through of his latest projects, he lights a cigarette and signals he's ready for our interview.

Felix Burrichter	Your wife told me earlier that back in the 1970s you used to live in the Edifício Copan [Oscar Niemeyer, 1957–66], just around the corner from here. When you moved there was it to be closer to the architecture faculty where you used to teach?
Paulo Mendes da Rocha	At that point the school [Faculty of Architecture and Urbanism of the Universidade de São Paulo] didn't yet exist. It was just because we liked living in the center of the city.

FB Was this a different neighborhood in the 1970s?

PMdR It was different. More restaurants, more shops, more people walking in the street. It's different now. A little worse, I would say.

FB More crime?

PMdR What city in the world doesn't have crime? They all do. São Paulo is not the only city with crime in the world. Besides, I'm the real criminal here! [Laughs.]

FB What about architectural crimes — are there many in São Paulo? In Brazil?

PMdR Those are probably the worst crimes of all! Generally they have to do with the colonial era. In all colonies you see serious architectural crimes. The way colonial powers navigate space is criminal since they deny the validity of pre-existing knowledge.

FB Speaking of knowledge, you graduated from the architecture faculty at the Universidade Presbiteriana Mackenzie here in São Paulo in 1954, which means that next year will be your 60th as a practicing architect.

PMdR I've actually been working since I was 20 years old, so it's closer to 65 years of working as an architect.

FB Wow! So you've witnessed firsthand every type of development in Brazil over the past six decades, from the optimism of the 1950s and 1960s, through the dictatorship that lasted till the 1980s, the subsequent devaluation of the real, inflation in the 2000s, and now the country's current economic boom.

PMdR Well, you know, time has its fractures — it's always been like that. History tends to happen in a non-continuous way, and so it has been with all these historical events that have happened in Brazil. In a sense, Brazil doesn't exist, and neither does any other nation state. It's just an ideological construct. For me, architecture is less the expression of state power; it is a human desire, tied to the mind of the human race.

FB Are you saying that in your work you are preoccupied more with the human condition, and not so much with the current political or economic conditions?

PMdR That's it exactly. There's a desire to make this planet habitable, and according to the given circumstances you can do it or not.

FB	So it's a desire for the present, rather than the past?
PMdR	Always! To start with, architecture is nothing. But it can become something. It is the construction of the human habitat. The planet is not habitable per se. The planet, and nature, are intrinsically not good.

FB	What do you mean?
PMdR	Because you die! Try to survive for three days in a desert or a forest. But slowly we've learned to build human habitat. One very interesting Brazilian example is the slums, which is also something that exists everywhere in the world. The favela is characterized by the richness of ideas, the ingenuity of its inhabitants. For architects, it is very difficult to negotiate what to do there in a traditional sense. You can say it has a plan, but its plan is to go against all the other plans.

FB	Would you describe the favela as organic?
PMdR	No, it's not organic, it's eminently technical. There is nothing organic that has been built by humankind. You can't do anything organic besides eating and shitting. The idea of the organic is a metaphor, a very unfortunate metaphor. Because the favela is very intelligent, it possesses a very peculiar and circumstantial type of intelligence.

FB	So how much of the favela's circumstantial intelligence do you incorporate into your work? For example, you work mostly with concrete...
PMdR	No I don't! I construct with what I can. It would be silly to approach architecture with a specific style or material in mind. In a city like São Paulo, which is ruled by real-estate speculation, you are always faced with adversity. I make the most of the available technical resources, just like the inhabitants of a favela. They look around and use what they have, since they know exactly what they need and what they want. Even the way they use their wasted materials is fantastic. Let me tell you a little story. First of all, this story is absolutely true. There was an architecture student whose work and research was about my own work. He was from São Paulo, but he went to live in Rio de Janeiro where he found a job after earning his degree — he went to work in the Serviço Social nas Favelas, run by the prefecture. One day he learned I was in Rio for an academic conference and came to see me. At the end he called me aside, gave me a hug, and asked if I had time to see something. I delayed my flight and went with him. He took me to the favela. The favela there had people from all the different working classes, a lot of competent people. Everyone there basically helps each other. There was an old lady living in this favela, and the student wanted to show me her house. Why? The house was almost identical to all the other houses in the favela, except for the entrance door. It was a red-lacquered refrigerator door with a golden crown on it, which she had adapted for use in her house. How did this happen? She was walking around a deserted area of the city and saw this refrigerator, and she had the capability to imagine what to do with it. She knew this constructor in the favela, and the guy immediately decided

to help her. He brought the door back to the favela, carrying it on his head, and now you enter her house via a lacquered red door with a golden crown, like it was a castle. To sum up this story: my friend forced his teacher — me — to see this, because it is a poetic narrative about what architecture is. The lyrical, poetic, and architectural values were all here in this story, and it was desire that made it possible.

FB Are you suggesting that contemporary architecture should be more susceptible to that sort of human desire?

PMdR Yes. That is what Copan is all about. Try to compare the Copan with all the private luxury condos with their 200-square-meter apartments. If you notice, the Copan has dwellings from 30 square meters to 150 square meters; the ground floor has a cinema, a theater, shops, a subway connection — everything you desire is there. It is a realization of human desire. Architecture is the realization of human desires and their necessities at the same time. It is poetry, objectivity, materiality, and necessity combined. Water, phones, transportation — this is architecture.

FB Are architects poets?

PMdR I think we are already poets before we become architects. [Laughs.] But stones are to architects what words are to poets. If a poet doesn't know the language and the words, he can't write poetry. It's a holistic process. So as an architect, if you think that the ideas are one thing, and the technology another, then you have a schizophrenic mind set. Art, science, and technology are all one thing, and architecture is a combination of it. But all human activities are artistic: the way you talk, the way you dress, all of this is human artistic expression.

FB You are considered one of the founders, if not the godfather, of the Escola Paulista. Is the difference between the Escola Paulista and the Escola Carioca, in Rio, which Niemeyer and Costa stood for, still relevant today?

PMdR I don't believe in this kind of labeling. Theoretically you can make this observation, but it is more or less a pointless one. Those historical schisms don't make any sense to me. They usually appear more to deny something that already exists than to create something new. And I am also not the godfather of any movement. It's not that I don't like it or I'm trying to be modest about it. But where would that leave Luiz Nunes, Attilio Corrêa Lima, Álvaro Vital Brazil, Affonso Eduardo Reidy, or the Roberto brothers?

FB But most people, when they think of Brazilian architecture, think of Oscar Niemeyer, Lúcio Costa... and you!

PMdR That kind of thinking is for magazines that need to award prizes. I don't like that. [Laughs.]

FB So how was it when you won the Pritzker prize? You didn't enjoy that kind of attention?

PMdR No, I did. [Laughs.] But you also have to understand that for Brazil it was very important that I received the Pritzker, because it recognized that the world is paying attention to what we're doing here. It's odd because you don't apply for this kind of prize — you just receive a phone call saying that you won. A group of smart people brainstorm together and designate the winner. It would be cynical to say no to it. And in my opinion, the whole process is very interesting because the committee not only decides who the winner will be, but also where they will hand out the prize, because they want to call the world's attention to it. In my case, I think they wanted to underscore questions about the transformations happening in the Americas. So they chose to present the award in Istanbul, a mixture between Asia and Europe, which also stands for transformations. I think that what is happening in Istanbul is happening in a lot of cities around the world, also here in São Paulo, in Brazil. It's a vision of a very fast type of transformation and now, more than ever, we perceive ourselves as just a lost little rock in the universe.

FB What kind of transformation is contemporary Brazilian architecture going through right now?

PMdR Brazilian architecture has always possessed a very strong consciousness of geographic transformations, but at the same time the architecture that is done here can only be interesting when it possesses a universal dimension. It goes beyond geography. It is a comprehension of something that has always existed. There is no longer such a thing as a "Brazilian architect."

FB You've built in France, Japan, Portugal, and Spain, but most of your projects are in Brazil, and particularly here in São Paulo. Is there a place in the world where you would like to build?

PMdR I've done very few things abroad.

FB But would you like to do it?

PMdR No. It's a lot of work. [Laughs.]

FB So you don't like to travel?

PMdR I'd rather solve the problems I have inside my own house and hopefully that could serve as an example. This question about geography and the contemporary city is a current topic all over the world.

FB At the 2012 Venice Biennale, Yvonne Farrell and Shelley McNamara of the Irish firm Grafton Architects presented a beautiful show which paid homage to some of your designs, including that of the Estádio Serra Dourada [Goiânia, 1975], which in turn, they said, inspired their design for a stadium in Peru. Since we are talking about universal ideas, is that a good example of how your solutions for different projects can work on many different scales and in many different contexts? Did they come here to visit you in your office?

PMdR Yes, they did come once. And yes, it is a very good example, even if I

didn't really do anything. It was entirely their idea, not mine. They just used my projects as examples. But let me give you another example. David Chipperfield, who was the chief curator of the Biennale in 2012, wrote to me early on, when the idea of the Biennale's theme, "Common Ground," was still in a very early phase. I told him immediately that I wasn't interested in having a pavilion there. Instead of using a room to show plans, elevations, and models, I'd prefer to use the opportunity to create a narrative and talk about the planet by engaging theater professionals from different capitals of the world. They would perform plays in their hometowns for the duration of the Biennale. As an example I suggested two plays. One was Brecht's *Life of Galileo*, since its subject is the planet and how to navigate within it. It is a beautiful text. In the play, Galileo has already been arrested and he has to renounce his famous theory or be publicly burned. One day his student arrives and Galileo asks him, "What's all that noise outside?" The student replies, "You don't know? It's Carnival and everyone is drunk and singing this new song about the world spinning around the sun." In that moment, he knows that his discovery has already become common knowledge. The other play I suggested was *The Physicists* by Friedrich Dürrenmatt, a Swiss author. Dürrenmatt imagines that all these important physicists, like Werner Heisenberg, are all together in an insane asylum. They all went crazy because of the nuclear bomb, since it wasn't something they wanted. I said to David Chipperfield, let's commission plays all over the world as part of the Biennale's program, regardless of the scale of the theater companies. This was my project, human thought as common ground and the formation of consciousness. This is common ground to me!

FB So did it end up happening?

PMdR No. There was not enough time. But I think that is why architecture schools are extremely important nowadays. It is architecture that allows all other forms of knowledge to flourish.

FB Are you an optimist?

PMdR No. I don't think so.

FB But you are certainly not a pessimist.

PMdR I have no qualities! [Laughs.] Neither optimistic nor pessimistic. My dream is to see the world get to know itself better, knowing that we are subjected to celestial mechanics. That is why I think that Brecht's *Life of Galileo* is so interesting. Nowadays I see a new popular culture being established. We are entering a phase in which urban transformation is happening at a very fast pace and in a very exuberant way. And we have to fight for the future. Especially if you want a city where public transportation and housing is for everyone, without the separation of social classes — there is no future for classist logic anymore.

FB So yours is an optimistic outlook after all?

PMdR No. It is exactly the opposite: it's a battle. It's the struggle of architecture to achieve a city for everyone, because the city is both a university and an important producer of art and culture. Let me tell you another story. I really like to tell stories! [Laughs.] This just happened 15 minutes before you arrived. I usually buy my cigarettes in a bar just in front of where we are right now, but, since it's being renovated, I had to go to another one. It was really crowded, but next to the bartender there was this small speaker very quietly playing Dave Brubeck's "Take Five." So I bought my cigarettes, and I asked the guy if he could turn up the music a little bit. He agreed, and suddenly this crowded bar fell into complete silence listening to this amazing clarinet solo. This is the city I live in. This is the real demonstration of what common ground is. This is the city's purpose as man's supreme work of art. Human life is very short, but at the same time we know that we were born not to die but to carry on. So I hope that the human race and its qualities can exist eternally in the universe.

FB If Oscar Niemeyer is anything to go by, you have at least another 20 years ahead of you, if not more.

PMdR [Laughs.] Yes, of course.

FB Have you ever thought about quitting architecture?

PMdR No. Never. I will practice as long as my destiny allows me to.

BRUSSELS

OFFICE KGDVS

Interview by Felix Burrichter

Brussels: capital of the troubled kingdom of Belgium; seat of the European Union; bilingual babble; urban mess. Located on the fifth floor of a nondescript corner office building, a mere five-minute walk from the city's opulent Grand-Place, the sober premises of OFFICE Kersten Geers David Van Severen (aka OFFICE KGDVS) couldn't be in starker contrast to the often-chaotic cityscape they overlook. Unlike many of their contemporaries, principals Kersten Geers and David Van Severen (son of Belgian design icon Maarten Van Severen) have entirely bypassed the trend of maxing out on digital modeling technology, concentrating instead on what are still the fundamentals of architecture: enclosure and geometry, or, in the words of art critic Christophe Van Gerrewey, the ideal of bringing "order, structure, and spatial legibility to the world." Their attempts have not gone unnoticed: not only were they selected to represent Belgium during the 2008 Venice Architecture Biennale, two years later they also won the Biennale's Silver Lion for a small but powerful installation called "7 Rooms, 21 Perspectives," a collaboration with photographer Bas Princen. These days OFFICE KGDVS is busier than ever, with projects in Antwerp, Brussels, Leuven, and Paris, not to mention their elaborate design for a traveling Lucas Cranach exhibition. Despite a looming competition deadline for a large urban master plan for Brussels, Geers and Van Severen found the time to tell PIN–UP about their humble beginnings, their love for Los Angeles, and why there isn't a rectangle they don't like.

Felix Burrichter	When I first discovered your work I thought it was fascinating that you completely eschewed the fashionable formal language of blobs and computer-aided design.
Kersten Geers	Well, the truth is that David and I never really grew up with computers and we don't really agree with them... And in a way we were spared the worst, because what today might look like a formal dead end was still all the rage maybe five or seven years ago, when we started. And even though we developed our practice as an answer, a stance in response to what we saw around us, it was more the dominance of the Dutch architecture of the 90s that we reacted against, because we didn't like it very much either...

FB What didn't you like about it?

KG It was so much about the scheme, about the diagram. We were just put off by the notion that a building could be resolved by making a crazy diagram, and that that diagram can in some way translate itself into a building. Those buildings were often very bad, but that didn't matter because they were like the diagram! [Laughs.] So for us there were always two aspects: on the one hand a very banal, almost naïve belief in the fact that architecture is much simpler and that it's about making things possible spatially — or not possible — by considering perimeters, walls, openings, etc. And on the other hand it was also an ideological position, understanding architecture as obstruction, as something that stands in the way, or stands in the way of itself. But not so much as work that is a linear translation of a position but rather a position that emerges from within the work, which makes it perhaps a bit more tautological... But it is fundamental and in a way it is normal, especially in art practices.

FB Can you give an example?

KG Take Ed Ruscha and the way he talks about his work. He can't really exactly explain why he did a painting the way he did it, but he can explain what kind of precision he was after. And a set of different paintings with a certain kind of precision together make his work. And even though he says that his work is premeditated and that he knows the goal, he doesn't yet know the means by which to achieve that goal. It's exactly the same situation for us: we do more or less know what we're after but we don't exactly know what we're going to make. Because if you could say, "I think architecture should be so and so and hence I made this," why then still make it? It would be just an illustration of an idea. I do a little bit of writing but I never write about our own work, as such, because very often the explanation kills it.

FB How did you and David meet?

KG We always say that we met in Los Angeles.

FB Oh really?

KG Not really. We already knew each other from the university in Ghent, but I'm a little bit older. We went on the same school trip to L.A. — I was in my last year and he was in his second year — and we both caught the same vibe and had the same fascination for L.A. We actually have kind of a double overlap because, just like me, David also studied in Spain with the architects Abalos & Herreros, who were very important for us. Once David finished school we decided to work together.

FB And that's when you founded OFFICE Kersten Geers David Van Severen?

KG Well, we had some smaller projects that we worked on together but we hadn't really founded an office yet. And one day the Japanese magazine *A+U* asked to publish one and asked us, "What's the office's name?", so we came up with the simplest of solutions: OFFICE plus our two names. Almost immediately after that we went back to L.A. One of our clients wanted to build something there and asked us our opinion. We actually told him that we didn't think it was a good idea, but he said he'd go ahead with it anyway and asked us whether we still wanted to do the project. [Laughs.] Opportunistic as we were we said yes and moved to L.A. for three months, bought a printer, fax, and a table and set up a little office.

FB What was it about L.A. that you liked so much?

KG Maybe we were slightly naïve, but L.A. was very important for us at that time. We were reading Reyner Banham's *Los Angeles: The Architecture of Four Ecologies* — the first edition of the book had David Hockney's *A Bigger Splash* on the cover, and it was kind of fundamental for us. It summed up a whole feeling of a European in Los Angeles, this particular look, a very specific way of making images. Then there is the city itself… It sounds almost banal, but there is this bizarre joyfulness, and the wideness of it and that of the desert around it… It's just amazing! You know, I kind of share Hockney's fascination for everything. If you wanted to be cool you'd have to name a much more complex artist, but there is an accessibility to his work, a directness that David and I both really like.

FB There is a manifesto of sorts on your website in which you state that OFFICE proposes "formal compositions without rhetoric." Isn't it sometimes harder to agree on something formal than on an intellectual idea or rhetoric?

KG Well, perhaps it's a bit silly to say it like that, but David and I have the same taste, we like the same things. And even though we're not a couple, we almost work like one. Often we don't even really talk about why we like something, we just agree — it's a bit like Beavis and Butthead. [Laughs.] I think it's also very important that there is an aspect of trust. Learning from Abalos & Herreros was very fundamental and defining for both of us in that way, not only in what they talked about but also how they talked about it.

FB Judging from the names of many of your projects, you seem to have a fascination with numbers: "25 Rooms" [villa, Ordos, China, 2008], "7 Rooms,

21 Perspectives" [Arsenale Garden Pavilion, Venice, Italy, 2010], "18 rooms" [modern mansion, Ghent, Belgium, 2005], "7 rooms" [exhibition, deSingel, Antwerp, Belgium, 2009], "3 Villas" [Ibiza, Spain, 2007], and so on.

KG Yes, numbers are nice in the same way that something like Ed Ruscha's book *Twenty-six Gasoline Stations* is. You make a collection of an amount of things and by just counting them they become relevant. It's not that seven is better than eight, or whatever. It's the aspect of measuring that is important. Maybe it's a contemporary version of proportion, since we lost the original proportional systems, whether they're Greek or Renaissance orders of architecture, or the golden ratio. And unless you're an educated neoclassicist there are no more references. But we do use the metric system and I think it's a contemporary way of adding proportion to things, measuring things, and of controlling things you can't control.

FB Is that why, in addition to a strong element of enclosure, there is a certain rigidity and severity about your architecture?

KG I think it has to do with our conviction that if you want to show the power of architecture, you have to play at what it's best at, which is to bring hierarchy to space and to make a difference between inside and outside. The notion of a perimeter is very important because it has to do with territory, with organization, and it goes back to the oldest ideas about what architecture is about. Whether you go see a Renaissance villa, or Roman infrastructure, or city planning in ancient Egypt, they all share an interest in a logical, phenomenological perception of space and organization. Not as symbols, but as spatial types. Our Mexican border-crossing project [Border Garden, 2005] is of course the most extreme version. As a reaction to the double razor-wire fence, we proposed to build an even higher wall, which you have to enter to leave it again on the other side. I think it's a very beautiful notion that architecture is more about intention than invention. You bring in all the elements you have — the architectural vocabulary — and you have to be very intentional about what you're going to do with it. It's all about composition and about drawing lines. And it's obviously easier to control a rectangle than it is to control a multifaceted volume. It is either that rectangle that is important to us, or its leftover space. So yes, it's about rectangles, but it's not like, you know, we hope that the universe will be exclusively populated by square people. I think it's always about control, and letting go a bit.

FB It's kind of ironic then that you chose to open your office in Brussels, which is such a mess of a city.

KG It's funny, we never really connected that until recently. Usually if people ask us what kind of architects we are — Belgian, Flemish, or whatever — we always say that we're European. So in that way we have always avoided the Brussels topic. But to a certain extent it's true that there is only one place in Belgium that is urban, with all the mess that comes with it, and that aspect of urbanity is very attractive to us. But being in Brussels also has a lot of practical reasons. Both David and I have non-Belgian wives and I speak

English at home and David speaks French, so it's easier to be in Brussels than, say, in Ghent, which can be very provincial. But sometimes we also hate it because it can indeed be too much of a mess and as an architect here it's sometimes impossible to intervene.

FB Do you make a clear distinction between your more speculative projects — Cité de Refuge [2007], and even the Belgian Pavilion at the Venice Architecture Biennale ["After the Party," 2008] — and the more "real" projects such as the commercial and residential buildings you're working on?

KG We have a tendency to think that in a way there are no different kinds of projects, that we approach them all in the same way. Take the Belgian Pavilion, for example, which was very much a "real" project, part of a competition we won, and which was built. But of course it was also a rhetorical argument about what the Biennale stands for, as a kind of circus of architecture — and the problem of representation in architecture. I believe though that the complexity of what you propose should always have a set of elements open for interpretation. And part of that interpretation is intended, and the other part is not, and that's the true value of a cultural product that it is able to do that. I've heard some interpretations of the Belgian Pavilion where I thought, "Wow, that's not how I ever thought of it!" Some I approve of, and others I don't. That's how it goes with these kinds of things.

FB What about Cité de Refuge, your project for Ceuta, the Spanish enclave on the Moroccan coast near Gibraltar?

KG Well, you can't propose a project like that and pretend you're not taking a position. But it's very much a real project with elevators, stairs, and real spaces for real people, not some kind of Superstudio-style dream project, with hippies walking through a gridded Neverland. It's just the sheer size of it that seems unrealistic, even though it's very much in proportion to the amount of money the European Union puts into the reservoir funds to "protect" Europe from Africa. Because on the one hand, even though it's on the African continent, Ceuta is part of Spain, but on the other, for people who actually crossed that border, they're still on the wrong side of the Mediterranean. So there's the ambiguity, and it's a very sad situation, the way people desperately make attempts to cross the border, the terrible conditions in which it happens, the enormous amount of money that is invested for protecting an idiotic piece of land, you name it. As architects you can't really change that, but what you can do is make the problem more understandable and use architecture to unmask this aporia. So Cité de Refuge followed the tradition of the old city-states which existed all around the Mediterranean during Roman times, when the Mediterranean was the center, rather than the border. So the square-like building we proposed functions at the same time as a no-man's land, border, and bridgehead to Europe — neither in Morocco, nor in Spain — and as such an attempt to change the point of gravity in a very specific spot, without resolving

anything. But then there's a certain aspect to a project like that where it starts having its own life.

FB Besides Abalos & Herreros and, of course, Maarten Van Severen, which other architects or designers would you consider as influential on your work?

David van Severen There is no doubt that my family influenced me a lot and I was confronted with architecture from a very young age. I remember my father taking me to the Mies van der Rohe pavilion in Barcelona when I was very little, and I would always be in his atelier, making things. And then later, when my father was discovered by Vitra and worked together with Rem Koolhaas on the house in Bordeaux, or the Seattle library and the Casa de Musica in Porto, I'd go with him and help him out, for example with the concrete kitchen in the house in Bordeaux. And then there's also my grandfather, Dan Van Severen, who was an abstract painter. His work is very purist, and that's also something that influenced me. So all of that is already part of my DNA, even without really wanting to cite this as direct reference.

KG Even though I wouldn't compare our work to theirs, I'm also fascinated by these architects of the 60s and 70s who, to a certain extent, got a little bit marginalized by this boom of architecture in the 90s. They're all being called Postmodernists — for lack of a better term — and I disagree with that. Take Hans Hollein, for example. I think he was a very interesting architect... But it's true that his recent production is very bizarre, and then you have a tendency to look at all that work through that bizarre perspective. James Stirling is another example.

FB If one were to make a list of organic architects, your office would definitely not be on it. But despite the strong idea of grids and numbers in your work, nature still plays a very important role in a lot of your projects.

KG Yes, of course! Nature is even fundamental to our work. To us it's always about the position of architecture in relation to the reality of the world, and to life. So in that sense architecture can perhaps be understood as an organizing device, and if there was no nature to organize... In fact some of our projects, even when they're finished, would be nothing without nature. Today you seem to have all these gangs: there is the eco-architect, the organic architect, the diagrammatic architect, the computer architect, whereas in a way we just consider ourselves architects. We make very simple things, with very simple means, in part because we like them, but also partly because that's what our ability is. Life is already more than complex enough!

PARIS

RICK OWENS

Interview by Stephen Todd

Rick Owens is reclining on a gray woolen daybed, a sort of soft monolith perched on a rectangular platform, its curved sides rising some two meters from the floor. The California-born fashion designer is wearing mid-calf cut-off jeans, oversize basketball shoes and a sheer, slinky cashmere singlet. The room's 18th-century paneled walls are smoky yellow and peeling around the edges. Through two huge French windows, I can see the Assemblée Nationale, or lower house of parliament, and, opposite, the H.Q. of American Condé Nast. A statue of Justice presides over the elegant Place du Palais Bourbon. It's the epitome of upper-class Parisian chic. But inside, we're somewhere else. And this is just the beginning...

The two rooms of the elaborate *piano nobile* are quite literally the façade of Rick Owens's home, studio, and showroom. Behind them, connected by a long rectangular passageway, a five-story, bunker-like structure stretches out to a small patio. Built in the 1950s, the one-time campaign offices of François Mitterrand have been stripped of their low acoustic ceilings and spongy paneled dividing walls and reduced to the simplest structural shell. But this is no Pawson-esque asceticicism. On floor after rough cement floor, tangled wires hang from ceilings: Eva Hesse meets *The Day of the Triffids*. Plasterboard is left raw and spattered with filler, a kind of Richard Long mural gone feral. The traces of recent excavation are proudly displayed, like punk piercings or scarifications. And scattered throughout are prototypes of Owens's new furniture line. Somewhere between Hollywood glamour and downtown L.A. doss-house, the chairs, daybeds, plinths and vases are totally in tune with the designer's ostensibly laid-back but in fact highly structured sense of style. Just as his clothing looks like it is inspired by the drape-and-go weathered wardrobes of Hollywood's homeless (it was), so too does his furniture look like dystopic décor for the globe-trotting dispossessed.

I first met Rick Owens at his home and studio in West L.A. He'd lived there for years, originally behind one blacked-

out shop front, then two, and by the time I visited in 2000, three. Across the road was the parking lot serving his partner Michele Lamy's restaurant, Les Deux Cafés, where gleaming stretch limousines would deposit their glamorous clientele. But inside Rick's place, you could have been anywhere. Or nowhere. Cocoon-like, womb-like, dark — it was the kind of space any self-respecting Gothskater would be happy to call home. If it seemed at the time a million light years away from the glitz of Hollywood, it was completely unreachable from Paris. What's surprising is how effortlessly Owens seems to have transported his moody, broody aesthetic to the City of Light.

Stephen Todd Rick, it's amazing to see you here, reclining on your daybed — rather like the one in L.A. really — in possibly the most bourgeois part of Paris.

Rick Owens Yeah, isn't it? It all pretty much happened overnight. We went from selling to ten stores to selling to 200, and the move just seemed to make sense. That said, it's not just an environmental change; it's a personal, psychological one as well. I'm not very good at opening up. I need my own insulated, private space — somewhere I can retreat to when it all gets too much. As an only child I was spoiled; I never learned how to play with other kids. Communicating with others is a lot of work for me, as opposed to just creating my own comfort zone. I'm getting better at it, but that means I need to protect that intimate space even more. I'm loath to ever let too many people in...

ST This whole arrondissement is like a protected zone. There are gendarmes all over the place to guard the parliament and embassies.

RO There's a chilliness to the neighborhood that is glamorous. It's like being in a Helmut Newton picture all the time. And the security has some upsides to it. When we first moved in, we lived in these front rooms, and Michele left the iron on when we went out one night. The place caught fire, the security guards saw it, broke in, put it out and cleaned it up. They left a note saying, "We're sorry we had to break in but your house was on fire. You can pick up the new keys at such-and-such an address." Isn't that sweet?

ST Well, it's not the usual behavior we associate with the special forces. So you lived in these rooms at first?

RO Yeah, when we first moved in and were waiting for the back part to be ready. But the wedding-cake part of the place is not the part we really prefer. It needs a bar, or a sink, or a desk. Once in a while we put out the furniture and pop down and read, and eat bonbons, and swoon.

ST True, there's something very swoony about your furniture. It's all very cradle-like, slightly effete, but in a chunky kind of way. It's like you're creating a new range for a new room. A *boydoir*...

RO Actually I had Marcel Proust and his cork-lined bed in mind a lot of the time. The chaise longue is like a cradle, but it's also like a coffin. That's what it's all about really: life and death. This couch I'm sitting on, it's not really me. I had it reupholstered, but it's too upholstered. It's Armani, not me. The cushion should collapse more. I like it when the cashmere pills. When the surface is luxe but not treated with too much respect.

ST How did you start making the furniture line?

RO For my first Paris showroom I needed benches, and a friend said, "I have a

friend working with Gaetano Pesce. He can make you 50 benches in two days." And that guy — Jacek Nowak — is still here, working away upstairs in what would have been the ideal guest room, but he insisted he couldn't work in any other space. From producing quite utilitarian pieces for the showroom, we just naturally moved into making more statement pieces. Then when we were doing the men's collection showroom we thought, "Hey, let's show the furniture too." It was like putting a show on in the backyard. But it was meant to be a one-shot thing; then it got bigger and I wanted to keep Jacek so I thought we should get serious. But in the beginning they were just personal projects, done on a whim.

ST That's a big whim!
RO It's a big house!

ST True, but what's interesting is that for all its immensity and rawness, it still feels extremely insular.
RO The front rooms act as a kind of filter zone. And then at the back there are these huge trees, then the patio which is enclosed and gives on to the garden of the Ministry of Defense. Like Los Angeles, strangely enough, it's a quiet little oasis, a blind space.

Between the highly decorative front rooms and the cement 1950s structure, a less elaborate, windowless 18th-century room acts as a transitory space. It is dark, cavernous, and crammed with all manner of domestic detritus.

ST So what's this room?
RO Err, we're not quite sure. Right now it's kind of an anything room. We pile all sorts of stuff in here.

ST Like the life-size sculpture of yourself you showed at the Pitti Uomo fair in Florence this year.
RO Yeah. The sculpture came out of the fact of having a house. I was like, "Well, now I have a home I need a portrait over the mantelpiece."

ST But you don't have a mantelpiece.
RO And this isn't exactly your everyday portrait.

ST Uh, no. You had it done by the folks at Madame Tussaud's, right?
RO Uh-huh. It took several sessions of sittings, measurements, all that. It was like having a couture dress made. The hair was put in follicle by follicle, even the pubic hair. You develop a special relationship with someone you're paying to immortalize you. Like a bourgeois portrait, it's about a man building a monument to himself. It's a big expression of ego. There's something very poignant about a man needing to leave a monument. It's like toying with mortality. And then, I saw myself from behind, from the sides. I saw my parents.

ST	Did your parents see it?
RO	I sent a picture of the Florence installation to my parents. When it was operational it pissed a huge arc across a darkened room. I've nothing to hide from them. But they were so shocked — they were, "Is this a reaction to us?", and I'm like, "Well, are you surprised?"

ST	Why?
RO	My dad is ex-military, very homophobic, and ultraconservative. We really care for each other, but it really hurts how much he has to make an effort. I make it really hard for him. It's almost biblical, heartbreaking, this man trying to get close to his son and the son making it harder and harder. After I sent him the pictures, we were in Booksoup in L.A., and I heard my dad asking the sales guy, "Excuse me, do you have anything on water sports?" The guy was like, "Water polo?" "No, it's a homosexual practice." "Well," said the sales guy, "I'm homosexual and it's not an exclusively gay practice." It's actually kind of affectionate, his reaction. It's not angry.

ST	Urine is something of a leitmotif for you. I remember you once sent me a self-portrait of yourself kneeling and peeing into your own mouth. What's going on with that?
RO	I'm sexually obsessive; I find what goes on in sex clubs fascinating. But it's also about isolation. Me peeing into my own mouth, it's cyclical, like a serpent swallowing its own tail. Also, there's a recycling element to it, something positive in there. I'm still trying to work out what it is. Also, with the sculpture you need to add in the fact that there was a big black object penetrating me while I was urinating.

ST	Was the pee yellow?
RO	No, clear. It was perfume. No, joking. I was having a great time. I was just giggling all the time, adjusting the penis.

ST	Oh, it adjusts?
RO	It did, but now it's stuck in one position.

ST	So what about all this stacked-up furniture?
RO	Well, there are some chairs made from matte-black varnished plywood. They look temporary, jerry-built, but in fact they're massive.

ST	I love the fact they have packing-crate-style cut-out handles. It's not as if anyone's going to run off with them. And what's the fur?
RO	Oh, that'll be mink. I like the severity, the blockiness of the designs, but then there's an added softness. You just wanna touch everything. And they're all monumental — it's such an American thing: supersize everything.

At the back of the first story, wide glass doors open onto an elevated patio. Paved in pebble-mix tiles, it looks over a magnificent garden.

ST Is that the Ministry of Defense?

RO Uh-huh.

ST It's kind of girly, all those sash curtains and curvy windows.

RO Well, the minister of defense is a woman. Every month a visiting dignitary comes to visit, so they wheel out the brass band to play the Marseillaise. The bigwigs come in, review the troops, shake hands, and leave. It's a completely useless affair.

ST But it's extraordinary that you can just peak over the top of your back fence into the defense ministry. That's mighty neighborly of them!

RO Don't worry, I'm sure we've got a flock of machine guns trained on us right now... Anyway, inside to the right here is our kitchen.

He motions to a black-varnished cardboard monolith held together with gaffer tape. It is actually the maquette for an in-store installation for Revillon, the high-end fur house of which Owens is creative director. Inside are a stainless-steel fridge and a coffee machine.

ST That's a long way down if you get the munchies in the middle of the night.

RO We have a private stash upstairs. And there is an elevator, although it doesn't work. We need to go up by the old wooden staircase.

SECOND FLOOR
From the landing, Rick's office is on the left. It is a long, rectangular room, echoing the downstairs showroom. A low-backed black chair, like a futuristic Aztec glyph, sits sentinel in the middle of the space. Near the disused elevator sits one of Owens's Pedalo chairs — a curved seat and back carved from a single form, the base an inverted arc of resin.

RO We call it the Pedalo because it's like one of those machines you peddle around lakes on.

ST It's covered in cashmere, but this time it's pilling. You're happier with that?

RO Absolutely! It's just as soft as smooth cashmere, but this way it reminds you of the life that has passed over it. It's not just a dead object, but a living artifact. It's less Armani.

Technical specifications are not what interests Owens most in his furniture line. Yet he has a fascination for the manufacturing process. Across the landing from his office is a narrow space stretching from light well to garden in which benches are covered with resin blocks, unfinished plywood, metal rods, paint cans...

RO This is Jacek's workshop. It's beautiful, better than the furniture in a way. There was a time in my life when I thought it was all about having a ton of

cute kids who would tell me about their nightclub exploits, but now I know that *this* is the triumph of my life: having mature, serious adults who really know what they're doing. Actually having a workshop is the ultimate dream for me. I love this room.

THIRD FLOOR
From the left of the landing is the fashion atelier. The room is piled high with a jumble of pelts and patterns. From the ceiling, electric wires are plaited into impromptu three-pronged chandeliers, their sockets coming from the BHV department store (the same place, incidentally, that Marcel Duchamp found his bottle rack and Daniel Buren his very first length of striped wallpaper.) It must be hard keeping track of things in this space. I notice that whenever Owens needs to locate Michele in the building he Blackberries her.

RO Well, yeah, it's kind of like a living, breathing environment. Sometimes it seems to have a life of its own. Oh wow, look at this rack of shaved mink— it's like a beautiful fog.

ST So all the furniture we see throughout the building is designed by you and made on the premises by Jacek?

RO Yes, all of it. We're always like, "We need a table Jacek. We need an airplane Jacek..."

FOURTH FLOOR
The main bedroom is an all-but-empty, raw-cement and plaster space that is dominated by a totemic bed set on a platform enclosed by a half-cylindrical structure. The bed is covered in Swiss Army blankets, stapled onto the plywood support. Tiny metal switches, like those in an old cockpit control panel, activate two built-in spotlights. In front of the bed, on a black-plywood box, sit a flat screen T.V. and an iPod.

ST Apart from the bed lamps, there is no lighting in this room.

RO It's for sleeping!

ST And no curtains. Aren't you concerned about the neighbors' prying eyes?

RO Well, there's no light at night, so what can they see? Besides, once you're on the bed you're effectively shielded from anything behind you. It's like a personal bunker.

ST The rugs on either side of the bed are in fur, right?

RO Of course. But I don't want to get too *Lord of the Rings*... I like seeing this iPod island in the middle of all this cashmere and rough felt and fur.

Across the landing, garden-side, is a private study with an enamel-painted desk, a wool-covered barrel chair, a packing-crate-bench. On the side of the

light well is Rick and Michele's dressing room. At first glance it's difficult to tell the difference between his and hers — both sides of the room have the same gray, green, and black tones lifted by the occasional muddy brown. The same high-heeled platform boots. But Rick's side has the horsetail belt (literally, a leather strap featuring a horse's tail that hangs down the back), and Michele has a lot more tailored python jackets. I think.

FIFTH FLOOR

From the top-floor landing, a hatch leads up to the roof. To the left of the landing is the sitting room — the same dimensions as the bedroom, but playing Mike Kelley to the bedroom's Joseph Beuys. Unlike the other spare spaces it's a riot of sculptural furniture and objects. A wall-length bookshelf is full to overflowing. A freestanding room divider provides a backdrop to Owens's monumentally phallic floor lamps. An L-shaped lounge system is composed of low-lying arc-backed platforms covered in army blankets and topped by flat mattresses. A similar platform, flat this time, occupies the center of the room.

ST Strange — in almost all your furniture you need to recline. It's impossible to sit up straight on this couch! The mattress, the plywood arcs — it's very skate park, very L.A.

RO Well, I've spent a lot of time watching the Sports Channel recently. The skateboarding is so inspirational — it's pure expression, like dancing. It's joyful. Also, I really appreciate the pure economy of sticking some wheels on a board and doing this dance. It's contemplative, glamorous, reckless, dangerous, doing that illegal stuff. And the skate-park aesthetic itself is something special — everything worn away from use, paint peeling, posters tearing off. Matthew Barney couldn't come up with such an extreme landscape.

ST As a fashion designer, you refer to yourself as a "Scotch-tape Vionnet." As a furniture designer I'm thinking of you as a staple-gun Eileen Gray.

RO I love Eileen Gray. But then I'm inspired by a lot of different designers, like Le Corbusier, Joe Colombo, Emile Jacques Ruhlmann. I really liked the old Art Deco pieces that I saw in pictures as a kid. They appeared so stoic and monumental. But when I saw them in real life, they were actually so small, like teeny doll furniture. My furniture takes that base, but supersizes everything. I kind of like that monumentalist, rationalist, Italian-fascist look, but a skate-park reduction of that aesthetic. Like my clothes, everything is reduced, cartoon-ish, almost dumbed-down. When you move from sophistication to crudeness you generate a kind of internal energy along the way.

ST The lamps look like giant willies in cashmere condoms.

RO Well, if pee is one motif, another is the big boner. I did a collection of skirts; they kind of stuck out at the front, so there was the Boner, the Holy Boner, the Double Boner. So you see, the lamps make sense in the context of my work.

ST But when you're not covering everything in cashmere or mink, you resort to utilitarian army blankets.

RO I've always been obsessed with Swiss Army blankets. There's something about their in-built sense of history I find fascinating. Also, the olive-khaki color is really great. French blankets are gray, which is less interesting. These ones I bought in a Naples flea market. If they're too itchy, you can always throw a cashmere blanket over them.

ST So are they Italian or Swiss?

RO I keep insisting they're Swiss. Maybe it's a Beuys thing. What am I doing? I'm weaving a spell, and I can tell it any way I want.

ST Army blankets are obviously also about protection. Beuys's own myth was that he survived hypothermia following a plane crash by wrapping himself in army blankets.

RO Protection is really important to me. Recently I discovered Paul Virilio's *Bunker Archeology* and I was like, "This is the book I've been looking for! This is where I want to be!" These hugely protective cement environments built by the Nazis along the French coast to fend off the Allies, they were so haunting, so beautiful. Solid, impenetrable, the kind of places you can crawl into and pull a casket over yourself.

ST Living in Los Angeles formed the basis of your aesthetic vocabulary, specifically the down-at-the-heel side of west L.A. Do you miss living there?

RO Oh god no. Because it's actually the same routine: studio, restaurant, gym. I actually forget I live in Paris most of the time. I read about stuff happening and think, "Wow, it'd be great to be able to go see that." Then I realize, I can! And you know, to be honest, I'm not really attached to place. But I'm really feeling very comfortable here right now.

BUCHAREST

ANCA PETRESCU

Interview by Aric Chen

"If you think *she's* something, just wait until you see her building," the Romanian architectural theorist Augustin Ioan told me on my first night in Bucharest.

Ioan was referring to Anca Petrescu, the architect of one of the 20th century's most brazen expressions of megalomania: Bucharest's colossal People's Palace, begun in 1984 by the Romanian dictator Nicolae Ceauşescu, five years before his country's bloody revolution ended with his execution. I had come to Bucharest to interview Petrescu, who, wearing a camel skirt-suit and gauzy white scarf, had just met me at my hotel to set some last-minute conditions: before she would talk ("I will give you special information," she promised), she wanted 500 dollars and a signed agreement pledging that I would not "damage her image." It felt like a scene from a bad Cold War spy movie, and only after hours of arm-waving and heel-digging did she accept that I would meet neither of her demands.

Petrescu has reason to be sensitive. Fifty-seven when I met her, she was only 27 years old when she won the competition that would lead her to design Ceauşescu's most conspicuous folly. With nearly 4,000 rooms occupying roughly four-million square feet, it's now called the Palace of Parliament but remains the world's largest building after the Pentagon — a looming confection of patchwork historical styles, packaged in totalitarian gigantism and dripping in crystal chandeliers, scrollwork, and acres of marble and heavy curtains. Saying it's merely big and ostentatious would do it no justice.

Still, this behemoth was just part of a much larger scheme — also overseen by Petrescu — that included Bulevardul Unirii (Unification Boulevard), a monumental thoroughfare that cuts through the heart of the city, on axis with her Goliath. All told, between a sixth and a fourth of Bucharest's historic center, including centuries-old churches, was obliterated to make way for the new construction. The monetary cost — estimates start at three-billion dollars and soar upward from there — was astronomical in a time marked by dire shortages of food, electricity, and medicine.

When I met her, Petrescu still worked in the palace: from 2004 to 2008 she was a member of the country's legislative Chamber of Deputies, representing a right-wing political party. Unlike Albert Speer, Hitler's chief architect, she remains steadfastly unapologetic about her complicity with a tyrant. Like Leni Riefenstahl, Hitler's filmmaker, she draws a distinction between her work and the politics it served. Old habits die hard, and Petrescu sometimes exhibits the communist-era propensity to make a delusional charade of the facts: "I was not Ceausescu's architect; I was the architect of the Romanian people," she insists. But in truth, she does not strike me as evil incarnate, but rather as someone who at a young age was caught in the right place, at the right time, on the wrong side of history. In some ways, she cuts a sympathetic figure.

After all, it's not just totalitarian regimes that produce totalitarian visions — the West is littered with examples — and Petrescu's building appears to be acquiring new associations as time passes. Alhough it will forever be a symbol of crackpot ambition at the price of human suffering, it has also become, if anything, a dazzlingly kitschy icon of the city, as well as its most popular tourist attraction. The day after my first encounter with Petrescu, she gave me a tour of the palace and invited me to return the following day to conduct our interview. Through an interpreter, she answered my questions in a large paneled conference room near her office.

Aric Chen	It seems unusual that someone — especially a woman — got such an immense commission at such a young age.
Anca Petrescu	I was fortunate to live in a time when there was no discrimination against women; more than half the architecture students in school were girls. From the time I came to Bucharest to study architecture — I grew up in a medieval city in Transylvania called Sighisoara — I became what you'd call a self-made man.

AC How did you come to design this building?

AP As destiny would have it, in my fifth year of school I had a professor who decided to provoke us with some big projects, and my group was given the exercise of planning the area where this building is, which was then called Arsenal Hill. In my sixth year I decided to design a whole urbanistic plan for this area. Then, on March 4, 1977, a major earthquake destroyed a large part of the city, and, right afterward, in April, Ceauşescu decided to renovate many of the damaged buildings. For this specific area, he inaugurated a national competition that was advertised in all the newspapers. I applied for it because I had been studying this part of the city for two years and knew it well. I was 27 years old.

AC At one point, you supervised hundreds of architects who were working on this building, in addition to those along Bulevardul Unirii. How much of the design is actually yours?

AP About two years after the contest for the urban plan, in 1980, the contest for this building started and I applied again. And then the president asked for a separate competition for each of the rooms. There were another 112 competitions and I won all of them.

AC You won all 112?

AP It was a real hysteria for competitions. There wasn't just a competition for every room, but for every column, every lamp. There was a competition for each detail.

AC And you won every single one?

AP The competitions were supposed to have not more than two or three competitors, and my big advantage was that I was very young. And when you're very young and ambitious, you'll work 24 hours to win every small detail. If I'd lost one of the competitions, then I would have lost the direction of this project.

AC Yesterday, you told me that many of the decorative elements were taken from traditional Romanian architecture. What else were you looking at?

AP I was guided by a few very classical principles like [Pope Sixtus V's] urban plan of Rome and [Haussmann's plan for] Paris — the axes that allow buildings to really reveal themselves.

321 ANCA PETRESCU

AC In France, the use of axes, whether by Louis XIV or Baron Haussmann, had much to do with the centralization and expression of power. Is that why axes were so appropriate here as well?

AP No, it was my own option and nobody asked for it. Axes are also present in cathedrals, and they don't necessarily have to do with the symbolism of power. They are symmetrical constructions that give an inner balance to those who look at them.

AC I have to ask you, though, do you think that the government that commissioned this building was concerned about making the viewer feel balanced, or was it more concerned about projecting its control over the city and the people?

AP I was not concerned with what the government or president wanted at that time. I did my job the way I felt I was supposed to do it. This could only have been a symmetrical building at the end of an axis, because asymmetry would not have been natural. All the examples of the history of architecture illustrated this idea.

AC Why did this building need to be so big?

AP There were supposed to be many institutions, with monumental halls, stairs, and axes.

AC Most say it's because Ceauşescu wanted everyone under one roof, so he could consolidate his power.

AP I don't know if this was the purpose, but he did have more functions in the state, and maybe that's why he wanted all these administrative bodies in the same building. But now we're taking advantage of it because a lot of democratic institutions are all together here. And anyway, it wasn't about control, because it was impossible to control the people.

AC The artist Vito Acconci, who is now an architect, once told me that architecture is necessarily a totalitarian activity, because no matter what, you're controlling the experience of the user.

AP That's very wrong. Only a bad artist would have such ideas. An architect has to bring a spiritual joy to each person entering his building, and, if he fails to do so, he's really the worst architect in the world. From this point of view, you could unfortunately say that 90 percent of the architects nowadays are not architects, but rather people who just compose lines. A real architect finds the optimal balance between the three dimensions, and it's only then that the proportions impress you and the architectural work becomes an artistic object.

AC Much of the historic city was destroyed for your project, and I'm wondering if you had any misgivings about that at the time.

AP I would like to point out that the plans for the main axis originated in the time of King Carol II [also known as the "Playboy King," he ruled Romania from

1930 until being ousted in 1940]. And to all those critics of this building and this area, I would like them to study the way Paris was developed, or look at Brussels. Do you know how much is being demolished now in Brussels for the headquarters of the European Union? You can never modernize or improve the structure of a city without incurring losses. Here in Bucharest, there were a lot of buildings that were supposed to be moved to other locations to avoid demolition; some were, some weren't. But very few were valuable buildings.

AC What about the 16th- and 17th-century churches that were destroyed?

AP A lot of them were moved. Others were indeed demolished, but it's really a pity that these same critics, in the 1990s, didn't take care of the really valuable parts of Bucharest, like Lipscani and the other historical areas that have been falling apart, one after another.

AC At one point, I think your construction was consuming up to 30 percent of the national budget at a time when people didn't have food, power, or medicine.

AP There was a lot of major investment going on, which a nation has to do. And this building is really an important part of the national patrimony, as it is considered one of the wonders of international architecture. The fact that the population was indeed starving, and that there were insufficient supplies, has nothing to do with this building. At the time, Romania didn't have any foreign debt, so it could afford it. It's the rulers' fault that they didn't know how to manage these problems well.

AC By rulers, you mean Ceauşescu.

AP All of them. There was enough money; they only had to change their policies toward the population. It's very good that Romania invested in important buildings, in the subway, in infrastructure. In France, as soon as Mitterrand died, critics said he should have built more hospitals and schools instead of all those imposing buildings that are now bringing a lot of fame to Paris, like [I.M. Pei's pyramid for] the revamped Louvre. What's more important is what the nation gets in the long term. This building now hosts a lot of international conferences that can bring a lot of prestige to Romania. In my opinion, this is why Ceauşescu wanted to build it — to bring more fame and prestige to this country. He actually said it several times. It's also why it's made of 100-percent Romanian materials, to show the capacity and richness of this country and its technology.

AC How involved was Ceauşescu in the design of this building?

AP As much as any other client, not more.

AC Has your view of him changed over the years?

AP I have never been interested in whether I am working for a Ceauşescu or a Bush or a Saddam Hussein. I was ambitious to win these contests and, at

the end, to make a great architectural work, which I really hope I managed to do. I wasn't interested in him or in politics.

AC But you've felt the ramifications of the politics. After the revolution, you had a difficult time. You were sued; you received death threats. I even heard someone tried to burn your house down.

AP That's just a legend. But I really did have a difficult time, which I think is normal, because people unfortunately confused this building with the person who ordered it. In January 1990, after the revolution, I wrote a very long article for a Romanian newspaper, defending the building [which at the time was not complete] and saying it should be completed and given to democratic institutions. There was also an invasion of international journalists — I gave almost 500 interviews — who all had a very, very wrong perception. They thought this was Ceaușescu's building, but I had to explain that it wasn't. This building had a public administrative purpose — it had nothing to do with living space for Ceaușescu.

AC But it did. The Ceaușescus had—or were going to have—apartments here.

AP It was never a private apartment for them. It was just for protocol, when foreign leaders visited. It wasn't for living; I doubt they would have even spent one night. But I want to add that at this time, after the revolution, there was a public poll in which 80 or 90 percent of the population wanted to keep this building as a headquarters for democratic institutions and not destroy it.

AC You say you've divorced politics from your architecture, yet you're now a member of parliament from a right-wing political party.

AP My entry into politics was due to this building, which I thought was worth every sacrifice. It was also because of MNAC. [Romania's national museum of contemporary art, which is now housed in the building and has installed a pair of exterior glass elevators that slice through its façade. The museum's director, Mihai Oroveanu, said, "It was very clear we tried to provoke this building, which everybody hates, by scratching it." Petrescu had her own design for the museum, but lost a highly contentious battle to have it realized.] I considered its plan to be a big fraud, and I spoke out. I was very persecuted because of this, and it was only then that I was threatened with death. For a while, I wasn't even allowed to enter this building. Now, as a deputy, I have an ability to protect this building and to make sure it's completed properly. I would also like to say that my party [the Greater Romania Popular Party] is not an extremist party. I like that it has a greater respect for this national palace. I should also mention that in communist times, I was not a member of the Communist Party. I want to emphasize that Ceaușescu actually chose the plan of somebody who was against communism.

AC You were against communism?

AP Yes. He chose a project, not a person, because I was against communism.

AC You'll have to forgive me if I tell you I find that hard to believe. It was very dangerous for anyone to be anti-communist, especially someone in your position.

AP I really was not a member of the Communist Party. I wasn't against Ceaușescu, but I wasn't a member of the Communist Party. My father was imprisoned during communist times because of his beliefs.

AC You're still designing. I think you've designed some projects for Club Med. How did you get from here to there?

AP I don't work any more with Club Med; it's been three years. But I have a lot of clients all over.

AC Has your relationship with Ceaușescu hurt you in the eyes of Western clients?

AP It has helped a lot. Having designed one of the biggest buildings in the world, they know of my ability. I have no complex about this building.

AC Who are some of your clients now?

AP I cannot tell you their exact names, but you will see the projects published. But I can say that right now I'm working on a hotel for Sheraton.

AC Where is it?

AP That's top secret.

BRUSSELS

BORIS REBETEZ

Interview by Felix Burrichter

The concrete steps that lead up to Boris Rebetez's studio are dangerously thin. The building, a former brewery located in St-Gilles, one of Brussels's more working-class neighborhoods, houses several artist spaces.

Upstairs, Boris Rebetez, a shy Swiss artist who has been living and working in Brussels since the late 1990s, greets me in his studio. He occupies two spaces that he sometimes shares with his wife, an artist. Raw and slightly shabby, but meticulously organized — a blend of Swiss order and the urban chaos so representative of the European Union's capital. On the wall are collages, drawings, and snippets from magazines; in one corner stands a small playpen where his baby daughter occasionally spends her time ("Only when the temperature allows it"). A large stained-glass installation hangs from the wall, a piece Boris has prepared for a solo show at the gallery Etablissement d'en face, in Brussels. It is there that I first came across a catalog of Boris's work. What struck me immediately was the fact that, in an age when computer manipulation allows artists to modify images in unparalleled ways, Boris guards a tremendous respect for printed matter. His image manipulation is solely the result of precise cuts with an exacto knife — to startling effect.

Felix Burrichter	I was really intrigued when I saw your work for the first time. The way you juxtapose fragments of spaces, in a way that they become one entity — it is irritating and familiar at the same time. It reminded me of an essay about spatial perception that argued that as a grown-up, you never really see new things, whether it's spaces or people. Through your childhood and early-adulthood memory, you have set categories in your head, and everything new you see is simply a variation of something you have seen before. Everything is compartmentalized into fragments of what you already know. So looking at your collages, I had that strange sensation, trying to recognize familiar things — but really you can't. How did you start working on these juxtapositions?
Boris Rebetez	I started working probably ten years ago. In the beginning it was very naïve — I would find a calendar from the 60s or 70s, for example, with a lot of the same pictures. The quality of the print was very interesting to me because it almost had the quality of a painting; they didn't have that realistic aspect of today's photography. The colors were all blurred, not very sharp, imperfect — almost like old Technicolor films. And I had the idea of cutting these pictures and bringign them together to make a new image. I wanted it to be a very normal image, but at the same time totally wrong, because it only existed within the act of seeing. What you said about memory is very important to me because I make a lot of collages, but in the end I only choose the ones that remind me of something. We always look for parameters of our personal culture or from the general image culture — including for me everything that comes with being born and raised in the 1970s: television, the flow of mass media that constantly invades your daily life.
FB	You were born in Switzerland.
BR	Yes, in the French-speaking part, in the countryside near a village close to Basel, by the French border — a region known as the Jura. When I was 13 we moved to a small city, into a flat in what is called a *cité HLM* — the projects, so to speak.
FB	Isn't the preoccupation with architecture something very Swiss? Architecture is and always has been very highly regarded in Switzerland — many great architects are Swiss and there is an undeniable legacy, history, and national pride for architecture. Do you consider your interest a personal one, or do you also accept that it could be very much influenced by that?
BR	I perfectly accept this idea. For example, I was also born very close to La-Chaux-de-Fonds, where Le Corbusier built his first projects, so I grew up with this knowledge. But the fact is that I really began to work with architecture once I moved to Brussels. At art school in Basel I had previously worked with architecture, but rather unconsciously. I realized that I began

to work more and more intensely on that theme once I moved here. I think Brussels is also a place where you can ask yourself a lot of questions about architecture.

FB In Brussels there is not the same level of appreciation or sensibility for architecture as there is in Switzerland — especially when it comes to preservation. They're still erasing entire blocks to make room for large office buildings, a lot of them for the European Union.

BR Yes, it's true. It's quite the brutal opposite to Switzerland. Architecture is quite bad in Brussels, but it's also very interesting because of this big chaos that never seems to end — and it's been going on for 200 years. Switzerland is very good for this meeting of architecture and landscape — there is a real dialogue. Switzerland is a country where whenever there is an architectural decision to be made, there is a democratic process — experts discuss these decisions, etc. Here in Brussels, it's more like anarchy; everybody does pretty much what they want. But it also gives this city a very realistic aspect: there is no overall harmonious arrangement and all urban tensions are perfectly visible.

FB You could also call it *architecture à l'arrache*. Isn't that similar to what you are doing with your collages: tearing things apart and putting them together again?

BR Well, yes — except I'm hoping to with a slightly more harmonious outcome. [Laughs.]

FB When an artist deals with the concept of space, it is always interesting to see how the work is appropriated within an exhibition space. Last year, you had a large show, "Two Story House," in Basel's Museum für Gegenwartskunst. How did that go?

BR It was a ground-floor space, and it was actually not a great space, I'm afraid to say, because it felt like a big garage. The museum was built in the 1980s, and it has a very Postmodern feeling and the space is kind of sunken. I wanted to repeat the shape of this awkward space, so I made a large installation that repeated the dimensions of the space, but on a smaller scale and as if it was turned inside out, like a sock. But the structure also functioned as a pavilion where people could go in and walk through. The idea was to turn the spectator into a part of the exhibition — as soon as you entered the pavilion you found yourself exposed just like its architecture had its inside exposed. It created a kind of schizophrenia between the space you discover and the other architecture, which is quite similar but at the same time strange.

FB In that exhibition, you showed your sculptures that also deal with space and architectural objects. What is the relation between the images you are creating with your collages and the objects?

BR The sculpture I made for the exhibition was done in a tinted mirror, which

was often used on office buildings in the 1970s and 1980s. I tried to make the quality of the sculpture like something you could find in real life, like these office buildings. It is important to me that it could be something very banal in the street, that it would remind you of something like that — which is where it might be similar to the collages. But for me it's more the idea of creating a kind of proto-world, where all things have their own function — it's not so much about developing a style. That's why the sculptures, the collages, and the drawings are all very different.

FB Are you interested in contemporary architecture?

BR Not really. I don't really have a very strong interest in architecture itself. It's more the idea of space or situations, or what I call an idea of place, which is interesting to me. It's more the things between the architecture — not the object itself. If I did, I would try to be an architect. I don't have the intention to build a building. I think as a citizen we use architecture and we are influenced by architecture, but I don't have any visions for a better architecture for the future. I'm more concerned with things of the past, things that have already been lived in, that have a life. New architecture is less interesting to me because it feels too fresh, but not yet alive.

FB Moritz Küng wrote an accompanying text for your Basel exhibition in which he quoted you: the contradiction of "the deserted street full of people." When buildings have been lived in by people, there are contradictions, there are different uses of the same space, different appropriations of space that have sometimes nothing to do with what the architect intended. Is there a space — a real, existing space — that has these kind of contradictory qualities that you're fascinated by?

BR Maybe not a space; it's more like a moment. It depends where... It depends on a lot of things.

FB Well, maybe it was just a very complicated way of asking you whether you have a favorite building.

BR My favorite building in Brussels was the Martini Building, which doesn't exist anymore. It was built in the 60s by Jacques Cuisinier, but it had been empty for over 20 years before they finally destroyed it. The owner was waiting for the real-estate prices to go up. It was conceived at the time as almost a small village: there was a shopping mall, apartments, a school, a theater, and so on. But ironically, for the longest time there was only one person living in the building: the supervisor. It was probably one of the most beautiful buildings in Brussels.

NEW YORK

CHARLES RENFRO

Interview by Ben Widdicombe

The New York headquarters of Diller Scofidio + Renfro look like a Hollywood version of a famous architectural firm. Models of prestigious projects dot the open-plan office, creating a miniature skyline, while the slim young men who bustle between them seem to dress alike in variations on a single theme: gray sweater, dark pants, and a white-collared shirt untucked at the waist. Clutter on the sleek, purpose-designed desks suggests a benevolent regime that doesn't mind its vision being subverted by such inconveniences as human use. And a brown cuckoo clock mounted at the rear quietly mocks the cool lines created by white walls and pillars located high up in the Starrett-Lehigh building, a 1931 behemoth which boasts 2.2 million square feet of floor space and eight miles of windows. On the night I visit, a howling storm is dumping 4.6 inches of rain on the city in a matter of hours. Inside the office, chunks of plaster are missing from the ceiling, and a row of plastic buckets is quickly filling with water. When partner Charles Renfro appears, he is wearing an untucked white shirt, dark pants, and a sweater. He is a slim man, handsome and charismatic, and seems especially proud of the view, which is now completely obliterated by the driving storm. "On a good day, this is awe-inspiring at this time of night," he muses as rain hammers against the black window.

Ben Widdicombe	You started working with married couple Elizabeth Diller and Ricardo Scofidio in 1997, when the firm comprised only six people and was still operating out of Diller and Scofidio's small loft apartment near Cooper Square. When did you move from the East Village into these offices?
Charles Renfro	In 2006. It became too much, and because Liz and Ricardo were desperate to have some privacy, they bought an apartment. When the [Cooper Square] management started seeing them leaving the building, they became suspicious that the loft was being used as an office. So ultimately they essentially forced us out by raising the rent. But it's fine, because what this place importantly adds, besides a little more space — because we went from having 1,000 square feet to almost 7,000 square feet and 50 employees — is perspective. So much of our work is about critical analysis and cultural analysis, and this space is perfect, because there's New York [pointing out the window] and we're in it, but we're out of it at the same time, and it's framed perfectly. We're on the edge. It offers a wonderful conceptual vantage point from which to see the city. I get really distracted because I'm up on the north side, with views of the river and the Hudson Yards, and sometimes I find myself looking at all the various transportation forms, just completely spacing out.

BW And do you have designs on the Hudson Yards? [A huge chunk of western midtown Manhattan, currently used as a rail yard, which the Metropolitan Transportation Authority wants to develop.]

CR Maybe, maybe not. It is slightly dangerous to bring someone who's writing something through this space. One of the things that's happened in this past year, when the economy's been down, while we haven't gotten a lot of substantial, big new work, is that a lot of people who are just casting around for ideas for when there's an upturn in the economy have approached a lot of architects asking them to help them think through these things. We've had a privileged position on several of these projects where we've been able to think along with some fairly interesting people about fairly interesting projects, but they shall remain nameless at this point.

BW Have you seen a bounce-back in the economy?

CR It seems to be coming back — the weather today offers a perfect metaphor: when it rains it pours. We've gotten invitations to join several limited competitions, and we've gotten four of them in the past two weeks for major projects. So it's a sign and they seem funded, but let's win them first, and then we'll worry about the funding.

BW Do you often enter time-consuming competitions only to have funding for the project disappear when you win?

CR	It's happened, and it's happened with us because we were the upstart-institution darlings. We worked with the ICA in Boston to make their big move to the first building they ever made, and it was deemed a great success. Some institutions that were thinking about making the same kind of big move approached us, one in San Francisco, one here in New Jersey. We won competitions, we knocked off some fairly sizable competitors including Zaha Hadid and Steven Holl, only to find the projects falling flat on their faces. It's really frustrating when that happens.

As he walks me through the space, Renfro pauses by a small model of a building that seems to have been cleaved in half and stuck back together again.

CR	Here's a little project being built at Brown University — it's our first freestanding university job. University work is one of the things that keeps architects going these days. It's really cute and simple and sort of a sexy project; it's all about voyeurism and connectivity. It's an interdisciplinary arts facility, so it will have performance, art, media, science, English, film, etc. It's all there in this small building! Essentially we designed three giant loft levels, stacked them into a single multi-story structure, then sheared it right down the middle with a very high-performance glass wall. The floors are offset so you can see from one space to the other and watch what people are doing. Hopefully it will engender some collaborative work. If nothing else, it's a fun voyeuristic experience. There's a great stair where the landings have been expanded into "living rooms" — places where you can hang out and socialize.

BW	Are they good places for the students to have sex?
CR	Well, they're a little open. But aren't we not supposed to talk about sex?

BW	Are you kidding? This is PIN–UP magazine!
CR	[Laughs.] Okay, well I guess you could penetrate back and forth, and there's a lot of gazing back and forth, a lot of spatial penetration. You can do with the building what you want. We're trying to make it a sort of a holodeck: loft spaces where you can realize your fantasies. There's been a lot of discussion in the architectural world about the ability of a building to engineer behavior. There was a lot of pseudo-scientific social research started in the 70s that is being rethought with more interest in its sensual, less objective, and more subjective aspects. How can architecture in the public realm promote behavior that's spontaneous and unplanned? As opposed to, "We know what architecture has to do to solve these problems and serve these purposes," which is how science-oriented architecture has operated in the past. So this project is a new experiment.

We pass a model that looks like a sushi platter, right down to the chopsticks with the firm's name embossed on them.

CR　This is a project we won but lost in San Francisco. We hope that this will re-emerge as a true project. We love the clients, they're wonderful people. But as is true with many of these smaller institutions, great people do not always have the capacity to make great projects.

We look at another model from a lost competition, this time for a school in Copenhagen, with a sloping, grassed-over roof like a hillside.

CR　I love this project. The brief was written by Mother Earth herself, and it was all about kids growing up in environments where they could run naked and be barefoot and grow their own plants to eat. The most important factor was that it is on a piece of reclaimed land in the harbor in Copenhagen, so what the client really wanted to focus on, aside from all the earth stuff, was the water. They wanted 50 different ways to experience water, from white-water rapids, to a diving tank, to a swimming pool, to ice skating. We also added a whole bunch of things like a tidal pool that penetrates the biology lab so that it can be studied, and the gym which is under the swimming pool that's kind of the central hub. We wanted the building to merge with its site so that, like an amphibian, it is partly land and partly water based. But, guess what! It was too expensive.

Finally, we pause by a model for a mid-sized building with a zigzag network of landings on the outside, leading from the sidewalk to the roof.

CR　This is the Museum of Image and Sound in Brazil, smack in the middle of Copacabana Beach in Rio. And wait, get this: it houses Carmen Miranda's collection!

BW　Of?

CR　Hats, shoes, films. It's her whole collection of all of her memorabilia. And until only last week the building was a discotheque called Help. Help was a two-story building completely under-utilizing the site, and it was also notorious for being one of the only safe havens for prostitutes and drug dealers in the city. When the government of Rio said it was going to condemn the building there were a lot of protesting prostitutes. So what we've done, which is very exciting, is to welcome them back.

BW　Does the client know you're planning to do this?

CR　Well, the client has told us to put a disco back in, so we hope the disco will have as open a policy as it did in the old building. But we've done something that I think is not only good for the prostitutes but good for everybody: we've made a museum circuit that's outdoors. So you can walk all the way up to a rooftop movie lounge and restaurant without paying admission. One of the most notorious favelas is very close, and what's nice about the building is that it merges the horizontal democracy of the beach with the dramatic verticality of the hillside, which is very poor.

Leaving the Starrett-Lehigh building, Renfro and I fight the rain for two blocks before settling into a meal at Bottino, the Italian restaurant which serves as a cafeteria for the artists, gallerists, fashion, and creative people who began moving into West Chelsea in the late 90s.

BW Where are you from in Texas?

CR From Houston. Actually, I'm from Baytown.

BW Houston is derided by a lot of people.

CR Derided in a certain sense. I'm the first to call it an armpit, but it's a lovable armpit. We all know that some people have fetishes about their hometowns, and I do actually have a fetish about Houston. Partly because it's my home but also because it demonstrated a crazy can-do attitude and was not afraid of spending ludicrous money on projects that were harebrained ideas that some of the local rich kids thought up. You just got to see it happen. When I grew up it was during Houston's boom years in the 70s, so I got to see the first air-conditioned domed stadium, the Houston Astrodome, when it was fresh. Everybody believed in the car, and cities needed to be able grow and sprawl to let everyone have private property. Across from the Astrodome, there was an amusement park called Astroworld, and Houston is sweltering in the summer with the sun blazing down, humidity of 100 percent and outside everywhere there were tables and benches with air-conditioning vents blowing at you. Everywhere you went in the park, the outside was air-conditioned!

BW Powered by oil, I'm sure.

CR Powered by oil. A.C. made the place tolerable, but oil made it exciting. No other place had the wealth or the gumption to do things like air-condition the outside. So there's that side of it, and there's also a great art scene there. Dominique de Menil [the late French-American socialite and art patron] basically saved Houston single-handedly and made it okay to think critically and interestingly about art. She created a culture of art appreciation that exists to this day, and it remains one of the most exciting art communities in the country. Pairing that with the crazy wildcatter mentality means a lot is possible. There are a lot of artists who have expansive spaces to work with. There's a ton of installation and environmental art going on there, things that need space. But it's a godforsaken place in terms of city planning, and any sort of conventional wisdom of how a city should work is lost on Houston. It's frustrating for someone, particularly an architect, who finds Houston an exciting place.

BW Earlier you mentioned that Oslo had "Sydney envy" and wanted a landmark like the opera house. Would you want to do a big project like that for Houston?

CR It would be great to come back and work in the cultural realm, and that possibility exists. There are several museums which are expanding. Perhaps something more specific to Houston would be something abso-

lutely ridiculous and landscape oriented or in the category of myth-making. For instance, if we took the approach we used in the Blur project that we made in Switzerland in 2002 — a crazy man-made cloud sitting on and formed out of lake water — that kind of over-the-top gesture as a permanent intervention in the city of Houston, as an icon, as a destination, as a religious establishment, would be super exciting... for me.

BW Is it legitimate for an architect to want to create a monument out of a public building, or is grandiosity a danger?

CR It depends on how you're defining "monument." There has been a collusion between the economy, private clients and some corporate clients, and architects' ambitions in the past ten years. We have reengaged with the notion of the icon, which kind of went away in the 70s and 80s. Modernism lost its erection; it became impotent after Lincoln Center. That was its last gasp. There was some wonderful architecture, like what Paul Rudolph was doing, but none of it was ever iconic. And then something happened in the 90s: Bilbao, Guggenheim's expansion, the idea of cultural retail-ism, the creation of cultural franchises that used architecture as marketing images to become tourist destinations, it all started working together. There was a lot of money to be found and there was a lot of ambition, both from institutions and from sponsors and patrons who wanted their names up in lights. We were all guilty of it, we all had icon envy. We all thought it was increasingly important to make a building that was recognized in a realm beyond the architectural circle.

BW It seems some architects have conflicting drives: on one side there is public service, and on the other a messiah complex.

CR Reconciling ego and public service is a tricky one, but they don't have to be mutually exclusive. One thing that's happened since the economy started to fizzle is that the phenomenon of the ego-architect, who is making iconic structures for an institution that wants to exert its influence and become a recognizable trademark, has died down a bit. That has worked to my company's advantage, and it's played well to the way my personality works. If I'm not solving a problem and making a client happy, then I'm not making great architecture. At the same time, if I'm not making something that's an invention, or a new kind of experience, that's a failure too. A place has opened up for a new generation of more sensitive and collaborative architects. The New York High Line is a perfect example. It's a project that does not scream high design. It was made in collaboration with dozens of agencies and design partners, but is modest in its architectural ambition. It's about doing the right thing and doing it well. And, in this case, the right thing is an invention that no one had applied to public space before. Thus it satisfied a certain ego side of things.

BW When I look at the beautiful glass fences on the High Line, I always wonder if anyone has to clean them or if the rain takes care of it.

CR Oh my god, you sound like a client! Or the maintenance manager!

BW My mother is what I sound like. She'd look at all that glass and ask, "Who cleans it?"

CR It's a perfectly fair question. Sometimes using a new material requires using new levels of energy, and often glass is one of those materials.

BW So, people clean the glass on the High Line?

CR Um, the elements can help take care of it, but there is a large staff of maintenance people. I do believe the High Line is probably the most staff-intensive public park in New York, and it's caused some controversy, but the maintenance is paid for from private sources.

BW Can I ask you about your film-studio project in the United Arab Emirates?

CR Officially I'm not allowed to say anything about that.

BW That's fine, because there's a factory in China we can talk about. I understand it's a whole residential industrial campus you're doing?

CR I was teaching at Parsons last semester, and I taught this project which is also a real project in our studio: a handbag factory with associated dormitory facilities. It's a compelling and relevant project that most architects wouldn't touch. But it's one that I'm totally fascinated by. I think if we don't come to terms with the means of our luxuries we're really doomed.

BW So this is a client commission you were bringing your students in on?

CR I did teach it to the kids at Parsons, but I wasn't trying to get them to design a project for me. Rather, I wanted to get a whole bunch of young minds around the idea that everything we buy comes from somewhere, there are people and lives involved, and there is architecture at the most basic level of this chain of events.

BW Who is the client?

CR It's a woman, actually, which is also really interesting to me. She inherited a textile company from her father and built it up into a luxury handbag line. But the twist to the story is that rather than making knock-offs or handbags to be sold in the West, she decided to make her luxury-goods line primarily for the Chinese market.

BW What's the brand?

CR I can't tell you, but it's a brand that has one store in New York and several in Europe, but mostly the stores are in China. There are several parts of the story I find compelling. It's a new town for the 21st century, and there are 4,000 workers that need to be housed. The client really wants to improve these people's lives, and make this the most sustainable factory project in China using the most advanced technologies available. And she's adding all kinds of social programs and spaces for education, for broadening these

kids' experiences. Essentially she's turning her factory into a university for kids that come from the countryside, as a kind of vocational education, as a stepping stone towards a better life. China is without doubt the most exciting place on earth right now.

BW Especially if you're a country boy who has always wanted to make handbags.

CR Or be an architect!

NEW YORK

ROLU

Interview by Jill Singer

What is ROLU? In its most literal sense, ROLU is co-founders Matt Olson and Mike Brady, former punk-rock musicians who met in Minneapolis in the early 1990s and began working together as landscape architects over a decade ago (the name ROLU pays tribute to their mothers' maiden names, Rosenlof and Lucas). In 2010, ROLU debuted their first furniture collection — a series of 22 pieces in plywood and oriented-strand board, inspired by sculptors and furniture greats like Scott Burton and Enzo Mari — that quickly shot them to the forefront of the American furniture-design scene. But to hear them tell it, ROLU is something much more amorphous than that. It is a concept and an ethos, both the sum of its influences and the result of a long list of collaborators, among whom are Patrick Parrish, the New York gallerist who gave them their first show and ultimately became their dealer, sound artist Alexis Georgopoulos, with whom they mounted an installation at New York's Museum of Arts and Design, and Sammie Warren, a one-time third partner who left ROLU just a few days before I met up with Olson at the Noguchi Museum in Long Island City, Queens. Olson was on his way back to Minneapolis after a month-long residency on Captiva Island, the former home and studio of Robert Rauschenberg and the site of the inaugural Rauschenberg Residency. Olson is ROLU's figurehead and de facto mouthpiece — he's been running the firm's much-loved blog since 2007 — and, after spending a month on a private island with only a dozen or so residents, was ready to talk.

Jill Singer	Let's start with the Captiva residency. Was there a specific project that you worked on there?
Matt Olson	We actually built these crazy aluminum chairs, new versions of our Primarily/Primary Chairs — the ones with the fur. Instead of the wood armature we used metal and acrylic. It's transparent, but really strong, too.
JS	Did you go down there knowing what you were going to work on?
MO	No. Rauschenberg's dream was to create a small version of Black Mountain College, kind of a collaborative free-for-all. So there were choreographers, photographers — everybody did something different. When they asked me, I was concerned because I'm not the maker in ROLU; Mike and Sammie make things, and I think things. So do they, but making things is not my role. But the Rauschenberg folks said, "If you want to just ride your bike and talk to people, that's fine too." It's really open. I also shot a music video when I was down there for Alexis Georgopoulos. I collaborated with a choreographer named Allie Hankins and we put a camera on her forehead to see the dance through her eyes. There was this beautiful French artist, Laura Brunellière, who helped and it was great because the choreographer would stop and then it was Laura's job to try and recreate the moves. She's not a dancer. So she would laugh and start trying to dance and you would see that through Allie's eyes. It was about the space in between them and learning in motion.
JS	Being relatively isolated on Captiva, did you have any epiphanies or new thoughts about the way you guys practice ROLU?
MO	I think it was almost more reinforcing. The way we work borders on recklessly plowing forward and trusting, rather than starting with a premise. A lot of friends who are designers are about narrowing; I'm more interested in expanding. While I was there, I was reading about Black Mountain College and thinking about the way Bob worked, and it was like, "Oh yeah, this does work out." Because sometimes I get scared that we should be more about precision and clarity, but now I'm pretty certain that will just come later.
JS	Is it possible that you feel that way because you're thinking rather than making, and you're trying to resolve all of these disparate ideas in your head?
MO	I don't think there's a hierarchy to building versus thinking. I don't know that objects are really that different from ideas. I will remember this Noguchi sculpture and until I see it again in real life, it will just be an idea or a memory.
JS	Memory seems to play a big part in ROLU's work. You often create a piece in the spirit of another artist, but it's never a 1:1 reproduction, it's more like a half-remembered interpretation. I recently read a quote by you where you explained it like this: "We seek to recreate an image in a way that is vaguely related to appropriation, but since we generally re-contextualize the objects we reproduce by making them in simple hardware-store materials, we think

it has more in common with sampling in music." What do you mean by that?

MO My grandfather was a modern architect and, when I was little boy, he had this coffee-table book about modern architecture. There were these pictures of the Mies van der Rohe Farnsworth House, four images on two pages and they were iconic. I'm sure you've seen them. They're still burned into my mind and I feel like, if I were able to draw, I could make them perfectly. When I started blogging, I started noticing that the way pictures surround us now is different and I was thinking about the way samples work in music. A lot of times you know the source, but it is becoming something else. That first line of furniture we did, which we called "Field Recordings Made of Wood," was trying to allude to that.

JS How so?

MO If you're standing in a public square, recording sound, things are unfolding at a fairly quick rate. That work happened like that. It was based on some Scott Burton stuff, some Schindler, some Rietveld, but it came together as a group. We came to New York and built 22 pieces in about two weeks. It was this fast-paced explosion that seemed more like a field recording, a set of sounds, than a strategic group of pieces. Most of the time we think about totality and what pieces mean to each other. But the only thing those pieces have in common is their material.

JS I think when you look at them together they actually do seem very similar. They all share a certain visual blockiness, and many of them have a similar geometric base.

MO Yeah, but I think that's something outside of us. I believe there's some kind of order that we're a part of and it reveals itself. As a studio we create situations where work is produced but part of the outcome seems to be happening based on decisions that we never made. That's true of all the work we do. We're usually surprised by the outcome. There are definitely connections, but it's not necessarily by plan.

JS Going back to the overabundance of Internet imagery, I wanted to ask you if you were on Pinterest?

MO I'm not, no.

JS That's surprising.

MO I know, it is. I had to stop Tumblr, too, because it was too easy.

JS You like the thrill of the chase?

MO Yeah, and I like to learn. If it's too easy to just hit a button and it's on your wall then it's harder for me to care.

JS I find Tumblr frustrating because so much isn't attributed. You find something, and you're like, "Oh my god! What is this amazing thing?", and you'll never know.

MO See, I like that. I've had a long debate with R. Gerald Nelson who wrote a book about Tumblr. He can't stand it that these images are out there and it doesn't say who it is. But I feel that it's leading to a breakdown of the academic, institutional hierarchy around art history. That excites me. We're in a moment where, if you wanted to, you could write your own history. An art historian would say this Noguchi sculpture doesn't have anything to do with Donald Judd. But It does to me — it's exciting to me that you can put Judd and Noguchi together and it makes a perfect image, visually.

JS Do you have any formal training in design or art?

MO No. I went to school for one year for psychology. My first semester I got a 0.0 grade-point average — I flunked all my classes.

JS What were you doing?

MO Just drugs. The second year, I was asked to move along and I went to treatment. Then through my 20s I was in a band and toured.

JS But you were around design growing up?

MO My great-grandfather was a Herman Miller dealer in Sioux Falls, South Dakota, and a few other small towns around the Midwest. And as I already said, my grandfather was an architect. My dad's dad was a violinist. To me, it all kind of makes sense.

JS You mean it's in your blood?

MO It is, in a way. But I do feel like I study. There's an architect named David Salmela who is based in Duluth, Minnesota, but works internationally. He's great, and is self-educated. Richard Nonas — he didn't study art. I'm always attracted to people like that. I know so many people who have, like, a Master of Fine Arts from Yale, so I'm a little self-conscious about it. But you know, when I did music for a living, I didn't know how to read the chords. People would urge me to study music, but then they'd say something like, "When you're writing and you need to be creative, you just forget everything you've been taught." And that never made sense to me! The upside is that, again, I don't have much sense of an institutional framework. To me, it makes perfect sense that the magazines of Archizoom connect to the zines of punk rock's past, and that punk rock's ethos connects to Enzo Mari's *Autoprogettazione*, and that Sottsass connects to Angelo Plessas, and Kaprow makes me think of Abraham Cruzvillegas who connects back to punk rock. It doesn't seem like a linear set of events — it all seems like water, mixing together like the ocean. And the non-Internet exposure I've had to art history presents things in an impossibly boring and linear matter-of-fact fashion.

JS Even if you have an MFA from Yale, though, you have to keep it up. And you seem like you immerse yourself in this stuff everyday.

MO I do. This is my life. I have a wife and a dog and my interests and that's about it.

JS Your shows often have elliptical titles like "When Does Something Stop Becoming Something Else" and "Everything is Always Changing All the Time," which was a quotation from John Cage. Do you ever worry that, because you reference obscure texts, it will come across as overly intellectual or pretentious?

MO I can't control what anybody else thinks. But I am sometimes bummed out because I feel like I'm the most gregarious and jovial person and totally not intellectual at all. Sometimes people say, "Man, I don't know what the hell you're talking about," and I can tell that they're inferring that it's somehow convoluted in an intellectual way. But it doesn't feel that way to me. I think you just have to do what you want to do in life. You can't worry about what other people think.

JS Actually I've had one of those "I don't know what the hell you're talking about" moments! I didn't know who Scott Burton was before I knew your work. I was looking him up and I saw he has this seat that's kind of similar to the stools from Max Lamb's China Granite series. Have you ever talked about collaborating with Max?

MO We have talked about it. You know, somebody told me that Max Lamb didn't know Scott Burton's work, and I believe it because we had a crazy thing happen: we did a project at Sit and Read Gallery in Brooklyn last year where we poured a concrete Burton, and a week before that, Oscar Tuazon, one of my favorite working artists right now, poured a concrete Scott Burton in Rome! When I saw it, I got really anxious, but we really didn't know of each other's projects.

JS Did you contact Tuazon after the fact?

MO I did. And it was way more interesting than it was weird. I guess I believe there is some sort of order outside of us that makes that kind of thing probable.

JS I think part of it is the Internet, where all of those images are out there so much more than they would've been before.

MO I think we are all becoming each other, and the Internet is speeding it up. We're all seeing the same things and sharing the same ideas. It only makes sense that people would come to the same conclusions. How many blogs look just like *Haw-Lin*? But nobody's like, "This is bullshit!" One of the things I'm interested in is, if you say something to me that's profound and it enters me and I carry it around, when does that become me? Or does it always stay you? And where did it come from before you? I think there's something really productive in seeing the ways in which we're connected. I also think a lot of artists or designers feel nervous about saying, "Yeah, this is based on a Noguchi," they hope nobody knows. We've always been excited to share what we're doing and where it's coming from. Almost every piece we do says "after" at least one person — after Carol Bove, after Scott Burton, after Sol LeWitt. We want to point to the past and its presence in our now.

JS	At Design Miami last year, you released a geometric shelving system with Mondo Cane, but it wasn't named after another artist — it was called "Seven Stacked Benches (After Shelves)." Was that meant to be tongue in cheek?
MO	We always want to point to a place where something's come from. In the same way a chair informed by Burton is "after Burton," these are shelves, but they aren't shelves in the way most people would think of them. They're seven benches that stack and happen to form shelves. In our minds, books don't sit in rows, and objects are not ordered. They lean against and support and become each other by mistake and by chance. So we tried to create shelves that put forth an opportunity to create an environment that looks like the mind looks to us.
JS	Even though ROLU is primarily known now for furniture, your scope is much wider, in part because you're often collaborating with those outside the design world. What are some other recent projects?
MO	Absolutely! Heck, we're doing all kinds of stuff. I was just commissioned by a group of museum directors who had a symposium at the Aspen Institute called "Propositions for the Future of the Art Museum." It was a really impressive group of people, if a bit intimidating, and I did a project to kick off the symposium. It was a film and a book and a set of activities, and it was set up like an A.A. meeting. I felt they were addicts and that their institutions had become addicted to a way of thinking about patrons and art and money and parties and publicity. We made Hélio Oiticica-shaped cookies and sent bad little Styrofoam cups and Folger's coffee for them to drink. And then the book, it's funny, it was really about love. I was encouraging them to take a daily accounting with the staff of the love that happens inside the buildings they run. People fall in love in museums; people fall in love with objects, ideas, they get hope. There's so much love, but I don't feel like institutions ever really think about it that much, so I think it's a great moment for them to ask themselves what they could do. Although I don't really know anything about institutions. [Laughs.]
JS	And yet lately you've been working with so many of them. This summer you were in residence at the Walker Art Center for two weeks. Did you run into any problems because you weren't used to working with that kind of monolithic organization?
MO	When the chief curator of the Walker heard we were going to be remaking work from their collection during our residency, she was rightfully very concerned. [Laughs.]
JS	What did you make?
MO	We remade about 22 pieces: a Richard Nonas piece, an Ellsworth Kelly, a Sherrie Levine, a Félix González-Torres. We made 350 On Kawara "Date Paintings." We did Yoko Ono's *War is Over*. She actually wrote to me, which was cool.

JS Whoa, that's a future collaborator right there!

MO She was very brief: just thank you for doing this project. It was absolutely beautiful.

JS How does the landscape-design aspect of your work fit into all of this? Do you still even do that?

MO Oh yes, totally. We're working on cool stuff right now. That part of the practice is different because the stuff we make and show at the gallery is really expensive. The idea behind the landscape part was always that we could also afford it ourselves.

JS Has your landscape-design practice changed at all since the ROLU name has become so much better known?

MO Yes, a lot of times people will say stuff like, "Oh we just assumed you didn't do this anymore." I think people are confused, and it probably hurts the business side of things. [Laughs.]

JS How did you and Mike originally meet?

MO Mike studied art, and he had a day job doing construction and building. I knew Mike from music and I had been working in advertising as an account planner. I had spent my 20s doing music and I thought, "I've got to do something real," so I thought I could go into advertising. It was not my thing at all, actually. So I wasn't working and Mike was doing this big landscape project for the director of the Walker Art Museum at the time. He said, "You want to come and work on this project with me?"; I was like, "Yes," and he was like, "Really?", and that's how it started. Something just clicked. But when it comes to being a business, the only way we knew how to do it was like a band.

JS What do you mean?

MO Like using fliers and the Internet. Sending a signal into the world. We didn't go to the bank and say, "We need a loan for 400,000 dollars to get an office." We used my old Volvo and we were driving around like "Sanford and Son" piled up the back. I think it was about three years in that we got too busy, so then I went to the office side and Mike took over the building stuff. But we always wanted to sprawl. We were like, "We want to do furniture. We want to do big art projects with the public." I think we must have sounded really naïve.

JS To what do you attribute the fact that you've actually been able to do all that, and be successful at it, too?

MO Trust. And just doing what you care about. It sounds like a cheesy corporate poster, but I think if you're doing what you love, it will guide you where you should be. It's been the case for us. We feel really lucky and grateful. A lot of it has to do with the people we've met. They've been really supportive and generous and friendly and kind.

JS So we've been through furniture, set design, landscape architecture, film, music videos... Anything else?

MO You know, there was a documentary on PBS a year or so ago about the Eameses. And I was struck by how the people who worked with them for years were astounded by the breadth of stuff Charles and Ray worked on. They'd be like, "One day we'd come to the office and they'd be like, 'We're going to make a film today! We have to move all the desks.' And we'd come back the next day and they'd say, 'Let's put it all back together, we're going to work on a park.'" I got kind of mad; I was like, "That's not weird, you're weird. Look out into the world! How can you just do only architecture?!" When we were starting ROLU, maybe we were naïve to think we could work on so many things, but I'm glad we were naïve in that way.

JS Speaking of the Eameses, is there a historical figure you consider to be the patron saint of ROLU?

MO I would say Rauschenberg. I would also say John Cage. I would say Yves Klein. I would say Noguchi. I would say the Eameses. It's kind of like, what would anything be without everything else?

NEW YORK

OLE
SCHEEREN

**Interview by Felix Burrichter and
Pierre Alexandre de Looz**

Ole Scheeren has a light foot — something you wouldn't expect from the guy shouldering what could be the Chinese government's most important architectural commission ever. Having joined Rem Koolhaas's Office for Metropolitan Architecture in 1995, Scheeren became partner five years ago and is now leading construction of the China Central Television Headquarters (CCTV) and its adjacent TVCC building — a behemoth undertaking more than three times the size of Ground Zero. Scheeren shepherds a team of 50 architects as well as up to 10,000 construction workers, on duty 24/7, to meet the looming deadline of the 2008 Olympics.

While CCTV will not be Beijing's tallest structure, it will certainly be a spectacular addition to the skyline of China's capital. Designed as a giant loop, a powerful image in symbol-conscious Chinese culture, CCTV will allow for an unusual confrontation of public and private functions: alongside millions of square feet of office space, it will feature a state-of-the-art broadcasting theater, cultural facilities, and a five-star hotel. While many high-rises offer one-stop express elevators to a viewing platform, CCTV promenades visitors through all of the 51 floors, providing peek-a-boo glimpses into T.V. studios, cafeterias, and the like — an unexpected candor for what some people (especially in the ever-suspicious West) deem China's No. 1 propaganda outlet.

It is easy to see only the conceptual side of OMA's work. This is one of the reasons Scheeren and his team were more than happy to showcase the project at MoMA — as he put it, "to show that CCTV is actually happening." And yet, the conceptual turn of phrase trademarks German-born Scheeren as much as it does OMA's founding partner. During our early morning interview, PIN–UP was treated not only to Scheeren's well-structured smarts but also to an all-around package of polite reticence, humor, and aristocratic good looks — the perfect circumstance to hear about fashion, Beijing nightlife, and of course, CCTV.

Felix Burrichter	What brings you to New York?
Ole Scheeren	A couple of meetings. I also went by MoMA to discuss the logistics of extending the exhibition we have there right now.
FB	Have you gotten good feedback for the show?
OS	Yes, the feedback was quite good. And I think the show is nicely embedded in its context.
FB	The context of New York or of MoMA?
OS	Both.
Pierre Alexandre de Looz	In the show, hung alongside the images of the CCTV building and the models, there were many old drawings that Tina [di Carlo, the show's curator] pulled from the MoMA collection: Cedric Prices's Fun Palace, Buckminster Fuller, Superstudio, Kisho Kurokawa… Do you feel that CCTV is almost the realization of a lot of those utopian ideas of the 20th century?
OS	I think it's interesting that at this point in time China is actually in a position to realize these ideas; it's not only about us and CCTV, it's largely about the context, both historically and politically, and really a convergence of a series of events and developments that opened a window for the project to happen. In that sense architecture is almost all about timing: it is usually a fairly narrow time span during which the potential exists for certain things to happen. And it is indeed quite interesting that the country which perhaps least participated in the Modern architecture movement is all of a sudden in the position to execute some of the most radical visions that have been developed over the past [50–100] years in other parts of the world. I even wonder if CCTV would still be possible in China right now — I think it was really a particular moment, a window that opened and closed again.
FB	Why do you think it wouldn't be possible anymore now?
OS	There are a number of reasons why CCTV could happen then, in 2002. With the emerging economic development and China joining the World Trade Organization, there was the recognition in the rest of the world that China was actually happening — and quite importantly China's recognition of itself as a new power on the global stage. And ultimately everything got boosted and propelled by that psychological wild card of the Olympics. When Beijing was awarded the 2008 Olympics, it unleashed an enormous amount of enthusiasm and energy that architecturally speaking accumulated in a series of projects, of which CCTV is only one. But CCTV clearly happened within that momentum of a future vision and a kind of set target and deadline, when China will represent itself to the world and when the world will look at

China — so it's an extremely symbolic moment. Now we're already way too close to the actual date of the Olympics to start a project like this, so this moment concludes a very specific chapter in the process of modernization of the country.

PAdL Would you sum it up as a kind of national branding exercise?

OS I don't like to sum things up; it's somehow too reductive as a perspective. It obviously had something to do with the expression of a particular power. But if it had been purely about symbolism, it could have happened in a much easier way. So to condemn the project to a purely iconographic value I think would be a big mistake, because CCTV exceeds the level of ambition and effort that one would need to devote to achieving a mere effect. The effort is really related to all the other things the project does and proposes simultaneously. The client, and ultimately China, is committed to executing these aspects of the project to the full extent: the programmatic shifts, the organizational effects, the public ambitions. The building realizes far more than a daring geometric form and to me that also signals that there is an awareness and a conscious decision on the part of the client to want more than just an icon or symbol.

PAdL I imagine it's probably a very ferocious political arena to operate in. Was there a lot of political negotiating?

OS What is really most important in the context of CCTV is to maintain a strategic operation rather than a predetermined plan — a system that continuously allows you to renegotiate, not only with your counterparts but actually with yourself, the way you ultimately think, execute, and further the project. You constantly have to watch your environment, since it is changing so rapidly and not necessarily consistently, and then assess how you actually act in this context.

It's a very interesting situation because it reaches an extreme level in which the status of knowledge or experience is maybe no longer the same as what we're used to. Knowledge and experience are extremely valuable in a stable context. If you know how certain things work, you can apply that knowledge repeatedly. But that implies that the context to which you apply that knowledge is still receptive to it. The moment the context is not develops so rapidly that its mutations are neither consistent nor steady, that's when the whole status of knowledge changes and a much more dynamic way of operating is necessary.

PAdL You've literally lived on-site now for over two years. How has the overall operating climate in Beijing changed? Or was there a particular moment where you felt the carpet was pulled from under your feet, where you had to readjust your strategy?

OS There have been several moments like that, or, as I said, it has been a continuous process of adjustment and readjustment. I have been working in Beijing for five years now, since we started the project in 2002. Within that

period there have been a lot of cycles: the change in political leadership and the implicit difference that that made in policy; the issues arising from this being the only central-government project in Beijing's central business district — the business district is a planning project by Beijing city, but CCTV is related to the government — so it became the point of contact of the two sides to negotiate their respective positions within this part of the city. But it certainly also happened on the legal or technical level that construction laws changed, and not necessarily in a coherent way. And all of these things you can only really deal with and take care of through a continued direct involvement and presence. If you're not there, if you're not physically part of that process, you will not find out early enough that something has happened, and therefore won't have the possibility to react quickly enough, renegotiate things, and maneuver accordingly.

FB How has life in Beijing changed? For example, when did the plastic surgeon move in downstairs from you...

OS ...and at what point could you actually see the visual effects of it?

FB Exactly.

OS Well, things have changed dramatically over the past few years. When I moved to Beijing, it all seemed to be a quiet residential environment. Now my apartment shares the same floor with a Japanese karaoke bar, a Chinese interior design firm, and an old lady's flat... There seem to be no limits to the mix. Traffic is total chaos. In the past years I've completely abandoned all modes of transportation: no more bicycles or cars, I just walk.

FB But Beijing used to be the capital of bicycles!

OS There was an initiative by the Chinese government, towards the end of the 90s, which was, "For every bike, a car," and that was obviously a promise or an appeal that has started to fulfill itself. In 1999, I did the show "Cities on the Move" that was curated by Hou Hanru and Hans Ulrich Obrist. For the exhibition in London the artist Chen Zhen created a piece in reaction to this statement by the government. It was a huge snake that was made out of bicycle tires, and out of its belly came 20,000 little black toy cars that started to spread all over the gallery. It was a really powerful piece, probably the most frightening of the entire show.

PAdL You've talked a lot of the social potential of CCTV. It was obviously on the minds of a lot of the people whose work was shown alongside in the MoMA show. Do you feel that that is the responsibility of an architect?

OS For me, it's maybe the most interesting and exciting part of the work. I think there are other legitimate positions in architecture that can be pursued, but the social — or in certain cases you could also say collective — aspect is the part that interests me most: beyond the sense of aesthetics and design, beyond the comprehension of either object or space. In this way architecture is really an issue of responsibility, of taking responsibility.

FB You went to school in Karlsruhe, Germany, in Lausanne, Switzerland, and at the Architectural Association in London — but your father was also an architect.

OS My whole trajectory was not really linear. In retrospect it might develop a certain linearity, but it didn't really have one then. There was the question of architecture as an intellectual or academic pursuit, and then architecture as a kind of built, physical construct. My father was an architect, and my parents were still studying when I was born, so as a baby they would always take me to school — I was known to dismantle all the students' models at the architecture department. And strangely enough, it's a memory that is still strongly imprinted in my brain: these long abstract university corridors with the occasional shelf full of study models. During my teenage years, I built basically two houses together with my dad, so there was also an early confrontation with physical reality.

FB What kinds of houses?

OS Houses for us to live in, essentially. And then later I also worked for many months on construction sites, because I wanted to see what it was like to be on the other side, to understand the whole context from that perspective. And it was actually fairly shocking to feel the vibe among the workers when the architect shows up. It's a strange mixture between fear and anger, a kind of cold stiffness.

 When I was 21, I did my first independent project, which was a fashion store. Previously, towards the end of high school, I had started my own model-making office. All of that was partly to survive, to make a living, but also because I was really interested in testing out the relationship between drawing and physical reality. When you build a model you essentially have to redraw the entire project, with the dimensions of all the materials that you have available. And this was all pre-computer age, so a completely manual process.

 By the time I finished high school, I was absolutely certain that I would never want to become an architect, because in some way I knew too much about it already and I thought it was the worst profession that you could ever start.

PAdL What did you see that was so bad about it?

OS You could easily sketch a fairly sinister depiction: It's a profession that is completely encapsulated in dependencies that restrain it to a point that only in very rare and lucky cases you are able to realize what you have been working on, and then also go beyond the predefined standards and expectations from either the client or the environment. It's also a job in which by default 50 percent of your life is essentially wasted, because half of what you work on will never happen — most projects simply never get built. And I think it's a job that requires an enormous input of time, in relation to accredited achievement. It involves an enormous complexity, both in intellectual terms, but also in organizational terms. Few other professions

require that simultaneously to the same extent. And it's still a service directly bound to the production of physical reality that doesn't have the benefits of repetitiveness and industrial production. And because it produces physical reality, it's not a speculative domain, so it doesn't have the volatility of speculative value: it is almost entirely measured against real value. And that's exactly the limitation of architecture: the investment is enormous, but it's bound to a set of physical properties that are necessarily not always perfect. And the value of the service is only measured in direct relation to the physical properties of the product, not to a potential associated or speculative value that other domains operate with, from the Internet to the stock market to art. Architecture has not really managed to mobilize similar mechanisms in order to define its value.

PAdL So how did you escape all that?

OS I didn't. [Laughs.]

FB After Karlsruhe, you decided to go to Lausanne and work with Luigi Snozzi?

OS As a teenager I traveled a lot. Rather than looking at books or magazines I drove around in my little car, through France, Italy, Holland, Germany. During one of those trips in Switzerland I met a woman who is the owner of a house Snozzi built. She told me how he had changed her life through architecture. She essentially told me how absolutely nuts and crazy he was, but so into his thing, his architecture, that he ultimately convinced her to build something she had never wanted — a modern piece of architecture — and it made her an incredibly happy person. Somehow that's what made me want to study with him. Interestingly, the only thing Snozzi would lecture about were his own projects. I really liked that. He didn't judge others, show what he deemed good or bad; he simply explained his work, his projects, his thoughts. He used to say, "If you want to do things like Jean Nouvel, then go to him. I can't tell you how to do that." Snozzi was like that, extremely pedantic and precise at the same time. He spoke much about the city — it was his actual concern, even if he had mainly built houses — and in some way his architecture was quite political, and concerned with the relationship of the individual to the larger group. He was one of the figures of the far left in late-Modern architecture.

FB Someone told me you're now rather an arbiter of style in China.

OS It's funny you say that, because quite recently a very popular Chinese magazine asked me if I would write a style-watch column. And I had to tell them I was totally interested but entirely inappropriate for that position.

FB Given your work on the Prada stores in New York and Beverly Hills, are you or were you ever contractually obliged to wear Prada?

OS There is absolutely no obligation. Actually, as long as I was actively working on the projects I completely refused to wear any of it, and I really only started to wear it after the completion of the New York store. But in fashion,

I quite like the Belgian designers, like Ann Demeulemeester, Dries van Noten, and Raf Simons.

FB Are those designers available in Beijing? Beijing is not known to be the best city for shopping in China, or the most fun, for that matter.

OS It's true — Shanghai is much more commercial and Hong Kong is certainly still the center of shopping. If that's more fun is another question. Obviously shopping is still limited in Beijing, and the stuff you find is not always up to date. But it's getting better. Which goes back to the question you asked earlier: how has life changed in Beijing? The fact that a shopping culture starts to emerge is obviously part of it. Five years ago there were probably five magazines available, sold on the back of a bicycle in the street. Now you have about 800 magazines that are plastered on countless kiosks around the city. The cars have changed colors, too. It took me a while to figure out why every photograph I took of the streets in Beijing had a particular feel to it; then I realized the cars only had three colors: red, white, or black. That completely defined the experience of the streetscape. Also the nightlife has changed. I had some of the best nights out there, when it all started, when everybody was just so excited to be partying and having a good time; there was absolutely no attitude. Obviously also that has changed. Now every club has a bouncer, has been renovated three times in two years. It's all getting glitzy, and more — but not really — impressive.

PAdL Do you still go out?

OS Yes, but less.

PAdL What do you do to relax?

OS I take very long walks on the CCTV construction site. [Laughs.]

FB So what are you going to do when CCTV is over? The next project is a tower in Singapore?

OS Singapore is already a parallel project — a 500-foot-tall residential tower in a tropical city. But I'm always trying to avoid the question, "What is after CCTV?" It's difficult to answer. But Singapore is already happening, and we're also looking at another project in Bangkok right now, which is very exciting, because it's a city with an incredible energy and I would really like to realize something there.

BERLIN

CLÉMENCE SEILLES

Interview by Matylda Krzykowski

The hallway leading up to Clémence Seilles's studio in Berlin-Wedding is lined with various stones, marble, plasterboard, and other raw and inexpensive building materials — many of which she finds in the street — while her atelier itself is a *Wunderkammer* of peculiar-looking DIY tools. Clémence moves a few things around and excitedly shows off one of her favorite pieces: a device that produces paint splashes in various textures. The young French designer's love for such gadgets borders on the indulgent, but thanks to her skilled hands and her fantastical imagination, it contributes to the production of precious artifacts that include everything from lamps, chairs, and shelves to sculptures and entire room installations. Born in St-Tropez and trained at the Ecole Supérieure d'Art et de Design de Reims and the Royal College of Art in London, Seilles moved to Berlin in 2009 to assist designer Jerszy Seymour, with whom she also teaches at the Sandberg Instituut in Amsterdam. In her short time in the German capital, she has established a small, yet impressive body of work that is distinctly her own. But her solo work is just one aspect of her career, as she explains in her charming French accent. She is just as happy collaborating with other designers, or with artists, filmmakers, scenographers, and fashion designers. Seilles doesn't purposely set out to blur the lines between disciplines or break any rules — for her they simply don't exist. Her first and only condition of activity, it seems, is the freedom to be nothing more, and nothing less, than what she makes.

Matylda Krzykowski	You were born in St-Tropez and now live in Berlin. How would you compare the two places?
Clémence Seilles	Wow, what a question! You can't really compare them. For me, St-Tropez is the place of my birth, that's all. But it's also a fantastic and weird source of energy, somewhere between something totally spoiled and the nostalgic pop-culture picture of the young and fresh Brigitte Bardot. But today Bardot is busy going senile, and nouveau-riche Russians have become the spectacle for desperate French rednecks.

MK Sounds very pop!

CS No, St-Tropez is very much dead. The pop life is in Berlin, or actually Europe in general. But Berlin works very well as Europe's capital. Locals and foreigners can get together with not too much debate over where you're from and why you're here — it all happens quite naturally. And it's easy to move around everywhere in Europe from here. London has the same quality of being international, but at the end of the day you feel very much like you're on an island, which restrains the communication and moving around on the continent

MK As someone who appears very French at heart, did you imagine you'd end up in Berlin one day?

CS I am very French. Somehow. But even when I came to Berlin for the first time in 1999, when I was still a teenager, I could already imagine living here. It's not that I was so interested in German culture, but I sensed that this place is very open to receive and to give.

MK And you moved to Berlin in 2009?

CS Yes. I moved here because of Jerszy Seymour. After my studies in London, I was looking for an interesting person to work for as an assistant. Most of the people I wanted to work with happened to be in Berlin, like Raoul Zoellner, Clas Ebeling, Owen Hoskins, and of course Jerszy, so it wasn't exactly a coincidence. For me, people always come first, and I like to take advantage of the experiences available around me. In Berlin there are a lot of experiences available, and you can have both learning experiences — like assisting an established designer — and the opportunity to realize your own projects. You don't have to look too hard to find the mental and physical space or for inspiring people you can work with. And both are important to me, since as much as I like to experiment by myself, I also rely on the energy of others and the magic that happens when you work with someone else.

MK I think your collaboration with Clas Ebeling, with whom you did the Authentic Sources chair series as well as the Batik Lamps, is a very good example of your channeling other people's energy. I asked him about his work the other day, and he just smiled and said that, compared to you, he only does 0.1 percent.

CS [Laughs.] He's another person with another way of being. In Berlin you find a huge range of creators with many different ways of working, from the hysterically productive to the hyper-contemplative, super-slow-production artist. But when Clas and I met, it was obvious we would do something together, maybe because of the attraction of our different projects. After I did the Osmoses Lamps [2010], I wanted to work more with textiles; at the same time Clas was pushing his textile research into how to create special patterns, so we started a little textile laboratory together, creating fake marble patterns, synthetic-stone patterns, etc.

MK You don't really work within the so-called design industry — I even heard that instead of selling your work, you sometimes do some kind of trade.

CS It's true, I don't work with the industry so much. It could happen, but what's more important to me is to work with situations. Take the Osmoses Lamps for example. It began as a self-initiated project, no gallery involved. A few months later, the HBC art space here in Berlin organized a show called "Art Barter," where artists were invited to trade their work for anything except money. I traded my lamp with a Frenchwoman called Marie Petit in return for a one-month stay in her villa on a wild Croatian island — one lamp in exchange for a one-month holiday! Then I met Clas Ebeling, and he and I decided to go to Croatia together and work on a textile project. It's the experience of the making that is the adventure, and the context of creation is completely part of a project. So instead of getting the materials from far away, we shipped ourselves far away with our materials. In a way, it was the reverse of what designers usually do.

MK So what happened in Croatia?

CS It was just a fucking hippie trip! And we did some batik. You know, it's not that easy to go on a hippie trip. But when you're there on a fantastic island, a wild island, it's easy to come out of yourself because the surroundings give you this energy and possibility.

MK So how did you come up with the idea and the material for the Batik Lamps?

CS The materials come from an ancestral technique, batik. It's an expression of artificiality — probably the first expressionist school that happened before a few centuries later we gave it a name. The shape is a growing force, a triangle that occurs often in my work. In the end it doesn't matter what the shape is, because I'm not a Raymond Loewy, or someone like that. I think I'm rather an expressionist. Making batik on an island with waves splashing and crashing right next to me is very expressionistic. In a way the Batik Lamps are a contained, growing wave that finds itself in the shape of a triangle.

MK The other night you invited me to dinner at your house here in Berlin. A lot of the people whose names you mentioned earlier were there. It seems you organize dinners like this regularly, in order to gather all the significant players around you?

CS I do it often, yes. It allows me mastery over them by way of generosity! [Laughs.] They are all my artist friends: Adrien Missika, Emile Ding, Claudia Comte, Jerszy Seymour... But the night you were there, someone very important was missing: Elisa Valenzuela. We met when we were at art school in Reims when we were both 19 years old. Since then, she has become an outstanding luxury Parisian glamour woman as well as a talented post-acid punk photographer and filmmaker. She is a dangerous explosive cocktail that I want to taste. She and I are working together on a science-fiction movie project involving all the artists I just mentioned. They'll be making psychedelic sculptures that will act as the décor.

MK Sounds like quite an explosion! How did the idea for that come about?

CS It's been an ongoing project, but we want to shoot it before the end of this year. But it's not just a film, you know. We will also present and produce it partially through exhibitions related to scenography, performance, and timing issues. We're in talks with the Centre Pompidou in Paris to organize screenings and special events around the project in 2013. Right now we're still working on the funding for it, and we're not quite there yet. But for me, this project is a total priority. I have sleepless nights to make it happen.

MK Is it your first time working with film?

CS Yes, and it's really new for me to face such a representative and narrative medium. Coming from a design education, and moving freely to various contexts, the film medium appears as an ultimate format of representation.

MK So what's the film about?

CS It's set in a post-apocalyptic earth where newborns and adults will rebuild the whole planet by mistake. Each time they fart they release a sculptural form, carrying the traces of the old world. All sculptures and background elements are a sublimated representation of this extinct world. Elisa and I wrote the script in an impulse to illustrate a physical demonstration of buildings: the narration, the décors, the collaboration frame...

MK And what would those buildings look like?

CS First of all, I would look for someone to work with. Not necessarily an architect — more a fashion designer, or an artist.

MK But in a building there are so many rules you have to follow...

CS But that's just a commodity. You hire a technician or any other person who knows the basics. But for the actual project, for the poetry, which is what I'm interested in, I would look for an artist, not a technician. I would approach this with unconditional romanticism.

MK Are you as romantic in your role as a teacher at the Sandberg Instituut?

CS Maybe! [Laughs.] But I go there exclusively for workshops, which are initiated by all of us in the Dirty Art Department [Jerszy Seymour, Stephane

Barbier Bouvet, and Catherine Geel]. I set the students up to work together and create a dialogue among their individual projects. That's how I work most efficiently, bringing the students into the action. Sometimes there is a brief, which is an excuse for them to make something — it could be a banquet for 50 people, or a giant sculpture taking over the whole room. So that way the students are being prepared for the workshop; and when it starts I do maximum one day of discussion and then I want them to use what is around them, and they act.

MK How would you describe your teaching method?

CS In a sense, I help to show them how much their projects are connected to each other. I make them make things without forcing it. I want them to expand their forces. But in the end they do their own thing.

MK Can you be more specific?

CS For example, if I have two students that are thinking about two totally different projects, I will sometimes see a potential for them to work together for the benefit of each other's project; I explain to them what kind of link I see in their approach, then a conversation happens that gives value to their own project, and I give them space to deal with that. I just told two students to work together on an installation for the open studio day. The outcome was very good — it was a step that gave them a different perspective on their own development.

MK Do you also encourage them to use the same kind of DIY building materials you like to use in your work?

CS I would say no. It would be absolutely terrible to wish on them what I do! [Laughs.] But, of course, it happens that I share with them what I know, what I have, where I get it from. I think it's good to give them an insight into your own references and sensibilities.

MK At the beginning of the year you went on a trip to Russia. Is that what inspired the title of your *Datscha* sculptures?

CS They also use that term here in Berlin — *Datscha* is what they call the little cottages outside of the city where you go on the weekends to work in your garden. They're actually the main source of inspiration for the kind of material I find in building-supply stores. In Germany these stores have a very generous variety of garden gear, paving stones, etc.

MK What is your strategy for choosing the different materials?

CS Agglomeration is the key. I collect wood, various metals, minerals, representations of nature, and fake or recomposed fragments of nature developed by the industry for an urban world. Garden tiles are available as a product, but I also use various "poor" building materials that I find on the street, like pieces of asphalt, stucco, or other leftover industry products. Even if these components have exhausted their regular use, they

still have wonderful expressions by themselves. I copy what I call "recipes from industry." First, I start in my workshop to build a laboratory of dust and dirt. Then, for example, I talk to the companies that make roads, building materials, or garden tiles in order to get tips for the best methods. I make my own experiments for space, furniture, or for science-fiction movie décors.

MK And this idea of agglomeration is inspired by your trips to building-supply stores and to these dachas?

CS Yes, I love these DIY stores and trips to dachas. It's a bit of a white-trash project!

MK Pop life, hippie trips, white trash... And the other night you also had a bit of a rock 'n' roll moment when, standing at the window, you yelled *"Nazdarovie!"*, downed a shot, and threw your glass out into the courtyard.

CS Yes. I call that a "Why not?" moment. It's something very stupid and nothing you think about very much — you don't see the consequences. It can cause some surprising, inspiring situations, but it can also turn out to be quite bad.

MK And how often does Clémence Seilles have "Why not?" moments?

CS Not every day, but every other day.

NEW YORK

ANNABELLE SELLDORF

Interview by Ricky Clifton

For the past 20 years, German-born Annabelle Selldorf has established herself as the go-to architect for the upscale New York art set, having worked with the likes of David Zwirner and Jeff Koons. Her uncompromisingly classic and tastefully understated designs, including furniture, appeal to artists, gallerists, and collectors alike. High-profile commissions such as the infamous Abercombie & Fitch flagship store on Fifth Avenue have rounded out her portfolio. Now, as her office has grown to over 40 employees, Selldorf is working on a number of luxury condominiums in Manhattan, completing her impressive evolution from high-end niche architect to full-on power player on the New York architecture and real-estate scene. PIN–UP paired the usually no-nonsense Selldorf, who has a reputation for Teutonic rigor, with former cab driver, artist, interior designer, and general downtown demimondain Ricky Clifton, with whom she worked on the Hauser & Wirth residence on the Upper East Side. The two sat down for an informal chitchat in Selldorf's offices in Union Square, former home to Andy Warhol's Factory.

Ricky Clifton	Your father, Herbert Selldorf, who is an architect in Cologne, was he a big influence on you?
Annabelle Selldorf	Yes absolutely, but not in the Frank Lloyd Wright kind of way, stomping through the house in his black cape. Actually, both my parents were a big influence — their way of living, their way of looking at the world.

RC What did your mother do?

AS My mother was just supportive of my father, and worked with him a lot. My parents did something that I think is very wonderful: they had a whole life concept. Life and work was almost the same for them...

RC I have a friend who is a banker and he told me once, "You never work," And I said, "What do you mean? I always work!"

AS Exactly.

RC So your father started with interiors first, he didn't go to architecture school?

AS No, he didn't go to architecture school. It was a company called Vica, that was part of the family, my grandmother started it and then her children joined her after the war.

RC How old is that company?

AS It's been around for a long time. Now it's no longer called Vica, it's part of another company now. In large part it was something that was a response to post-war Germany: how do you start your life over again? My father was working with his siblings, and they had a company and they provided interiors — they would do room design, have furniture made, upholstery, and curtains. Very sort of *haut bourgeois* with a Modernist slant. At first I didn't think that that's at all what I wanted to do. But by the time I finally signed on to the idea of being an architect, I wasn't eligible for architecture school in Germany because I was never a very good high school student. But somehow I was accepted at Pratt Institute in Brooklyn. I went there thinking I would perhaps go there for a year or so, and next thing you know, 30 years later I'm still here.

RC And then you stayed in New York all the time?

AS Yes. I didn't know where else to go! [Laughs.] How long have you been here?

RC I moved here in 1975, and a couple months after I moved here I came to do a movie as a conceptual artist, and I did costumes for my best friend Jean-Paul Goude. Back then he was the art director of *Esquire*. He lived over here, Andy Warhol had his Factory upstairs, and I had this idea for *Esquire* to costume celebrities' pets as other celebrities. So the first of the series was Andy's two dachshunds Amos and Archie as Jacques Cousteau and the Pope.

AS	You're kidding?
RC	And it's on page three of the Warhol diary.
AS	That's hilarious! So this building where my office is really means something to you?
RC	Yes, but let's get back to you. So did you go to Pratt for architecture?
AS	Yes, because by then I really knew that that's what I wanted to do.
RC	What did you do before that?
AS	I apprenticed in a number of different architecture offices in Cologne, and then I started working in Richard Gluckman's office. And I worked there until the early 80s, approximately. Then I went to Italy for a year, in Florence...
RC	Aha, I think I notice the influence! What's the Italian word for fascist architecture? It starts with an "r"...
AS	You mean *Architettura Razionalista* — rationalist architecture?
RC	Yes! That's my favorite! All that early 1930s early fascist stuff. To me that's just great. And I can see elements of that in your project for Hauser & Wirth — the doorway, for example.
AS	Yes, absolutely. Of course, that's where a lot of influences came from, too. Florence was such a great experience, because maybe more than anything else it made me want to be an architect, because I spent all of my time going around looking at architecture. It was the first and only time that I really had the time to just be dedicated to studying. When I was in New York, I always worked at the same time as I was going to school, so that was always very stressful. But in Italy, I didn't work, I just went from place to place, and I had some really wonderful professors. So when I came back to New York, I realized that I didn't like working for other people that much. And in my youthful enthusiasm, I thought I could work at night, and hang around during the day, going to museums, looking at art... Of course that doesn't at all happen that way. I realized you can't really control how much work you do or don't have — if you don't have enough work you worry that you might not have money to eat, and if you have too much work you have to put out.
RC	So, what was your first job that you did as an architect by yourself?
AS	My first job was a kitchen renovation. It took forever, and it took up a lot of my time because I was involved in it until the very last detail. After that was done, someone else came around who had another kitchen and bathroom to do. So all of a sudden, I had done one job and I was already in business. One thing sort of led to another...
RC	What was your first architectural project?
AS	One of my first real jobs that I did was a gallery space for Michael Werner, on 67th Street. That was a job that I really loved.

RC Were the people from the early projects art people as well? Because that's something I realized, that you're doing all these projects for people in the art world.

AS You know, I think it's an affinity to the same aesthetic. And in the case of the Michael Werner space, that was sort of the first of many others, where you realize that people look at the same things. Some of it is as simple as having the same tastes, but as an architect of course you also establish an architectural idea. But that overlap was good. So then I worked with David Zwirner, which was the first project of many others to follow. This was his first gallery on Greene Street, where we were both on our hands and knees doing a lot of things ourselves. But in a way it was really great to grow up together in that way, because then you really appreciate what you accomplish. And that has always mattered to me, to be around people and to deal with people who have similar interests. I'm sure it's the same thing for you, and always will be.

RC I sort of work with a lot of friends who are artists, and then, as you said, one thing leads to another. It's also kind of a social thing, I don't know…

AS Yes, but it also boils down to a shared sensibility. How would you describe what you do? Is it decorative arts? It's probably more applied arts, right?

RC I don't know how to describe it. I do painting and sculpture, printing and all that. And I find furniture and objects and I am producing a lot of different things that all become environmental to me — and I never do the same thing twice. When I get desperate about explaining this, I often ask if the person knows who Jorge Pardo is. My gallerist, Lorcan O'Neill, told me not to say that, but I'm using the name as a figure of speech.

AS Yeah, and I think that's actually very good, making Jorge Pardo a technical term! [Laughs.]

RC You know, my favorite project you have ever done is the Neue Galerie on Fifth Avenue. And the café downstairs, which is named after my favorite café by Joseph Hoffmann, Café Fledermaus. And I thought it would be great to do some weird tile work down there. I love that place. Did you find the paneling for the Café Sabarsky upstairs yourself?

AS The paneling was there, but so much of the rest was not there. So now when I go I don't remember anymore what is old and what is new, because it overlapped. Maybe that's in some ways apt to describe how I work. Because it's not all about saying, "This is what I did," but to find a sort of pact, where far from being distinct and soulless, you just decide where you want to articulate and where you want to have your own separate identity versus being part of a bigger thing. And I think that's a pretty interesting and relevant idea in architecture, where we deal with the urban condition all the time. You know, the Neue Galerie is a prominent object on a street corner but it still has to be part of a larger environment.

RC But you consider that! Some people don't. You know, Rem Koolhaas did a design for the Astor Place Hotel, which was never realized, and it had these bombed out windows — it looked like Beirut. It wasn't a bad idea, but it was completely ignoring the whole neighborhood. Every building in sight on Astor Place has arches, so I thought what a great opportunity to pay homage to the arch, like the "Square Colosseum" [Palazzo della Civiltà Italiana, Guerrieri, Lapadula, and Romano, 1938–43] the EUR area outside of Rome.

AS I know what you mean. I think it's legitimate to ask, "What is the function to provoke?" I think there is more than one way of doing that — it doesn't always have to be antagonistic, it's not all about urban antagonism.

RC But you also worked with so many artists — David Salle, for example.

AS Yes, I've worked with Eric Fischl, I've worked with Not Vital, and I've worked with Jeff Koons... And recently I did a cabin for an artist. Working with an artist is fun, but it's such a different kind of exchange. It's a visual exchange, rather than a verbal one. If you admire somebody, then it's a big treat to do something for him or her.

RC So tell me about the apartment building you're doing on Eleventh Avenue, 200 Eleventh. I looked at the interior renderings on the website, and it looks like a French artist's studio, with the stairs coming down into the living room, the large windows — almost like the Atelier Ozenfant or something.

AS I think that's definitely true. What happened is that we were asked to do this building, and more than anything I cared about was to create something that was in some way related to the neighborhood. And the design is pushing it a little bit, but it's also a building that comes to the ground solidly, that isn't all glass. It has relatively small windows, but I think the way they frame the views is quite extraordinary.

RC Is every unit the same?

AS No, there are about four or five different types. But it's quite complex, because they're all duplex apartments, so they have this yin-yang thing going on, hooking into one another. But the real reason why everyone is talking about the building is because it has parking that allows the cars to come to each individual floor.

RC Which is like the Starrett-Lehigh building on 26th Street and the West Side Highway.

AS Yes, exactly. And the funny thing is that it grew out of a necessity, but it became something that was very exciting because it had never really been done before. But the original necessity came from the lack of an actual basement, which could have provided for a garage.

RC I guess you could have one, but then you might have a little water problem.

AS You got it. So we figured that it was worth the extra effort.

RC Well, I think it's also really sexy.

AS I don't know about that. [Laughs.] But what I really like about it is how the exterior volume relates to the interior.

RC How many floors does it have?

AS There are 18 floors, but they are very, very high-ceiling floors. So each of the floors has double-height spaces. The construction is up to the 13th floor now and you can really already see what the interiors are going to look like.

RC Good, because what I always hate is low ceilings. All the Trump buildings have really low ceilings because they're trying to fit in as many units as possible. The only exception is the Trump World Tower. It's in that Sidney Lumet movie, *Before The Devil Knows You're Dead* — the drug dealer lives there. You should rent that movie. But all the other Trump residential buildings feel like office buildings.

AS Yikes.

RC I guess another interesting building is your collaboration with Philip Johnson on the Urban Glass House. How did that happen?

AS Well, Philip Johnson died before I really had anything to do with the project.

RC So he did the architecture, and you did the interiors?

AS Actually the person who did most of the architecture was his partner in the firm, Alan Ritchie.

RC How did it happen that they asked you to do the interiors?

AS Well, it was a really strange thing because it was really my first opportunity to work with a developer. Somebody I knew who had worked on a variety of projects called me up one day and said, "We purchased this building with the skin already designed by Philip Johnson's office, and we're going to develop it." Then they asked me whether I would like to work on it. Initially I thought I didn't want to do that, because everything was already decided for — they already knew how many units, etc.

RC The layouts...

AS No, we did the layouts. But the positioning of the units already existed, and we thought maybe there is not that much to do — because if it was just about selecting the bathroom tiles, I wasn't really interested. But then we started working on it and we realized that if we pushed things around here and there you could actually make some really great apartments. And in the end I'm really proud of it, because it did end up being a lot of work, but that really helps, because it gives you stamina. And a nice effect of that project was also that it made me look very carefully at Philip Johnson's work — of course liking some things much more than others. But I really have a lot of respect for what he did.

RC You know I'm from Fort Worth, and Philip Johnson did all these buildings down there, and when I used to drive a cab I picked him up a couple of times — him and David Whitney [Johnson's boyfriend]. You know, in the middle of the night....

AS Is that true, here in New York? I never realized you used to drive cabs... You lived dangerously!

RC Yeah. Back then you could make a lot of money. And after I stopped driving a cab I was a cater waiter for about three months. Back then the best catering was Glorious Food. And they called me up one day and told me, at the last minute, to come to Lever House. And I got there and it was the dinner to celebrate the fact that they had saved Lever House, because they were going to tear it down. It was hosted by Jacqueline Onassis, for whom I also used to do floral arrangements. So I was pouring wine at the table behind her and she tapped me on the shoulder and said, "So you changed jobs?" And Philip Johnson was behind me listening, and I said, "Well, I also drove a cab and I picked him up twice." I told him that I was from Fort Worth, and he said, "Yeah, I remember you. You're the one who said I'm the Maria Callas of architecture." So everyone was laughing, but the Glorious Food people were all glaring at me. Needless to say I never worked with them again.

AS [Laughs.] Uh-oh! That's hilarious. Listen, I am sorry, but I really have to go now.

RC That's okay, I think we've talked about everything but Anna Wintour's residence, which I saw mentioned on your website — but no pictures.

AS Oh, just forget about that.

LOS ANGELES

PETER SHIRE

Interview by Katya Tylevich

Peter Shire is painting a ceramic bowl when I arrive at his studio, a warehouse of earthly delights in Echo Park, Los Angeles, his neighborhood since childhood. Shire still occupies the nearby mid-century-modern bungalow he grew up in, which has had its fair share of coverage, not least for his colorful, decorative additions to it. In photographs the house appears sparse and uncluttered, but not so Shire's studio. Packed to the brim with stuff, the gutted industrial space serves as a crash course in the artist's multifaceted background. On graduating from L.A.'s Chouinard Art Institute in 1970, Shire immediately joined the "unclassifiable" file, drawing from architecture and industrial design while rooted in fine art and ceramics. Later that same decade, Shire's work caught the eye of Ettore Sottsass, who subsequently invited him to be part of the Milanese Memphis movement; the Brazil Table (1981), Peninsula Table (1982), and Big Sur Couch (1986) are just three of the celebrated pieces Shire designed during his Memphis years.

Like a giant suitcase, Shire's studio holds both the essentials and souvenirs of his evolution as an artist: glass vases and ceramic teapots; plates, bowls, and paints; steel fragments of large public artworks; tables in progress and tables from his Memphis days. There are cabinets filled with drawings, shelves full of books, and an entire wall displaying more than 150 knives. But the studio is also full of sound: the sawing and hammering of a workshop full of people, a radio turned to symphonic music, and Shire's colorful and nonlinear manner of speaking, where thought A is bridged with memory B to make point C. "She's going to make fun of everything I tell you," he laughs when his wife, Donna, comes in. By this time he has moved on from painting the ceramic bowl to cutting a watermelon into cubes, all the while being followed by a camera crew from Louisiana State University. Meanwhile, Shire and I have our own retrospective going, a five-hour conversation in which we discuss nostalgia, kitsch, Karl Lagerfeld, and just who the audience for his work might be.

Katya Tylevich	It seems you live in a very clean and structured modern space, while your studio is more organic and disorganized. Is that a sign of two different sides of your brain at odds?
Peter Shire	No, the house only looks that way for photo shoots — it takes us two months to get it looking like that. We take our own photos of it for the verisimilitude, to show what it's really like. But the truth is, I work at home, and have to clean up if people come over for dinner. Really, I think of home as a refuge. I used to think of Echo Park as a refuge, but that's changed.
KT	Why?
PS	In two words, real estate. It used to be more tolerant, this neighborhood. All of Los Angeles used to be more tolerant. Greed has always been a prime factor in this city, but now it's somehow more critical and more vicious. I used to think Echo Park was off to the side when it came to those things, but maybe that was just my own nostalgia.
KT	How do you define nostalgia?
PS	Nostalgia can be explained by the role that palm trees play in Los Angeles. Palm trees aren't indigenous to the area, first of all, and second, there aren't even that many of them here — it's just that when you look over the horizon and see palm trees, you associate them with Los Angeles. So looking at Echo Park and saying, "It's bohemian," is the same kind of nostalgia.
KT	Palm trees seem to play a role in the definition of "kitsch," don't they?
PS	Oh, kitsch is a word I love. And I'll tell you what I love about it: we all use it a lot, and we all more or less know what we mean when we use it, but not one of us can really define it. Another word like that is "platonic," but I won't get into that now. As for kitsch, I've struggled to find a definition that could be encompassing. What I've come up with is that kitsch is the substitution of spurious values for real ones. In other words, plastic flowers. Or a bathroom cabinet from Home Depot with a fake-marble plastic top and sink that costs 89 dollars. I know, it's a broad definition, but it's something.
KT	Do you find it fits with other people's definitions of kitsch, especially when it comes to art?
PS	Do you know this guy named Charles Phoenix? I was at a party with him and he and I were basically having this exact conversation, so I asked him, "Well, how do you define kitsch?", and he said, "Everybody knows what kitsch is — kitsch means quality!"
KT	Are you reclaiming the definition from being a derogatory word?
PS	The thing is, kitsch ranges — there's high kitsch or camp, which can be kind of charming, there are flamingoes and things that are wonderfully kitsch, and entire books about kitsch that are not even on my meter. The whole

concept seems to defy the idea of taste. Then there's kitsch done for effect and real kitsch. I think the latter falls into the same category as "real" bad architecture, which nobody criticizes.

KT What's "real" bad architecture? Is it architecture that purports to be good, but isn't?

PS It's architecture that's not even a player, not in the game at all — buildings that don't register. Most of the time we look at the major percentage of a city without even thinking about it, it's just gray. We don't think of "real" bad architecture as cool in any way — we don't think of it at all. And so it enters into a kind of purgatory. Examples include McDonald's stands or developments purporting to be a semblance of security and even graceful living. That's kitsch — that's real kitsch!

KT Do you differentiate between architecture, design, and art when they meet in your own work?

PS Those things are all swirling around inside me. I steal a lot of forms and shapes from architects. [Laughs.] They appeal to me. But I work with the idea that it doesn't matter how you get what you need. What I mean is, if I need a circle, I'm going to think, "What's the easiest way to get the circle I need?" I won't think the way that some ceramic artists think, for example, which is, "Well, you can only make it out of clay," or, "You can only use plaster to make molds," or any of that rigid, self-imposed, puritanical stuff.

KT Speaking of puritanical things, I remember reading an old interview with you in which you described your work as a reaction to the strict boundaries and limits of Modernism.

PS I said that?! [Laughs.]

KT Something to that effect. Do you deny it now?

PS Probably. In principle. Whatever it is I said, I do love Modernism, despite being involved in all this weird stuff currently called Postmodernism.

KT Since we've been discussing nostalgia and kitsch, I wonder if you think there's any room for it in Modernism? Or is Modernism meant to sweep such sentimentality under the rug?

PS Yeah, that's the big glitch, isn't it? That goes back to our conversation about cleaning up the house for a photograph. People don't live that way. They don't operate that way. People collect things. People get terrible gifts from their loved ones that they don't want to throw away. You hold onto terrible things because you love the people who gave them to you.

KT Are we talking about clutter versus modern architecture?

PS Well, if you really think about the idea of cleaning a Mid-Century modern home in order to take a photograph of it, it raises the whole issue of how before and immediately after the war people didn't have stuff the way that

we have stuff. Now people can't park their cars in the garage anymore because their garages are so full of it. So people didn't always have things, but now they do, and they still want to imitate the photographs that [Julius] Shulman and the other great photographers took of those modern homes. Of course, even then, Shulman and those guys were removing objects and things from their shots, and people cleaned up for the photographs, and so on. Still, the look they captured remains a valuable one, in part because it's been printed, it's been validated, and it looks great. And wouldn't it be great to achieve that look? Wouldn't it be great to be very pure and spiritual?

KT Is it a futile aspiration?

PS There are people who can do it. My wife's father could throw things away. Oh, he was something else!

KT Can you throw things away?

PS Me? I can't throw anything away! My wife can empty out drawers without even looking at them, whereas I start to look through everything in them, and then I can't throw any of it away.

KT Where do you see your own pieces? In picture-perfect modern settings? Or surrounded by the terrible gifts that people receive from loved ones?

PS I do feel that the main thrust of my work is domestic — it's on a domestic scale — and that probably comes from having started as a ceramist, as a potter. That allowed me to see things in a real house, on a very human scale. Now, a lot of artists and designers really see their works as existing on a museum scale, so their works aren't made for anybody in that respect. What's wrong with that picture? I want to put my finger on it. It almost feels like you can't talk about this stuff without getting on the FBI's purview, but the double-bind of art and design is that we often deal with people who are not only interested in the exceptional, but who can afford it. And, really, that's what you're asking me, isn't it? Is my work for a "normal" house or is it for the home of someone who has enough money to build a gallery or a museum-like addition? That's a very difficult question to answer. It also costs a lot of money to make everything. So maybe the answer is both.

KT It doesn't seem like an answer you take lightly.

PS You know, I once had a woman ask me, "What are you doing these days?" I think she expected a litany, but the only thing more disgusting than listening to someone else talk about him or herself that way is listening to myself doing it, so I thought about it and finally I said: "What am I doing? Well, I'm thinking about the reason that I make things and what they're really worth. And I'm thinking about what I should be continuing to do, and what I should be stopping." And she paused and thought about it for a minute, and then she said, "Well, my husband's a lawyer and they don't think about that." [Laughs.]

KT As someone who seems to exist in a category between art and design, do you work in an artistic vacuum or are you conscious of a client or audience?

PS My problem is that I don't think of a specific audience, because if I did, I'd probably sell more! [Laughs.] Although public art is a funny one, because strictly speaking it's supposed to be for the public. [Laughs.] And in that case, I do of course think of the people looking at the work and how I can include them. For me, the ideal is to include not only formal, but also intellectual issues in art.

KT Do you think it makes sense to categorize art — for example, as conceptual or applied?

PS My take is that many people who call themselves artists today are really tradespeople, who come from a line of tradespeople. In general, there's an atavistic — I mean, it's in our DNA, if you will — need to do things, make things, produce and be part of the world. I guess the whole meaning of economy is the exchange of goods and services; in other words, the flow of what everybody does for each other. And if we're a protracted tribal society, that means we cooperate. We don't all grow our own food, we don't all milk our own cows, or make our own shoes, etc., etc. Anything that's really necessary is produced industrially, which leaves all these people — young and middle aged and older — in need of something to do. So what I'm getting at is that sometimes you look at an artist's work today in a gallery, and your first thought is, "Give me a break, that's weaving!", or, "That's shoe-making!", only now it's conceptual.

KT It's interesting you bring that up — weaving, shoemaking, and trade — because wasn't your father a craftsman as well as an artist?

PS Yes, he was a carpenter and he graduated as an illustrator from Pratt in 1932. My father was terrific at what he did, and also quite complicated. No, not complicated — I hate the word, it's so silly. I'll say that he had a lot of dimension. He later became involved with the labor movement and leftwing activities in the 30s. He was very diligent, a real disciplined guy, and he was so funny. When he retired, they called him up for jury duty, and I later found two books entitled *How To Be A Juror*, which I know he probably read in full. Anyway, he had a family to support, so he became a carpenter. But I don't think he felt conflicted with the part of him that was an artist. I don't know if he felt disappointed. What was interesting, looking at his illustrations after he died, was that he was a natural. You know, he barely needed to warm up. You can tell that the only time he did things was when he had something to say.

KT And as a working artist you don't have that luxury?

PS It's different. As professional artists, we have modes and tricks and systems and so on, theme and variation and motif, all that stuff. You get a thing going, you develop it, and so forth. But my father didn't think about those things. Looking through his work now, there are many scenes I recognize from when

we went to the beach, or when we were in the mountains, or when he was working with one of his friends.

KT Since we've mentioned DNA already, do you think you inherited your father's need to say something through art?

PS Probably. Even more than that, I think there's a transference. I don't know that this was primary in my becoming an artist, but I definitely find myself feeling that I'm doing it for two people — my dad and my high-school art teacher.

KT Do you think that growing up in a Modernist home also molded your psyche at all?

PS Oh, on all levels. But to put it simply, yes, we were snobs! [Laughs.]

KT In what respect? Design snobs? Architecture snobs?

PS Yeah, yeah, all of it! But, you know, my parents were involved in leftwing politics, and in the real effort to help the poor, and to help working people. They were heavily into ideas of justice, and fair play, and thinking. One of the things I've come to lately is that they were interested in the idea that a system could enforce and codify fair play. These days, we simply don't believe anybody could do such a thing. Nobody believes in anything really, not in the same way.

KT In that environment, did you romanticize becoming an artist when you were young?

PS Absolutely. Yes, I did.

KT Did it seem attainable at the time?

PS Well, you may have noticed that everything's a little story with me. In this case, my story is a memory I have from back then. I'm in the hallway, having a conversation with this young guy, and all of a sudden he interrupts me and says, "Boy, look at that woman over there! I have to go over and talk to her right now, because if I keep standing here talking to you, I'll never do it." And off he went. So that's the way I felt about becoming an artist. I didn't want to talk about what a good idea it would be, I just wanted to do it. There's more to it than that, of course. Another way of thinking about it is, you know how Japanese people cook their rice in a pot? They never open the pot while it's cooking, so that they don't let the steam out. The idea is, don't let the pressure off. It's the same thing as that guy going to talk to the beautiful woman right away. Don't let the pressure off. If I talk about it, I'm letting the pressure off, and I'm letting out all the energy I could be using to do whatever it is I'm talking about doing.

KT Does that mean you'd rather be working than talking to me right now?

PS I'd like to tell you that what I do these days is eat watermelon. I average about one watermelon a day.

KT That's good for your kidneys isn't it?

PS Good for the bodily humors, as they say.

KT Just one last question then. Can you tell me your famous Karl Lagerfeld anecdote from the early 1980s, when he furnished his entire apartment with Memphis?

PS Actually, it's a story of a story that we were told. Apparently he came in, swung his cape around and said, "I'll take everything!" As I understand, he was with Andrée Putman and she was putting together these two apartments for him, one in Monte Carlo, which was all Memphis — he could pull it off — and the other one in Paris. She took a lot of teapots, as well: the colorful ones for Monte Carlo, the black-and-white ones for Paris. So when I've told the story before, I think I've been quoted as saying, "Oh, I couldn't live with a room full of Memphis!" But what a stupid remark! [Laughs.] I think you can do any darn thing you want, even if I think of the work as a spice, and not necessarily a main dish.

LOS ANGELES

JULIUS SHULMAN

Interview by Fritz Haeg

On a sunny Los Angeles Sunday afternoon, I arrived at the appointed time at Julius Shulman's Raphael Soriano-designed hilltop residence. The house is reached by a long, steep driveway off Mullholland Drive. At the top is a quiet wooded retreat. I rang the bell, but there was no answer. I called and left a message. I waited another half hour, then decided to leave. That evening I got a call from Julius: he apologized and recounted how Benedikt Taschen had suddenly arrived in town just before we were to meet, and whisked him off to his John Lautner house, the Chemosphere, to show Julius the new three-volume monograph of his work for the first time.

When Julius and I finally met a few days later, he cheerfully welcomed me into his studio from behind his desk. He was sporting a bright-red pair of Marilyn Monroe-printed suspenders. He obviously enjoyed the frequent ritual of admitting young admirers into his modern den. I was impressed by how in-the-moment he was. I was also surprised by how keen he was to talk about his land, trees, garden, and animals, even more than about his own house or architecture in general.

Fritz Haeg	Being on this property and in this house for so long, how have your feelings about it changed? In a lot of your early photos we often see the buildings just built — they're brand new — and the landscape is restrained and bare, then you go back 50 years later and the landscape grows in and the house mellows...
Julius Shulman	When I first saw the property I knew that was it, there was nothing on it, just a little brush up on the hill. As a child growing up on a farm in Connecticut, we were surrounded by forests and a lot of land. When I came out here in 1920, I thought, "This is great! I want to live in the hills and simulate that sort of landscape." I was only ten years old when we arrived in California. I bought this property in 1947, we moved in in 1950, a year later I began the landscaping. All of the trees, shrubbery, and vines were planted by me. I landscaped it and built the retaining walls with broken concrete from my neighbor's property. I created a jungle way up on this hill. We have animals here. Every day people come here and take a walk into the back and they see a couple of bucks.

FH	We just saw one this weekend when we stopped by!
JS	Yes, everyone does. They have those big antlers; there are two of them. They're brothers. Actually my gardener, Mike, who lives out in Santa Clarita, was saying that they like hay. So this weekend he brought bales of hay to spread around the property, to entice the deer. I like having them around. When people come to visit I tell them to go behind the house but don't talk too loud, so as not to scare them away.

FH	Some people might think when looking at a photo of a modern building from the 40s or 50s that this is the perfect moment of the house, when it's photographed right after it has been built. But then you visit it 50 years later and landscape grows in and the deer come...
JS	Look at what I've accomplished here in 50 years. All of the trees were planted from seedlings. There is a little pond that attracts animals. It's like a paradise on top of the hill.

FH	So you would say the house is better now than it was when first built?
JS	Oh definitely!

FH	What is it like for you to visit buildings that you photographed decades ago, to see how they've changed with time?
JS	There was the house on Mullholland Drive that I first photographed for Neutra after it was first built. They couldn't afford to finish the landscaping right away after construction had finished, so he had me come back a few years later after the landscaping had been planted to take some more pictures. I went back every year to photograph it. Like my house: when I first photographed it in 1956 for *Progressive Architecture*, it was bare all

around and the landscaping I had planted hadn't grown in. Now it's difficult to photograph this house because it's hidden. I planted a jungle! When I was a child I lived in a forested area like this, and I had that in the back of my mind when I created this place.

FH That's really interesting to think about this life that exists outside of the building, and how that affects the building over time.

JS Yes, especially since nobody lives in a house that long anymore. I've been in this house for over 50 years. People come here to visit me from all over the world and they can't believe that we're in the middle of a big city. This is Los Angeles, four- or five-million people — who knows how many there are. It's so peaceful up here on these two acres. It's such a big city, but up here it's like being in the country.

FH How has L.A. changed since you've been here?

JS Well, don't forget that in 1927, when I arrived, there were 576,000 people here. By the next census, there were nearly one million. Double in ten years! Then you count all of those people from Santa Barbara to San Diego, north to south.

FH It doesn't feel like we're in the middle of all of that up here.

JS Occasionally a helicopter comes by, and that's about it — the only sign of the vast city beyond.

FH Do you look at very much contemporary architecture? Do you look at all the current magazines?

JS Look at the pile of magazines surrounding us here! Look at the books all over the place!

FH So you keep on top of what is going on now?

JS Well of course I do, it's my job!

FH Do you have any thoughts about how architecture has evolved in Los Angeles, from when you first arrived to where it is now?

JS I'm glad you used the term "evolved." It happens gradually. In the new monograph you can see the whole progression: Modernism is very much alive, you can see it through the 40s, 50s, 60s, 70s, 80s, and through today. It's been 70 years now and it still looks good.

FH I've had the pleasure to meet a few people, maybe in their 80s or 90s now, who were, like yourself, original clients for these modern architects in Los Angeles. Like you, they still live in the original houses. There is something about them that I think is so unique. They took this early risk to hire young architects, to build these radical houses for them...

JS Well, wait a minute, I'm not so sure it was such a risk. In my case, in 1949 I hired Raphael Soriano to design this house. The blessing in my life has

been to cherish the concept of Soriano's steel-and-glass house that he designed for me. There are two acres up here that you can spread out on. You can actually have a glass house. There are no neighbors up against you. In recent years, the city acquired 53 acres of land on top of the hill behind me that will be managed by the conservancy and will never be built on. There are possums, skunks, raccoons, foxes, deer, bobcats...

FH Do you think most of the early Modernists here shared the same sensitivity to the landscape?

JS No! Neutra thought it got in the way of the architecture. Schindler was one of the few that was interested in the trees and the landscaping. Today, people don't stay put, they move around so much, they don't make the investment. They sell their house before things have a chance to grow, and then buy another house.

FH Maybe for that reason they don't make the early investment in the landscape that you did here.

JS I planted every tree on the property from a little sapling, redwoods that are now over 50 feet tall. It's a blessing. On Mullholland I can point out the name of every tree. I love nature!

FH Were there architects that you shared that with? That had a similar affinity...

JS No, no! They were too busy making a living, making buildings.

FH In some ways it's similar: dealing with the landscape as you're photographing from the outside, and then from the inside, how you photograph the people and how they live... The life inside and out.

JS Being inside looking out, you're still in nature. Look at where we are sitting now. Look at the garden through those windows. Nothing's changed in 50 years. But what does change are the wonderful shadows of the trees on that wall. And it's so wonderful in the morning when you come in here with the light striking that wall from the east, and the sun moves behind me, and it will go over your shoulder, into the south and west. It's an amazing visual experience that changes continuously. The shadows shape the morning light...

FH A lot of people say that Neutra and Schindler were opposites, and that one has to choose one or the other, because they represented two opposite ways of thinking.

JS When I selected an architect for my house, I chose Soriano. I knew it couldn't be Neutra, he was too rigid a person. He designed according to what he wanted. Soriano was rigid, too, that's why he died a pauper — he drove people away from him. If someone said, "Mr. Soriano, there's a great view up there, can we just angle the roof up a bit to see that?", he'd just grumble. He could get very angry. If they persisted, he'd say, "There's the door, goodbye!" He was very focused; he had rigid ideas about the grid,

steel framing, and glass, which I accepted, because it was appropriate for the site. I had plenty of land, so I didn't have a problem with all of the glass. Modern architects didn't think of privacy in those days.

FH Why is that do you think?

JS Because they were so wedded to the concept of what "Modern" was. This was a problem on small lots, where the architects used all this glass facing their neighbors, and the owners would have to put up blinds or plant trees to shield the views in.

FH Who would you have hired if you had a 50-foot lot instead of this two-acre lot?

JS Well, I must say, you mentioned Schindler before? I knew all of the architects in that period and Schindler was high on my list. I respected him greatly.

FH Did you know his wife Pauline? I'm curious about the events that she had at their house on Kings Road.

JS By the time I met her those had passed, but I knew about them.

FH That would have been in the 1920s?

JS Yes, exactly. They lived a very open, bohemian life — much more informal than Neutra.

FH Did you also know the Eameses very well?

JS Yes, his own house is very special. He was very creative with available materials, prefabricated industrial steel and glass. You know, in those days you couldn't just go to Home Depot and get everything you need to build a house.

As we walk back up the garden path Julius, shows me a sunken area near the house.

JS Every ounce of water that comes from the sky onto the roof pours down into here. It is a dead-level roof, but fortunately it all drains to this one spot and runs down this chain. So no water is lost in the downpours we have here, it all stays on the property, goes back into the ground here.

FH We need to learn those lessons again don't we? We finally got some rain last week, too…

JS Yes, we really needed that.

Back in the house we sit in the living room and he proudly shows me his copy of the massive new three-volume monograph of his work. As I page through the book I make the mistake of asking him a question.

FH Is there anything you feel that young architects need to know today?

JS You can't look at the pictures and talk at the same time. You can't thumb

through the book like you're doing now; you're flipping the pages without looking! To answer your question, it's right here in your hands! You don't realize what you're seeing. There are thousands of books available for young architects today that have important stories from the past for them. Benedikt Taschen said in the essay he did for this monograph, he made a statement... Here, open that book, look at the index...

FH Here it is, page 30: "The Living Memory of Modernism."

JS Yes, exactly, that is what he says in the preface, that through these books young architects can learn what was done before them, what they can gain by understanding what happened before they were born...

At the end of our conversation, he showed me photos he had taken throughout the years. We lingered on one in particular, a photo taken from a neighboring roof looking into the large windows of a modern high-ceilinged living room below, with fireplace aglow. He realized that this was the "Santa Claus" view of the house — this really got him excited. He said that he had looked at this photo hundreds of times and never thought of this before. He got out a pen and paper and made a note of the page number to have an assistant make a slide of this image for his next lecture. He wanted to say to any children that might be in the audience, "Hey kids, this is Santa Claus's view when he parks his deer on the roof, and gets ready to go down the chimney to deliver the presents." Throughout my three-hour visit, this was probably the most animated I had seen him.

LOS ANGELES

HEDI
SLIMANE

Interview by Pierre Alexandre de Looz

An elected son among chieftains like Lagerfeld and Saint-Laurent, Hedi Slimane is nonetheless something of a lone ranger. With a talent as natural and crisp as grass off the plains, he charted an unconventional trail all the way to the helm of Dior Homme, unfurling a slender trademark look with sharp-shooter precision that included everything from suits and cosmetics to furniture and interiors. It was Ziggy Stardust at the Bauhaus; Rimbaud in black-tie; his native Paris resurrected in smoked glass and fluorescents — and it captured the zeitgeist of most of the noughties. There was much for the design world to envy and, most importantly, Slimane won the heart of fashion. Then, three years ago, he rode off into the sunset, or the next best thing, starting a new chapter just off Sunset Boulevard, CA, in a Modernist Beverly Hills rancho. For Slimane, who has made a career out of elegant ambiguity — dressing cowboys as Indians as it were — Los Angeles is less home than an occasional perch for his poetic verve, roving eye, and, as PIN–UP learned, burgeoning car collection. He continues to translate his vision through an online diary, curatorial projects, and photographic essays. For PIN–UP, Slimane reveals the details of his pool policies, his picks of the L.A. art scene, and why he may never renovate another home.

Pierre Alexandre de Looz After living and working in Paris all your life, was it an aggressive move on your part to relocate to L.A.?

Hedi Slimane This was not really a move, technically. Spending more time here this year came naturally. Besides, I always wanted to have a house in Los Angeles, and always had a feeling for it. Unfortunately, I'm not in Los Angeles that often, to say the least — it's more like a sort of occasional retreat.

PAdL What kind of freedom can you find in L.A.? How does the city compare to Paris, New York, or Berlin, where you've also spent a lot of time?

HS In no way can it be compared to any urban circuit. L.A. is like an ethereal, mythical space, overwhelming nature all around, threatening and inviting at the same time. Space is obviously freedom — being remote, as opposed to isolated, is also a relief.

PAdL Do the city's architecture and spaces affect you?

HS They totally affect you, as well as the absence of architecture, the chaos in absurd juxtaposition, the linear, reduced, sometimes abstract feel, the cardboard nothinghouses, the décor of it all, elongated palm trees in shadow, all shining in the sun.

PAdL How has L.A. informed or changed you or your work? Is it easier for you to work here?

HS I can work anywhere, but when I can, I love working in Los Angeles because I feel appeased and focused, outside any distraction, or any disturbing environment. I don't know if it does or did change anything really. It just makes what I do quieter, gives a distance, or implies some sort of dissociation.

PAdL In your work as a designer, and now as a photographer, you're mostly known for black and white, and gradations of gray. Has the palette of your new hometown changed your idea of, and approach to, color?

HS Not really. Black and white is strictly the expression of light and shadow. California light and sun end up readable for me, unmistakably, in black and white, as others may perceive them in color. My pictures are lit differently, and of course the subject reflects the specificity of it all.

PAdL Is art more powerful in L.A. than in New York or Paris?

Hs There's an interesting, and strong, historical scene here, beside New York. Paris, I'm afraid, lost it for too long, and is certainly irrelevant internationally, with the exception of a few renowned galleries.

PAdL Do you have a favorite museum in L.A.? Do you have a favorite artist?

HS I'm not too fond of the museums here, although there's a group of great

new curators now, but I do like the galleries, and both the historical and the emerging art scene, which is very strong and vibrant. I always felt for John McCracken, and I follow most of the new generation. I'm currently curating a show about California called "California Dreamin' — Myths and Legends of Los Angeles," to be held at my gallery, Almine Rech, in Paris in February 2011. The show will be about a reduced iconic representation of L.A., and will feature works by Ed Ruscha, Chris Burden, Raymond Pettibon, hopefully Mike Kelley, Jim Shaw, but also younger artists, such as Sterling Ruby, Aaron Young, Joel Morrison, and Patrick Hill, among others.

PAdL Two of the most important things in L.A. are cars and houses. Where and how do you live? What is your vehicle of choice?

HS I live in the only area I would ever consider, my truly favorite by far, which is the Trousdale Estate, a protected early-60s neighborhood in Beverly Hills, just off Sunset, hidden just behind the last of the Hollywood Hills. The house is a classic Beverly Hills mid-century-Modern glasshouse, built by Southern architect Rex Lotery in 1962. It is very architectural, but somehow has a certain quality to it that I always appreciate in West Side houses. As for cars, I can only drive classic cars, since I still don't get contemporary testosterone-overweight car design at all, destroyed by software applications. So I drive very archaic vintage Rolls Royces.

PAdL What do you listen to when you drive?

HS Oh it's quite eclectic, from old Stones or Bowie to classic Soul from the 60s, to current English Rock. Sunday early morning, when the streets are empty, and the air is still fresh from the night, might be the most appropriate time to play all-time favorite tunes.

PAdL What is your favorite room in your house? What do you do there?

HS The T.V. room — because I'm obsessed with the T.V. application from Netflix, by far my favorite website in the world. Watching movies with my friends is the most comforting thing for me.

PAdL What's the best thing about having a pool and a garage?

HS I have to admit that I don't use my pool nearly as much as my friends do, since I'm always working on something. I do like the garage a lot, though. But I still need more space, and more cars. In fact, cars are the only things I would really like to collect.

PAdL Do you enjoy having guests?

HS I usually don't, but in Los Angeles I do. The house is really quiet and peaceful. And has beautiful trees.

PAdL Did you remodel your house after buying it?

HS I heavily remodeled it — I reduced it to its purest, plainest expression, trying to bring it back to a "silent," mid-century-Modern, untouched, vintage state.

I also landscaped the whole thing, picking up each plant, over many trips to L.A., in a dozen nurseries around the city. The remodeling was a total nightmare, and I will never do it again in California. I am traumatized by it, literally. I strangely had the worst experiences with it, dealing with the worst people in the construction world. It was all quite unnecessary, too. The house, though, is the only house I could have bought. It was as if it had chosen me. I redesigned it in 3D prior to the remodeling, and it now has integrity again, as a pure and classic 60s Trousdale house. It has already aged and faded very nicely. I also wanted to discover an architect I didn't know through this project — the last thing I wanted was a generic coffee-table-book signature house. Rex Lotery only built a few houses, and it's pretty rare to see one on the market. I found out that for a while he was associated with the architect Ray Kappe. I always wanted to contact him about it, but I haven't gotten around to it yet. I don't collect really, but I did give it a European Bauhaus/De Stijl feel, which is not exactly the local taste, I guess.

PAdL Back in 2007, you designed a line of furniture. Would you consider going further into interior design, decoration, or architecture?

HS I always did these things quite naturally, as I was designing all the stores for Dior Homme when I was there, but also all the cosmetics corners and displays. Design for me is in fact a holistic matter, 360 degrees.

PAdL Should architecture be vulnerable?

HS It is by nature, but Los Angeles architecture is far too vulnerable, and left unprotected. The city of Beverly Hills, for instance, has many building-code rules, as they should, but they completely lack a committee that protects classic architecture with respect to the original feel when remodeling is done. I'm quite concerned as to what would have become of this house if I hadn't bought it. And I tried my best to restore it, respectfully, to its original state. I don't understand why California in general doesn't protect its history, and in particular the unique quality of its architecture, which is so renowned and revered around the world.

PAdL Do you have a favorite architect, designer, style, or period?

HS Mies van der Rohe, I guess — and obviously the early ages of Modernism, the Bauhaus school, and its descendant in post-war Germany, the Ulm School of Design. On a different note, I'm also fond of the extreme Classicism of the French 18th century. Beyond my personal taste, I'm always responsive to each city's respective architectural legacy.

PAdL Are quintessential cities like New York and Paris over?

HS Any city goes through cycles, both creatively and culturally. New York or Paris will have better times again in the future.

PAdL Does L.A. have a gender? A smell?

HS I assume the nature of Los Angeles is to be undefined, therefore genderless, unlimited, layered. Rather than the smell it's more about air... open air, oxygen, dry air, vacuum cleaned, and immaculate pencil sky.

PAdL If L.A. were a feeling, how would you describe it?

HS It is pretty much a feeling or a vibration, a rhythm as well, a slow motion with sudden accelerations. A car ride.

MILAN

ETTORE SOTTSASS

Interview by Horacio Silva

Unleashed on the world at the 1981 Milan Furniture Fair, Memphis — the short-lived, Milan-based collective spear-headed by the Austrian-born Ettore Sottsass — mesmerized and appalled the international design community in equal parts. With its wholesale disdain for conventional good taste and rejection of the Bauhaus dictate that form should follow function, Memphis showed up to the party in leg warmers and didn't care who saw it robot-dancing.

Love it or hate it, Memphis furniture, lighting, textiles, and home accessories embodied the irreverence, idealism, and risk-taking of Postmodernism, as well as the garishness of the decade it ushered in. But even among this group of iconoclasts, Sottsass, whose work prior to Memphis included seminal designs for Olivetti, stood out like a stripper at the Vatican.

As he approached his 90th birthday, Sottsass continued to be a provocative force in the worlds of design and archi-tecture. For PIN–UP the grandmaster of flash sat down for an exclusive phone interview from his home in Milan.

Horacio Silva	Ciao, Ettore. I was looking forward to our eating spaghetti and doing the interview in Milan and then we both go and get sick. How are you feeling?
Ettore Sottsass	I have pain in my back, as always. So that's a big problem because I cannot walk at the moment.
HS	I'm sorry to hear that. Are you still using a wheelchair?
ES	Using everything... even herbs!
HS	I'm surprised you haven't designed yourself a wheelchair yet.
ES	I haven't actually, but I designed an interesting office chair to work and get around in. And at this precise moment I am using that chair.
HS	I can just imagine you racing around the house as we speak. Tell me, you know, I went back on the weekend and did some reading in preparation for our talk, and I have to ask you: why is it that so much architectural writing is boring and turgid?
ES	[Laughs.] Because architects and architecture critics are not good writers, first, and not the best philosophers, second. I don't read articles on architecture. I look at magazines, but at the design and photos.
HS	I can't blame you. Reading these pieces was about as exciting as watching an experimental dance about a building. And you're a fun one to write about — I think, anyway — but everyone always neglects the elements of humor and sex in your work.
ES	That's true. I wouldn't call it sex, though, but Eros, which is much more subtle. You follow?
HS	Sure.
ES	Okay, I don't think you can survive life without Eros, while sex — we can survive without sex.
HS	You might be able to!
ES	[Laughs.] For some people it's harder, true. But I am most interested in materials that you can tell stories with. With sex, the story is very short.
HS	Sometimes...
ES	Yes, yes, you can try to organize sex, but that's another situation. To me, life is Eros. Like, for instance, not everybody's interested in colors, but others are seduced by colors. But you cannot call colors sexy; colors are Eros, or a stage of Eros. Every color has a story and it's very tied to tradition and context. So for instance — I don't know — red has a different impact or meaning, depending on whether you are a young Communist revolutionary or a surgeon.

HS That's an interesting take on erotic allure. But some of your work is a lot more explicit, the architectural-pornography series, like the "Planet as Festival," comes to mind.

ES Ah, my period of radical design. We wanted to destroy... Not to destroy, because I don't like this word, but to change the situation, the academic status quo.

HS Go on.

ES So we were organizing design effects like the porno architecture. I designed a drawing about the political relationship between architecture. So there was the museum, the prison, the church, the bank, etc. In my design, they were all related in a very funny way. And there was a possibility to send water over all these kinds of academic visions, if you know what I mean...

HS You mean like an orgasm? You naughty man! It reminds me of a story you told me that the Shiva Flore Vase was your way of putting a big penis on the table of design because the design world was so limp.

ES And remember, I took the ceramic, that penis, and I put in a photograph of a Chinese judge because, I mean, the academic world is very political and boring, no? I was also being ironic. At that time we had the necessity to discuss our profession, to discuss design in general. Why do we design? Why are we architects? So there was a period of great interest in thinking.

HS Do you think that period is possible now?

ES It would be possible, but it doesn't happen. Design now has a very precise destiny.

HS To be sold?

ES Exactly.

HS You say you're not one to be wistful, but are you ever nostalgic for those periods when design was thought of as something that would better the world?

ES No, I don't think so. I left design. I abandoned design and I design only for galleries.

HS Is it fair to call you more a theoretical designer, then?

ES Yes. And because I'm designing for galleries, I'm free in many ways. All my curiosity is about what you can do with design or with architecture, how far you can go — taking care of certain architectural necessities, of course. But it's design without commerce, with no idea of price or even without destiny, you know?

HS You talk a lot about destiny, which is interesting, because your father was an architect, and you were surrounded by architecture from an early age. Could you imagine any other life or were you destined to be an architect?

ES No, I cannot imagine another life. When I was a child, my father was working at home. And if your father is an architect, you see only pens, paper, drawings, and everything that has to do with architecture. When I was maybe four, I was designing and drawing cemeteries! I grew up feeling the odor of architecture, the smell of paper. And that's why, probably, I have always been very sensorial.

HS Eros!

ES Exactly. And I remind you that even Mies van der Rohe, the head of functionalism, if you look carefully at his Barcelona Pavilion, there is a sculpture of a naked woman looking on a pond of still water. So the senses are very strong even there. The functionalists tried very hard to be very mental, but you cannot live without the senses.

HS Tell me, as a child of World War I who later served in the in the Italian Army during World War II—what do you make of the current political climate and its likely effects on design and architecture?

ES It's horrible so who knows what the effect will be. I cannot read the newspapers anymore, because it is too depressing. The politicians and people in power are only prepared to kill, not make people live well; just to kill an enemy or to get more land or oil or whatever.

HS You have been reluctant to talk about your time during the war, about your time in Yugoslavia…

ES No, I sometimes tell stories to friends. I don't have a problem with it. You know, I had a very strange life as a soldier because I never shot.

HS You never shot anyone?

ES No. I never shot anything. I was able to tell my *commandante*, my — *come se dice*?

HS Your superior officer?

ES Yeah. I told my superior officer that I was very good at organizing, for instance, parties for soldiers. I also organized a theater for soldiers and food for the soldiers stationed on the border. I told the officer that I didn't want to have anything to do with guns. And luckily he said, "Okay, if you are like that, do that. Take chocolate to the soldiers on the front." [Laughs.]

HS But then, at one point, you went from being a soldier to a prisoner of war.

ES Yes. Because the day that Italy renounced being allies with the Germans, I was on a train traveling for vacation. And the Germans with guns took over the front of the train and said, "You are prisoners of the Germans now."

HS And that was in Yugoslavia?

ES Yes, in Yugoslavia.

HS And how long did you remain a prisoner?

ES I think a few months, but Barbara says it was more like six or seven weeks.

HS I've read somewhere that you were actually in a concentration camp.

ES No, I never was, because they asked if we wanted to work for the Germans and avoid going to a concentration camp. So me and twelve other soldiers decided to work instead. We were in an Ustaše prison — the Ustaše were the Croat fascists — but I was never in a concentration camp.

HS What effect did the war have on your design, if any?

ES Actually, during the war I took some pictures and was very interested in some local peasant or vernacular architecture. But immediately after that period, you know, you go after girls or you go after, I don't know, after food. You don't care so much for architecture.

HS At what time did you get re-excited about architecture? Was it when you went to America in the mid-1950s?

ES No, just after the war, when I designed low-income housing for workers in Sardinia. And then we — my father and I — did a school in the Dolomites, a big building for exhibitions in Turin, with a restaurant, a theater, gardens, and other various buildings.

HS What made you want to go to America?

ES At that time America was different than now. For us, America was a dream — not only a dream as a political situation, but a design dream. We knew Charles Eames, for instance, who was for us a sort of god. Then when George Nelson was in Milan, I met him in the house of Giò Ponti. And he asked me, "Why don't you come to America?" And I told him I didn't have the money. So he said, "If you come to America, I'll give you 25 dollars a week." That, at that time, for me, was an immense sum of money. So somehow I found enough money to buy a ticket for the airplane. And I went to America, working for George Nelson. He was really a very elegant man. He was like a father, like a great friend.

HS Was this New York?

ES Yes, yes. I did some drawings but I didn't really work. But I felt the smell of America. I had brought with me some watercolors to paint and I sold one or two. And then everybody was very, very kind. But as I said, I had the feeling that there was another America.

HS Yeah. You probably don't have the same fascination for it today.

ES Ah, no.

HS That's very diplomatic of you. Last time we spoke, you were still a little upset that some people mainly remembered you for Memphis. You got sick of telling the same story about a movement that you never intended to last.

ES Well, that's the story of every movement. Every strong intellectual movement lasts not more than five years. You cannot be strong forever. So Memphis disappeared for that reason. I mean it didn't disappear at all — all the people that were in Memphis are very good professionals, very good architects, whatever — but the group separated. But it doesn't worry me any more to talk about it.

HS Does it amuse you that Memphis pieces are going to be the antiquities of the future?

ES I think that Memphis will be remembered for a long time. But whether they become the antiques of the future, I don't know or care.

HS Ettore, as someone who has always resisted constraints, how do you feel about the constraints of old age?

ES Very badly. [Laughs.] I accept it because you have to accept it. So I am always working in some ways. As I told you, more designing for galleries than creating big buildings. And I'm writing. I go on being — existing. But, naturally, old age is old age. I cannot move from this room. So I stay here. I have a very beautiful room and a table to work on. I have Barbara nearby who helps me every day. And I do have some friends and collaborators who come here. We work together, sometimes for hours, sometimes for shorter periods. Depends. But old age is a pain in the neck — or, in my case, a pain in the back.

PARIS

OSCAR TUAZON

Interview by Amelia Stein

Oscar Tuazon is an unlikely American in Paris. Born in a geodesic dome built by his parents in small-town Washington State, he didn't travel outside America until the age of 32 and only speaks rudimentary French. But in 2007 — after years of living between Los Angeles, New York, and Tacoma — he followed his wife Dorothée Perret, editor of culture journal *PARIS, LA*, to the French capital, where they have settled with their three children, Rain (one), Tacoma (five), and Nuage (eleven). The family's Montmartre apartment has become the latest example of a typically Tuazon kind of building/living experiment: large-scale sculptures absorb the living room, bathroom, and even the bedroom (the last iteration of which was sold in its entirety as a sculpture to the Saatchi Gallery in London), in continuous dialogue with the architecture. When I met him, Tuazon was in New York at the opening of "People," three new sculptures commissioned by the Public Art Fund for Brooklyn Bridge Park. Essentially made from cement and the trunks of local trees, the structures double up as basketball hoops, handball walls, and a water fountain. Moreover they are temporary, which is exactly how Tuazon likes it: his is a sort of inverse architecture in which the transience of a work and of the materials that comprise it are honored and even encouraged. Natural materials do not promise anything, they are made available to the artist or maker on the condition that they return to the earth with time — a temporary custodianship, which Tuazon takes very seriously.

Amelia Stein	You grew up outside Seattle, Washington. Can you tell me about your family home?
Oscar Tuazon	When I was ten, the architect Ibsen Nelsen designed a house for us, and my parents built it. It was not a big house, but each of the elements were sort of separate and you would walk between them. My parents are bookbinders, so there was also a bookbindery in there. They made blank books — sketch books, photo albums. They'd come to know Nelsen because he used to order these custom-made sketchbooks and I think they may have traded him some books for architectural work.
AS	They traded notebooks for the design of your house? That seems like an imbalanced trade!
OT	It does, doesn't it? There's probably more to the story, but that's how I remember it. But the house that I was actually born in is a geodesic dome that my parents built together. And I think, even though I didn't grow up there, that that house has been really important to me. It's in my DNA.
AS	Did the geodesic dome work as a home?
OT	No, not really. As soon as I was born they moved out. It was leaky, the windows were plastic sheeting... It was totally hand-built by two people who had never built anything in their lives, so it was bound to have a lot of problems.
AS	Geodesic domes were usually built in clusters, right? Someone would build one and then their friends would build one right next door.
OT	Yeah, a lot of it comes from a communal context. But in this case, it was just in the middle of the forest. It's funny because now all of the forest around it has been cut down, and so it's there in the middle of a barren hillside looking very strange. Somebody used to live there for a long time, but now it's being used as a horse barn, which is probably more appropriate.
AS	There are obviously traces of the geodesic dome in your work — a structure that can be dismantled and that essentially failed, repeatedly, upon execution.
OT	Yes. Initially what attracted me about it was that these technical failures also had an interesting relationship to the ideological context that produced the geodesic dome in the first place, which, in my mind, is this sort of back-to-the-land movement and this moment of frustration with the urban situation. Although I'm not so much involved with the geodesic question any more, what remain interesting to me are the technical problems. I'm always interested in the way a structure can fail. In a lot of ways, in architecture particularly, when a building fails it can be more interesting than when it performs the way it's supposed to. That iconic image of a Buckminster Fuller dome on fire, with black smoke pouring out of it, nine years after the

1967 Montreal Expo — I think that's kind of fascinating.

AS Do you think your relationship to natural materials, like wood, will change as they become more scarce?

OT I actually feel more like that about stone. Certain kinds of stones are quite rare. But it's not something I really think about, actually. For me, what's more interesting about a material is its lifespan and how it ages. It's interesting in terms of an art object, which has traditionally been conceived of as a physical object. I like to think about it as decaying, falling apart, and ultimately being replaced. One of the things I'm trying to work on is the idea that a work will need to be repaired. Buildings are thought about that way; as a brick building ages it will need to be repointed, or bricks will need to be replaced. Somehow the form of the building and the essence of the building are able to stay the same, while the materials can ultimately be completely renewed. In wood buildings that's even more typical, right? You'll have to replace the siding and eventually replace the roof, replace the foundations. What is the object? I now try to think about designing that into an artwork, so it becomes something that is in other people's hands.

AS You've said that before about a work, I think it was the piece of marble in the woods — how you liked the idea that it was going to exist on its own with no need for anyone or anything else.

OT Yeah, *Niki Quester* [2009], a marble block in a tree — that's something which, rather than decaying, is growing. It's like I've set up a situation and now it's making its own decisions and creating its own form and, to me, it has autonomy that way. It's got its own life.

AS What do you find appealing about that?

OT Well, I think in one way it disintegrates the aura of an artwork. It returns it to being a thing. I've just done this project here in Brooklyn Bridge Park, and to me what's exciting is that those sculptures exist, and will be interacted with, and perceived completely independently of me, or of being artworks at all. They're just things that are going to function in the park and people are going to play basketball with them, or take a nap on them without having to perceive them as artworks.

AS In a way, what you're describing is the inverse of what a monument is supposed to be. A monument is supposed to be revered and not used in a utilitarian way and not touched or approached.

OT Yeah, that's true. They should be anti-monumental.

AS You've said that with the "People" sculptures in Brooklyn Bridge Park you didn't want to compete with the New York City skyline. But do you ever feel as if you just want to make intrusive alterations on a huge scale?

OT No, I don't actually. It's weird because I like to work large. But it's not a question of scale, it's a question of size. Monumental gestures have less impact on me than something I can interact with on a one-to-one basis.

The fountain piece in Brooklyn Bridge Park, for example, is something you can perceive at a distance, but its effect is very subtle. It asks you to come close to it. The effective moment in that work is to be able to touch it and feel the water. In terms of the Manhattan skyline, what I think is important is to somehow turn your back on it, and to create an experience where you're more able to think about yourself, and have the space for yourself. I've thought about parks a lot. A good park can give you the feeling of seeing things that nobody else has seen; it's discovery, basically. You find an area in a park that you've never been to or you feel like nobody has ever been to, which of course is absurd in a city of ten-million people, but there are seasonal things in a park that are completely new all the time.

AS Why did you move to Paris?

OT I met my wife — she's French. At the time I was living in Tacoma, and for a year we were having this very long-distance relationship. Finally someone had to move, and I tried to convince her to come to Tacoma, but ultimately I decided to move to Paris. It was nice because it gave me a lot of freedom — just the freedom of being disoriented and not knowing the language.

AS It must have been intense for your wife to always have to act as your translator.

OT [Laughs.] Yeah, it's true — but she's been very supportive and taken good care of me. I found it nice, it's like being a child where you can't understand what the grown-ups are saying.

AS Do you feel more American in Paris?

OT Definitely. I always thought it was funny that I was a sculptor in Paris, because, really, the urban situation — the housing, the spaces you can find — isn't conducive to sculpture. In a weird way, you could write the history of modern art and contemporary art just based on the architecture of the different cities in which that art developed. The scene in Paris has always had a very strong conceptual element to it, and an immaterial tendency. I think that has a lot to do with the fact that people have these small apartments and can't afford studios. And then you think about, I don't know, the kind of work that developed in New York, postwar painting and sculpture — it had something to do with the particular kinds of spaces that were available. Anyways, I just thought it was quite ridiculous that I was living in Paris and doing large-scale sculpture.

AS What does your Parisian place look like?

OT It's an apartment, social housing, that my wife has had since before I moved there. For a long time I would build things into the apartment. I had this huge bed structure on the upper floor and I had my studio there for some time, which was insane. I was running power tools and mixing cement in the bathtub. I was really working in the living room, making these sculptures that would fit exactly the dimensions of the elevator. Now I have a studio in

the outskirts of Paris — it's very rough and I can do whatever I want, so the apartment has kind of returned to normal.

AS Do you imagine the conversations you might have with your one-year-old daughter when she starts building things out of wooden blocks?

OT Well, I've got two older daughters as well: I've got a five-year-old and Dorothée has an eleven-year-old. They've always been pretty active in what I do. Nuage, the older one, used to work in the studio with me when I had it at home and now she's at an age where I'll sometimes take her if I'm going to install a show or something. Sometimes she thinks it's stupid, which is kind of typical for her age. She's also like, "It's dirty in here, it's disgusting!" But there are certain things she really likes — we've made work together and it's actually pretty amazing. One time when we went to the studio together, I had a work that I needed to make that I'd kind of been putting off, and I knew the materials I wanted to make it out of and I knew, somehow, the dimensions. But I was still in that beginning phase. And so we talked about it together. I tried to explain what I was thinking and — it was amazing — she started doing some drawings. She knows my work very well, so the drawings she made were very perceptive about the volume and the structure that I was talking about, and we conceived the work together. It was really cool. It's rare, actually, because I work with a lot of people and it can be difficult to have that level of comfort.

AS Your career and work have obviously been directly influenced by the way your family lived and where you grew up. Do you think your career will influence your kids in an inverse way, making them want to get as far away as possible from art and spaces that transform constantly?

OT My parents were constantly building houses or remodeling houses, and I think I absorbed the excitement of transforming a space just naturally from being around that. I have no conception of what it must be like to grow up for Tacoma, Rain, or Nuage. I didn't leave the country until I was probably 32. I didn't really leave Washington State until I was 18. I grew up in a very small town. Rain is turning one year old this week and she's already been back and forth between France and the U.S. five times. She went on her first trip when she was only ten days old, so she draws upon a completely different environment. I try to incorporate the whole family in what I do, but what I do means travelling all the time and living this very strange lifestyle. In a way, I do try, I think, to replicate or explore some of the things that were interesting for me as a kid, but it's completely different. Maybe they're going to want to live in a small town in the middle of nowhere.

AS Does moving around so much influence your relationship to accruing things?

OT I do try to shed stuff. But at the same time, being a sculptor, you're constantly producing things. The studio is always full of material. I'm always ordering material. I need it for projects. One of the things that drives my work is just this compulsion to empty the space out. I'd like to have the space empty

of stuff, of materials, of half-finished works, even of furniture. Because the studio is a squat, it came with some old furniture — chairs, and desks, and tables, and stuff — and those have all been cannibalized and turned into works. The flipside of that is, of course, I'm creating this ocean of stuff that goes out into the world. It's great to think about it from someone else's perspective, someone who might enjoy it, or lose it, or preserve it. I find that an awesome and humbling thing that anybody would find something I do valuable enough to live with. But from my own perspective, I really don't want to have anything to do with it! [Laughs.] I don't want it around anymore — I want to get it out of the way so I can move on to the next thing. And then I wonder: where the hell does it go?

AS Well, the bedroom you built for your home eventually got bought by the Saatchi Gallery.

OT Yeah, it's funny how these things happen. I'd never thought of it as an independent work, it was more a way that I could hide the bed underneath the floor so that I could move into the guest room and make my studio there. But then we had a fire and the bed was either going to get trashed or... [Laughs.] Oh, I really shouldn't say that it was either going to the dump or to some collector's house, but it's this thing of an artwork in the process of decay.

AS When you build a utilitarian object — a bed, a chair, a table — do you find yourself wanting to make it sculptural?

OT I think the line between a design object and sculpture is interesting. I would like to invent a new way of thinking about it. I'm fascinated with tables because you can't argue with the functionality of what a table is supposed to do. But I always feel like somehow there is a way of reinventing it — and not in an aesthetic way at all. Just that simple thing of making a horizontal plane at a certain height that people can eat at. In a way, that's a really open set of requirements. So, of course, you can find a million different ways to get there.

AS I suppose you're still dealing with parameters like the size of the room?

OT Sculpture needs to have those same criteria built into it to be successful. I don't think you can just go into the studio and be like, "I want to make something that looks nice." I try to think of making a sculpture like making a table; I may not be able to explain the criteria that it is trying to fulfill as clearly as in the case of a table, but it needs to have that kind of structure built into it.

AS Do parameters ever frustrate you?

OT No, no, for me that's the most exciting thing: to work against parameters and to work with parameters. I worked in architecture with Vito Acconci for a couple of years and that was a huge revelation for me. You could use the parameters to form the work in a way that I found more open, or more

subtle, or more challenging than the idea of how site-specificity had been practiced in sculpture up to that point.

AS Where parameters were limitations?

OT Yeah, and in very stark terms. I think the development of site-specificity in sculpture came out of an ideological struggle that presented things in an almost cartoonishly simple way. What you find in architecture is that the program is so complex and the process of having to plan a building is so multifaceted that you can't always sustain an ideological position in the overall construction. So, to me, it was exciting to find that mode of working.

AS How did you come to work with Vito Acconci?

OT I had always been an admirer of his work, and he came to speak at the Whitney program while I was there, back in 2001. After he left he needed somebody to pack up his studio because he was moving to a new space, so I got hired just to pack boxes and I kind of never left. I was never really offered an official position because I wasn't a trained architect, but I found things I could do to make myself useful there, and I just stuck around. I've always worked with architecture, though. I've actually just bought a cabin in the woods on the Olympic Peninsula where I've started to think about actually designing and building that structure. I'm not sure what I can say about it other than that it should be a house as a sculpture or something. I guess I'm interested in taking the various functions of a house and atomizing it, breaking it down into a number of smaller different events. I'm into building small, interconnected rooms, which is a funny idea for a place where it's raining 328 days a year, to try to explode the house out, it doesn't make sense yet. But if you can think of a table as a sculpture, you can think of a shower as a sculpture.

AS And how does your wife feel when you start making alterations to the house?

OT She's always been very open about that. [Laughs.] It's kind of a crazy adventure. One of the things that I always admired — and this comes back to the dome thing and the kind of architecture that I like — is this impulse to build your own space and then have to adapt your way of living to that space. One of the things I've been interested in over the years is this nomadic or quasi-homeless or backwoods way of living. The idea is that the architecture is so demanding and so difficult that you have to adapt your whole lifestyle to it. I'm not that hardcore — in the end I just made a weird bed in my house — but I think that's the ideal that architecture should aspire to: not to accommodate existing functions or existing uses, but to demand new ways of living.

NEW YORK

RAFAEL VIÑOLY

Interview by Felix Burrichter

Size matters to Rafael Viñoly. Born in the small South American country of Uruguay to a mathematician mother and a filmmaker father, he began his career in Buenos Aires before moving on to bigger things, founding his namesake office in New York in 1983. A decade later he was catapulted to international architecture fame with the Tokyo International Forum (1989–96), a giant infrastructure hub in the heart of the Japanese capital that comprises acres of offices, auditoria seating up to 5,000, and vast public plazas. Since then he's amassed an impressive portfolio whose projects rarely drop below the 1,000,000-square-foot mark, and include everything from courthouses, university buildings, museums, airports, and office towers to full-blown urban master plans. Despite the scope of his work — over 350 projects on five continents — and the size of his office (which includes branches in Chicago, London, L.A., and Abu Dhabi), Viñoly still remains the sole partner in the firm. But unlike other architectural one-man-shows of similar caliber, he is decidedly averse to designing in a signature style — just one of the many idiosyncrasies characteristic of him. PIN–UP met Viñoly at his New York headquarters, which are located in a spacious former slaughterhouse in Tribeca. Equal parts no-nonsense and exuberant, he spoke with candid enthusiasm about abstraction in music, arrogant architects, and why math is fun.

Felix Burrichter	**You emigrated twice in your life: first from your native Uruguay to Argentina when you were little, and then as an adult to the U.S. How has that affected your view of things?**
Rafael Viñoly	It strikes you as always very difficult if you're an immigrant — or at least it's a very difficult thing to pretend that you're not. Those who do pretend usually end up lying so loudly that it ends up much worse. In Argentina my family and I were very much immigrants too, even though Uruguay is just a short walk across the river — but it was such a different culture.
FB	**Different in what way?**
RV	Well, Argentina is a large country which has always had the very rich, with a sort of tempestuous history of leadership. It was always saved by the commodities essentially — even when it was a meat importer it was always a grain exporter. The ups and downs of that enormous income always created a number of very tense relationships in terms of the whole organization of society. So it has a very turbulent political history. And Uruguay couldn't be more different. I mean it's a poor country — it's a small country, which has maintained a stable population of close to three million for the last 75 years or so. And, you might say in opposition to that it's a country that has always been incredibly cultivated, with a great accent on education — it's a very civilized place, even in moments of great depression, or military occupation. But the whole thing is an invention because Uruguay is a product of the British trying to plug the river exit to the ocean and control both Argentina and Brazil who were at war for a long time. So it's a strategic thing, and then it became almost an idiosyncrasy if you will...
FB	**It's the Belgium of South America.**
RV	Yeah, well to that extent it is. I mean, in the 30s and 40s it was called the Switzerland of South America — but Switzerland is more boring than Uruguay. Uruguay is also pretty, and it's now going through an extraordinary moment of revitalization.
FB	**You're building there now, right?**
RV	Yeah, we just finished this airport there which was very successful [the new terminal at Carrasco International Airport, Montevideo, 2009], and we're doing a couple of other minor projects. But it's a very interesting place. For me at least, it's one of these things that gets implanted in your brain and you never really quite realize it until you get to my age.
FB	**When you started your career in Buenos Aires, what drove you? Were you always convinced you wanted to be an architect?**
RV	No, not at all... It was a decision that was somehow in the air because my mother had studied architecture. At that time, it had this social characterization of being a serious business — something where you needed

skills that could be learned — and it had all of those things that make you think you're getting into something which is organized. Originally I was supposed to be a musician, but I sort of chickened out...

FB What kind of musician?

RV Oh, I've played the piano since I was four.

FB Do you still play?

RV Yeah. I have two pianos here in my office!

FB You play here sometimes? During the day?

RV All the time. Music is a very different thing, it has exactly the degree of abstraction that I think architecture has a very hard time reaching. Architecture couldn't be less abstract, right? Music has this dimension which is not verbalizable — it's just absolutely, unbelievably esoteric. That's something I appreciate very much, so for me, what made me go into architecture was what people used to call a "vocational crisis." I had this sense that there was something that I couldn't actually, really get to. I mean in terms of musical excellence.

FB What about your father? He was a filmmaker, right?

RV Yeah, a theater person too and all that. Well, that was a very strong influence because I've always had this idea of the construction of things by the way he worked. To a certain extent a film director is always in that kind of leadership position where you need to coalesce a number of different inputs from people who most of the time don't have anything to do with each other.

FB What was behind your move from Argentina to the United States? Was it a logical move?

RV No, no, it was completely illogical and totally arrogant in a way, because we had an office in Buenos Aires that was very successful, and we were doing a lot of interesting work. But at a certain point, in a very strange moment of awareness, I became totally clear about the degree of involvement with the military government, because our client was primarily the government. And so, there is a moment when you kind of realize this thing — you know, no persecutions, no dramatic stories about the horrific crisis Argentina was going through at that moment — and then, the fact that when you're 33, 34, and you've been relatively successful... you believe you can do almost anything! And that's what happened. I landed here, but I realized a month and a half into it that I didn't have any way of doing anything. So it was pretty tough, but the best experience in the world, because it makes you conscious of your own choices in terms of citizenship and attachment to a place that you recognize as a giving place — as a place that has literally given you something.

FB Are you an American national?

RV Yes. It was a very important decision on our part.

FB You said your emigration from Argentina to the U.S. was a very arrogant move. Would you consider yourself naturally arrogant? Or does becoming an architect engender arrogance?

RV I think this profession has that kind of stigma, and I think I do suffer from it too. I mean, it's a very difficult thing not to be. The craft requires an enormous amount of intensity and — regardless of what kind of practice you want to have — ultimately, you're involved in an industry which is complicated, in which the subject matter is always extraordinarily expensive, and in which you move huge amounts of assets in one way or another. And if you add to that the frustration of how circumstances have changed over the last 50 years in architecture, architects having lost a very important position in that process — through their own, our own, fault, I think — then sometimes the arrogance gets mixed up with resentment and things get really bad. So, I think it is a collective disease. I don't know many people who are really, truly, honestly humble. You can be humble, but you have to be outgoing. If you don't have a profile that projects a certain degree of authority, you get completely crushed. And that's easily transformable into a certain degree of arrogance, which I think is a horrific thing, because it muddles your vision and makes you believe things that are not really true. So going through that process of having to demount that arrogance was an extraordinary learning experience.

FB In Buenos Aires you already had big civic commissions, and you've said your motivation was always to build big.

RV I do have a certain interest in scale, large scale, because I think that ultimately what one does is — for better or worse, consciously or subconsciously — to end up influencing things. These things always condition somebody else's life somehow. Some people have made extraordinary changes with very tiny work, and I think that's a remarkable thing. To take the example of Mies, for instance, the Farnsworth (House) is an extraordinary building, but I think the Seagram [Building] has actually become part of the vocabulary of the experience at a very popular level, in which the quality is not just the result of an elitist perception of architecture — it affects the public in ways that no other buildings do, and I think that that's what's connected to the idea of scale. I've also always had a rather... one might say strategic view of what's happening with the construction industry as a whole, and I think that architects — architects of some repute — are only ever involved in a fraction of the work that's produced annually. Probably less and less. And I think that's something you really need to work against, because the sensitivity and the vision of an architect — the training and the craft — is something that's completely unique. It's not the same as being an artist, or a mathematician, or a scientist, or anything like that. Architects, as opposed to many other fields where design is just the basic vocabulary, perform a role that is absolutely fundamental. It's the closest to politicians in a way. You maybe think you're not really affecting the course of people's lives, but you are.

FB What do you think are your intentions as an architect?

RV I always have the same mantra for myself, which is: you're not in a box thinking about architecture, because that in my view puts you out of architecture. I think that architecture is everything that gets built, and I think that if you are in the building industry then the degree of specificity of everything you do is absolutely paramount. You can't come out with a preconception or an aesthetic agenda in and of itself, you just have to submerge yourself in the "conditions of possibility" as the Marxists say. And I think that's great!

FB To return to the idea of "building big," are you interested in creating monuments?

RV No. I don't know what they are other than some fake glorification of authority.

FB But some clients will ask for a building that is also a monument...

RV That has been replaced by this dubious notion of being iconic — which is a completely different thing because the latest interpretation of the word is that it means "different than others." And while there's nothing wrong with being different — nothing wrong with being not-so-different either — there's a consumeristic notion about the fact that all of a sudden the client has this control over what you're doing predicated on some vision of what architecture is today. It's a completely cultural reaction. In other places, rather than make it iconic, they ask you to make it beautiful and that's a different thing. I always find that a much more challenging commission. And that sort of reconciles you with some of the aspects of this business in which you need to have that unique idea, where what you're doing contains the seeds of beauty. There are very many good minimalists, but if you look at Donald Judd, that's beautiful on top of being minimal. And that's a dimension that's so tough to relate to. It's not always, in my view, the result of what people understand as iconic, by which they mean weird, out of context, or self-referential.

FB What do you consider your greatest architectural achievement?

RV I don't know... I can tell you the things with which I feel the happiest and they're always things that import not just what the building is, but what happens to the building. And I think that's a very theatrical sensitivity in my work.

FB Do you have an example?

RV Yeah, there's the airport in Uruguay, for instance, which is very intimate in a way because it's all about this question of asymmetrical symmetry, which is very difficult to see because it's not a simple arch, it's not a simple form, and it doesn't have any high-techie things like all airports have today. But it gives people a sense of pride which is completely beyond the limits of the building. There are subtle ways in which you can change the way people work or live, that when people understand it and they make it part of themselves, they generate a degree of happiness which is quite rewarding I think.

FB Is there a building you feel has been overlooked by critics?

RV Many, many buildings!

FB In New York for instance?

RV In New York it's very difficult to find a building that hasn't been either totally discarded, or demonized, or made into a jewel, because it is just part of the hype of the place. But I do think there are certain things that have to do with infrastructure that to me are really totally remarkable. There is soon going to be the first exhibition on the grid of New York, which is organized by this wonderful lady that I know, Hilary Ballon ["The Greatest Grid: the Master Plan of Manhattan," at the Museum of the City of New York]. It is one of the most intelligent and sophisticated ideas, which is collective — and people haven't studied it, and it is in the grid that this city is really planned. If you read about New York, it's always about the buildings and not the infrastructure, which is what makes the buildings so amazing.

FB Earlier you used the word "happiness" in relation to architecture. Do you think a building, or architecture, can also be too serious?

RV It all depends on how people relate to it. I think that architects tend to make it even laughable, or incredibly anal-retentive, and it's neither. It shouldn't be something that surprises you every morning, because by the third morning you're not surprised anymore. And it shouldn't be grave, or trying to generate a sense of gravitas that doesn't come from the real character of the organization of the building. I saw a building, maybe a year and a half ago, which is to me one of the very unique pieces... It was a visitors' center for the concentration camp in Dachau [Florian Nagler Architekten, 2009], and it has exactly that incredible balance between rigor and metaphor, without becoming cheap. It's an incredibly subtle operation: when you approach it, you don't know whether it's happy or not, whether it's serious or not, whether it's dramatic or not — but it's all of those things at the same time. It comprises two slabs of poured concrete: one is lifted from the floor and the other is the roof, and then the structure is a series of wooden columns taken from the same forest where the building is. It has a huge amount of columns, which are in the perimeter and twisted in different ways such that the latch of displacement of the two slabs is controlled. And it is so amazingly powerful: it's completely based on an architectural idea, it doesn't depend on anything other than the media itself, which is its own construction and the logic of how you use it, and the connectivity with the site, and so on. I think it's quite remarkable.

FB Have you ever felt that you or your work have been misunderstood?

RV Oh, all the time! But that's alright... No, not all the time, it depends by whom — there are moments of misunderstanding with the client, or the people working on the project, or with the critics. Architecture has these kinds of fields in which the practice operates: the people actually practicing, the people teaching, the people talking about whatever happens in between —

and these three legs are amazingly uneven in the recent history of architecture. So, this lack of equilibrium and interaction between these three fields has dislocated the discipline to the point that — as I was saying before — architecture has been diminished in levels of importance which are really significant. And if you look at the last, say, 30 years in the architectural profession — which, as I say, is in crisis, although there are very important signs of recovery now — they were dismal. For 15 or 18 years we were all kind of chasing Philip Johnson — a person who was able to transform, to make banal, almost anything he touched, other than his own taste which was glorious. And then prior to that, this whole business about the hedonistic character of historic reproduction and all of that. And now everything has to be critical, or wacky, or triangular. It's all these things that become fashionable — when in reality what you're doing doesn't have the same cycles as industrial design, or fashion, or theater. I mean, how many times do you think an architect has a shot at doing something important in his or her life? It's a limited amount. Maybe you make a pitch every two months or so — advertising agencies make a pitch every two days!

FB But you're still one of the young guns — you're not even 70 yet...

RV Yeah, but I think it's sort of like what I.M. [Pei] told me once, "You don't know what you're doing until you're 60." It's not that he didn't build before that — it's simply because it takes all that time to really realize what is the fate of what you've been doing. Which is why I was always so interested in actually building. I mean, when you really look at it, for years up until now, the leaders of the discipline were people who'd never seen a brick in their lives! That's the truth. It's a completely unique phenomenon. It can only happen because the discipline is in retreat. Because it couldn't happen if you were in a technical field of any sort — you can't call yourself a pilot if you don't fly a plane. In architecture it was totally upside down! Now I think it's in much better shape. Just simply because people started to realize they'd been fooled around with — they went to school and paid a million dollars in education and they make 24,000 dollars a year...

FB Do any of your children want to become architects?

RV They were forbidden!

FB Why is that?

RV Well, it wasn't exactly like that, but I think this is a very tough moment for the discipline because basically the market has been oversupplied. If you had a child and they wanted to be an actor, you might be tempted to say, "Yes you can be an actor but, by the way, why don't you go and study mathematics or engineering or something, on the side, because it's a tough field." I think architecture's pretty much in the same place today: it's like being an actor, unbelievably tough, and unrewarded, and taken advantage of... Think about it for a minute. You do a residential building, right? In Manhattan, anywhere. And you do all the work — your responsibility is

enormous. You have liabilities associated with it, not to mention that on top of everything, you can have criminal actions against you. So you gamble all these people's money and ultimately, on average, you collect between 50 percent or 60 percent less than the real-estate brokers — who do nothing other than sell the apartments. So, you tell me whether that makes sense or not. It's all so completely screwed up!

FB You said that your decision to go into architecture was informed by your parents' respective professions. Do you think that ultimately you chose the one field that perfectly marries the fun of filmmaking and theater with the seriousness of mathematics?

RV Maybe. But you know, I actually think that mathematics is the more fun of the two. I have friends in Oxford who are mathematicians and I always tell them that they have the worst P.R. in world. [Laughs.] There is this whole notion about them being geeks, but they have an enormous amount of fun doing what they do. And they're involved in the most important pursuit today. And the great thing is that, unlike so many things today, you cannot turn mathematics into a commodity: you cannot market it, you cannot decorate it, you cannot sell it, you can't fool people around, you can't make it go by some form of mass-market propaganda scheme, or anything like that. It has its rules, and either you're good at it or you're bad.

BERLIN

ANDRO WEKUA

Interview by Simon Castets

The artist Andro Wekua works in many media — collage, sculpture, painting, and film — but he is best known for delicate room-size installations framing mannequins disposed in uncomfortable positions. His studio in Berlin is located in a quiet semi-industrial area north of the Tiergarten, overlooking the River Spree. On the walls of the 280-square-meter space hang carefully arranged reference images (film stills, found photographs, postcards), while works in progress, including models and paintings, dot the concrete floor. He moved to the German capital in 2006, after ten years in Switzerland, where he went to art school, and to this day he speaks German with a charming Helvetian lilt.

All this is a long way from Sukhumi, Wekua's birthplace, an ancient town in the Abkhaz region of Georgia, which enjoys a semi-tropical climate on the northern shore of the Black Sea. In the twilight years of the czars, Sukhumi was developed as a sophisticated and rather grand resort, a role it maintained throughout Soviet rule. But the town's fortunes changed dramatically on the break-up of the USSR, when ethnic violence degenerated into an all-out war between the Georgian authorities and Abkhaz separatists in 1992–93. Wekua's father, a leading political activist, was killed, forcing the rest of the family into exile in Tbilisi. To this day the self-proclaimed Republic of Abkhazia — whose capital is Sukhumi — remains closed to Georgian nationals. In response to the brutal randomness of the historical events of his youth, Wekua conceived the installation *Pink Wave Hunter* (2011), which he first presented at the Kunsthalle Fridericianum in Kassel, and then at the Venice Art Biennale. Composed of 15 architectural models placed on a long plinth, the piece represents different buildings from his hometown, reconstituted from childhood memories, found images, and Google Street View. Often amputated not only by the destructiveness of war but also by personal and collective forgetfulness, the buildings of *Pink Wave Hunter* speak of the frail state of memory in the face of historical trauma.

Simon Castets	What exactly is a pink wave? When I Googled it I got some funny results, such as a Cypriot holiday entertainment agency or a blog on feminism!
Andro Wekua	The idea came one night when I woke up sweating in my bed. I didn't understand what was happening. I went out onto the balcony to get a breath of air and saw a huge pink wave pass me by. Since then I've been trying to find this pink wave again because it was an indescribable experience. So the title just came to me that way. In my working process each piece leads to the next, so everything is a product of things that came prior to it. And this title came the same way, and it just made sense to me.
SC	When you first showed *Pink Wave Hunter* you had all the walls painted bright blue. It made the place look like a TV set or a cinema studio.
AW	Yes, it was done with the idea of stage design in mind. It's a color that was very present in Sukhumi at the time, in the cafés and bars. It's also the color of the sea and the sky. I thought it would be a good background for the buildings.
SC	Did you use the color to contrast with the bleakness of the buildings?
AW	Exactly. In Sukhumi, the weather is almost always good — it's a warm place with blue skies. Then the war came.
SC	In contrast to the violence of the Abkhazo-Georgian war, *Pink Wave Hunter* could be seen as hushed. Why are the buildings so devoid of human presence?
AW	*Pink Wave Hunter* is not directly related to the war in Abkhazia. The buildings come from images of Sukhumi taken after the war, when the city was, as it is now, mostly empty. It's like a stage where something once took place and maybe will take place again — like film sets where they build whole cities made up of just façades and, once filming is finished, the city of façades still stands and waits to be used for a different movie.
SC	I remember you once said that your memories of Sukhumi were so powerful that they often seem like a film in your head. I was reminded of this when I saw an image here in your studio from Francis Ford Coppola's *One From the Heart*. Instead of shooting the movie on location in Las Vegas, Coppola had a set designer rebuild everything in a studio, including the airport, which created a much eerier atmosphere. In a similar way, in *Pink Wave Hunter*, the reproductions of buildings in Sukhumi are based on Internet images, postcards, Google Street View, as well as on your own blurry memories.
AW	I like the comparison between *Pink Wave Hunter* and *One From the Heart*. A similar thing could also be said of Kubrick's *Eyes Wide Shut*, or Fassbinder's *Querelle*, two other films in which everything was recreated in a studio from start to finish. I think what interested me specifically in *One From the Heart* was the lighting, the colors, and this feeling of reality taking place

on a stage. It's something I also thought about while making my film *Never Sleep with a Strawberry in your Mouth* [2011]. But, just like you said, my memories determined much of what the sculptures look like. These were famous buildings in Sukhumi, and I mostly remembered their façades. Today in Sukhumi, due to lack of funding, they have been renovating only the façades of these empty, deteriorating buildings. That was actually one of the starting points for the work. Another starting point was that since I left Sukhumi, I've been dreaming of the city. In my dreams I always look for ways to get out of there. So one day I began to draw the streets, just to check how much I remembered. Whatever I did not remember and could not find in photographs stayed blank. You also see that in the sculptures.

SC Which of the buildings in *Pink Wave Hunter* did you have personal knowledge of?

AW I went inside a good number of them — cafés, hotels, houses, the train station, even some government buildings. Some of them were on my way to school.

SC Do they reflect your daily experience of the city, or did you decide to include some that were linked to exceptional moments in your personal history?

AW The installation is more concerned with elements of day-to-day life. But my house isn't there, my school isn't there, my kindergarten isn't there, so it's not that intimate.

SC Which only contributes to the sense of alienation...

AW Absolutely.

SC Do you know these Louise Bourgeois sculptures called *The Rectory* and *The Institute*? Both are buildings that are displayed in sort of cages with circular mirrors on the side. They are meticulously reproduced and no detail seems to be omitted, whereas her different house sculptures are far more freely rendered. Do you see a difference in your own work between buildings you have a personal attachment to and more anonymous structures?

AW It's funny because I made a small sculpture of the house where I grew up in Sukhumi, and it is much more detailed than the buildings in *Pink Wave Hunter*.

SC So it's the contrary: the intimate is replicated with more precision than the institutional?

AW Once I saw the finished sculpture, I started remembering some details that I had no recollection of before and which had actually been falsely represented in the piece. Another interesting experience was building something that you remember as being much bigger than it is as a model-size object. But to get back to Louise Bourgeois — they're all beautiful works — although the piece that actually came to my mind while working on *Pink Wave Hunter* was Mike Kelley's *Educational Complex*.

SC In some works from the *Educational Complex* series, Mike Kelley included indications as to what type of people were present in and around the space, such as rednecks, hillbillies, greasers, etc. Is there also a human element in your memories of Sukhumi?

AW In terms of my personal recollection, of course, I remember friends, relatives, and a lot of Russian tourists, but in *Pink Wave Hunter* what was important were the places and their emptiness.

SC After living in Sukhumi, you moved to Tbilisi. Do you also have memories from there that you reference in your work?

AW I haven't really used them in that way.

SC How often do you go back to Tbilisi?

AW Not so much, maybe once a year.

SC And would you like to go back to Sukhumi if you were allowed?

AW I have been thinking about it a lot. When something is forbidden, you want it more, somehow. So of course I want to go back. I will do it one day, if it's possible. But maybe the reality of things there today has nothing to do with what I have in my head. I often wonder if I want to keep all the things that I have created in my mind, or if I want to confront reality. I know it will be something different.

SC Do you think Sukhumi will ever regain its reputation as the Nice of the Black Sea?

AW I hope that one day it will at least become normal again. But when I grew up, Sukhumi was very much a place of Soviet times. For example there was no advertising, no billboards on the streets. It will never be like that again, of course. Which is okay — it doesn't have to become the same.

SC Now that you live in Berlin do you think a lot about East Berlin's Soviet past and the socialist architecture here?

AW I'm not that drawn to it. I have no nostalgia about Soviet times at all. I moved to Berlin after spending time here in 2006 when I was showing at the Berlin Biennale. I liked that you can have lots of space and quiet here. So my then girlfriend — who is now my wife — and I decided to move here from Zürich. I really enjoy it, but that doesn't mean I wouldn't move somewhere else.

SC Thanks to smartphones, Google Street View, and the like, it's now impossible to get lost anywhere in the world. Do you think that will have an effect on our memory? Will our brains have more space for new types of memories?

AW Well, I don't remember any phone numbers any more, not even my own! I always liked to get lost in an unknown city — I enjoyed the feeling of being estranged and of losing orientation. This kind of thing won't happen with smartphones. But I don't believe that if you don't think of one thing, you have more space for other things. I think if you have to think about space, it helps you think better about other things. The more things that you have to think about the more mental space you have.

SC In 1998, Pierre Joseph drew a map of the world from memory and entitled it *Le Monde*

Erotique. The title has always stayed with me because of its particular use of the word "erotic."

AW Well, memory and the creation of something new are almost identical for me. What Pierre Joseph did from memory is to create something new, a map that didn't exist before. So, by that token, creating something new can be erotic.

SC Last summer I read a front-page article in the *International Herald Tribune* whose headline ran, "Visions of a plague grip Tbilisi, but the vermin are hard to find." It described an alleged invasion of snakes and scorpions in the Georgian capital and the inhabitants' emotional response. The journalist implied that Georgians were highly superstitious and that their reactions were perhaps overblown, notably because the Georgian word snake can also mean Satan. It conveyed a sense of Georgia as a very remote, uncharted territory. Why do you think Georgia remains that kind of place in the media's eye?

AW [Laughs.] I remember seeing something on Georgian T.V. about snakebites. The situation in Georgia has been open-ended and uncertain for a while now, which always makes people feel unsure and superstitious. There are huge shifts between generations as well. But somehow people love those kinds of stories everywhere. It seems to me that such uncanny things can come out in American culture too at particular times, with all the insect-invasion movies and such. In Georgia, there's no budget for movies so maybe people tell these stories on T.V. instead.

NEW YORK

ROBERT WILSON

Interview by Horacio Silva

For over 30 years, the prolific avant-garde director and cultural producer Robert Wilson held court at 67 Vestry Street in New York, a NEA grant's throw from the West Side Highway. Wilson originally moved into an apartment on the eighth floor, but in 1996 he took over the entire sixth floor, where his friend the sculptor John Chamberlain had once lived.

The lifestyle-envy-inducing loft became not only a meeting place for some of the city's brightest creatives, but it also served as a *Wunderkammer* of sorts for Wilson's eclectic collection of approximately 8,000 artworks, furniture pieces, and cultural curios. That is, until the real estate supermogul Aby Rosen evicted Wilson in 2007.

A few weeks before a lot of Wilson's bounty was sold at auction at Phillips de Pury & Co. — the preparation for which kept Wilson's team of adjutants busy cataloguing and packing for months — he sat down with PIN–UP at his sprawling Watermill complex in the Hamptons to reflect on the objects of his affection.

Horacio Silva	Hey, mister. Thank you so much for agreeing to do this. First up, what is it with you and chairs? I was recently looking at some pictures of your old loft and it reminded me of *The Chairs*, the Eugene Ionesco play at the end of which the stage is stacked full of them.
Robert Wilson	[Laughs.] Well, they're one of my many obsessions. Is it that bad?
HS	If it makes you feel any better, you're not as bad as Achille Castiglioni. I interviewed him towards the end of his life, when his mind wasn't as agile as it once had been, and he had his assistants bring out so many chairs during the course of our conversation that, by the end of it, I felt like I was trapped in a furniture showroom.
RW	You haven't seen anything yet. Wait till you go to the downstairs galleries and the basement. Then you'll really think I have a problem.
HS	It must have been very sad for a hoarder like you to pack up everything after all those years.
RW	Well, you know, what are you going to do? It is what it is.
HS	It's easy to view it as a case of filthy lucre bulldozing the precious edifice that is the art world. But is Aby Rosen really the antichrist?
RW	No. Life is never that simple. And the truth of the matter is that maybe I should thank him. At one point I thought, well, maybe I'll fight him. But then I woke up one morning and thought better of it. The best way to win an argument is to say, "You're right and I'm wrong." You know? Then there's no argument. I heard an interview with Barack Obama not long ago and a journalist said, "Mr. Obama, you said so-and-so a few months back and now you're saying this and that." And he said, "You know, a few months ago I was wrong." And I thought, "Wow, a politician saying that he was wrong!" Sometimes you just have to recognize when you've made a mistake. Nixon should have just said that he lied. And Clinton should have just said that he did not have sex with that woman — at least not on that day. [Laughs.]
HS	Correct me if I am wrong, but your eviction was the result of your having moved from the eighth to the sixth floor. You effectively lost your artist-in-residence status when you moved to the larger space, no?
RW	That's right. What happened is that I moved in originally on the eighth floor and I had one quarter of the floor. [Wilson, an incorrigible scribbler, draws an illustration of the original floor plan.] And, at that time, John Chamberlain had the entire sixth floor and he told me — I guess it was in the late 70s or early 80s — that he was going to leave New York and move to Florida and that when he did I could take over his space. John was very surreal so I was very excited at the prospect. He had black vinyl on all the windows, all these

car parts and sculptures scattered around the place.

I was very much expecting to move in there but next thing you know the Dia Foundation came in — they probably threw him some money or whatever — and they decided to make a museum of his work. They kept it as museum for a few years, but no one came and after a while they closed it and used it for storage. So I told Alvin Friedman that I could find him a lot better storage than that, for less money. Anyway, it's complicated and boring but the upshot was that I eventually moved into the sixth floor and in the process my status changed. But I guess you could say when I moved into the sixth floor, that's when I started to collect things in earnest.

HS Oh, I heard that one of your uncles gave you a chair when you were twelve, a chair that was later taken away from you, and it was that incident that piqued your interest in collecting.

RW Yeah, that's partly true. I also bought a painting by Clementine Hunter, of people washing clothes, when I was twelve. And when I was 13 or 14, I bought five or six larger canvases. That really got me going. But even before then I was always collecting stamps and arrowheads and what have you.

HS What usually draws you to an object?
RW I think they are drawn to me.

HS How much do the objects you've collected over the years inform your work?
RW A lot. And it's often very random. I designed a prefab house this summer for someone in Germany. I was sitting here, looking at this funeral post from Madagascar. And I was just pondering the circular forms and next thing you know they became a design echo in the house.

HS What about some of your performances — any of those been inspired by your collectibles?
RW Sure. Way too many to mention. But you know my Bessie Smith Breakfast Chair, right? The design inspired a show I once did called *Cosmopolitan Greetings*. Let's see. Another time I bought a photograph in a flea market in Berlin and years later I found out that it was of Rudolf Hess. I built the whole of *Death, Destruction, and Detroit* around that photograph. And I based all of *Einstein on the Beach* on a photo of Albert Einstein I have. It was a piece I did with Philip Glass and everyone is dressed exactly the same way as Einstein in the photo — in a starched white shirt, suspenders, wrist watch, and tennis shoes. And I started with this gesture. [Wilson cups his fingers together.] I looked at photographs of Einstein over the years, and he always created this little space between his fingers, and I couldn't help but think that in that space he held the chalk when making his calculations. His favorite pastime was sailing, so he must have pulled the ropes on the sailboat with his hands in the same position, and he loved to play the violin so that's how he probably held the bow. This gap and the way he was standing, with round shoulders, became dominant motifs in the show.

HS It's strange to think that of all the amazing antiquities and artful objets de clutter that you own — the Chinese Neolithic pots, the aggressive Modernist art, the autochthonous masks, etc. — you're so attached to the cardboard cutout of Marlene Dietrich that you had on the back of your toilet door in the loft. I presume that's not for sale.

RW No, that's staying with me for good.

HS Where did the fascination for Dietrich come from?

RW I first saw her in about 1968, I guess, when she performed on Broadway and I had no idea at that time that I was going to work in the theater. I was fascinated with her. Then, in 1971, I was performing in Paris for a few months, on my first major work, *Deathman Glance*. The fashion designer Pierre Cardin was producing it and he was also presenting Dietrich at the Espace Cardin, which had just opened. I went to see her 17 times! I was just totally blown away by how precise she was in each performance. She would remove a tear every night — it was always right there at the exact same time. [Wilson does a hilariously campy impersonation of Dietrich removing a tear.]

HS Was she believable?

RW Oh, totally. She was like a great kabuki actor. She showed deep emotion and impeccable timing. One night after the show, I plucked up the courage to ask her out for dinner and to my surprise she said yes. She was such a riot. I remember one guy came up to us at dinner and said, "Miss Dietrich, you're so cold when you perform." She turned to him and said, "You obviously didn't listen to my voice."

And then she turned to me and explained that the difficulty is to place the voice with the face and it's true. She could be icy-cold with her gestures but the voice could be very hot and sexy. That was her power. I learned a lot of lessons from her, like how to stand on a stage. [Wilson stands in demonstration, looking every bit like a silver-screen diva.] She could just stand and do nothing and people would be riveted. The simplicity of her gestures was amazing. But she was like an atomic bomb.

HS What other Dietrich memorabilia do you own?

RW I once asked Dietrich what her favorite photo of herself was. And she said, "I don't know, I've been photographed so much!" After a few drinks she told me it was a photo of her by Horst in 1941. She said, "I finally learned to look at a camera in that photo!" Of course, she was looking away. I have that one, too.

I have her favorite shoes, the ones she had on when she fell off the stage in Australia. They took a photograph of her with her legs all mangled, broken, and bloodied and printed them on the cover of *Life* magazine. So she wrote across the cover of the magazine for me, "How ironic that the legs that made me have now broken me." I have the shoes, complete with blood splatter, downstairs.

HS	Do you ever try them on?
RW	No, they're not my size and they're encased in glass.
HS	Seriously though, why is it that of all the things in the old loft the only things that I recall being kept under glass were the shoes — not just Marlene's, but pairs that used to be owned by Rudolf Nureyev and Jerome Robbins? Why are they revered more than the other objects?
RW	They are and they're not. I adore them, but there have been times when I used to hang them on the wall. The glass was probably just to keep them clean. My sister, who lives a completely different life than I do — a very suburban television-sink-sofa-and-swimming-pool existence in Texas — visited me once on the sixth floor. She looked at my collection and her first comment was, "Oh, what a lot of things to dust!"
HS	Are you a duster or are you like Quentin Crisp who claimed that after a few years the dust pretty much stays the same?
RW	I'm with him. It's like directing a play — sometimes you just have to let go. It's the same with the loft and how you were asking me earlier if I minded having to leave. It's healthy to be sometimes forced into offloading things, it's quite liberating. I'm glad I had that time with all that stuff, but I don't know, it's time to move on.

NEW YORK

JAMES WINES

Interview by Michael Bullock

With his great white beard and jolly sense of humor, James Wines could be an architectural Father Christmas — and each building designed by his firm SITE a giant toy for the community. Since Wines founded the firm in 1969, SITE has gotten away with all kinds of tricks, turning department stores into forests and piles of bricks, museums into oceans of waves, and a skyscraper into the Hanging Gardens of Babylon. It even levitated a McDonald's. Although constantly blurring the lines between art and architecture, between the building and its environment, SITE's work should not be mistaken for Postmodern event design: the firm's special talent is to use alluring spectacle to focus attention on sustainability and to make radical ideas work for even the most commercial clients. So in this day and age, when "green" thinking has become so mainstream that even Wal-Mart has hired a former head of the Sierra Club, Adam Werbach, to make the big-box monster chain environmentally friendly, PIN–UP felt it was high time to meet with Wines, who, with his Best stores, figured out many of these issues decades ago.

Upon entering SITE's downtown-Manhattan office, it becomes immediately clear that this is not the corporate headquarters of some blue-chip architecture firm, but a friendly, family affair whose intellectual father figure is of course Wines himself. He sketches ceaselessly, a quick scribble of the hand supporting every thought, as if the pencil were a natural extension of his brain. Our conversation is frequently interrupted by his loud, infectious laugh, and by his charming wife, the jewelry designer Kriz Kizak, who works from the same office.

James Wines	So what kind of questions you got?

Michael Bullock	Let me start with the Best stores. They never get old!

JW No, I guess they don't. I just sent a couple of images to a conference in Seattle about big-box stores because they are the only ones still doing business. The Best stores were a big turning point for SITE because up until then I was mainly doing sculpture, books, lectures, or theory.

MB So one day you were speaking with the owner of Best and he tells you — what? "I need to spice up my showrooms"?

JW Well, the owner of Best, Sydney Lewis, and his wife, Frances, were great collectors — they'd come into the city on weekends and go on a dozen studio visits. They had a real passion. They would have these big parties and they'd pack the whole art world into an airplane and fly everybody down to Virginia. So you were sitting there and everybody you could think of was on that plane. I remember Phillip Pearlstein saying, "What if this plane went down? It's the whole art world!", and Chuck Close was like, "Yeah, I know what it would be like. The headline in the *Post* would read 'Andy Warhol and Friends Died in Plane Crash.'" So Sydney Lewis was being criticized because he was a big art collector and he was building these ugly box buildings.

MB So he was being hypocritical and you proposed to fix his aesthetic hypocrisy?

JW Exactly. How can you collect all this art and build these things? So I think he really took that to heart. But he was really public minded; in fact, they were amazing people. But at first he thought we would just tag some art on the front, or hang something outside. He wasn't prescriptive at all and he didn't know what we were going to do. I don't know if he knew it would be affecting the whole building. This type of store is an icon in the way that it's just one big box. Our idea was to change the meaning.

MB What was the first collaboration?

JW The "Big Peel" building and the "Ghost" parking lot were going on simultaneously.

MB When they were finished, he was obviously thrilled with them?

JW He was, and they got a lot of amused customers.

MB It's very rare to have a sense of humor translate into building.

JW I was using architectural means to write commentary. The absurdity of the whole thing. And also the inversion of people's expectations: when you're driving down a highway you have all these built-up expectations, that is if you're thinking about it at all. I remember I heard people say, "I never thought about a building till I saw that!" It was funny: the foreign press was saying,

"Phenomenal! Amazing! So American!", and the American publications were saying, "So un-American." [Laughs.]

MB How did SITE begin?

JW The 60s were when radical architecture was really starting again, here and in Europe. Everything was political: there were all kinds of rallies, events, and protests. Everybody was in that spirit of the moment, that drive to protest. In fact, architecture was one of the last to get into that arena. There had been an awful lot in art, and it wasn't until later that people realized, "My god, architecture is the most public thing of all!" So we zeroed in on that premise. We just questioned a lot and it all just happened together at once. I found a lot of confreres who agreed with me kind of overnight. Archizoom, Superstudio, UFO, and Archigram were around already. And all those things happening at the Architecture Association in London all had protest at their core, or came out of it. So it was really interesting in that there was a lot of support — not official support, since there was no kind of gallery showing or whatever — but it became a kind of street art, intervention art, and events.

MB How did you get connected with patrons for your bigger projects?

JW There were definitely key people in the art world, like Sydney and Frances Lewis. They bought a sculpture of mine early on, and then one thing led to another and they got more and more involved. Back then there was a lot of this crisscrossing going on. Almost all the artists were hybrid in the late 60s. It was nearly impossible to find someone on the cutting edge who was purely a painter or sculptor. Things were moving out of the galleries, Land Art was starting; Gordon Matta-Clark, cutting up, slicing up, or totally changing architecture, expanding it into the environment.

MB Were you friends with him?

JW Oh yeah. There was a bunch of us on Greene Street, all within a block of each other: Gordon Matta-Clark, Robert Smithson, Alice Aycock, Hannah Wilke. It was an amazing exchange of ideas. But that was the early 70s. It would be hard to do now with the price of real estate.

MB Is that something you feel is missing today?

JW Absolutely! And it is also missing in the substance of the work. But then again, those things kind of go in cycles. If you look at French art just before Cubism, everybody was making big bucks, they were all millionaires and had estates in the country. It was pretty official that artists could become grand masters... and then it happens again. But you always have to have a place for people to live. I see my daughter's generation and there's just no place to live with that kind of money when you have to pay 2,000 to 5,000 dollars a month for your studio!

MB So what made you move away from sculpture and break out of the art world?

JW It was very organic. My recollection of it is that I was never a careerist.

By the time the 80s came around, artists started really being into making money. And they could, so you kind of had to fit into some group, like Neo-expressionist, or whatever. In the 70s there was never any talk of that.

MB For you it was more about the thrill of seeing your ideas become reality?

JW More like getting away with it! [Laughs.]

MB When you were making the jump from sculpture to architecture, were you nervous?

JW Well, no, because I always thought there was something limiting about being confined to sculpture.

MB Is architecture sculpture on a much bigger scale?

JW Architecture is more liberating. As I look back at that period, the most interesting things become performance, or Land Art, or architecture; the public domain became more interested. But, interestingly, of those artists who emerged, the majority had a background in sculpture.

MB So it was a starting place to generate ideas that then grew into other venues?

JW Yeah, because it was somewhat confining and you had certain duties — size, or whatever.

MB Is that why you love drawing so much, because there are no boundaries?

JW Well, for most architects graphic representation is notational, technical, or illustrative and mainly used as an analytical tool to record design intentions. I consider drawing more as a way of exploring the physical and psychological state of inclusion, suggesting that buildings can be fragmentary and ambiguous, as opposed to conventionally functional and determinate.

MB So when it comes to actually building, do you partner with someone more technical to translate the ideas in your drawings?

JW We get along with architects, and we just collaborate. We always have, since the very beginning, with everyone sitting around a table: architects, engineers, visual artists, and we were just pulling minds from everyone. That's what made it interesting. We would sit around in some restaurant always discussing the idea of what's possible.

MB Now it's the Shake Shack [SITE's design for Madison Square Park in Manhattan]?

JW Well, a lot of people show up at the Shake Shack, but I have a feeling that they're not necessarily talking about art.

MB The Shake Shack is amazing because it fits into the park so seamlessly that you don't notice it, especially with the green roof.

JW Well, the idea was not to jump out like a sore thumb in a Victorian setting.

433 JAMES WINES

MB How did you come to do the Shake Shack?

JW Danny Meyer and Madison Square Park approached us. We could never have done it if it had been a new addition to the park. But apparently, when the park was designed in the 19th century, they had intended to put some type of kiosk there, but it never got built. So thankfully they didn't have to fight that battle.

MB Is it your only building in New York City?

JW Yeah, well, there is the second Shake Shack. It's a franchise. The new one is on 77th and Columbus, across from the American Museum of Natural History. Our design was voted by a poll of New York Architects as one of the most beloved buildings in the city. It was the U.N. Headquarters, the Whitney Museum, Lincoln Center, and the Shake Shack! And what's funny is that while we were designing a 500-square-foot kiosk, we were simultaneously developing this housing concept design for one million square feet.

MB It's amazing that while SITE takes on prestigious large-scale projects like the museum of Islamic Arts in Qatar, it's still up for designing a burger kiosk. While we're on the topic of fast food, I have to ask about the floating McDonald's.

JW Someone wanted to build a McDonald's on one of our client's parking lots, and he said, "If you want to build on my property, you have to use my architect." It was in 1983, and McDonald's had just gotten their new look, and we thought, "Well, we have to use this." So we just twisted that look around and did it comically, keeping all of the ingredients of that archetype, except that the parts were separated — the roof and the walls, everything was floating.

MB Does it still exist?

JW Yeah, but apparently they painted it and got rid of all the natural materials.

MB Do any of the Best stores still exist?

JW Only the forest building, but it's a church now, and they destroyed all the trees.

MB Why would they destroy the trees? That was the whole point.

JW I don't understand it either. They were actually growing really well. We made a great effort to free up the roots so they would grow over the years. And then, since they were protected — because they were inside the building — they grew even better. It was the perfect nature building: the interior was all covered in vines and the amount of greenery was unbelievable. The whole building looked like a garden.

MB Well, in a way it was the precursor of this project. [Points to a drawing of Antilia, SITE's design for a tower in India that is completely covered in greenery.] This looks spectacular! Is it being built?

JW Well, this was going to be a house with a series of public gardens, like the Hanging Gardens of Babylon. For the research we read up a lot on the gardens of Babylon because apparently they were around for almost 2,000 years as a sort of arboretum where you could go see all the plant life. The support system for the project is ingenious. I thought of it myself and I was very proud. I thought so much time and money is spent getting the materials to the top, why not build the floors on the ground and pull them up with the truss? So it's just a simple tower with an elevator core and a huge truss. Our engineer got really excited, but unfortunately in the end the client gave it to some local architect who did something similar but much cheaper. What drives me nuts is that these people have now turned it into a high-rise private home. I don't know if any of the public aspects survived.

MB I find it amazing that six years ago if you said the word "green" you were a hippie, and now it's this trendy thing. You figured out how to be green and make it enjoyable for the public way before anyone else. You've always combined sustainability issues without compromising pleasure.

JW Well, it's a big question, that transition from making environmental commentary to being really concerned. That's a big difference. How do you continue to be reasonably inventive and look seriously at these restraints? Because these restraints could lead to the world's worst architecture, and often they do. Most "green" buildings are pretty bad buildings. It's hard to find LEED- approved buildings that have any interest whatsoever. I don't think it has to be like that. In Italy, this whole field of sustainable architecture has been around for hundreds of years. There's a 600-year-old town in Italy, I think it's San Gimignano, and it's still in active use, and beautiful. My next book is actually going to expand on how the word "green" has become generic. It's "green wash," it's everywhere! General Motors is green, George W. Bush is green, Exxon is green, it's absurd! But I try to be optimistic about it, and I do think the industry is realizing it can't go on the same way forever. I know for a fact it's really affected a lot of architects' business: Frank Gehry lost a lot of work in one year. Nobody wants to spend that kind of money and then be heavily criticized for using titanium and aluminum, and all these obscene materials. We're really entering a period where the pressure is on. Hopefully that will inspire a whole new dialogue. You don't have to build ugly just to be green. In that sense we could be headed toward the greatest period we've yet lived through. Your generation may be lucky yet.

MB That's good — I'm sick of being jealous of your generation!

LONDON

BETHAN LAURA WOOD

Interview by Caroline Roux

She's only five feet 1¾ inches tall, and always wears flats, but Bethan Laura Wood stands out in any crowd. With her flamboyant vintage outfits — colorful layered 1970s caftans with Peruvian-printed scarves, oversize capes, novelty hats, and lots and lots of jewelry that she either buys at flea markets or makes herself — and luminous makeup (including a glistening pink dot on each cheek) she appears like the love child of Zandra Rhodes and Ettore Sottsass. But in 2012 the 20-something Royal College of Art graduate was also one of the youngest furniture designers ever to be granted a show at the prestigious Nilufar Gallery in Milan, alongside masters such as Andrea Branzi and Jurgen Bey. Much like her wardrobe choices, Bethan's designs show an obsession with detail and accumulation. Her new multi-component lights made out of super-light Pyrex, wooden cabinet surfaces exquisitely decorated with laminate marquetry composites, to foldable tables all combine a modern aesthetic with an old-fashioned appreciation for craftsmanship. Her studio in Homerton, which she shares with three traditional cabinet makers, is in full production for the pieces that will soon be shipped to Milan, so she invites me for tea at her home in East London, a magic treasure trove of clothing, vintage furniture, patchwork covers, and random objects.

Caroline Roux	That's quite the nice bike you have there. Where did you find it?
Bethan Laura Wood	Oh, my baby Penny Farthing. I got that for my 25th birthday I think, or 26th.

CR Do you ever ride it?

BLW I do! It's very slow, though. I've cycled to Soho before but I don't think I'll do that again. I do like the rhythm of it, so if I'm just trying to relax or hang out, it stops me from speeding everywhere too fast.

CR It's got quite beautiful lights, too.

BLW That's why I bought it.

CR You bought it for yourself for your birthday?

BLW Yeah, that was my excuse — and how I could afford to buy it! [Laughs.]

CR How much was it?

BLW Ooh, a lady never tells these things...

CR It's your age you're not meant to tell, not how much your bike cost!

BLW [Laughs.] Oh no, I can tell my age but I'll never say how much I pay for things.

CR So how old are you now?

BLW 27. I will be 28 on September 7.

CR You're 27 years old and you're about to show with one of the most important design galleries in Italy. How does that feel?

BLW Weird. And good. I'm very, very, very excited about it, and very nervous. When I met Nina Yashar, who runs Nilufar, we talked about laminate for two hours. It was amazing to find someone who wanted to do that — and who knew so much about it. She has an amazing eye, and such an amazing archive [which includes several thousand 20th-century pieces in various reserves around Milan]. Now I can go to the gallery and the reserves and touch lots of pretty things and not be told off because I look a bit strange and I'm not buying them.

CR Since you mention it, let's talk about the look, Bethan. You really do love to dress up, don't you?

BLW [Laughs.] I think I started making a conscious effort around 13 or 14. I was never part of a clique at school and even my best friend left me for the cooler people. I was like, "If I'm not going to fit in, I'll give you a really good reason." It also didn't help that I took my GCSE art two years early [GCSEs are usually taken at 16] so I spent my lunchtimes alone doing charcoal sketches from Degas.

CR Do you ever not wear makeup?

BLW You can usually tell how stressed I am by the composure of my makeup. If I'm going out, or am at home having time for me, then I like to do it because it's what I like to look at. But I have learnt a little bit about the proper place for clothing restraint. If I'm busy and need to get to the workshop, I don't put silly things in my hair — I'd end up attached to a band saw and killing myself. The technicians at Brighton [where she did her B.A.] gave me a boiler suit because I'd come in a tutu, which isn't really the thing to wear to a metalwork induction. [Laughs.]

CR The first time I met you, when you were still a design student in Brighton, you were wearing an ankle-length dress with a belt somehow fastened around the calf area. I spent the whole time wondering how you'd be able to go up and down stairs. The next time, it was a shiny black-and-white striped Pierrot-ish garment with a ruffled collar. How would you describe your current look?

BLW It's very Russian doll: layer upon layer until you hardly see my head.

CR Very Viktor & Rolf.

BLW Yes. I love Viktor & Rolf.

CR Are you part of the artwork?

BLW I actually used to be very militant about the fact that the way I dress had very little to do with my work. But now that I've started doing this very patterned, very color-based work in laminates, I can't really deny the connection. I now even dress in my own work, with the fabrics that I design.

CR Would you gender your work? Do you think it's feminine?

BLW I'd like to say no, but I know that it is. I try quite hard to not let my work go too much one way or too much the other, but at the same time I am a woman, and there aren't so many of us out there in the design world, so it's important that my work reflects that on some levels. The most important part is that it's made by me, and that it has my mark.

CR You're having quite an Italian moment right now, aren't you? Even before your show with Nilufar in April, you spent a lot of time in Italy last year, working with artisans.

BLW Yes. First I was in Venice at the Fondazione Claudio Buziol, and then in Vicenza, where I worked with the famous glassblower Pietro Viero. I also worked with an incredible lacemaker in Venice. Her name is Lucia and she feels very, very, very strongly about her craft, and what constitutes lace and what doesn't. She's also very passionate, and she will shout at people, and she only ever works on things she likes, "Because it takes me so long to make it!", she'd say. I made these confetti pieces with her, based on the confetti that was everywhere during the couple of weeks before and after the *Carnevale*. I got obsessed with it — it's the most beautiful rubbish

I'd ever seen. I wanted to recreate the confetti in lace to make something that is very impermanent very permanent. And to show off the really beautiful skills that create those different stitches. One small confetti piece took Lucia about two days to make!

CR How was it working with Pietro Viero in Vicenza?

BLW He's a lovely, lovely guy. The first time I went to visit Pietro, I looked at the shapes and the forms that he had around his studio, then started to design shapes and forms accordingly, just playing with outlines. Once I got a better understanding of what he could do and what he found difficult to do I'd tailor things for him. But I have to say, it wasn't until I started working with Italians that I realized how English I am. I suppose you don't know these things until you work with somebody whose systems and rules, the way they speak, the way they do business, the way they do anything is completely different. So I learned a lot.

CR Was it a total immersion in craft and in the Italian way of life?

BLW Oh god, yeah! I even stayed with his family while I worked on the project. There's so much joy in that house. His wife's amazing. She cooked incredible lunches, loads of courses: soup, pasta, pudding, coffee, grappa. You can't really say no to food when you're in Italy.

CR Are some of your major design influences Italian?

BLW Well, they change a lot depending on the work I'm doing. But since starting on all my laminate work, Memphis has become quite a big influence. One of my earliest design memories is seeing Memphis pieces in a gallery and not being able to understand it at all and totally hating it. But I love that it causes such a reaction. Now I'd lick it if I had a piece close to me!

CR Which piece would you be licking, if you had the choice?

BLW The Carlton Bookcase by Sottsass with all its arms. And I love Sottsass's totems, too. There's something so beautiful about the volumes and the weight that the shapes have, and the different colors. Another one I love is Eduardo Paolozzi. I've actually been writing and signing petitions to make sure they don't touch the tiles he installed at Tottenham Court Road [Underground station], because they're saying they're going to have to remove some sections to make room for the new tube lines. It's really worrying...

CR The piece you made during your London Design Museum residency in 2010 also has shades of Sottsass. It's another totemic system — a storage unit made of crates, entirely laminated with tiny pieces of laminate that imitate the look of particle board.

BLW Yes, the design is based on crates and references the shipping industry because the Design Museum used to be a banana warehouse. It was part of the brief, to make something that had a relationship to the museum and the

space. I designed the laminate pattern specifically for the project. It's all made from faux-wood laminates, that I was very lucky to be given by Abet Laminati. They have a fantastic archive of patterns.

CR Your work looks very modern, but it is very old fashioned in a lot of ways. It's really about craft, and objects, in a world where people currently obsess about technology and leanness. In comparison to the iPod, for example, your work appears quite reactionary.

BLW There are a lot more craft-based ideas coming through in design, and I definitely see my work fitting into that world, but I do always try to work in a way that is relevant to now. For example, all the laminate pieces are made with laser-cutting technology, which has completely changed the way you can cut things. Laminates are usually a material of mass production and I like to have a mix of mass production and hand production.

CR What kind of pieces can we expect to see at the upcoming Nilufar show?

BLW I'm making some new tables called Moon Rock. They're a continuation of Hard Rock, a series of tables I started making two years ago. There are seven tables, all different heights and different diameters. The tops are circular, like lunar craters. The legs will be open-framed, powder-coated tubular steel, alternating between a pearly white and a cream finish — very subtle. The taller ones will have a kind of 1920s feel, that intense verticality and vertiginousness that you see in *Metropolis*. Some of the colorways of the tabletops are quite candy bar, very 80s, which I really like. But if I have one too many of a certain color in there, it really pushes towards a 1980s five-year-old's bedroom. I like that too, but I'm not sure how many others will come with me. [Laughs.] So right now it's just about trying to find that balance.

CR You are also showing some lamps along with it, aren't you?

BLW Yes, I'm showing the tables together with Pyrex glass lights. They're called Totem because they're based on a stacking system with a central core made from glass. All the pieces lock on to one another along that core. It's very light glass, but very strong. It allows you to have a lot of layers together, and not massively compromise yourself because it weighs a ton. The forms for the core are based on the generic forms that I know Pyrex is used for: chemistry sets and bottles and those kinds of volumes. They have quite an ambiguity about them, they can look like an octopus or a clown or a robot, depending on the kind of light bulbs you put in. But I'm not going to see what they're going to look like together with the tables until everything arrives in the gallery, because the tables are being made here, and the lights in Italy. And then it's too late! [Laughs.]

CR It's like an arranged marriage, and they haven't actually met.

BLW It's a good-looking arranged marriage, hopefully.

CR What's the worst that could happen?

BLW That the lights fall down. [Laughs.] But it's good to be scared sometimes, to keep you on it. At the end of the day, all I want to do is make really good work and have a really good show and make the most of it. All I can do is work super hard and hope for the best, really.

CR Your tutors at Royal College were none other than Martino Gamper and Jurgen Bey, both phenomenal talents. What do you think you learned from them?

BLW Jurgen taught me to speak about the larger context of my work, and not to panic so much. He has the most amazing stories. When you hear him talk, see his passion, it's inspiring… He has a very narrow vision about particular subjects, but it allows him to go so far, and so fast. Sometimes it's hard to keep up with him. It's like you're in this lovely world where the light is beautiful and fairies are jumping around, and then he stops speaking, and suddenly you can't remember what he's said. So you have to train yourself to stay focused.

CR And what about Martino?

BLW How to go on crazy road trips, and everything about speed. He's really super speedy. He's got a great energy, and really makes you feel that you just have to do it, just get on, pick up something, cut it, touch it. He's really hands on. And joy, I think, is also something I learned from Martino. It really was so great to have those two teachers. They have two very different ways of working, but they have quite similar interests.

CR With all your traveling right now, what are your favorite cities?

BLW London. I love London, massively.

CR Why London?

BLW Just for its bonkers-ness! I love that one minute in one direction you suddenly hit Jewish-town and find those amazing hats that you can't go and buy yourself because you're not allowed in the shops. And then the next minute you'll be in beautiful Africana, and those amazing ladies with beautiful headpieces, amazing fabric on Ridley Road. And then the next minute you'll be down at Bethnal Green and you have a totally different ethnicity again. I just like that London is very cosmopolitan. I like the weirdness. But there are so many other places that I'd like to go. I'd like to spend more time in New York, for example. Or Iceland, which is on my top list of places to go. I haven't ever really gone abroad that much.

CR You're not a traveler by nature?

BLW No, we never were, as a family. My parents both worked very hard, and they didn't always have the time. And then there would be the years where my dad would tell us going to Ireland for the day was a family holiday. So yeah, I think I've only just started to get the traveling bug.

CR What is your idea of a really good night out?

BLW I'd actually love to go back to Boombox [a Sunday-night club that ran in Hoxton from 2006–2008 and which was very popular with artists, designers, and fashion people]. It was just a very crazy night where lots of people congregated in one place and got ridiculously dressed up to no particular theme. If you were a regular and made an effort you'd get in, and if you weren't a regular and didn't make an effort, you would stand outside and wait. [Laughs.] I just met so many creative people there who I wouldn't have met otherwise because Boombox allowed everyone to mix as long as you were creative enough to make an outfit.

CR Have you kept in touch with the people you met there?

BLW Quite a few, yes. [Milliner] Piers Atkinson gave me a hat today, so now I've got a fruit bowl for my head! And I see Gary Card [who recently designed the interior of the high-fashion, appointment-only LN-CC store in Dalston] when I can. There's also David White, a set designer, who does a lot for *Vogue* at the moment, and Fred Butler who's a great stylist.

CR Where in London do you go out now?

BLW I like Vogue Fabrics in Dalston at the moment. When it first opened, it was a proper bears' club, I'd never really seen that many gay bears before. I only knew dress-up gays who pranced. And these guys were all like, "Woof!" So I don't know if I'm going to meet my next boyfriend there.

CR Who's your ideal man?

BLW Um, um. I always love a dress-up. I once went out with a guy who started out dressing like a clown, and by the end of our relationship — it wasn't very long — he started wearing hoop skirts and stripper heels. I have no problem with a man in a dress or a man in high heels, but the look was just a little too childish for me. At the moment I do quite like facial hair. I like an older man.

CR Odd or older?

BLW Older. But odd helps!

Editor
 Andrew Ayers

Book Design
 Dylan Fracareta

Executive Editor
 Felix Burrichter

Acknowledgements
 Nicholas Boston, Michael Bullock,
 Victoria Camblin, Simon Castets,
 Carson Chan, Aric Chen, Ricky
 Clifton, Craig Cohen, Stuart Comer,
 Wes Del Val, Stephen Froese,
 Beatrice Galilee, Aurélien Gillier,
 Kevin Greenberg, Fritz Haeg,
 Geoffrey Han, Brooke Hodge,
 Michael Ned Holte, Emily King,
 Matylda Krzykowski, Michael
 Ladner, Pierre Alexandre de Looz,
 Will Luckman, Brian Phillips,
 Caroline Roux, Julika Rudelius,
 Adam Saletti, Kenny Schachter,
 Horacio Silva, Jill Singer, Amelia
 Stein, Stephen Todd, Katya
 Tylevich, Nina Ventura, Francesco
 Vezzoli, Ben Widdicombe, Linda
 Yablonsky; and all artists,
 photographers, and writers who
 have contributed to PIN–UP.

Mailing Address
 PIN–UP Magazine
 175 East Broadway, Suite 5a
 New York, NY 10002

Website
 pinupmagazine.org

PIN–UP Interviews

© 2013 FEBU Publishing LLC

Published in the United States by
powerHouse Books,
a division of powerHouse Cultural
Entertainment, Inc.

Mailing Address
 37 Main Street, Brooklyn, NY
 11201–1021

Telephone
 (212) 604–9074

Fax
 (212) 366–5247

E-mail
 info@powerHouseBooks.com

Website
 powerHouseBooks.com

First edition, 2013

Library of Congress Control Number
 2013940408

Hardcover ISBN
 978-1-57687-653-4

Printing and binding by
 RR Donnelley

10 9 8 7 6 5 4 3 2 1

Printed and bound in China